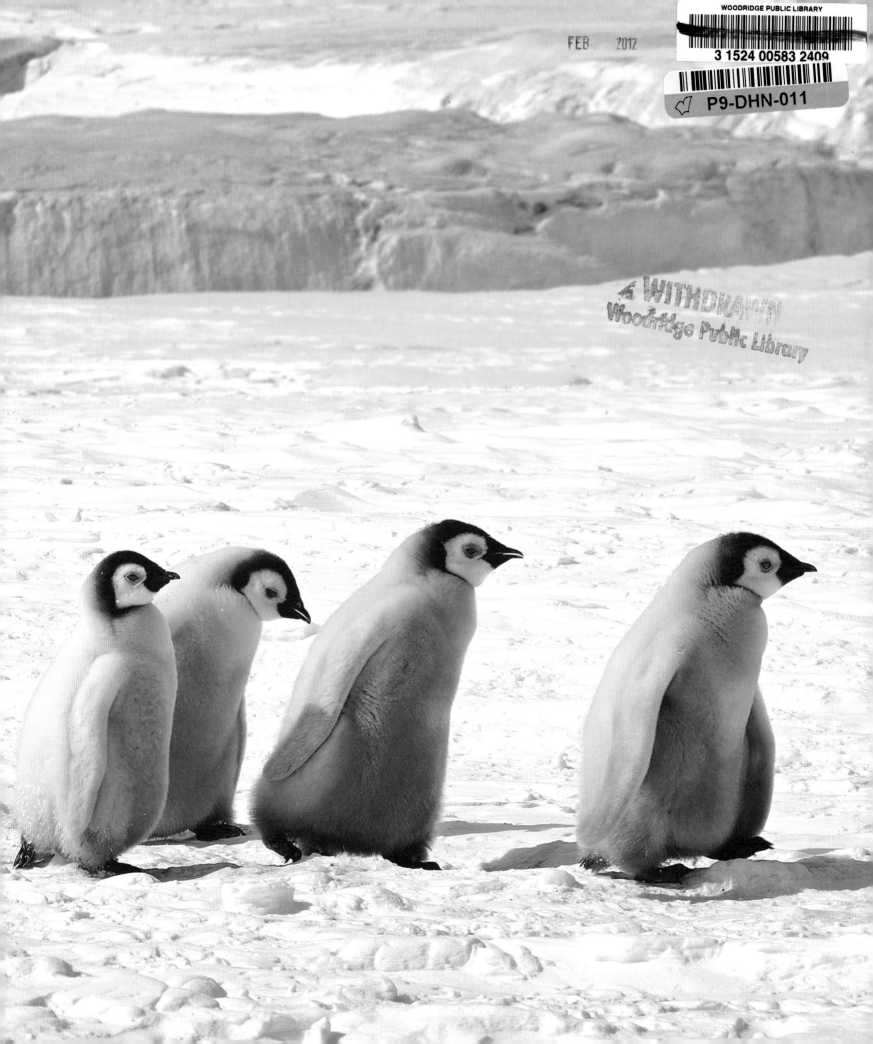

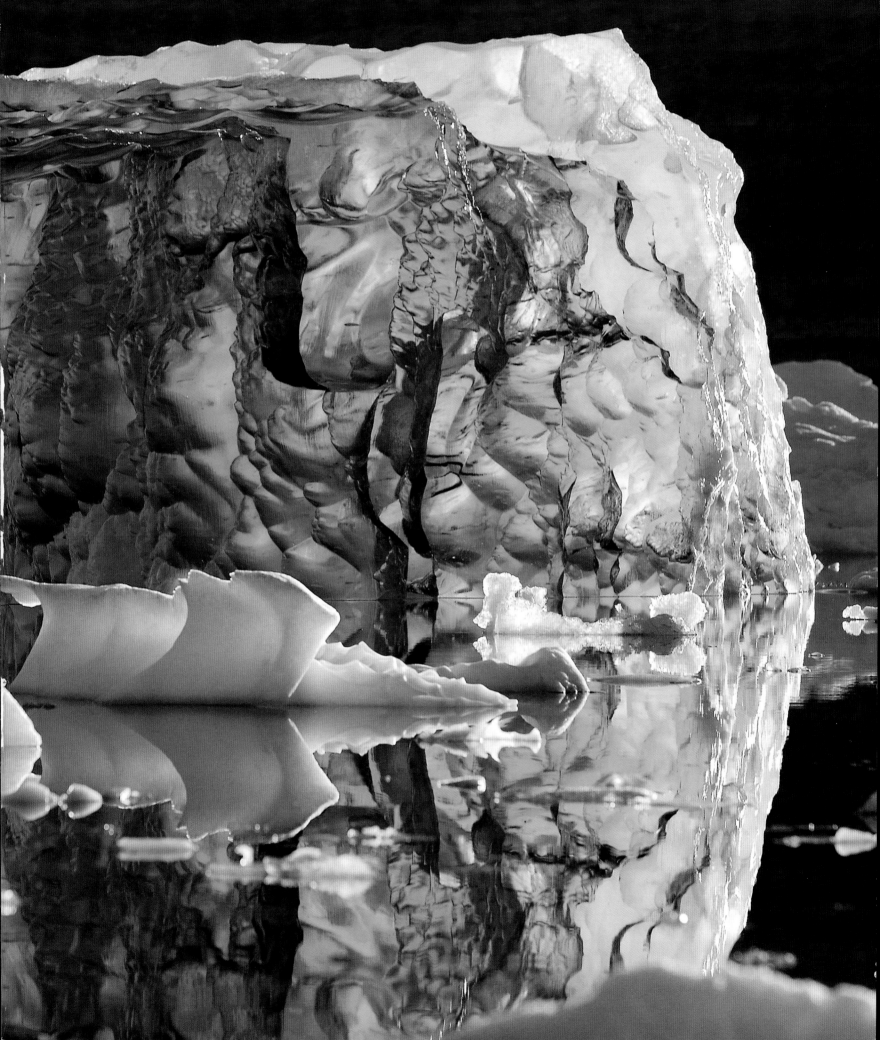

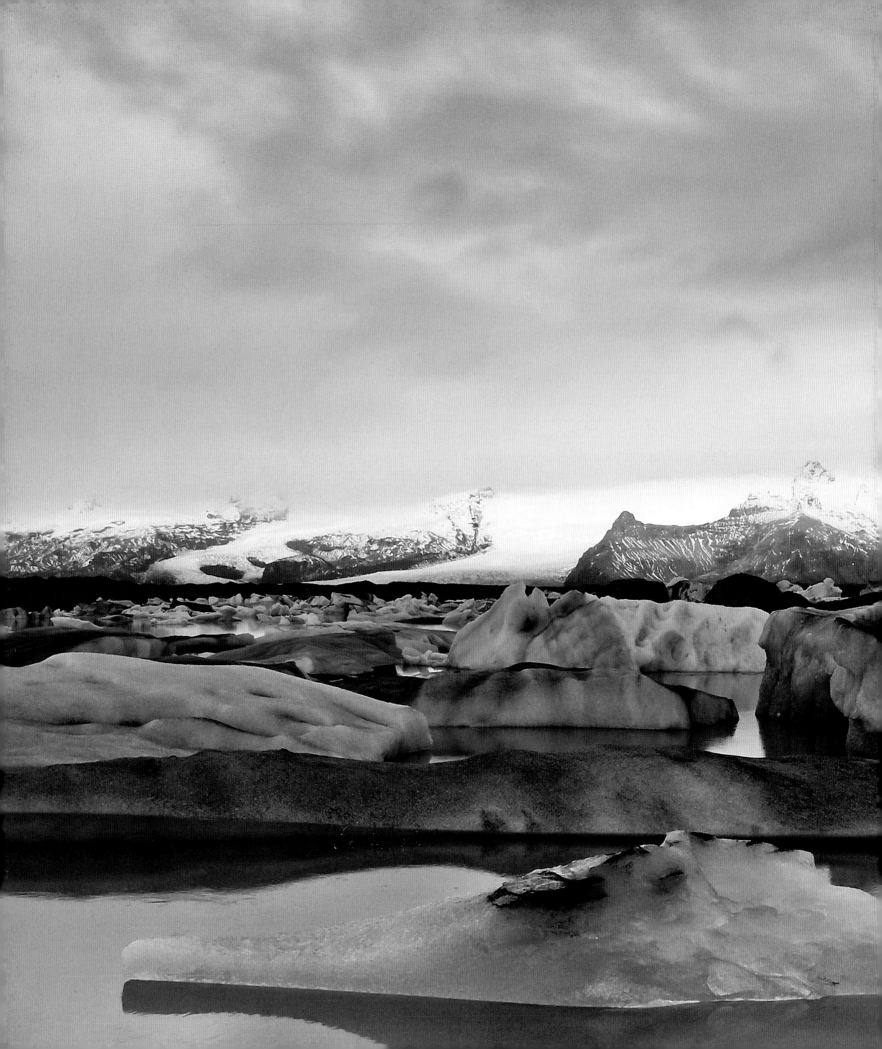

frozen planet

a world beyond imagination

ALASTAIR FOTHERGILL AND
VANESSA BERLOWITZ

FOREWORD BY
DAVID ATTENBOROUGH

FIREFLY BOOKS

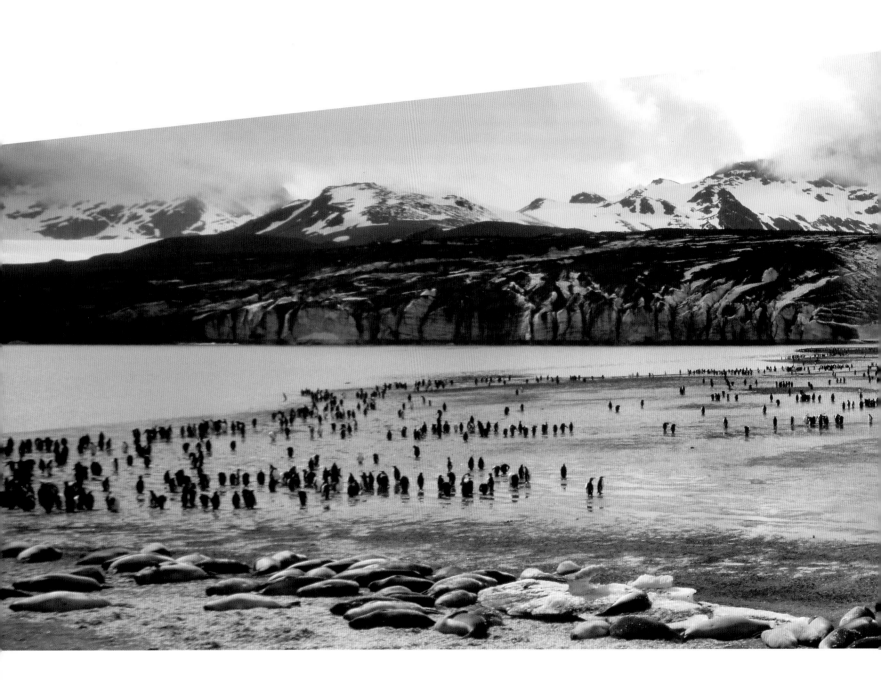

Contents

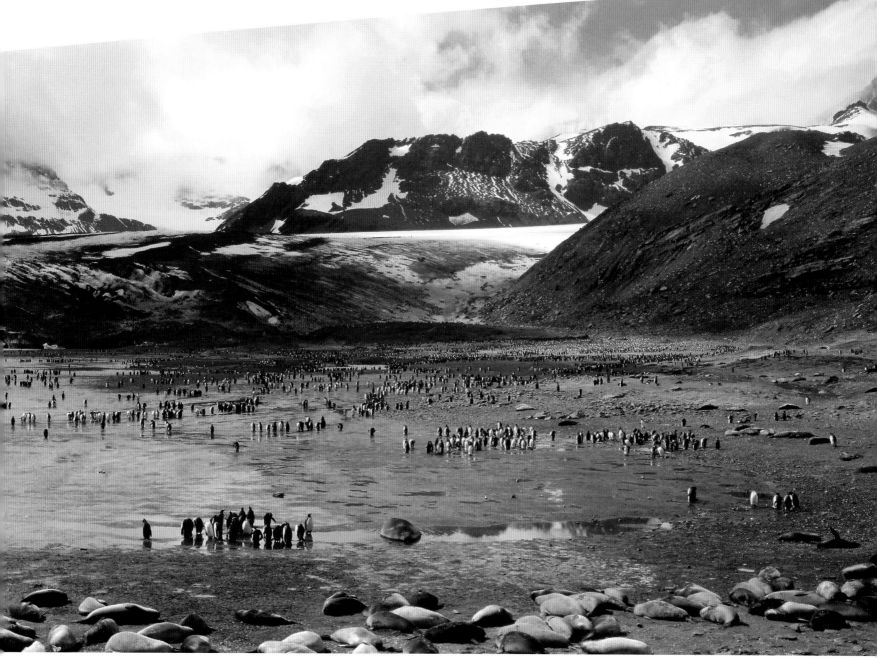

Foreword: David Attenborough

No part of planet Earth is more hostile to life than the snow- and ice-covered regions that lie around its two poles, the ends of the axis around which our globe revolves. Yet animals of many kinds – land-living mammals in the north, birds in the south and sea mammals in both places – have over many thousands of years evolved extraordinary ways of surviving there. The number of species that have done so is not large, and so they have few competitors. But, as a consequence, they are able to flourish in dramatic numbers. Life can be at its most spectacular, paradoxically, where living is at its most difficult.

In the north, the pole itself is covered by a frozen sea. A few people, surely among the most hardy of humans, have for centuries ventured out onto the ice and survived there by hunting. But to people living in more temperate lands to the south, these ice wastes have long represented the most inaccessible lands on Earth. That is so no longer. Today you can reach the North Pole by flying from Longyearbyen, a town in the Norwegian territory of Svalbard 1125km (700 miles) to the south, to a camp erected on the ice each year by the Russians. From there it is only about 115km (70 miles) to the pole. Some stalwart travellers complete the journey on foot, but many reach it by helicopter – as I did.

The day after my visit, back in the Russian camp, I noticed a crack a few centimetres wide in the ice between my tent and the stretch of levelled and cleared ice that served as a landing strip. The Russians in charge of the camp were unconcerned. Cracks often appear in the ice, they said. But that crack continued to widen. Two days after I had left, it was 28 metres (90 feet) across, and the camp had to be evacuated in a hurry.

For the Arctic, without question, is warming. Within the foreseeable future, the sea ice that covers the North Pole itself may disappear altogether each summer, and ships will be able to sail across from the Pacific along the northern coasts of North America and Eurasia and into the Atlantic Ocean.

The southern end of the planet is rather different. That pole lies not beneath an ocean but at the centre of a vast continent that is so far from populated parts of the world that humans did not even glimpse its coasts until less than 200 years ago. Once it had been discovered, people strove to reach the pole. To do so seemed the most

ambitious and daring feat that humans could devise, and men died in the attempt to be the first to do so.

No longer. You can fly there, too, and a great building now stands at the South Pole itself – on stilts to allow for the steady accumulation of snow around it. Inside, insulated from the extreme cold, scientists work the year round, looking out to the planets and galaxies that lie beyond and studying earthly phenomena that here can be examined in ways that cannot be done anywhere else.

And the climate is changing here, too. The ice beneath their building is 5km (3 miles) thick and is not likely to melt within the next few centuries. But the fringe of sea ice that surrounds the continent like a gigantic white skirt is now beginning to fragment. So mountains that once appeared to be lying well inland are now revealed to be islands separated from the continent in summer by open sea.

All these changes, in both the north and the south, are having a radical effect on polar animals. The very adaptations that enabled them to survive the extreme cold are proving to be handicaps in the warmer summers. Different species, living in slightly less hostile parts of the planet, are moving closer to the poles and displacing those that once had such places to themselves. Nevertheless, for humans, working there is still appallingly difficult. Hands touching metal can be stripped of their skin. A blizzard can imprison a traveller in his tent for days. Sea ice can split away beneath your feet and leave you lethally marooned.

But recording the wonders of these parts of the planet is now more important and valuable than ever before. To film wildlife, particularly during the winter, required camera teams to work in the toughest conditions on Earth. The pictures they produced in the three years that they worked on the *Frozen Planet* series captured behaviour and phenomena that had never before been recorded, either on film or electronically. And those pictures will become increasingly valuable as time passes. For this may well prove to be our last chance to record, in their full splendour, these astonishing wonderlands that have existed for hundreds of thousands of years before humans reached them and which now, within a century, may change beyond recognition.

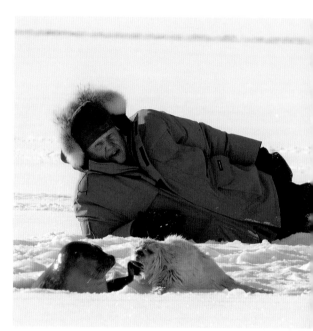

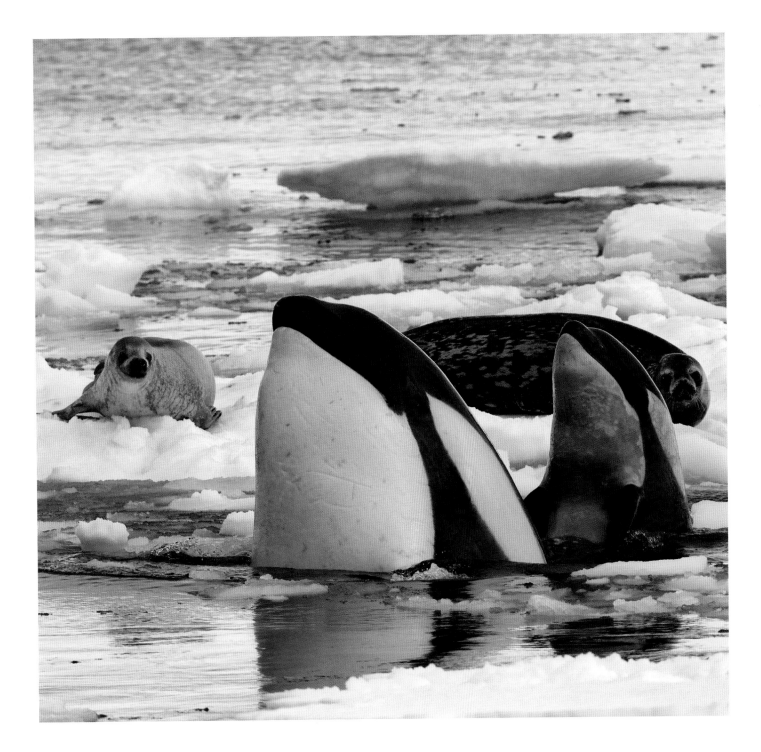

Chapter one | Pole to pole

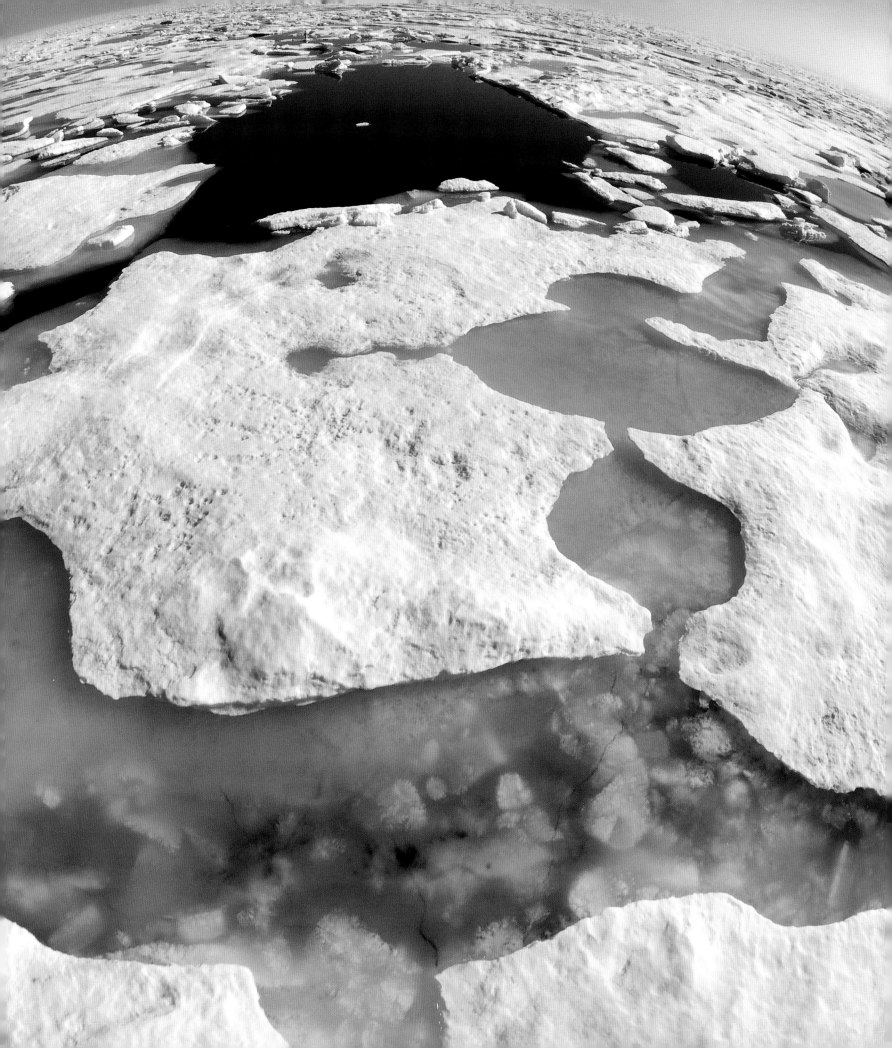

To the ends of the Earth

Standing at the North Pole is an unnerving experience. The ground beneath you looks like any piece of snow-covered frozen land. It's not. It's sea ice, and just a couple of metres of it separate you from the freezing Arctic Ocean – more than 4km (2.5 miles) deep at this point. The ice is also constantly on the move. Driven by wind and ocean currents, it can drift up to 40km (25 miles) in a day. For this reason there is no permanent North Pole marker on the ice. A hand-held GPS reading of 90 degrees north gives a reasonable indication. But to see a permanent marker, you have to dive to the seabed, where in 2007 the Russians planted their flag, made from rustproof titanium. The planet rotates around the axis that connects the North Pole and the South Pole, and so in one sense, if you stand at 90 degrees north – actually at the North Pole – you are more truly stationary there than anywhere else on the planet (except, of course, the South Pole).

THE RIDDLE OF THE FROZEN POLES

On 22 or 23 September at the North Pole, the sun sets and will not rise again for six months. Without its energy, the temperature plummets. Then on 20 or 21 March – the spring equinox – the sun finally rises again and doesn't set until 22 or 23 September, circling permanently above in one long six-month day. So given that the North Pole receives twice as much daylight as anywhere on the equator in these six months, why isn't it the hottest place on the planet? Now you arrive at the real reason that the ends of our planet are frozen.

The sun strikes the poles at an oblique angle and so has almost no warmth. The only part of the Earth that faces the sun directly is the equator. The oblique angle also means there is more atmosphere for the rays to penetrate before they reach the North Pole, which weakens them further. The sun stays low in the sky, and so you never experience the warmth of a high midday sun. What little sun does get through is mostly reflected back to space by the ice that blankets the ocean nearly all year round. Elsewhere on the planet, far less of the sun's energy is reflected back, and a good proportion of the amount that is gets absorbed by water vapour in the air. By comparison, the air at the poles is incredibly dry, and this also reduces the temperature.

Above

The sun rising over Antarctica, as seen from space. It will stay up in the sky for six months, circling anticlockwise low over the horizon. Antarctica is the highest continent on Earth, and so at the South Pole – even in midsummer, with 24-hour daylight – temperatures barely rise above -30°C (-22°F).

Opposite

The Canadian High Arctic – a typical view of sea ice in late summer. Snow that has collected in winter on the frozen ocean melts into blue freshwater ponds. These darker areas absorb more sun and speed up the melt.

Previous page

Blue iceberg, Greenland.

AN UNDULATING BLANKET OF ICE

As soon as you take a step away from the North Pole, in whatever direction, you are heading south. East and west have no relevance. From here to the nearest land – at the northern tip of Greenland – there is a 725km (450-mile) stretch of sea ice. Polar aficionados like to call it pack ice, and as soon as you start to walk on it, you can see why. The constantly moving ice breaks and then packs together, creating a dynamic, undulating landscape. As the fields of pack ice collide, pressure ridges build, some to the height of a three-storey house and four times that beneath it. The ridges can extend for miles across the frozen Arctic Ocean. These strange ice features are usually a sign that the ice is old – 'multiyear' ice that has remained frozen through the summer and grown further the following winter, thickening year on year until, in places, it can be as much as 8 metres (26 feet) thick.

About a quarter of the pack ice is young ice, newly frozen every year, and as it starts to freeze in autumn, it expands at a rate of up to 60 square kilometres (23 square miles) per minute until, at its maximum, there are nearly 14 million square kilometres (5.5 million square miles) of sea ice blanketing nearly 85 per cent of the Arctic Ocean.

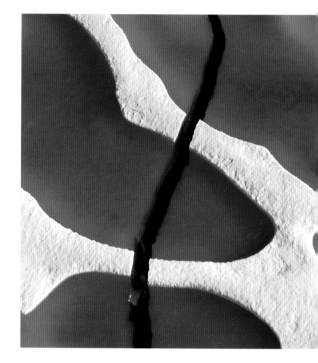

A LIFE ON ICE

A polar bear ambling across pack ice reveals its perfect design for roaming the frozen ocean. Its white-fur camouflage, long nose for sniffing out seals, meat-shearing teeth and ability to sprint at up to 56kph (35mph) are evidence of how its evolution from a brown bear ancestor has been fine-tuned by the ice and the seals on which it feeds.

It's a master at navigating treacherous icy terrain. Immense, broad paws enable it to distribute its weight so effectively that, at 362kg (800 pounds), a bear can walk on ice that would break under the weight of the average man. On fragile ice, a polar bear will adopt a spread-eagle walk and may even resort to crawling on its belly, dragging itself along with its claws. Though it will mostly walk about like a land bear, if the ice gives way, it takes to the water with surprising ease, revealing its maritime nature, suggested by its scientific name *Ursus maritimus*, or sea bear. And the polar bear is, indeed, a marine

Above
A crack in the sea ice made by strong tides. Arctic Ocean tides play a major part in the break-up and redistribution of the sea ice.

Opposite
An ice lead formed in the pack ice in late spring, Fugelfjorden, Svalbard. Leads can extend for hundreds of kilometres and be anything from a few metres to hundreds of metres in width. They provide a lifeline for people and whales attempting to navigate the pack ice.

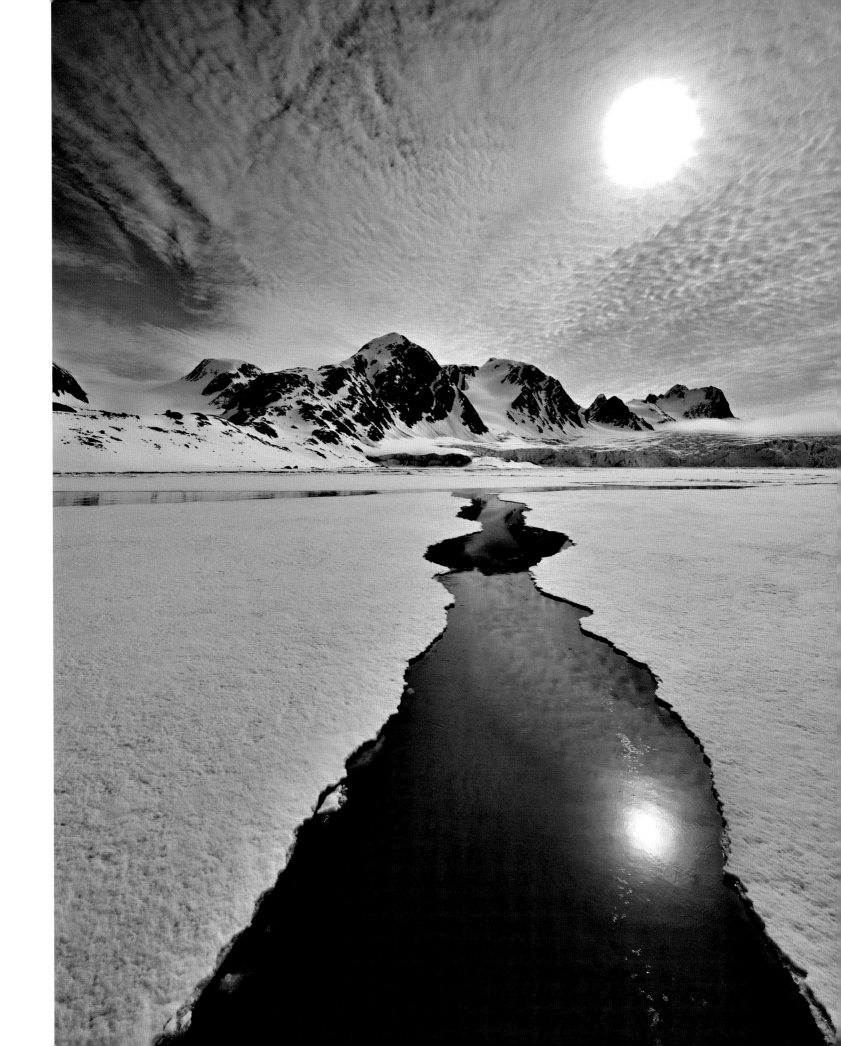

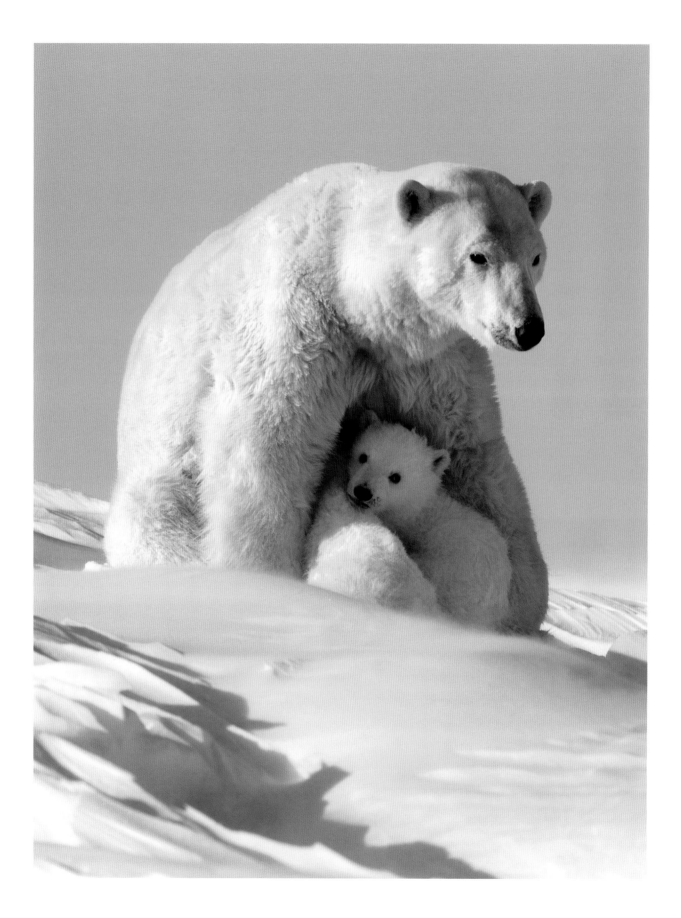

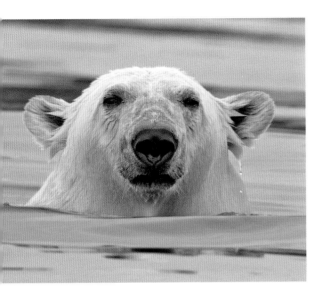

mammal, since it depends completely on the sea for its existence. In its lifetime, a polar bear will cover an enormous area of the Arctic Ocean – up to 259,000 square kilometres (100,000 square miles).

Such a nomadic nature makes it difficult to estimate how many polar bears there are, though there are thought to be 20,000–25,000. Most stay close to ice that is thin or breaks open regularly, using the ice floes as platforms from which to catch seals.

Few bears stray farther north than 82 degrees, where the ice is thick and there is a low density of seals, but in 2006, a bear was spotted only 1.6km (1 mile) from the North Pole – the northernmost sighting on record. The species' movement south is limited only by the extent of the sea ice – the frozen ocean is where the polar bear is most at home. It returns to land only when driven there by the retreat of the ice or, in the case of a female, in search of a safe, snow-covered denning place.

THE COLDEST PLACE ON EARTH

The Arctic Ocean is the smallest of the world's five oceans and is ringed by land masses – the northern tips of three continents: Asia, Europe and North America, the island of Greenland (the largest island on Earth) and several archipelagos. Overall, the climate of these Arctic lands is made less extreme by being close to the ocean, the temperature of which can never fall below -2°C (28°F).

In winter, this relatively warm water, though covered by the polar ice, stops the North Pole from being the coldest place in the Arctic. That record goes to Oymyakon, a town in Siberia with a record-breaking low of -71.2°C (-96°F). Such low temperatures occur when cold-air 'lakes' form over the interior of the Arctic land masses.

These 'temperature inversions' are formed when colder, denser air sinks and does not mix with the warmer air above. They are linked with some eerie phenomena. Sound travels much farther as it bounces back from the warmer air above, and so human voices can be heard over extremely long distances. And light rays are bent so that objects below the horizon may appear above it. This effect, known as looming, is a form of mirage that allows you to see a sun or moon that has already set, albeit in a distorted form.

Above
The sea bear. Polar bears are effectively marine mammals, dependent on other sea mammals for food. They are capable of paddling non-stop for more than 150km (90 miles) and have been seen swimming many kilometres from the nearest ice or land.

Opposite
A mother polar bear protecting her two cubs while they take turns to suckle. They will feed for up to 15 minutes or so, 6 or 7 times a day, and will continue to do so for months. At this age (they have only been out of the den for a week or so), they are particularly vulnerable to passing male bears.

GREENLAND'S GREAT ICE SHEET

When you look down on Greenland from a plane, you'll see little green land. In fact, this land was deliberately misnamed by the tenth-century Norwegian outlaw Eric the Red in a bid to lure settlers from Iceland. Anyone believing Eric's sales pitch would have been shocked to discover that 81 per cent of Greenland, an area seven times the size of the United Kingdom, is covered in ice. This is the largest body of ice in the northern hemisphere, comprising 8 per cent of all the fresh water on Earth, and is the only true ice sheet in the Arctic. It's a remnant of the ice ages, when gigantic ice sheets covered large parts of the land masses and continental shelves of the northern hemisphere.

The Greenland Ice Sheet has formed over thousands of years from layers of winter snow. At its deepest, it's more than 3km (1.9 miles) thick, and at its base, it's a quarter of a million years old. Today, it no longer stretches to the coast but is fringed by a relatively narrow border of land, uncovered about 9000 years after the end of the last ice age.

From a plane, the ice looks flat and featureless, but lose some altitude, and it appears to come alive. In summer, its surface is covered with turquoise meltwater, which courses through a network of channels. In places, the meltwater pools into azure-blue lakes, kilometres across – temporary oases of colour in a desert of ice.

THE ICE SPECTACLE

Down at ice level, the sound of the melt is deafening. Everywhere water is on the move. Gentle brooks flow into larger streams, which empty into roaring, angry rivers, churning through deep ice canyons that, if they were rock, would take millennia for rivers to carve through but here form in a matter of weeks. Though these channels may be less than 30 metres (100 feet) across, each will carry more water over the summer months than the Thames. Extreme caution must be exercised on their banks, since many of the major channels end in moulins (French for mill) – vertical shafts that swallow the entire river, the water plunging straight down 3km (1.9 miles) to the base of the ice cap. It's one of the most dramatic spectacles on the planet – nearly 500 litres (110 gallons) a second simply vanish from view. Over the few months of the summer-melt season,

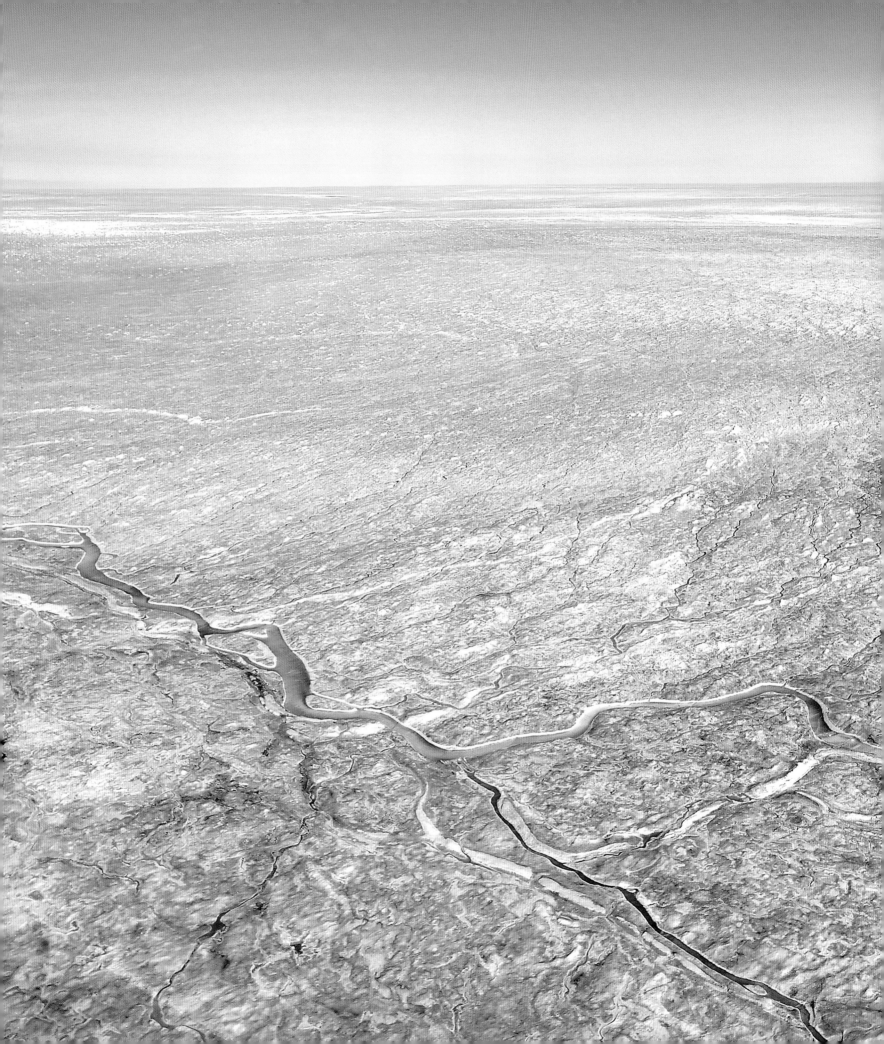

413 billion tonnes of water drain off the ice sheet through moulins and hidden drainage systems in the ice.

As you travel away from its centre, the surface of the ice sheet becomes increasingly crumpled and crevassed – evidence that the entire ice sheet is on the move, slowly flowing downhill under its own weight at a speed of up to 200 metres (656 feet) per year. Meltwater from the surface acts as a lubricant between the ice and the rock underneath. In the east and south, the ice is held back by towering mountain ranges, and so most of it drains towards the west, pushed out into the sea as giant glaciers.

THE GREENLAND ICEBERG FACTORIES

Spring is calving season in Greenland. When the sea ice melts away from the fjords, the glaciers are unleashed. A flotilla of icebergs, some as jagged as fairytale castles, others as smooth as giant eggs, calve from the ice sheet.

Lore has it that when you see just the 'tip of the iceberg' you are only seeing one tenth of it, the rest being hidden below the surface. But in reality, about one seventh is visible, because glacier ice contains many more air bubbles than most ice, making it more buoyant. These air bubbles are trapped in the snow as it is compressed into ice and are the reason that icebergs are white. Blue bands in icebergs are formed by the freezing of relatively bubble-free meltwater in the glacier's crevasses, which reflects back only blue wavelengths.

Icebergs from glaciers in Greenland frequently get caught by currents and carried southwards. Some of the largest drift as far south as 40 degrees north before they melt. It was one of these icebergs that sealed the fate of the *Titanic* in 1912, sinking the ship in less than three hours, and causing 1513 people to drown. Each year, tens of thousands of icebergs – more than 350 billion tonnes of ice – are produced from Greenland's glaciers. This floods the sea with nutrients, nourishing plankton, which in turn supports the region's rich marine life. The cold fresh water that drains from Greenland or breaks into the sea as icebergs also plays a part in the global circulation of ocean currents, influencing weather patterns far beyond the poles.

Above
Glacier ice detail, Disko Bay, western Greenland. Old blue ice (blue because of the pressure it is under) has been revealed by crevassing, which occurs as the glacier stretches and distorts.

Opposite
The aftermath of an explosive calving event at the Humboldt Glacier in northern Greenland. Large icebergs have drifted several kilometres from the front, while at its centre, smaller pieces of ice known as 'growlers' and 'bergy bits' are yet to disperse. The calving front of the Humboldt spans 110km (68 miles), making it the widest glacier in the northern hemisphere.

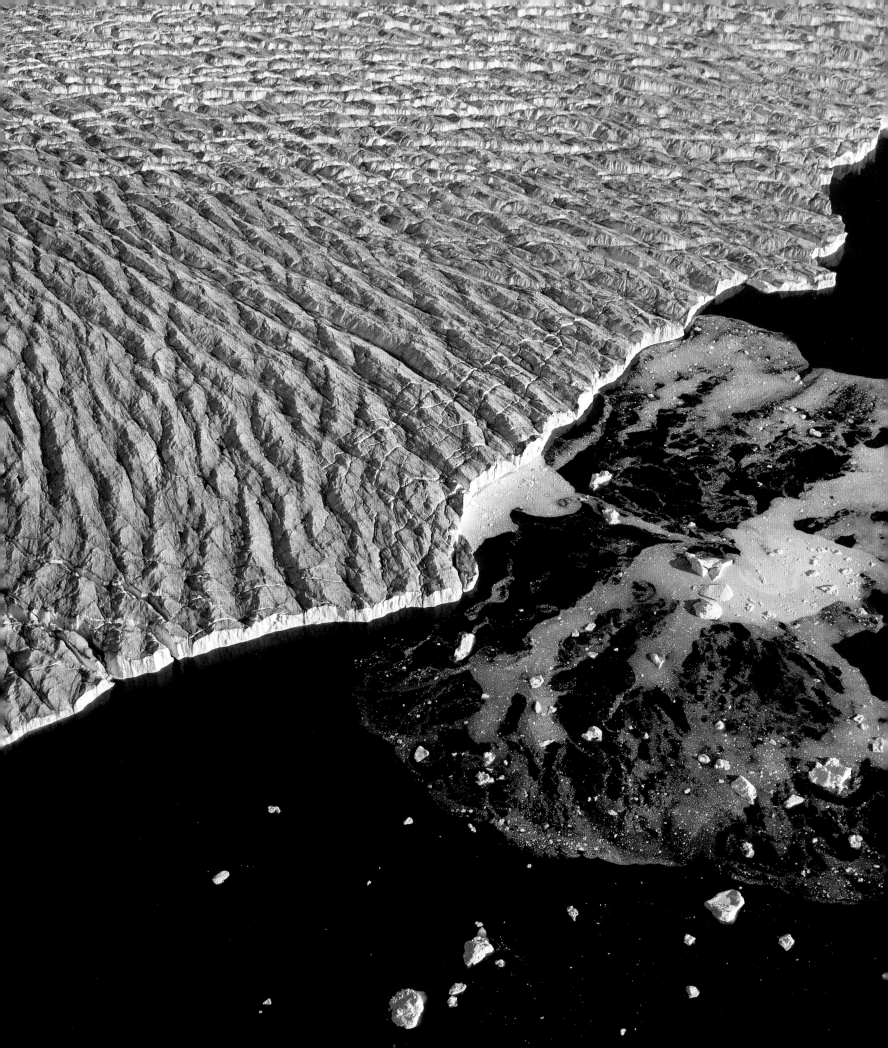

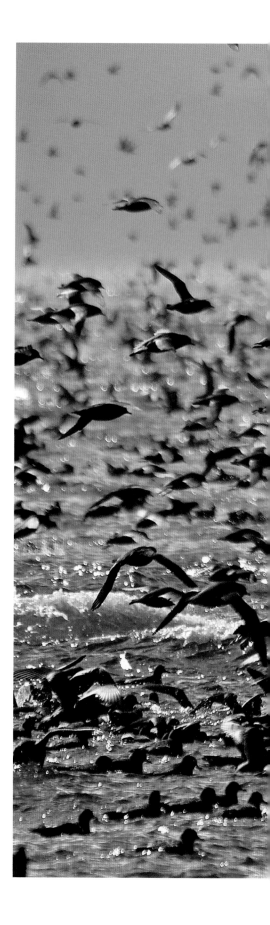

THE BIG MELT

Though the centre of the Arctic Ocean is locked in ice year round and relatively devoid of life, in summer the shallow seas that surround it become some of the world's richest. This transformation has its origin in five great rivers that empty into the Arctic Ocean – the Lena, Ob and Yenisey in Russia, and the Mackenzie and Yukon in North America. For half the year, these rivers are frozen almost solid, with ice waterfalls acting as giant dams. In spring, the thaw in the higher reaches causes water pressure to build beneath the ice. The ice dams give way and the river is released. In a matter of minutes the river becomes an ice conveyor belt, churning up riverbanks and snapping trees as if they were matchsticks. The movement of the ice can't match the speed at which the meltwater begins to hurtle down the river. In just 30 minutes, a 12-metre (39-foot) rise in the water level was measured on the Mackenzie River in Canada. The resulting flooding and ice damage costs North Americans $160 million every year. But as the great Arctic rivers discharge into the Arctic Ocean, they bring with them more than 5000 cubic kilometres (1200 cubic miles) of nutrient-rich fresh water. This represents 10 per cent of the world's freshwater run-off, fertilizing the Arctic Ocean and reducing its overall salinity.

Each year, the Lena River in Russia deposits a staggering 11 million tonnes of silt, creating a dark plume that extends up to 100km (62 miles) offshore. These annual deposits have built vast deltas along the coast, havens for wildfowl and shorebirds. The Arctic Ocean also mingles with the Atlantic via the Norwegian Current and with the Pacific via the Bering Strait, the cold, nutrient-rich water helping to fuel an explosion of life.

THE ALEUTIAN BLOWOUT

The Aleutians are a chain of jagged islands extending from Alaska and separating the Bering Sea from the Pacific. Each summer, ferocious storms combine with powerful currents in the channels between the islands to stir up deep water from the Pacific. Long hours of sunlight create a phytoplankton bloom, which fuels an explosion of northern krill. Though less than 2cm long, these shrimp-like creatures turn the sea red, creating giant slicks and attracting more than 18 million seabirds – the largest congregation on Earth.

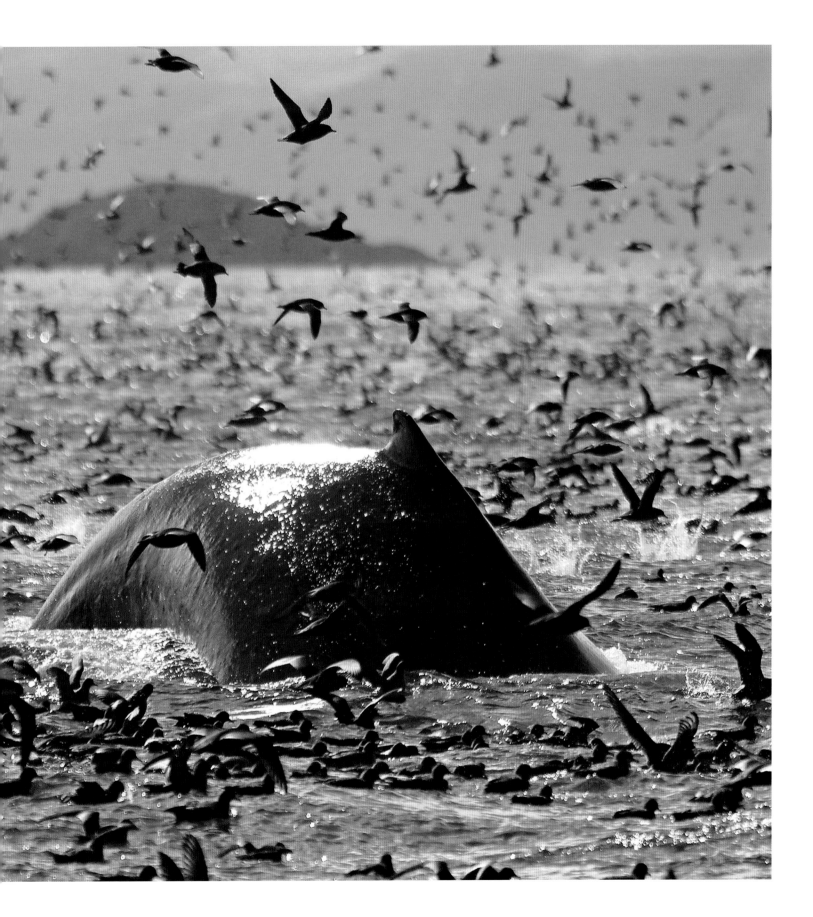

Millions of short-tailed shearwaters make an extraordinary six-week, 15,000km-long (9320-mile) journey from their breeding grounds in Australia and New Zealand, timed to coincide with the krill. Flocks are so dense that they blacken the sky. In coordinated attacks, the shearwaters dive after krill to depths of up to 50 metres (165 feet). They are joined by herring and mackerel, which in turn are chased by sealions and fur seals.

The last to arrive at the feast, all the way from Hawaii, take the biggest mouthfuls. Humpback whales are 'gulpers', preferring concentrated masses of prey so they waste as little energy as possible feeding. In one day, an average-sized humpback may eat a tonne of plankton, krill and small schooling fish. They feed among the great mass of shearwaters, rolling onto their sides to scoop large volumes of water and then filtering out the food, birds included if they fail to avoid the open mouths.

FLOWERING TUNDRA

The first land you encounter south of the Arctic ice is the tundra – a vast treeless belt of windswept, flat and rocky land, much of which was covered by ice in previous ice ages. On the rocks are occasional splashes of orange, green or grey lichens. These are partnerships between fungi and algae, combining the talents of both to withstand extreme dry, cold and windy conditions. They are so hardy that they can survive being freeze-dried close to absolute zero – equivalent to -273°C (-460 °F). Lichens are the first to colonize naked land exposed by retreating ice. Map lichen is actually used to date ice retreat, since it grows at a constant slow rate, with some specimens at least 9000 years old.

Farther south, the tundra becomes a patchwork of plant communities. Heathers, cranberry and blueberry and low shrubs such as willow dominate in some places. For the most part, though, the tundra is sedge meadow, composed mainly of cotton-grass sedge, topped by balls of white fluffy seeds in spring. Where cotton grass species grow in patchy clumps, they form tussock tundra. In rocky areas where the ground is neither too dry nor too wet – mesic tundra – wild flowers flourish. In northern Greenland, only 970km (600 miles) from the North Pole, more than 76 different species of flowering plants have been identified.

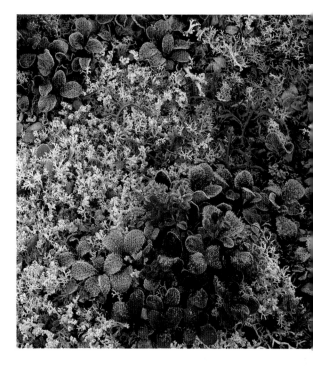

Above
Frost-covered bearberry and lichen in the High Arctic tundra.

Opposite
Siberian tundra in summer, Taimyr Peninsula, Russia. The tundra is a treeless belt of land stretching across the top of Europe, Asia and North America, just below the polar ice cap. It covers 20 per cent of the Earth's surface. In Siberia, where winters are long, with temperatures falling as low as -40°C (-40°F), the permafrost (permanently frozen ground beneath the upper layer of ground) can extend down to 600 metres (1968 feet). In summer, areas of snow and ice melt to form small ponds, or thermokarsts, creating marshes.

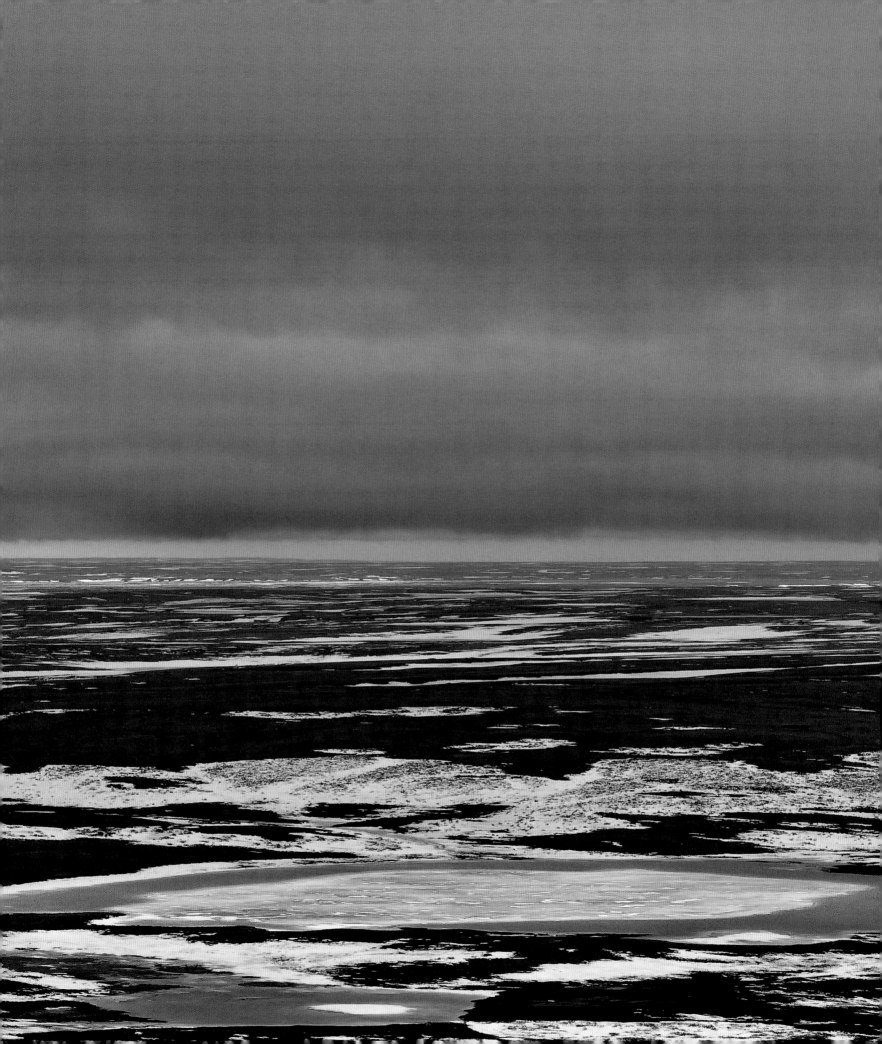

Arctic survivor. Inquisitive and adaptable, the Arctic fox is one of the few mammals that can survive winter in the far north. Its fur provides insulation at temperatures of -40°C (-40°F) or below.

Tundra camouflage expert. At the end of autumn, light-level and hormone changes cause the willow grouse, or willow ptarmigan, to moult from marbled brown into snow-white plumage. Only its tail remains black.

THE ALL-YEAR ANIMALS

In summer, the tundra fills with wildlife, most of which has travelled north on ancient migration routes. Each year, 48 land mammals, ranging in size from tiny voles to muskoxen, are joined by about 150 species of migrant birds. They visit the tundra to feed and breed, and when the first chills of autumn arrive, they simply fly south. The few resident birds – such as snowy owl, ptarmigan, willow grouse, redpoll, raven and gyrfalcon (the largest and most northerly falcon in the world) – are well equipped for the Arctic winter, with dense coverings of feathers, right down to their feet, in the case of the snowy owl and the ptarmigan.

All these Arctic overwinterers have a smooth, wind-proof outer layer of feathers and an inner layer of down that traps warm air close to the body. Indeed, the down of the common eider has the best insulating properties of any known material. Other tricks these birds use to stay warm include digging out snow-holes, standing on one leg to avoid losing too much heat, or standing completely still, allowing their feet to go cold while warmth is conserved in their bodies.

Large mammals head south when temperatures begin to drop. The half a million caribou head back to southern forests for the winter. But for small mammals, migration is not an option. The collared lemming ranges as far north as the very tip of Ellesmere Island, where it survives the longest winter of any land mammal. Its body is as close to a sphere as a mammal can get – the shape most suited for heat conservation – with short legs and tail and small tucked-away ears. Long, bristly fur on the soles of its feet and the densest winter coat of any rodent its size insulate it. As the days shorten, the lemming's coat changes to white – the only colour-changing rodent in the world.

Compared to the red fox, the Arctic fox has small ears, a short muzzle, fur under its feet and a white coat that gives the best insulation of any land mammal studied. Likewise, the Arctic wolf compared to the timber wolf has stumpy legs, rounded ears, a short muzzle and a white coat. Hunters such as gyrfalcons and snowy owls are white to escape detection by prey, while birds such as willow grouse turn white to avoid predators. So why does the raven remain black? Perhaps it is large and aggressive enough not to fall prey to falcons or owls, and being an opportunist feeder, doesn't need to sneak up on prey.

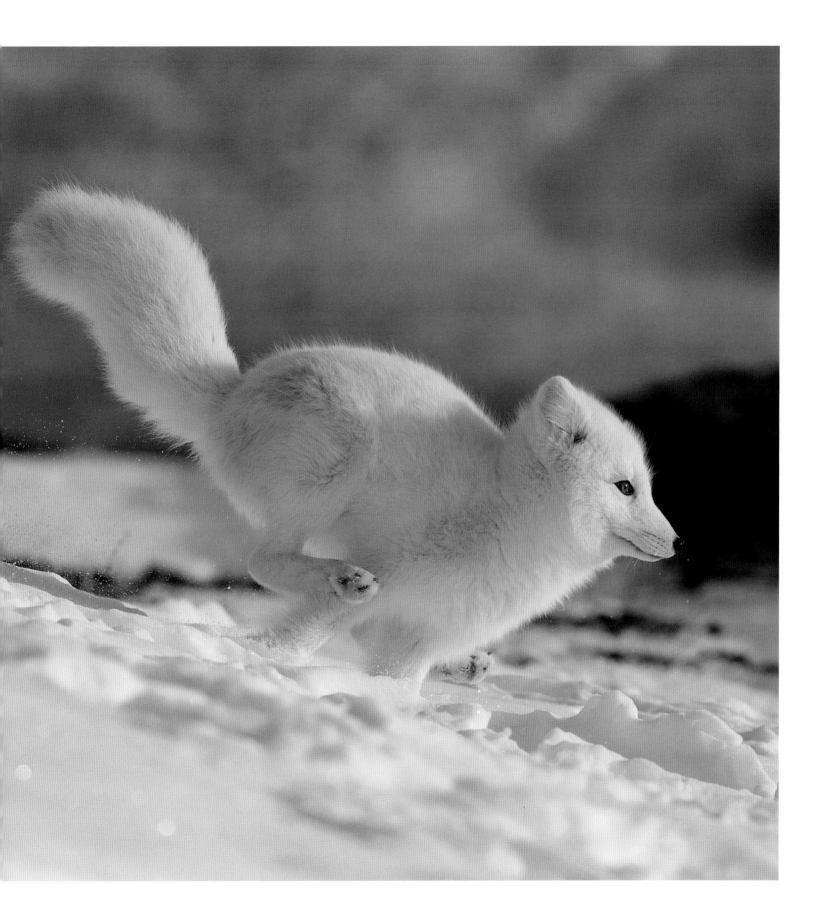

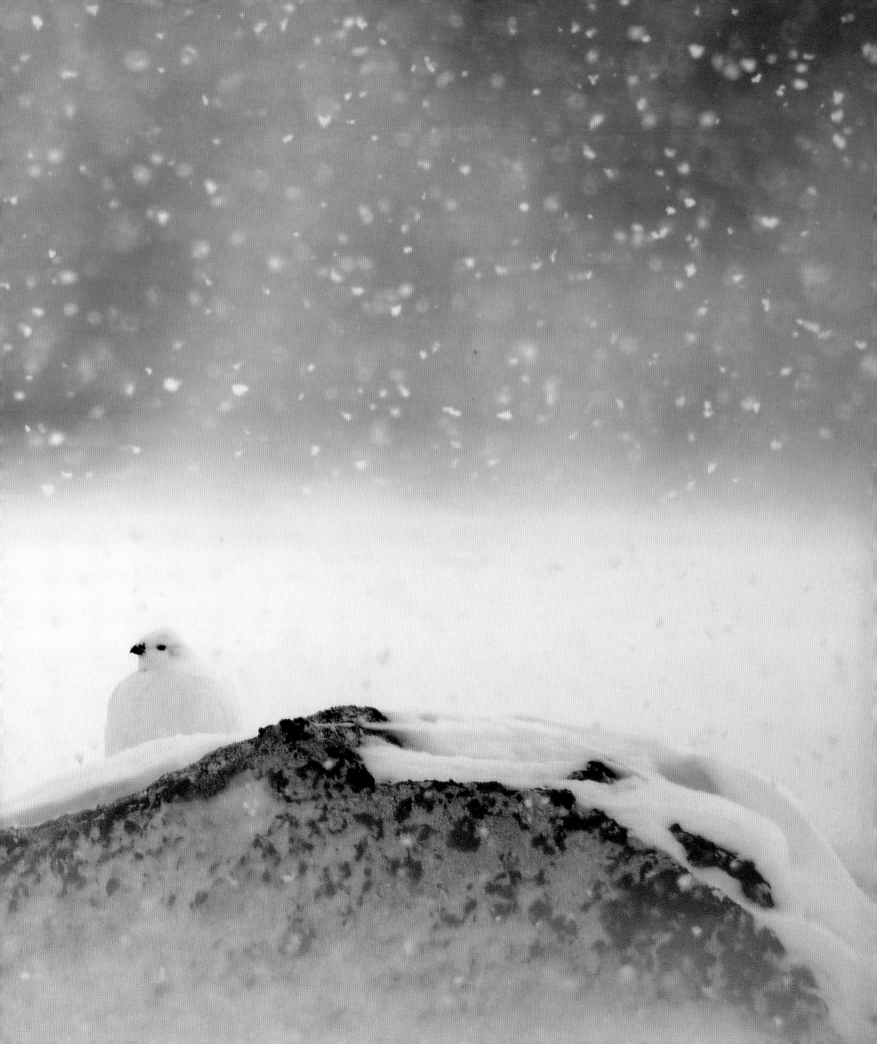

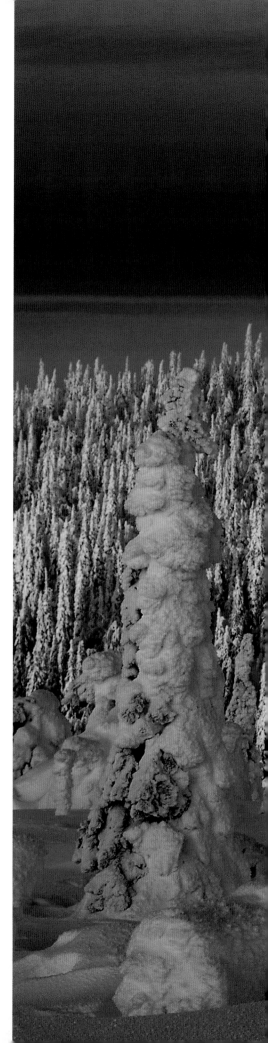

Right

Taiga forest in winter, Finland. The taiga is the greatest forest on Earth, containing at least a third of all the world's trees. The vast stretches of forest are restricted to one or two species of tree, usually conifer. Life is scarce in these forests as conifer needles are hard to digest.

THE WORLD'S GREATEST FOREST

At some point on the tundra, stunted and widely spaced conifers begin to appear. They tend to grow along a line: on one side, tundra, on the other, trees that grow in stature and increase in density as you travel away from it. The treeline is where the growing season begins to be just long enough. Because the growing season increases the farther south you travel, you might expect this line would run west to east following latitude. In reality it is distorted by factors such as soil quality, permafrost depth or temperature influenced by the proximity to the sea or to mountain ranges.

Stand among these waist-high trees, and you are at the start of the greatest forest on Earth. When the snow melts in summer, the taiga forest (or boreal forest, as it's known in North America) can be seen from space as a continuous belt around the top of the planet, broken only by ocean. The best way to understand the vastness of the taiga is to fly from Vladivostok in the east of Russia to Moscow in the west – a ten-hour journey crossing five time zones with a never-ending view of taiga forest. Breathtaking.

The taiga contains at least a third of all the world's trees – more than in all the rainforests combined. Considering its size, you might suppose that it holds a rich diversity of plants and animals, but for vast stretches it often contains just one or two species of tree. The animals are also relatively scarce because conifer needles are hard to digest, and when they are shed, they produce an acid soil that supports little invertebrate life.

Nevertheless, there are a few resident animals – those that can survive on needles, such as capercaillie, porcupine and moose – but their densities are low. Asia and North America were once connected through the Bering land bridge between Alaska and Siberia, and the same animals colonized all the Arctic's land masses. So the mix of animals changes surprisingly little. And since the challenges of living in the taiga are similar wherever you are, there has been little pressure for animal populations to evolve in different directions.

In summer, an enormous influx of migrants arrives to feast on the boom of insects that hatch from the many lakes. There is also a feast of berries to be had on the bushes that grow around their fringes, especially in the forests of northern Canada. But in autumn, the insects die, the berry and seed crops end, the snows arrive and the taiga returns to being a quiet, magical place, inhabited only by its few hardy residents.

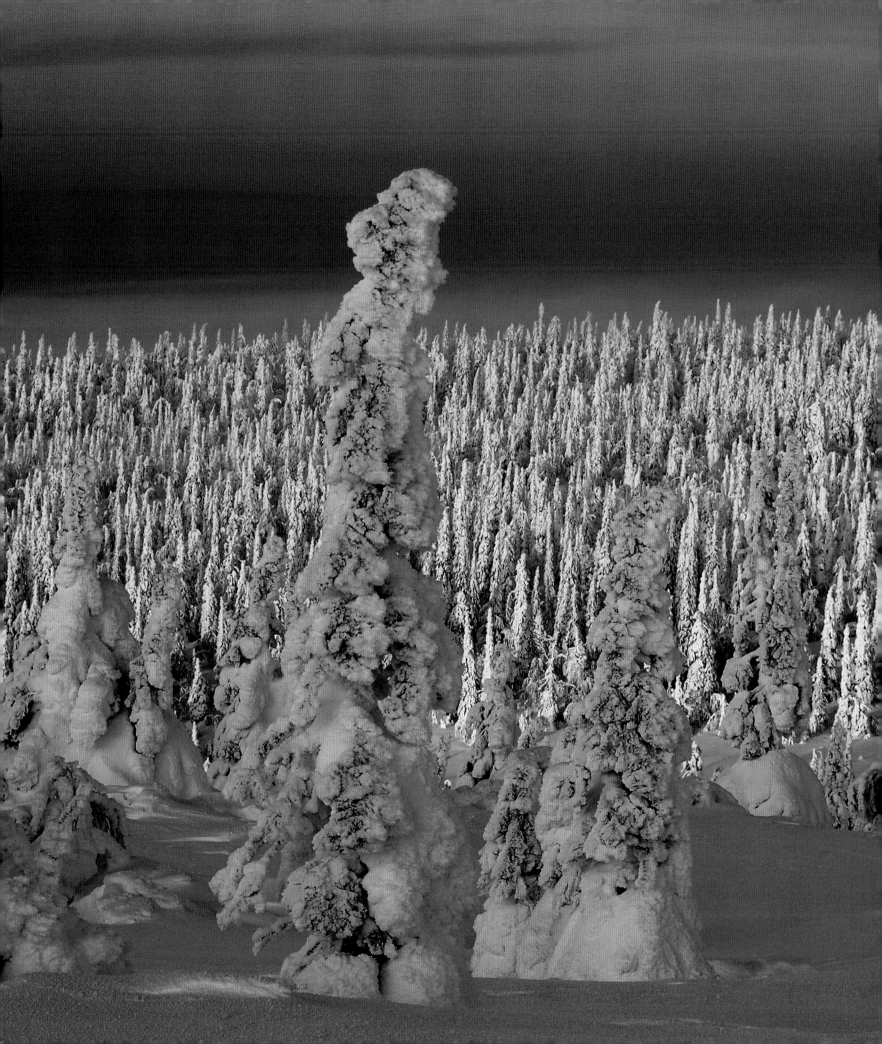

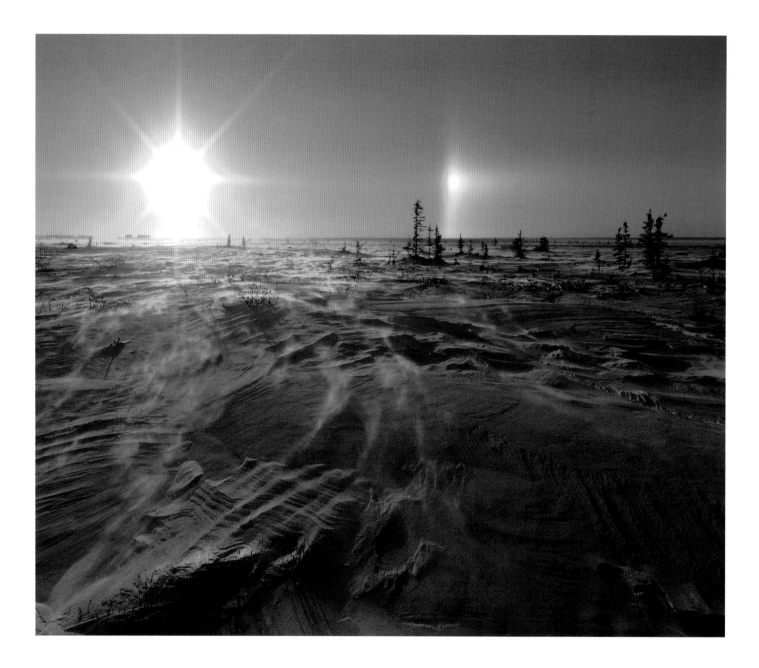

TO THE END OF THE ARCTIC

Deep in the taiga forest and heading south, we are by some definitions about to leave the Arctic. By others, we have already left it. So where does the Arctic end? For some it's a question of latitude: the Arctic is within the Arctic Circle – 66° 33' north of the equator and the limit of the polar night and the midnight sun – but this has no biological meaning. For others, the treeline is the great divide; but then the taiga forests still have a distinctly polar feel to them. Finally, many biologists use as their definition the 10-degree isotherm – where the average temperature for the warmest month (July) is below 10°C (50°F) – which is a line that mirrors fairly closely the northern treeline.

Above
The treeline – the furthest point north that a tree can grow. Stunted trees mark the point where the sun is above the horizon for the bare minimum of time to allow sustained growth.

Opposite
Muskoxen, Wrangel Island. Their thick outer coats and woolly undercoats enable them to withstand the extreme winters of the Russian Arctic.

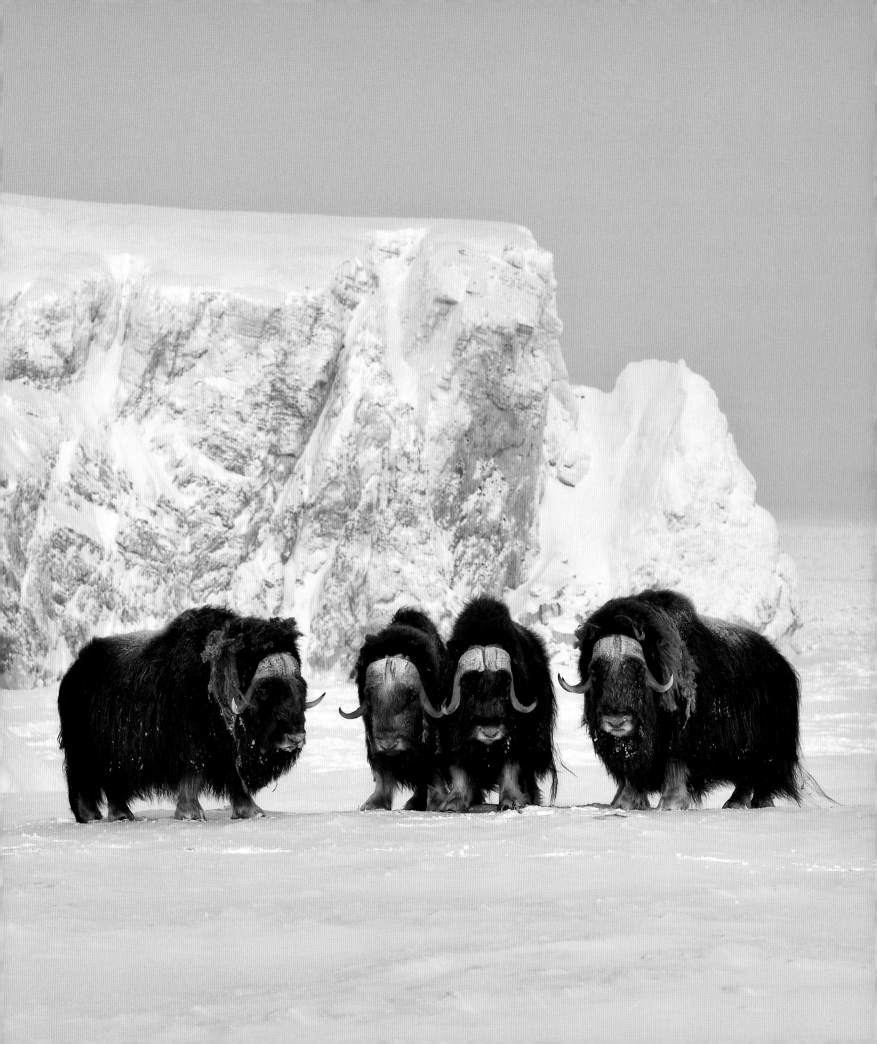

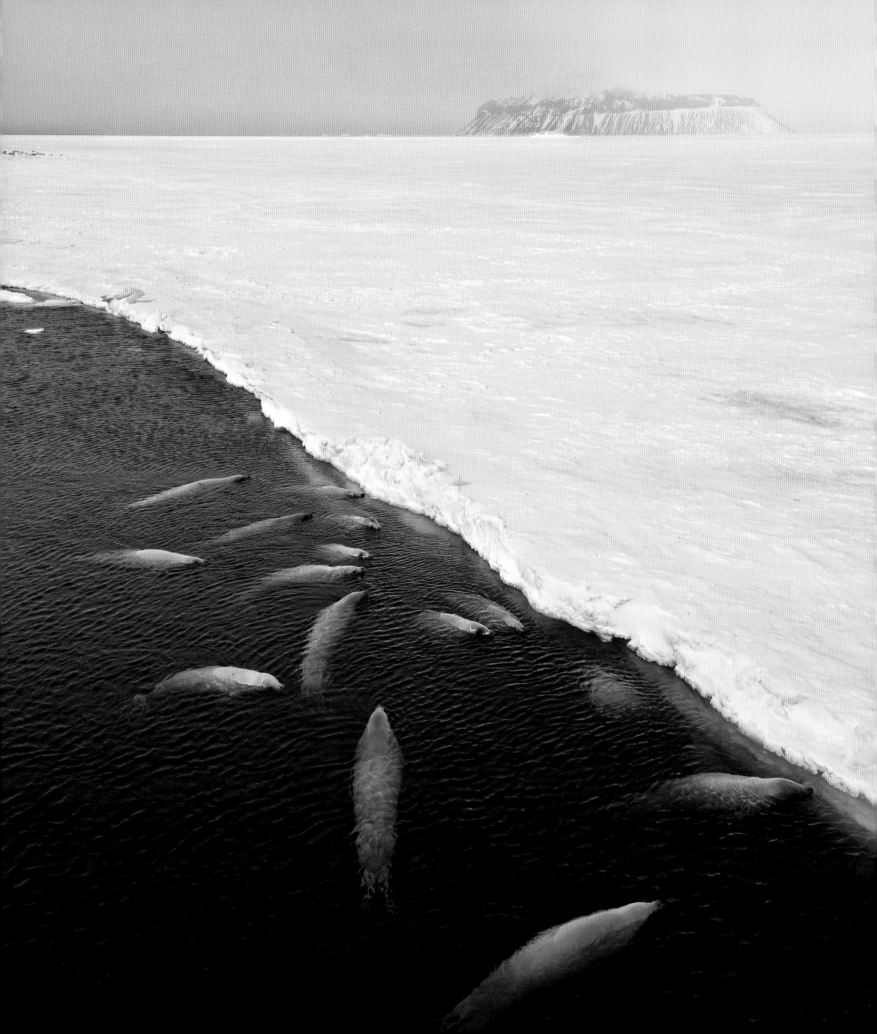

The frozen Southern Ocean

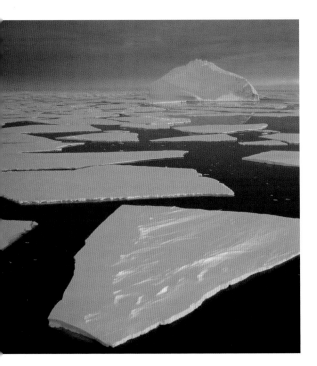

There's a point crossing the Southern Ocean where you sense that you have truly entered Antarctic territory. The winds pick up, the sea is rougher, and it feels significantly colder. You have crossed the Polar Front, a band of water between 50 and 60 degrees south, where cold surface water travelling north from Antarctica meets and sinks below warm water travelling south from the tropics. Strong currents begin to pull your boat to the east. You are experiencing the mighty Antarctic Circumpolar Current, which formed 34 million years ago when Antarctica was severed from South America and surrounded by ocean. The current is even thought to have triggered the growth of Antarctica's ice cap, isolating the newly formed continent from the warmth of the global oceans.

Today this current is the largest on Earth, moving a volume of water 135 times greater than all the rivers of the world combined. It's driven west to east by some of the planet's strongest winds, which prompted sailors to name the southern latitudes the Roaring Forties and the Furious Fifties. These wild winds rush around the continent, unimpeded by any land, whipping up the sea into terrifyingly large waves.

Though the Southern Ocean poses a serious challenge to sailors, it plays a vital role for the rest of the Earth. It covers 10 to 20 per cent of the planet, depending on where you define its northern limit. The Antarctic Circumpolar Current circles the globe, connecting all of the great oceans at their southern ends and ultimately the Arctic Ocean, enabling an a exchange of warm water from the north and cold water from the south, cooling the former and warming the latter, so maintaining the Earth's climate.

Go farther south and you enter the realm of the pack ice. Here, moving blocks of sea ice ranging from piano-sized chunks of 'brash ice' to 'giant floes' more than 10km (6 miles) across can crush metal-hulled boats as if they were tinfoil. In winter, much of the Southern Ocean is impassable as more than half of it freezes over, creating 19 million square kilometres (7.3 million square miles) of sea ice – a significantly larger area than in the Arctic. With the sea ice extending more than 2000km (1240 miles) out from the coastline, this effectively doubles the size of the Antarctic continent.

In spring, nearly two thirds of this ice cover is lost as an area of ice nearly twice the size of the USA melts. Antarctica's wildlife, the majority of which fled north in winter to feed in the open ocean, now returns to feed and breed, and the ocean explodes with life.

GREAT PREDATORS AND TINY PREY

Most people would expect a rich sea to have a great variety of fish. The Southern Ocean is the exception – of the 20,000 or so species in the world, only 120 are found south of the polar front. The cold doesn't seem to be the problem, as the Arctic is brimming with massive shoals of herring, capelin and sandlance. More likely, it's because Antarctica is surrounded by a much deeper continental shelf than the Arctic, and so there are few shallow seabeds on which fish can lay their eggs.

Of the fish that do occur, 85 per cent are found only here, cut off from other oceans by deep water, and are specially adapted for life in the world's coldest sea. The blood of most of them contains antifreeze, helping them survive in an ocean that is usually close to freezing. The 15 species of ice fish have such slowed-down metabolisms in the cold that their blood carries only 1 per cent haemoglobin – the pigment used by most animals to transport oxygen around their bodies – and so are ghostly white. The little oxygen they do need is absorbed from the oxygen-rich, stormy, cold waters of the Southern Ocean and carried by their plasma.

Either as prey or predators, fish play a relatively small part in the Southern Ocean's food chains. The vast number of squid and krill are the main prey, and birds and mammals are the major predators, probably because they have warm blood, are better at storing reserves of energy and are able to travel long distances in search of food – vital in an ocean where food distribution is patchy and unpredictable.

As in the Arctic, a brief polar summer triggers a bloom in plankton, which in turn fuels an explosion of Antarctic krill. Though there is thought to be a greater mass of krill than of any other single species, it tends to form large but discrete swarms. The mammals and seabirds that feed on it have to search far and wide for the occasional jackpot in an otherwise barren ocean. Baleen whales – such as blue, fin, minke, sei, humpback and southern right – have hairy combs that filter krill from the water, and they all arrive in spring for the harvest.

Several toothed whales can also be seen off Antarctica – sperm whales and killer whales. Sperm whales are rare, arriving to harvest deepwater squid, whereas killer whales are widespread and the only whale to prey on mammals.

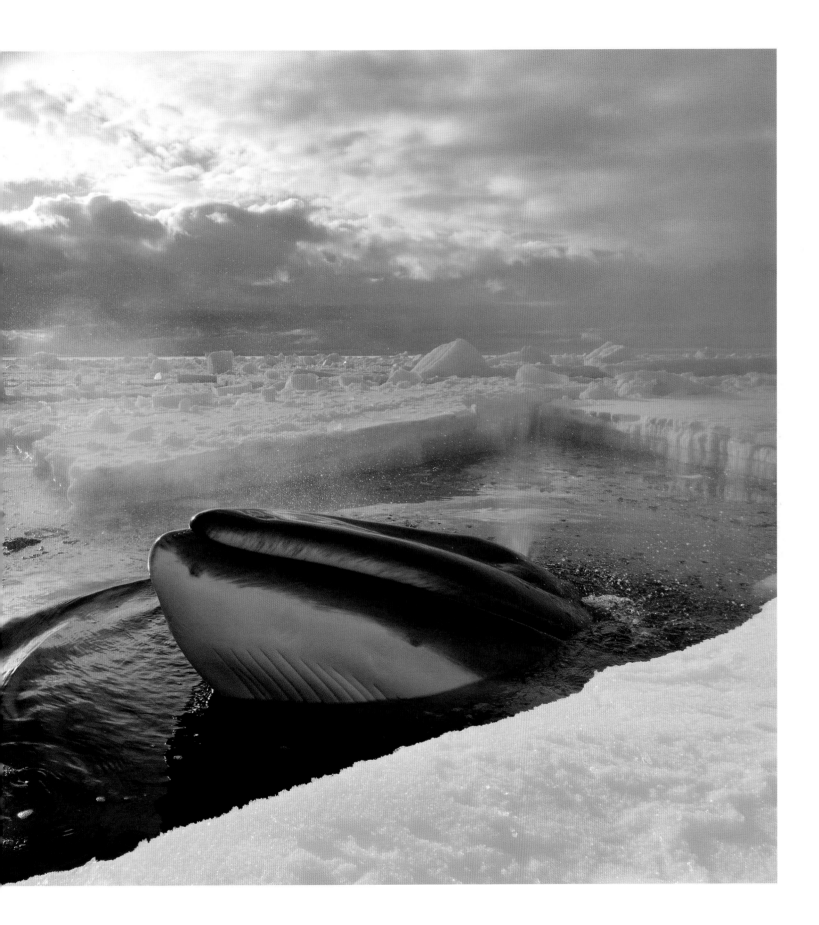

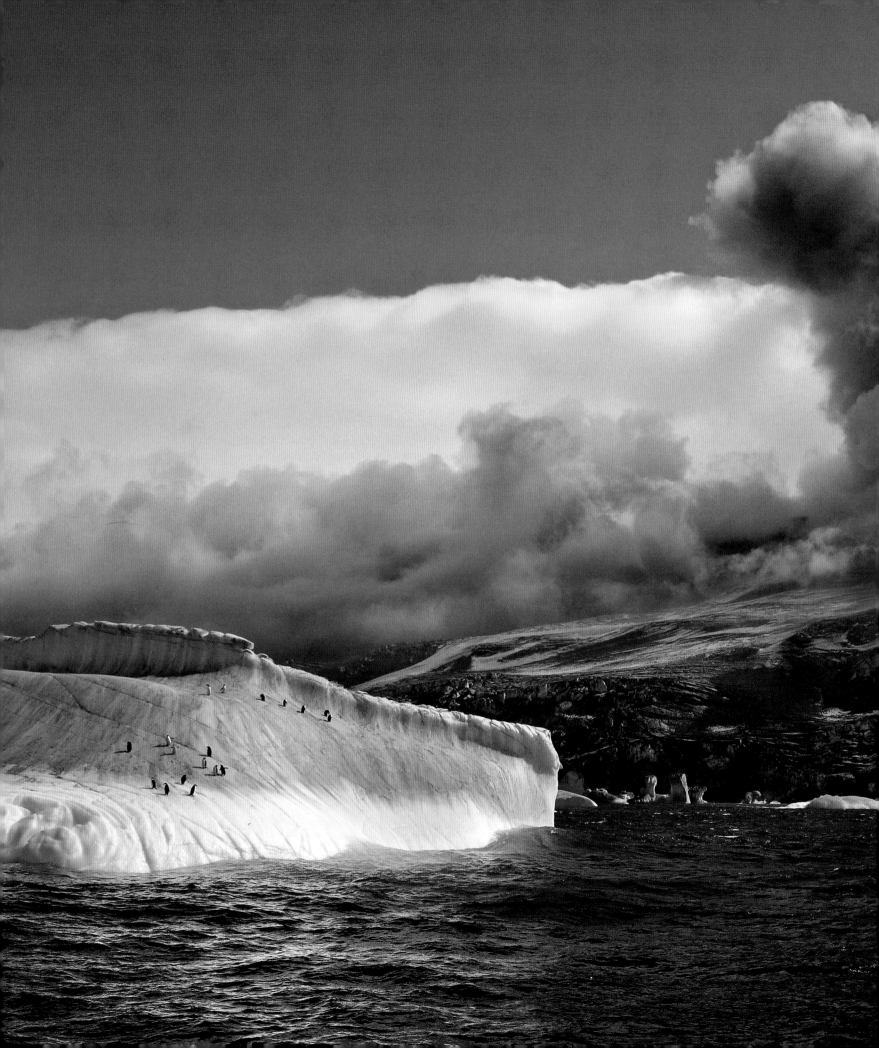

Left

Ash from Mt Belinda coats an iceberg occupied by chinstrap penguins. This volcano began erupting in 2001 and has expanded the size of Montagu Island in the South Sandwich chain, which lies south of South Georgia. But extremely steep ice and rock cliffs prevent the chinstraps breeding on the island.

THE ICE-FREE ISLANDS

For Captain Cook, the discovery in 1775 of the sub-Antarctic island of South Georgia was a great disappointment. When he first saw its coast, he thought he had reached Terra Incognita – the unknown land (Antarctica) and a holy grail for the early polar explorers – but when he reached its southern end, he realized he had only found an island, and so named its final headland Cape Disappointment. Today's travellers breathe a sigh of relief when they see a sub-Antarctic island on the horizon.

Though isolated, these islands can be incredibly rich in life. Groups of them are scattered in a ring along the Polar Front. The largest is South Georgia. Others include Bouvet Island, tiny, windswept and almost entirely covered in ice; Heard Island, which lies to the southeast of Australia; and the South Sandwich chain of islands, which are active volcanoes. All have one crucial thing in common – they rarely, if ever, get trapped in sea ice, which makes them extremely appealing to many Antarctic animals that rely on access to the ocean to breed and feed. Many of Antarctica's birds also rely on the islands to breed, as they are unable to lay their eggs directly onto ice and there is a shortage of bare rock in flying distance of the Antarctic continental coast.

A LAND FIT FOR PENGUINS

The only mammals in Antarctica are marine – whales and seals – and most of these head north in winter. The lack of ground-based predators has had a profound effect. Visitors to Antarctica not only find wildlife almost completely devoid of fear but also birds that have evolved to be flightless – penguins.

In spring, on the ice-free sub-Antarctic islands, every inch of coastline is crammed with birds nesting and seals pupping. Though Antarctica's bird species need bare rock for nesting, almost all are primarily adapted to a life at sea and depend on the ocean for their food. Some wander the ocean for years, only coming to land to breed. Only 45 of the world's 300 species of seabirds are found in the far south, but what they lack in diversity they make up for in number. There are 20 million breeding pairs of penguins and as many as 150 million petrels, though these are harder to count as they nest in burrows.

The albatrosses and petrels are both members of the same biological order, yet the wandering albatross has a 3.5-metre (11.5-foot) wingspan – the largest in the world – and can circumnavigate the globe, whereas Wilson's storm petrel is no larger than a sparrow and tiptoes from wave to wave. On top of their beaks, both have strange tube-like nostrils that are used to excrete excess salt, vital to birds with no access to fresh water.

The sub-Antarctic islands are surprisingly green, with large areas of tussock grass and even some flowering plants, though as you head farther south, they become bleaker. They lie along a submarine ridge, the Scotia Arc, which forms a huge loop linking the Andes of South America with the mountains of Antarctica. The biggest group and the largest archipelago is the 540km (336-mile) chain of the South Shetland Islands. Though surrounded by sea ice in winter, they have a climate that is moderated by the Southern Ocean and provides large areas of snow-free rock, vital to millions of nesting birds.

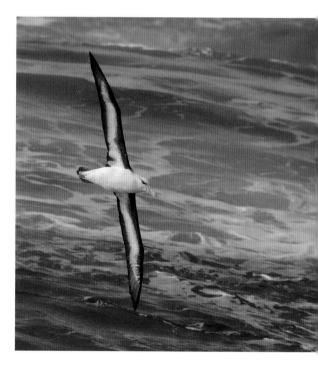

THE TIP OF THE CONTINENT

In 1820, after sailing south from the South Shetland Islands in a heavy mist, the explorers Edward Bransfield and William Smith finally saw a coastline. The midshipman later wrote that the scene was 'the most gloomy that can be imagined, and the only cheer that the sight afforded was in the idea that this might be the long-sought southern continent.' What they had encountered, at 64 degrees south, was the northern tip of the Antarctic Peninsula. For today's visitors, the peninsula stretches up like a hand of welcome.

Each summer, the ice retreats far enough to give most of the peninsula's coastline access to the sea, and the resulting maritime climate is milder than that of the rest of the continent. This is the gentlest face of Antarctica, an exquisitely beautiful area where most of the mainland's wildlife survives. Steep snow-covered mountains plunge straight into the sea. Most of the 0.32 per cent of Antarctica that is ice-free is here, and it's covered in breeding birds. Whales travel south as the ice retreats, breaking their journey to feed in mirror-like bays, and seals litter the ice floes. The elephant seals and fur seals that were common on the sub-Antarctic islands are replaced by leopard seals and crabeater seals. Crabeaters are thought to number up to 15 million, making them the commonest large

Above
A black-browed albatross crossing the Drake Passage on a calm day. This stretch of water between Cape Horn and the Antarctic Peninsula is famous among sailors as being one of the roughest in the world.

Opposite
Adélie penguins taking a break on a 'bergy bit' – a small iceberg that rises 1–4 metres (3–13 feet) out of the water. In the background is a range of freshwater ice, from small chunks called 'growlers' to a large iceberg more than 20 metres (65 feet) high, all calved from the glacier behind.

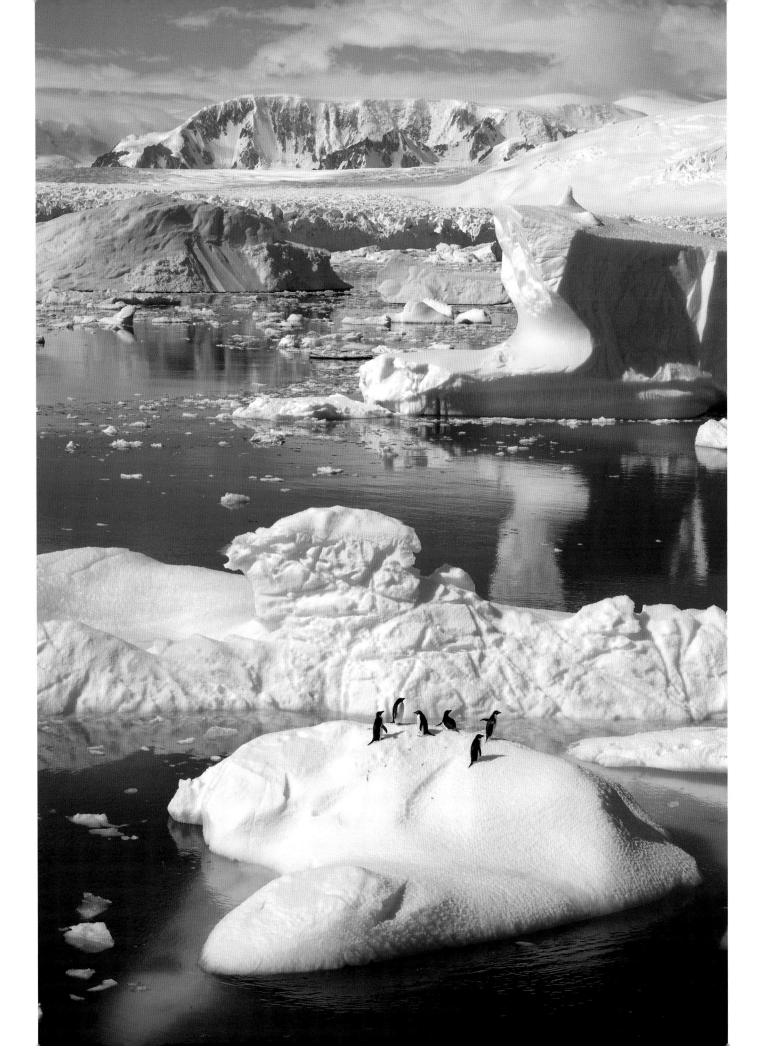

An early-morning view of Mt Erebus. It is Antarctica's only continuously active volcano and the most southerly active volcano on the planet. At its summit, nearly 4km (2.5 miles) above sea level, is an active lava lake.

mammal after humans. The toughest seal is the Weddell, which lives farthest south and is the only mammal to stay throughout the viciously cold Antarctic winter.

As you continue along the coast, the water comes alive with porpoising Adélie penguins. Each year, 5 million make their way back to breed in one of the 161 colonies that surround the continent – wherever there is a spit, beach or slope that remains ice-free. Their most southerly colony is Cape Royds. Only a few flying birds – skuas and petrels – venture farther inland, where to survive, life has to be highly specialized.

THE SNOW VOLCANO

Immediately behind the Adélie colony at Cape Royds looms the southernmost active volcano in the world (3794 metres/12,500 feet). When British explorer James Clark Ross discovered it in 1841, Mt Erebus (named after one of his two ships) was erupting '… emitting flame and smoke in great profusion … some of the officers believed they could see streams of lava pouring down its sides until lost beneath the snow.' Today, its constant grey plume is the only sign of the permanent molten lava lake at its heart.

Though the British Shackleton expedition first climbed Erebus in 1908, it was only in 1972 that the lava lake was discovered. Since then, it has been monitored year round. The teams have started to look at the impact of Erebus farther afield, analyzing whether the constant emissions of the volcano may be affecting worldwide weather patterns.

Beneath outlandish ice towers, or fumaroles, on the volcano's upper flanks lies a network of ice caves, melted out by gases and steam. They are continuously growing or shrinking, depending on how much heat and gas the volcano emits. Inside they maintain a temperature of about 32°C (90°F).

Each chamber is decorated with a different array of ice crystals, ranging from delicate feather structures to hexagonal ones that take up to 60 years to grow. Like snowflakes, each of these ice crystals is unique and startlingly beautiful. In 2009, scientists began a major mapping and sampling project in the caves. They suspect that some of the ice crystals themselves may be alive, seeded by extremophile (extreme-condition) bacteria, which flourish in the damp, warm cave interiors.

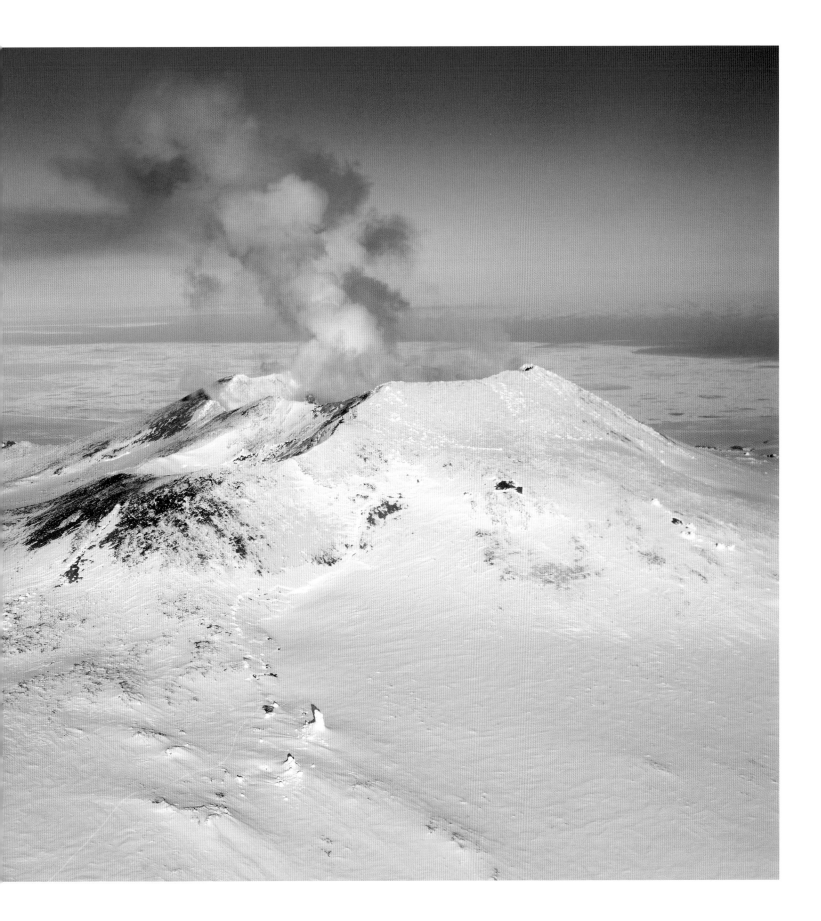

Right
The Transantarctic Mountains – a range that spans the length of Antarctica, from the Weddell Sea to the Ross Sea. With a total length of about 3200km (2000 miles) and a width of 100–300km (60–185 miles), it forms a barrier between East and West Antarctica. It is also one of the longest ranges on Earth.

THE TRANSANTARCTIC BARRIER

Looking south from the summit of Mt Erebus is the daunting sight of the Transantarctic Mountains, one of the longest and most spectacular mountain chains, stretching 3200km (2000 miles) from one side of the continent to the other. It divides Antarctica into west and east and holds back the East Antarctic Ice Sheet. Discovered by James Clark Ross in 1841, the chain thwarted Ross from reaching the South Magnetic Pole (actually in the sea) and blocked explorers who followed in his footsteps. Robert Scott and Roald Amundsen only succeeded in reaching the geographic South Pole because they discovered and climbed the Beardmore and Alex Heiberg glaciers, which breach this formidable chain.

The mountains are made of ancient rocks similar to those found in Australia – a legacy of the time when Antarctica was at the centre of a giant supercontinent – and the rocks were continuous with Tasmania. Nearly horizontal layers of sedimentary sandstone are interspersed by dark-brown layers of dolerite left by volcanic activity. The peaks are lifeless, but in the rocks is fossil evidence that plants and trees once grew here.

EXTREME LIFE IN THE DRY HEART

On a continent of ice, the Dry Valleys are oases of exposed red and brown soil that would not look out of place on Mars. They are kept permanently free of ice by the Transantarctic Mountains and form the largest contiguous area of ice-free land in Antarctica. In fact, the Dry Valleys are one of the few places in Antarctica where you can hear the sound of running water (meltwater from the glaciers). They are also relatively warm, with an average annual temperature of -17°C (1°F). This is due to a warm, dry wind that blows down off the ice at speeds of 320kph (200mph). It's warm because it compresses as it descends, and this process generates heat. It's also dry, and when it coincides with the rains that on rare occasions fall here, it evaporates the falling water, so that scientists report seeing rain descending but not reaching the ground.

As you walk across this inhospitable, boulder-strewn landscape, you understand why Scott called one of the Dry Valleys a 'valley of the dead'. In reality, the place is teeming with life – you just need a microscope to find it. Each summer, when

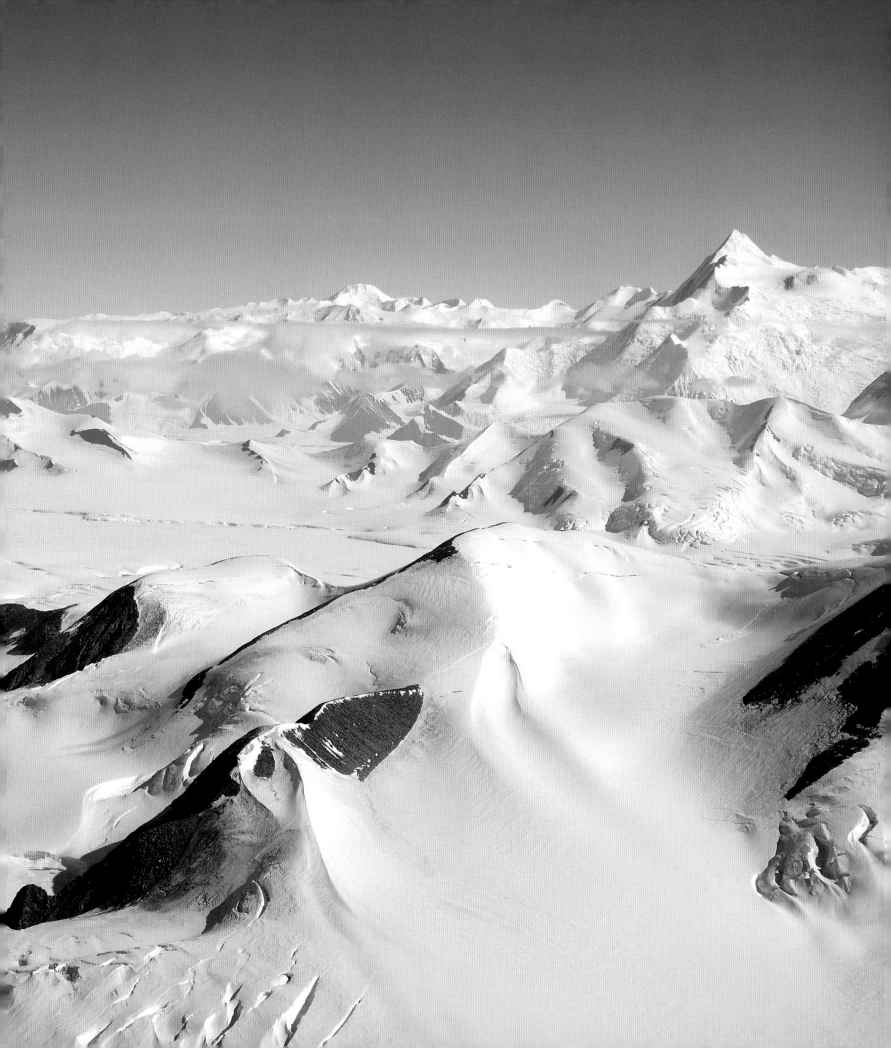

temperatures rise to freezing or just above, sun on the glaciers creates streams that feed freshwater lakes, and the valleys come alive. Freeze-dried algae in the streambeds and dried-up nematode worms in the soil revive. Red and orange algae streak the bottom of streams; black algae line the edges like pieces of burnt popcorn; and green algae form mats so big they look like seaweed. This is the start of a simple food chain, with the nematode worms feeding on algae, yeast, bacteria and other nematodes.

Another extreme ecosystem in the Dry Valleys is a colony of microbes that have survived for millions of years under a glacier, without air or sunlight. They appear to use iron and sulphate ions, rather than oxygen, at the heart of their metabolism and are the reason that the frozen waterfall Blood Falls is bright red, stained by the iron.

The Wright Valley is home to Antarctica's longest river, the Onyx, fed by the Wright Lower Glacier. It's ephemeral, flowing for only a matter of weeks in the brief Antarctic summer, and runs for some 32km (20 miles) into Lake Vanda. Though the lake is ice-covered year round, the water at the bottom is room temperature, 25°C (77°F) and is also eight times saltier than the ocean. Close by, Don Juan Pond is thought to be the saltiest lake on Earth – so salty that it never freezes. On the banks of some of the lakes are the mummified bodies of seals that strayed into the Dry Valleys thousands of years ago but could not survive the extreme conditions.

Today, the creatures of the Dry Valleys live such a marginal existence that even the slightest change in the climate could have catastrophic consequences for them. So scientists believe that here they are likely to witness some early effects of climate change.

The surfaces of the Dry Valleys are dotted with extraordinary natural sculptures, ventifacts rocks, with sensuous curves and polished sides, which look as if they are the work of a master stone-carver. The wind, though, is the only artist, its tools grains of sand and ice, which it has blasted against rocks for thousands of years. The ventifacts range in size from a finger to a house. The classic ones are pyramidal, their flat faces meeting in crisp angles and polished to a soft black lustre. The more fanciful shapes, resembling everything from turtles, elephants and birds to spaceships, are called tafoni, and result from a combination of wind and chemical weathering (salt reacts with the rock, weakening it). They are classic desert structures like those in the Mojave and the Sahara.

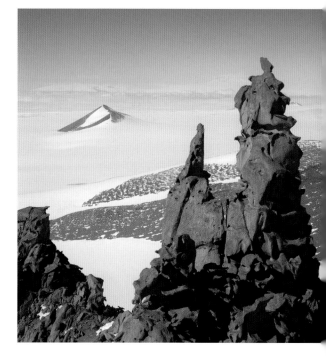

Above
Gargoyle Ridge, at the mouth of one of Antarctica's Dry Valleys in the heart of the frozen continent. These formations, called tafoni, have been carved by a combination of wind and chemical weathering.

Opposite
Turnabout Glacier intruding into part of Antarctica's ice-free Dry Valleys. The banding of the rock is characteristic of the area: golden sandstone deposited by rivers and lakes in geologically quiet periods, alternating with darker dolerite formed by the intrusion of molten rock.

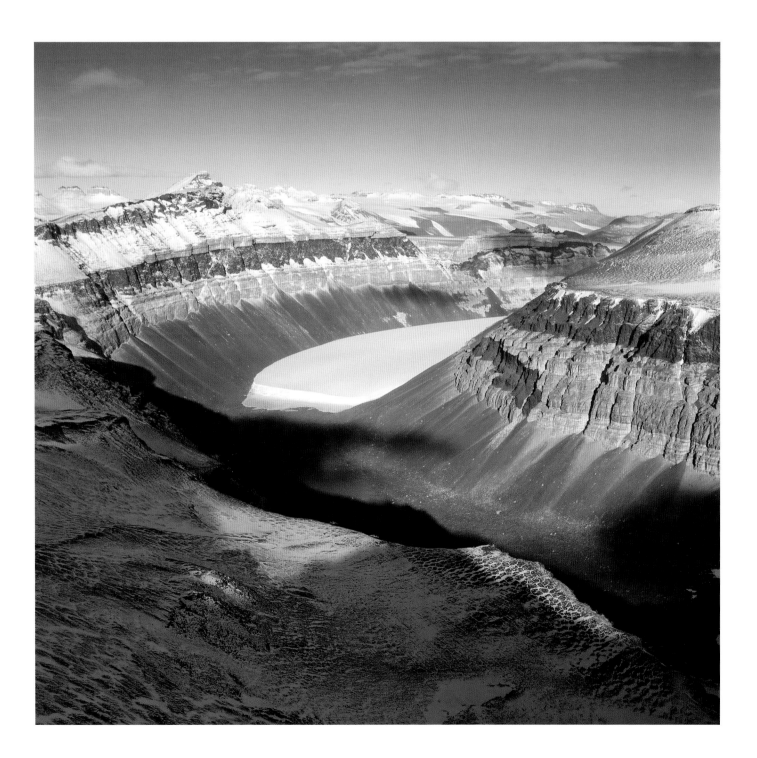

THE ICE CAP TO CAP ALL ICE CAPS

At the head of the Dry Valleys, the Transantarctic Mountains restrain the Antarctic ice cap. At the top of the Wright Valley, the dam is breached and the ice spills over. From the air, the Airdevronsix Icefall looks like a giant, frozen waterfall, with ice blocks the size of skyscrapers appearing to defy gravity. Though the icefalls are a dramatic demonstration of the unstoppable force of the ice, nothing can prepare you for the scale of the spectacle that lies beyond them.

As you gain altitude, the Antarctic ice cap, the largest on Earth, begins to unfold before your eyes. It dwarfs the Greenland Ice Sheet, containing almost ten times as much ice and covering an area roughly twice the size of Australia. On average it is 2160 metres (7087 feet) thick but reaches a maximum thickness of 4776 metres (15,670 feet) at Terre Adélie. It is this great volume of ice that makes Antarctica the highest continent on Earth, three times higher than any other; indeed, complete mountain ranges as high as the European Alps are simply buried beneath the ice.

In 1958, the Gamburtsev Range was discovered by the Russians. It's 1200km (745 miles) long, and the mountains are believed to be about 2700 metres (8900 feet) high, though they are buried in more than 600 metres (2000 feet) of ice and snow. Current models suggest that the East Antarctic Ice Sheet may even have been formed from the glaciers that began sliding down this range. The ice started to form about 40 million years ago, and today about 75 per cent of the world's fresh water and 90 per cent of the world's ice are trapped here. If today's ice cap melted, sea levels globally would rise by 65–70 metres (210–230 feet), drowning all the major coastal cities of the world. The continent itself, relieved of the enormous weight of the ice, would rise by 450 metres (1500 feet).

The Antarctic ice cap is the most humbling place on Earth. The ice stretches 2500km (1554 miles) from the edge of the continent to the South Pole, pierced occasionally by the tips of massive mountains. Nowhere else is as hostile to life, and to explorers past and present, nowhere else is as challenging. The atmosphere is so dry that surprisingly little snow falls – the annual average snowfall in Antarctica is only 5cm (2 inches). Even in the Arctic, it's only 50cm (20 inches). But because of the cold, the snow that does fall lingers. On the true ice caps, of Antarctica and Greenland, the snow never disappears.

Opposite

Beyond the Transantarctic Mountains lies the Antarctic ice cap – the largest concentration of ice on the planet. In places, the ice cap is nearly 5000 metres (16,400 feet) thick. It holds 90 per cent of the world's ice and locks up nearly 75 per cent of all fresh water. Entire mountain ranges are drowned beneath the ice.

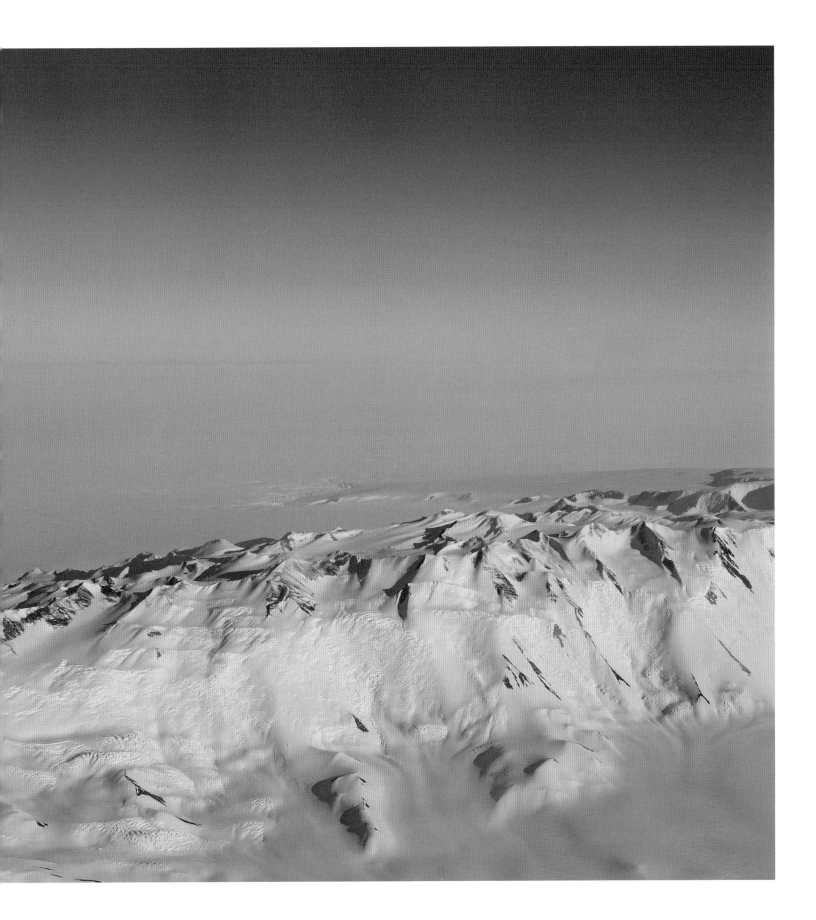

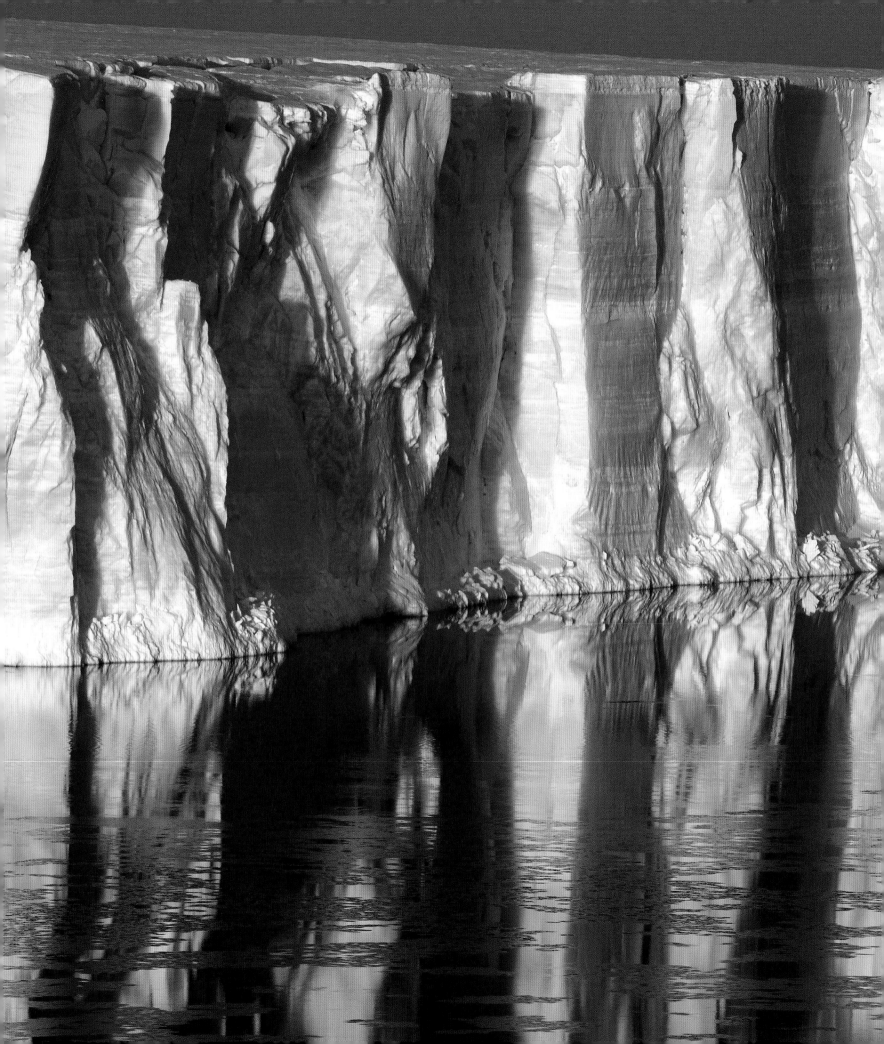

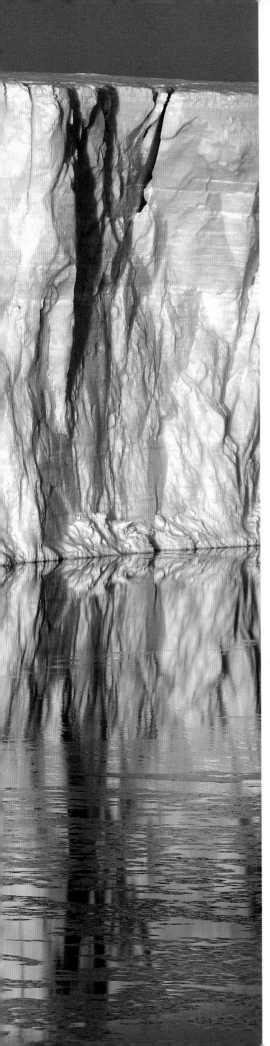

Nothing, no photographs or prose, can prepare you for the scale of icebergs in the Southern Ocean. In the Arctic, icebergs are measured in cubic yards. In the Antarctic, they are measured in cubic miles and can be the size of small countries. The largest on record was more than 330km (205 miles) long and 100km (60 miles) wide – larger than Belgium – and was sighted 240km (150 miles) west of Scott Island in the South Pacific in 1956. More than 90 per cent of all icebergs are born in Antarctica, from the ice shelves. These giant ice platforms are attached to the land and fed by glaciers that slide down from the ice cap. The largest ice shelf of all, at the head of the Ross Sea, covers an area the size of France.

TROUBLE AT THE POLE

On New Year's Day, a group of people gather in temperatures of -40°C (-40°F) around a simple pole on the Antarctic ice cap that marks the South Pole, the southern axis of the Earth's rotation. Walk around it and you walk around the world. It doesn't move, but the ice sheet above it does, by about 9 metres (30 feet) a year, as it continues its relentless slide down to the coast. So every year the marker is repositioned to 90 degrees south using GPS. When the Norwegian explorer Roald Amundsen arrived at the South Pole on 13 December 1911, he had to monitor the position of the sun to figure out that he had reached it. The world got to know of Amundsen's feat only months later, when he sent a cable from Tasmania about his success. It was short and to the point: 'Pole attained Dec 14 to 17.' At the time he sent this cable, Robert Scott and his men lay dying in their tents, a mere 18km (11 miles) from a depot with food rations. They had reached the Pole a month after Amundsen.

Scott's words on arrival hint at the terrible disappointment: 'The Pole. Yes, but under very different circumstances from those expected.' The 'different circumstances' were the discovery of Amundsen's marker where he had hoped to position his own.

When Scott and Amundsen reached the South Pole a hundred years ago, their achievement was regarded as the ultimate in human endeavour and endurance, and a source of great national pride. Today the polar regions have a rather different significance: we've come to understand that what happens there affects us all.

Chapter two | Spring

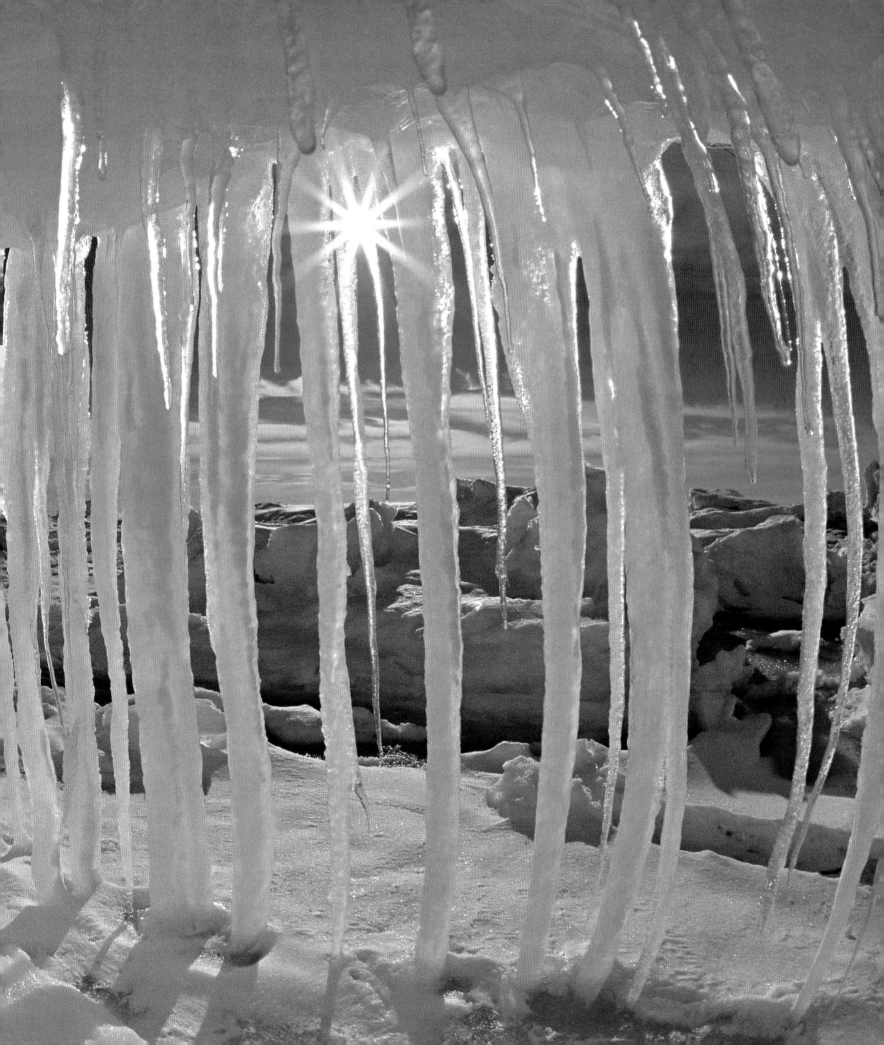

Life wakes up

After months of total darkness, everyone in the High Arctic is waiting for the return of the sun. In Svalbard, just 1126km (700 miles) south of the North Pole, the glowing orange lip of the sun appears above the horizon on 14 February – effectively, the first day of spring. In just two months, on 19 April, it will be permanently above the horizon, giving 24 hours of unbroken daylight. For the very few people that live here, this in-between spring twilight time is very special. There is enough light to travel by, and the low sun has a unique quality, painting the sea ice and snow-covered mountains with soft pinks, oranges and blues. The temperature, though, may still be -30°C (-22°F).

Cocooned in their natal den high on a snow-covered slope overlooking the sea ice, the polar bear cubs have been growing fast on their mother's rich milk, which is ten times richer than cow's milk and contains 33 per cent fat. But not until mid-March, when they are about three months old, will they be big enough to leave. By this time, their mother will have lost more than a third of her body weight, having not eaten since the autumn. She chooses a calm, wind-free day to break out of the snow womb. The first sign of her is a black nose poking through the snow. Then she breaks free and toboggans down the slope. This probably serves to clean her fur, but it also looks fun. Soon the cubs' tiny faces appear at the den hole, eyes blinking in the bright spring sunshine. Their mother calls to encourage them out to explore their new world.

For two weeks the polar bear family stays in the area of the den, returning to its warmth whenever the weather turns bad. They spend 85 per cent of their time in the den and sleep there at night. But each day, the mother encourages her cubs to go farther away. She is starving and anxious to get out onto the sea ice, where she can hunt. The cubs' emergence has been timed to coincide with early spring, when winter sea ice still surrounds Svalbard and when the ringed seals have returned to breed on it. But male polar bears are also hunting on the sea ice and are on the look-out for females to mate with. For them, the cubs are just a meal.

The mother needs to be especially cautious because travel with the cubs is very slow, with frequent nursing stops. Sometimes she will even have to carry them on her back when crossing areas of deep snow or water. But by the time she makes her first kill, usually when the cubs are just three or four months old, they are ready to eat meat.

Above
The emergence. A mother coaxes her cubs up the slope away from their maternity den on a snow-covered cliff on Svalbard, overlooking the frozen sea. The likelihood is that the smallest of the three cubs won't survive its first year on the ice, but with good seal-hunting, some mothers do manage to rear triplets past their first winter.

Opposite
The twilight of winter, Svalbard. As the sun nears the horizon, the glow changes colour.

Overleaf
The first journey. The mother has decided it is time to leave the maternity den and travel to the sea ice below, where she can hunt for her first meal of the year.

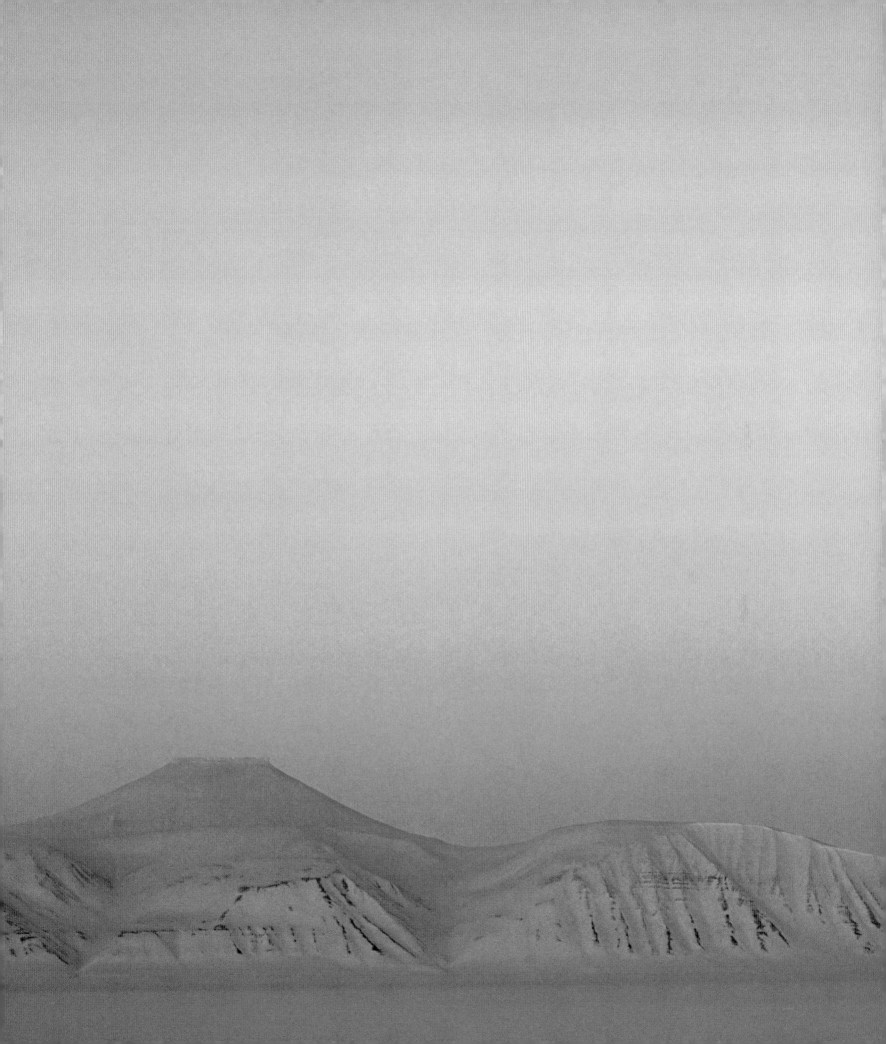

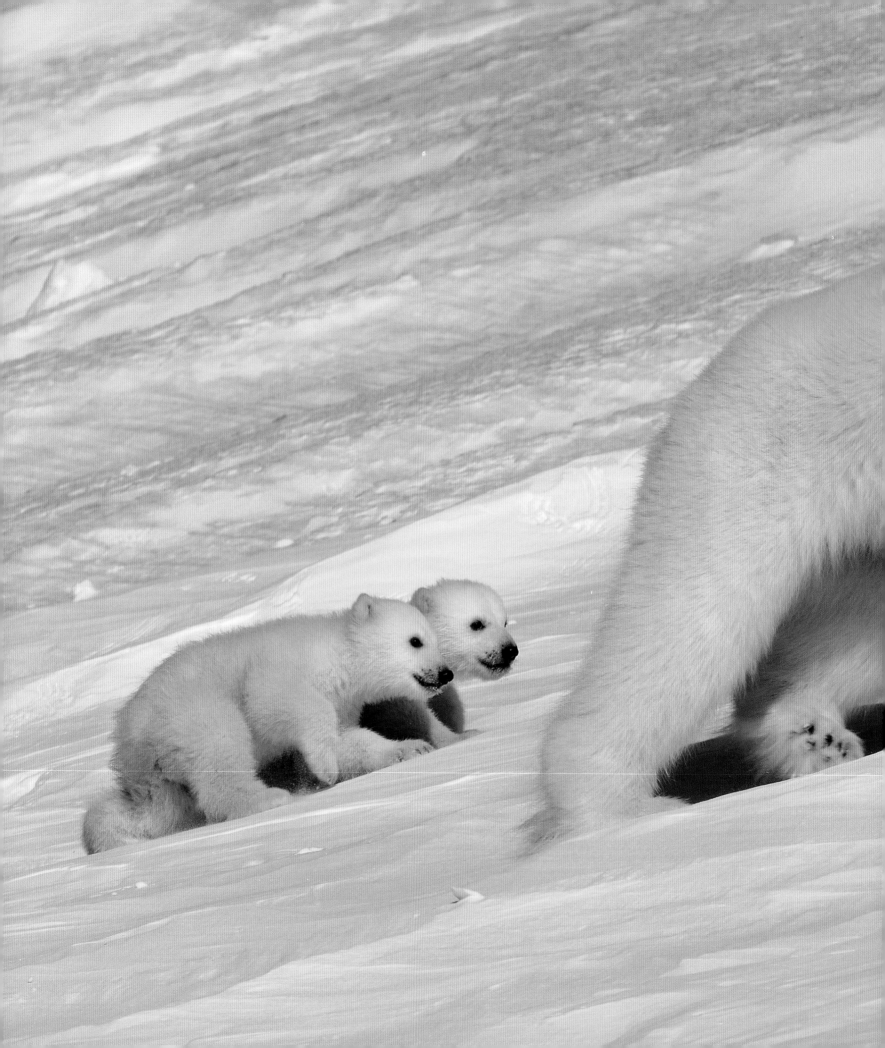

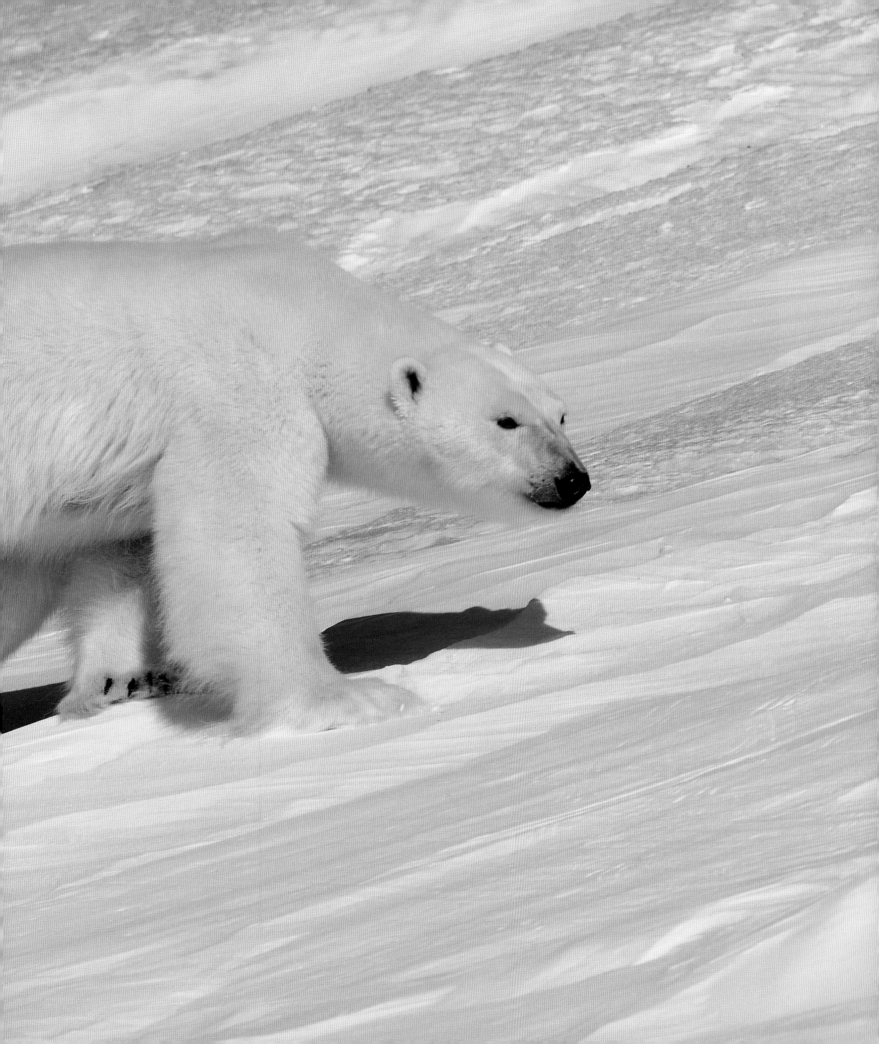

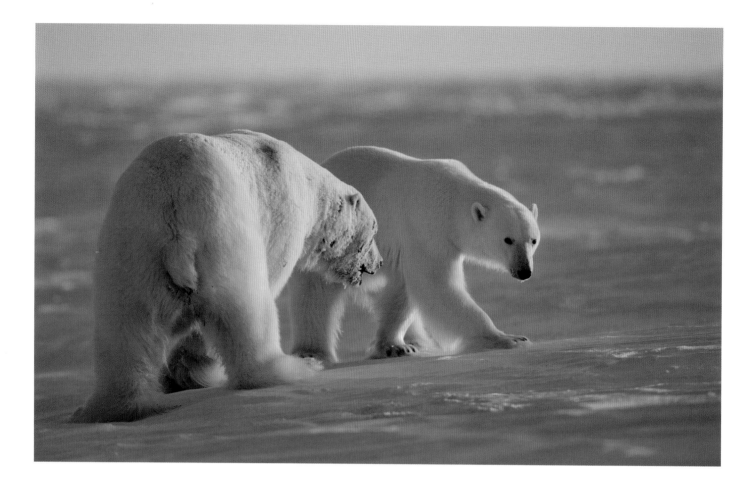

HUNTING FOR A MATE

Polar bears have a powerful sense of smell. It's thought they can smell seal pups under the ice from 1.5km (nearly a mile) away, and males also use scent to track down receptive females. For day after day, a male will follow a female's footprints, regularly sniffing them to be sure he is after the right female. With equal sex ratios and the fact that females are only ready to breed every three years (it takes 30 months to rear a cub), competition for mates is fierce.

If two males end up pursuing the same female, they will battle it out. Standing on their back legs, they will wrestle, trying to bite chunks out of each other. If they're equally matched, the battle may last more than an hour, leaving the loser covered in blood. The victor will then manoeuvre the female to higher ground, away from the feeding area and potential rivals.

Over the next few days, the female becomes positively coquettish and the male very attentive, and they will play and tumble in the snow like two puppies. She will only ovulate after they have mated a number of times, and so the nuptials may last for up to three weeks. But the male will play no part in bringing up the cubs, and the two bears

Above

Courtship trial. Here the male is trying to sway the female into mating with him, having chased off another interested male. He will guard her until she is ready to mate, and the two may stay together for several weeks, as long as she is receptive. Once fertilized, her eggs will remain dormant and not implant in her womb until the autumn. In the meantime, it's essential that she puts on enough weight for the pregnancy to be successful.

Opposite

The chase. This aggressive male, bloody from fighting off a rival, is chasing a female who is not in the mood for mating. He will keep following her, mirroring her movements, in the hope that she will finally become receptive.

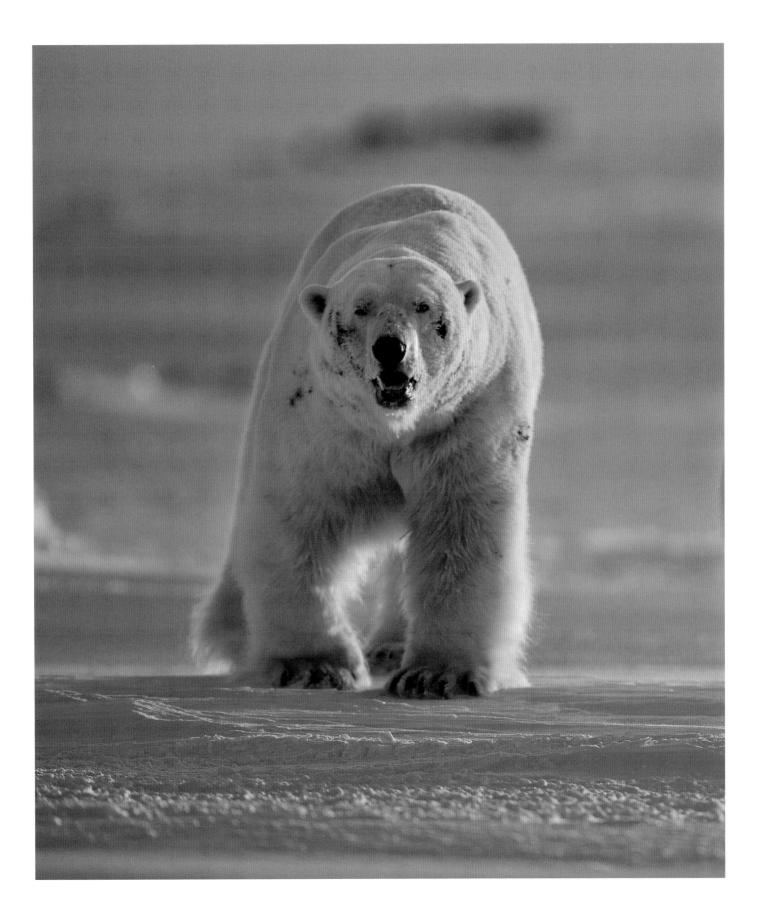

will probably never meet again. Indeed, it is possible that the female may mate with another male and that her cubs will have different fathers.

HUNTING FOR FOOD

The ringed seal has a population that could be as high as 7 million, making it the most numerous large mammal in the Arctic. It is the main prey of polar bears, which do most of their hunting (and obtain more than 90 per cent of their food) from April to July, while there is still ice from which to hunt the fat-rich seals. In fact, the life cycles of all the Arctic seals that breed on sea ice are dominated by the threat of polar bear predation.

Harp seals and hooded seals choose to have their pups farther south among the broken pack ice, where it is far harder for the polar bears to find them. But this mobile ice is in itself dangerous, and so the seals try to wean their pups as quickly possible to the point where they can swim. Hooded seal milk is so rich, containing 60 per cent fat, that a pup is ready to escape to the ocean in just four days – the shortest weaning period of any mammal.

Ringed seals breed farther north, where the ice is firmer, which makes it easier for polar bears to catch them. It takes the seals six to seven weeks to wean their pups, and so they have to hide them from the bears. In the autumn, when the sea freezes over, sheets of ice butt up against each other and create long pressure ridges. Snow gathers along the ridges, and it is here that the ringed seals create dens for their pups. Each of the dens has an escape hole through the ice to the ocean below, and a ringed seal mother maintains a number of breathing holes in the ice to confuse hunting bears.

In spring, polar bears, especially females with young cubs, hunt along these networks of pressure ridges, smelling for seal pups hidden in their natal lairs below. But catching one is far from easy as the pups are very alert to vibrations and will use their escape holes to exit into the ocean. So a bear has to move very slowly and very gently before pouncing to break through into the den. Most often, it will be unsuccessful. But hunting ringed seal pups towards the end of the spring, when they are full of their mother's milk and are more than 50 per cent fat, is well worth the effort. A polar bear

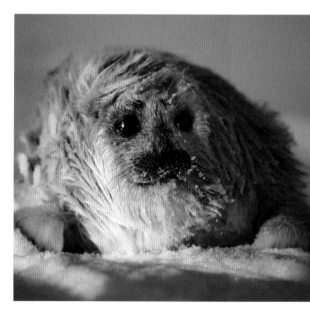

Above

Pup prey. An Arctic ringed seal pup out on the ice, where its mother will suckle it. Though its white coat indicates it's less than six weeks old, it is already able to dive – a necessity to avoid being caught by its main predator, the polar bear. For the bears, this is the key time for catching the fat-rich baby seals, while they are tied to their dens.

Opposite

Pack-ice hunting ground. A polar bear will have most hunting success in spring and early summer, when the ice is firm and it is relatively easy to prey on seals.

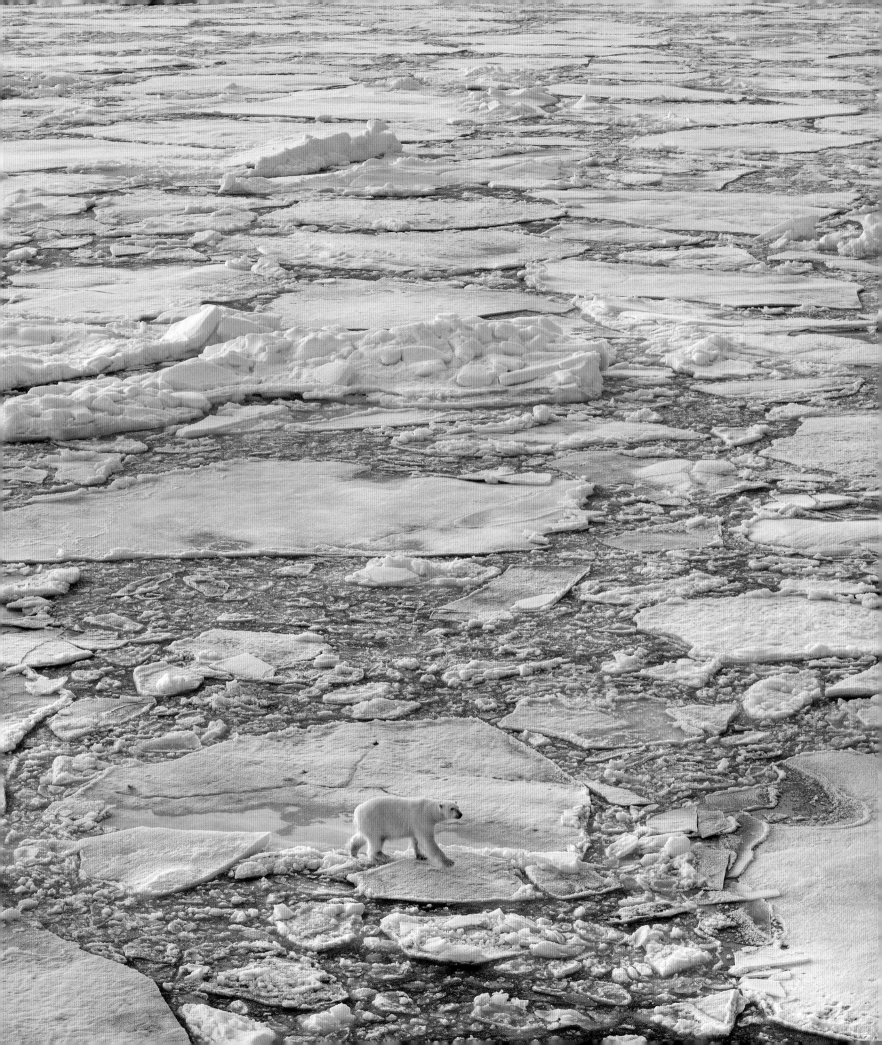

needs about 2kg (4.4 pounds) of fat per day to survive, and so an average-sized ringed seal weighing around 55kg (122 pounds) will keep it going for eight days.

Once the seal pups can swim confidently, they are far harder to catch, and with every passing week, the sea ice starts to break up. In March, at the start of spring, the Arctic sea ice covers more than 15 million square kilometres (5.8 million square miles). But over the next six months, two thirds of the ice will melt. This massive seasonal change dominates the lives of all polar animals, and for polar bears, it means the ground melts beneath their feet. In Hudson Bay, Canada, over the past 20 years, the early melting of ice has reduced the polar bears' hunting season by nearly three weeks. As a result, average bear weight has dropped by 15 per cent, and the Hudson Bay population is down by more than 20 per cent.

Below
Still-hunting on sea ice, Hudson Bay, Canada. This is a typical still-hunting posture, when a polar bear has smelt a seal and is waiting patiently for an opportunity to grab it when it next surfaces to breathe.

Opposite
The aquatic stalk. Here the bear slowly slips into water between ice floes, without making a splash or even disturbing the surface.

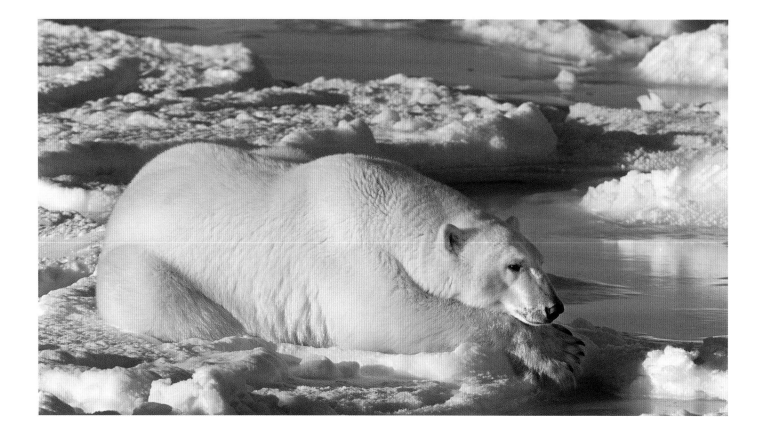

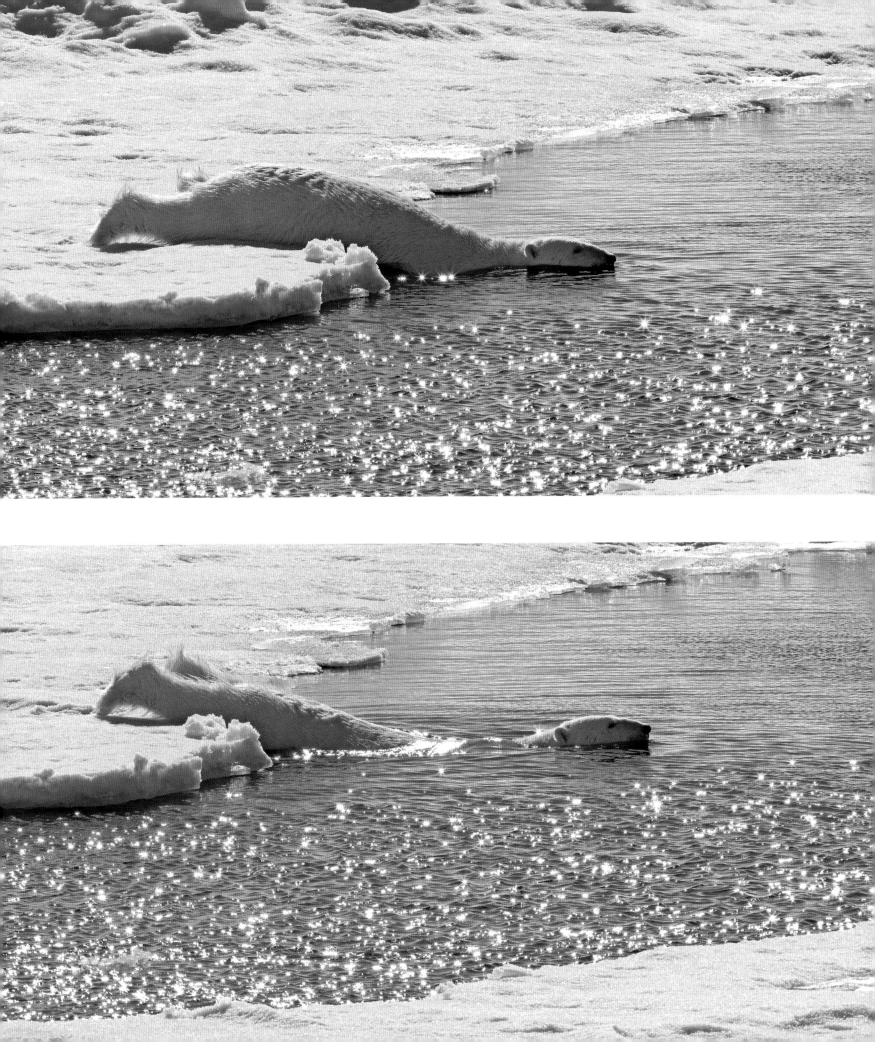

Stalk, smash and grab

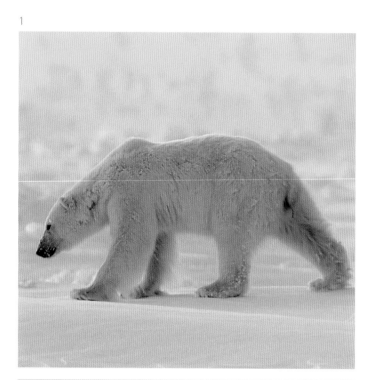

1

4

Above

A polar bear hunting seals on pack ice, Canada. Ringed seals are a polar bear's preferred prey, breeding where the ice is firmer, which makes it easier for the bears to get to them.

Right

The technique.

1–2 In the endless daylight of spring and early summer, polar bears patrol the pressure ridges, smelling out seal pups in their dens under the ice. The slightest noise or vibration will cause a pup to use its escape hole, and so a bear has to move very carefully.

3–6 Once a ringed seal den has been located, a polar bear rears up and pounds down on the ice, trying to break through to the pup below before it can escape into the sea. When the snow is soft, a bear is successful roughly once in every three attempts. But with hard snow, it may have to try 20 times before breaking through.

If it breaks into an empty den, a bear sometimes keeps its head in the hole. The theory is that this blocks out daylight and fools the seal into returning to a den it thinks is safe. Whether or not this is true, polar bears are undoubtedly very clever predators.

2

3

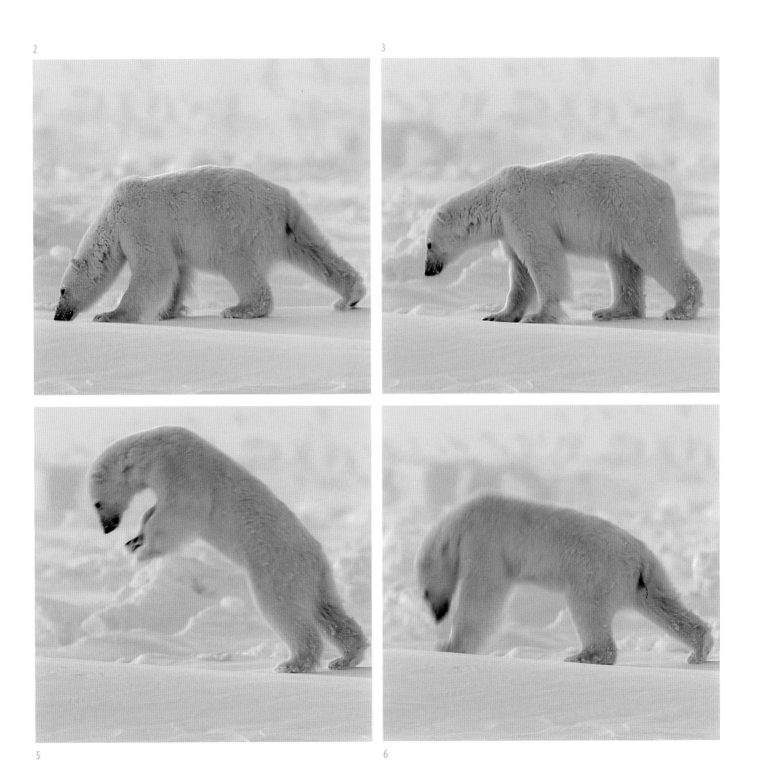

5

6

THE BIRDS RETURN

As the sun starts to melt the ice, animals that have spent the winter far to the south begin to return. Elegant northern fulmars glide in over the ice in their hundreds, and the cliffs come alive with the raucous activity of thousands of seabirds. Sixty-four different seabird species return to the Arctic every year to breed, and by far the most numerous are the auks – the guillemots, razorbills and puffins. In many ways, the auks are the northern equivalent of penguins. They share the ability to hunt under water and dive to depths after fish – a Brünnich's guillemot (thick-billed murre) has been recorded at 210 metres (689 feet), a depth only exceeded by the largest penguins. Of course, the big difference is that auks can fly. They need to. In the Antarctic, there are no land predators, but in the Arctic, foxes, wolves and even polar bears feast on eggs and chicks.

Another strategy to escape hungry predators is to nest high up on steep cliff-faces. Many birds, such as the guillemots and razorbills, nest there in their hundreds of thousands. These avian tenements are one of the greatest spectacles of the polar world. At the bottom of them are slopes of scree, which provide a refuge for the Arctic's most numerous seabird – the little auk. These starling-sized birds can squeeze between the rocks to hide from Arctic foxes. The biggest little auk colony, in Greenland, contains more than a million birds.

Above
The food run. Brünnich's guillemots returning to their communal breeding cliff on a Svalbard island.

Opposite
The return of the fulmars. The northern equivalent of albatrosses, fulmars may live to be more than 35, are faithful to their mates and return to the same nest sites year after year.

Overleaf
Glacial fishing frenzy. These kittiwakes are fishing at the edge of a glacier in Svalbard. Cold fresh water from the melting ice has created an upwelling of nutrients on which plankton are feeding, which in turn has attracted both fish and seabirds.

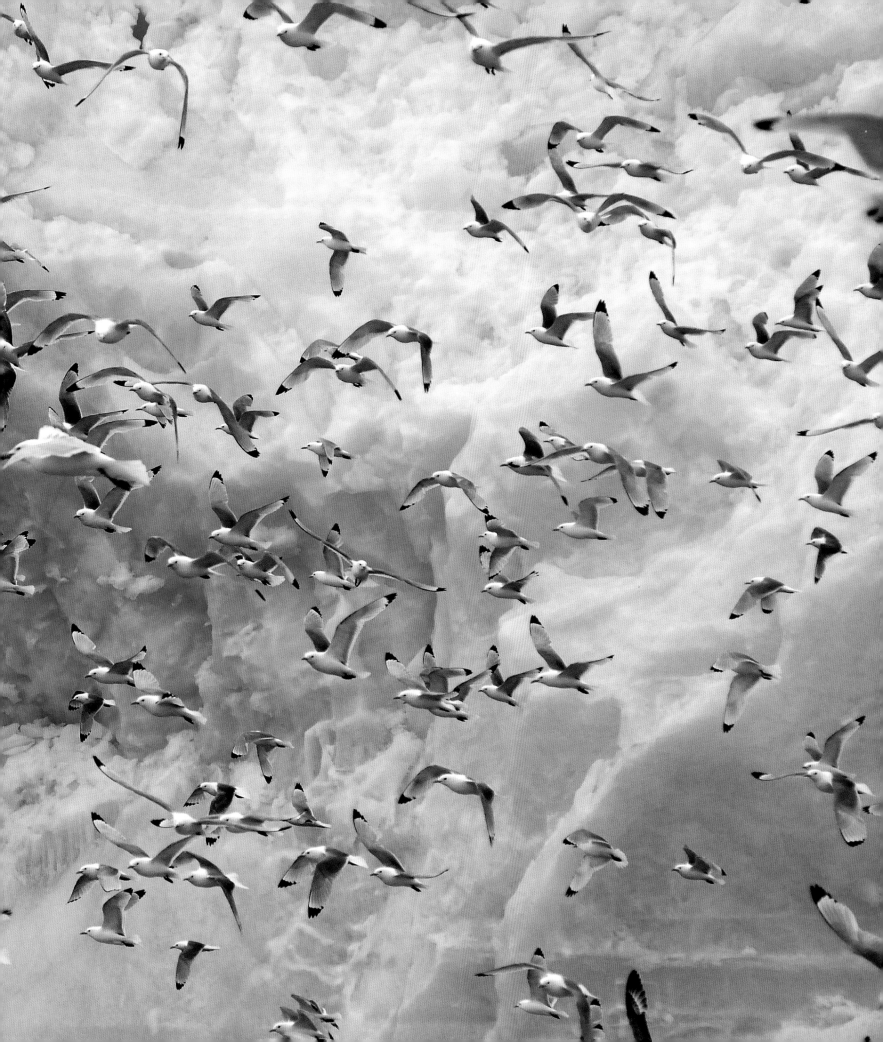

THE WHALES RETURN

The large cracks that open up in the sea ice provide pathways for returning whales. The first whales entering them, in April, are the 60- to 80-tonne bowheads, the only baleen (filter-feeding) whale that stays year-round in the Arctic. They wait out the winter at the ice edge or in polyna, large holes in the sea ice. A bowhead is designed for life in the ice. Its massive head, more than a third of its total body length and covered with a thick layer of fibrous tissue, can be used to break through ice up to 50cm (20 inches) thick, and an elevated blowhole allows it to make use of small holes in the ice to breathe.

Groups of bowheads keep in contact with each other with low moans and squeals as they search for ways through the ice. A bowhead's giant mouth, the size of a small garage, contains 600 of the largest baleens found in any whale. It uses these 4.5-metre (15-foot) sieves to catch copepods (shrimp-like animals) – 2 tonnes of them every day. Copepods are the Arctic equivalent of Antarctic krill. In winter, both these crustaceans feed on algae and other microscopic creatures living beneath the ice. When the spring sunshine melts the ice, the algae are released and the ocean blooms with vast swarms of copepods and krill – the basis of the Arctic and Antarctic food chains respectively.

Following slightly later than the bowheads come the Arctic's other two whales, the narwhal and the beluga. Like the bowhead, they have no dorsal fins, which makes it easier to move through the pack ice, using their backs to break through it. But unlike the bowhead, both are toothed whales. In winter, narwhals feed in the deep waters of the Arctic basin on sea squid, possibly diving as deep as 1500 metres (4922 feet). What narwhals are most famous for, though, are their 3-metre-long (10-foot) tusks. The exact function of the single tusk isn't clear, but as mainly only males sport them, it probably has a social function. Groups of males are often seen engaged in gentle fencing matches, which could be a way of sizing up rivals prior to mating, but no one is really sure.

As the ice melts, narwhals and belugas push farther into the pack ice, sometimes covering 80km (50 miles) in a day in search of new feeding grounds. Groups of belugas work together to stir up the ice and stop it refreezing around them. But in a cold snap, when the ice refreezes, they can become trapped in pockets of open water. Forced to stay put so they can breathe, the whales are easy prey for polar bears and Inuit hunters.

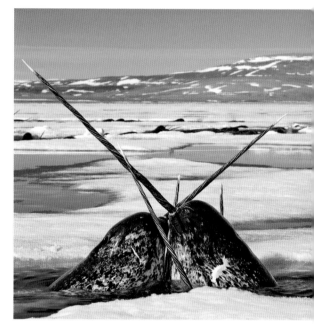

Above
Sparring narwhals. No one is sure exactly why these whales rub tusks, but being a male preoccupation, it may well be a way of establishing dominance and therefore mating rights.

Opposite
A bowhead resting after feeding at the ice edge, Baffin Island. Bowheads follow the edge of the melting ice, feeding on copepods by filtering them out of the water. They have the thickest blubber of any whale, an adaptation for surviving winter under the Arctic ice.

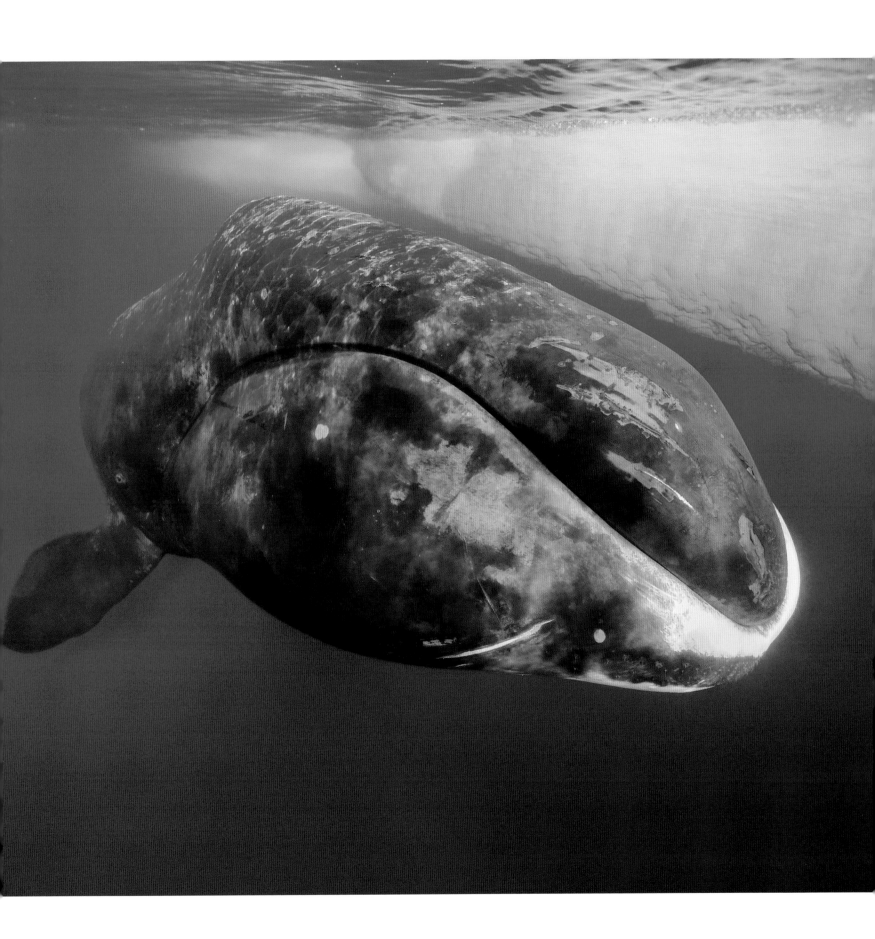

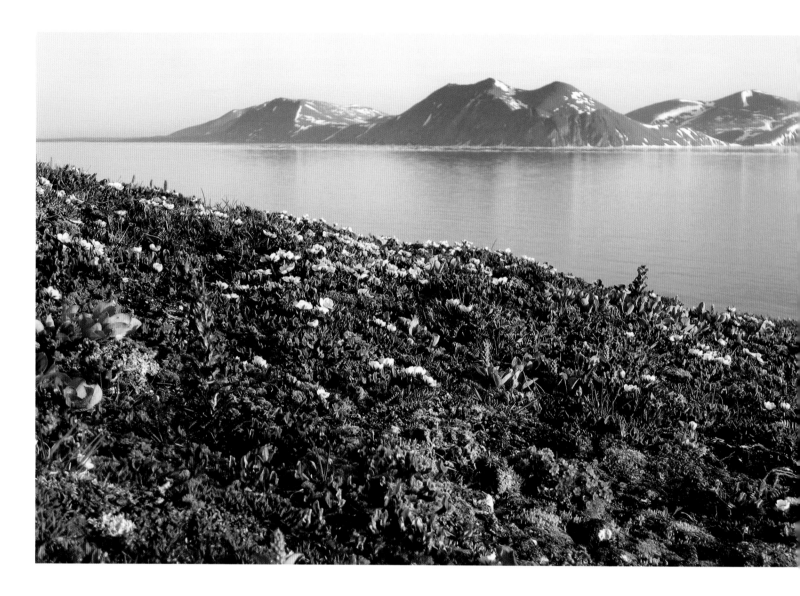

THE TUNDRA THAW

At the start of spring, the vast, treeless tundra that fringes the Arctic Ocean is still covered in snow. But as the returning sun starts the melt, small patches of vegetation emerge in sheltered areas. The growing season is so short that only the hardiest plants survive. Purple saxifrage is the most northerly-growing flowering plant, reaching 83 degrees north in Greenland. The only tree on the tundra is the Arctic willow. Though often no more than a couple of centimetres (less than an inch) high, it's a vital food plant for many animals, including one of the Arctic's most extraordinary insects.

The Arctic woolly bear caterpillar is one of the few insects active in spring, emerging early, having spent the winter frozen in its cocoon. Like some spiders and beetles, the caterpillar survives freezing by producing glycerol, which prevents ice crystals forming in its vital cells. When it thaws out, the caterpillar has barely three

Above

Spring flowering on an island off Chukotka in Russia. Flowers include pink Arctic milk-vetch, white mountain avens and blue Arctic forget-me-not, offering nectar for emerging bumblebees and butterflies.

Chapter two

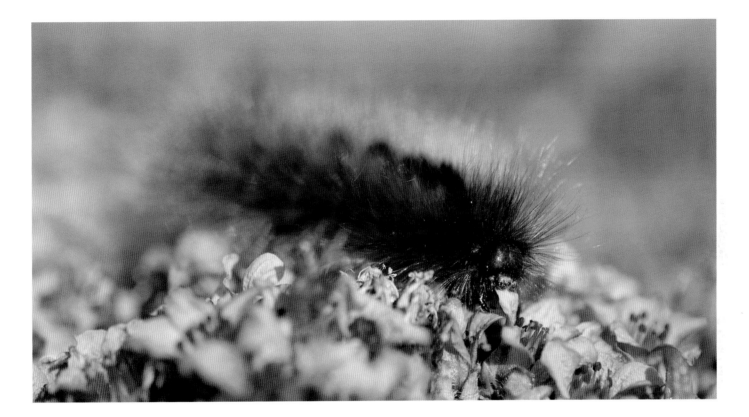

weeks to feed on the Arctic willow's new leaves before the plant pumps them full of toxic chemicals. The caterpillar therefore cannot build up sufficient food reserves to fuel its transformation into a moth. It has no option but to overwinter once again. Indeed, it is 14 years before the woolly bear turns into a pupa, making it the longest-lived of all caterpillars.

Above

Third-year woolly bear caterpillar on purple saxifrage. It has such a short time to feed, mainly on the new, toxin-free leaves of willow, that it takes 14 years to grow big enough to pupate and turn into a moth.

THE ANTARCTIC OASIS

By the end of the long winter, the Antarctic continent is surrounded by sea ice, covering more than half of the Southern Ocean and more than doubling the size of the continent. With the continent's wildlife ultimately depending on the ocean for its food, this turns most of Antarctica into a lifeless desert. But on the outer fringes, there are a few islands that never

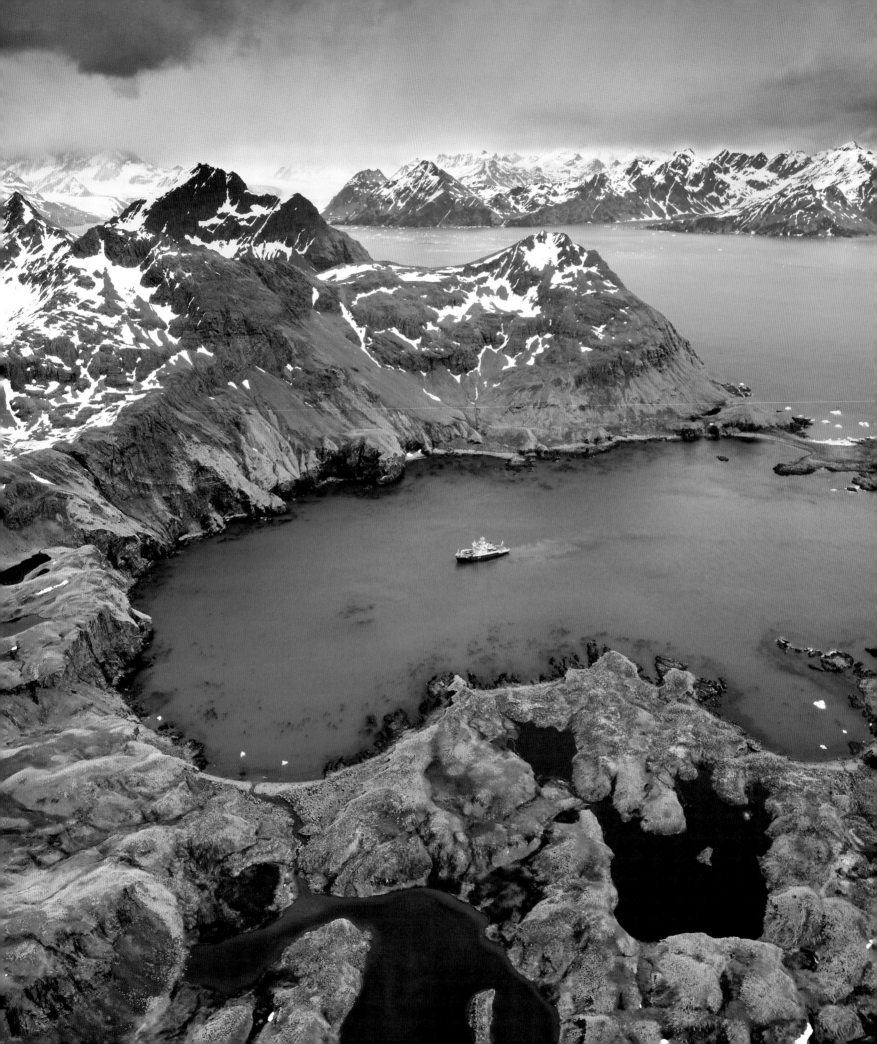

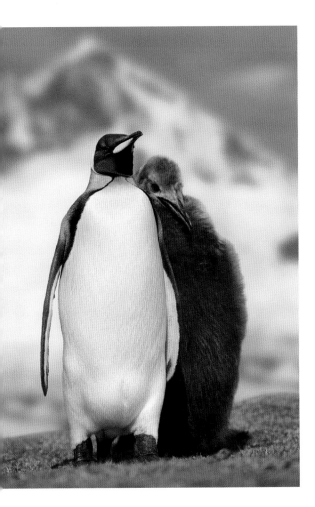

A nearly full-size king penguin chick
and parent, South Georgia.
The comparatively ice-free sea around
this sub-Antarctic island allows the king
penguins to fish all year round, making
it the perfect place to rear chicks that
take 10–13 months to mature.

Maiviken, one of South Georgia's many
sheltered coves. The steep slopes are
covered with mosses, lichens and
tussock grass, and in late spring,
elephant seals haul up on the beaches.

Mountains at sunrise along the spine of
South Georgia, late spring. Much of the
island is ice-covered year round, with
glaciers carving out deep valleys down
the mountains to the sea.

get ice-bound and which provide a vital year-round refuge for wildlife. The largest of the sub-Antarctic islands is South Georgia, which lies some 1500km (930 miles) east of the Falklands and a similar distance north of the Antarctic continent. It's 170km (106 miles) long and an average of 30km (19 miles) wide, and from the sea, it resembles the Alps dropped into the ocean. Huge glaciers flow down from a backbone of spectacular peaks. The south coast is an icy landscape much like the frozen continent it faces. But the north coast in summer is surprisingly green, with wide swathes of tussock grass.

THE WANDERERS RETURN

At the start of spring, in September, when South Georgia is still being battered by winter storms, sheltering among the tussock, up to their necks in blown snow, are full-grown chicks of the wandering albatross. Each weighs about the same as an adult mute swan and sits bolt upright on its nest, up to a metre (3 feet) tall. It takes just over a year for these chicks to be large enough to fledge, which means the adults can only breed once every two years. The growing chick sits out the whole of the winter while its parents fish the Southern Ocean, returning to feed it every two or three days. The adults' 3.5-metre (11.5-foot) wingspan makes them perfectly adapted for endless flight on windy seas (albatrosses tracked by satellite have gone all the way to the southern coast of Brazil in search of food), but it also restricts them to breeding around the windy northern fringes of Antarctica, where there is permanent access to the sea.

King penguins also breed on South Georgia, on the wide coastal plains of moraine left by retreating glaciers. Many of the colonies contain tens of thousands of pairs. During the worst of the winter, the large, fluffy brown chicks huddle together in crèches. Like wandering albatrosses, king penguins feed their chicks throughout the winter and are restricted to ice-free sub-Antarctic islands. Also, the chicks grow to be huge, standing almost a metre (3 feet) tall, which means it takes 10 to 13 months to rear one to full size.

By late September, when spring is just under way, the king penguins are joined by South Georgia's first summer visitors. Male southern elephant seals appear out of the surf, pulling their blubbery 4-tonne bodies up onto their traditional breeding beaches.

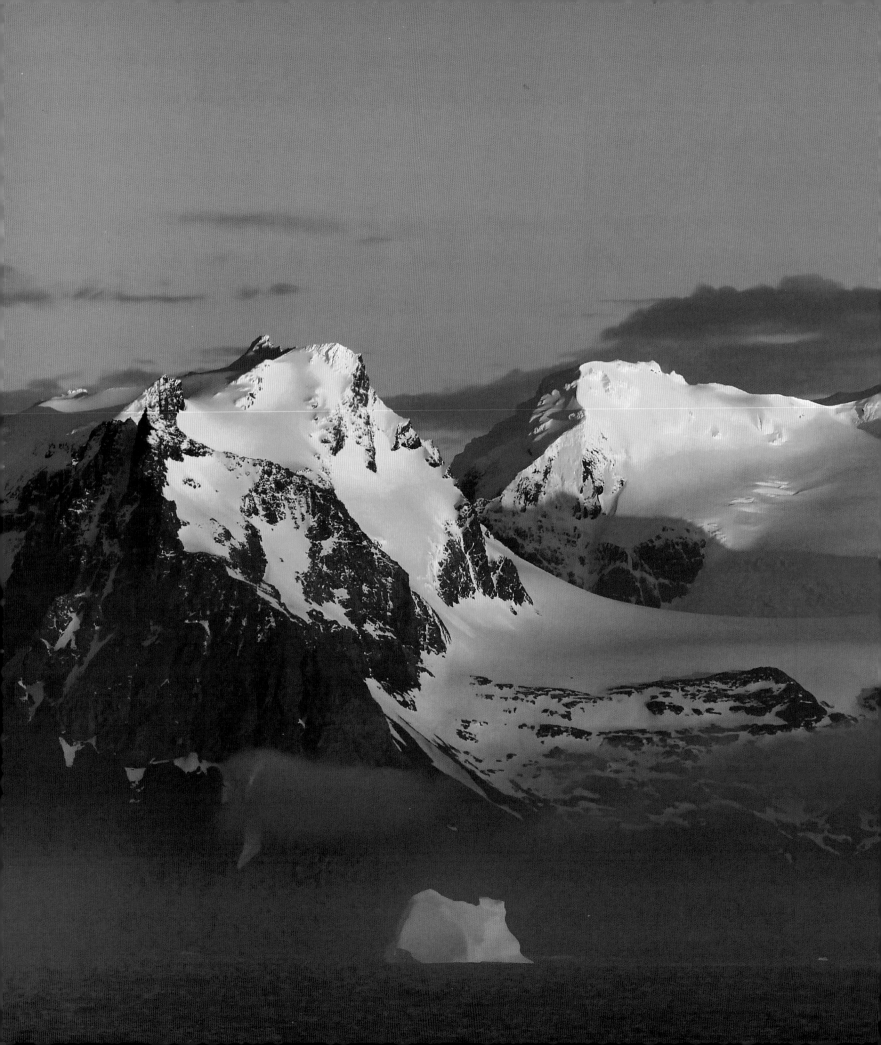

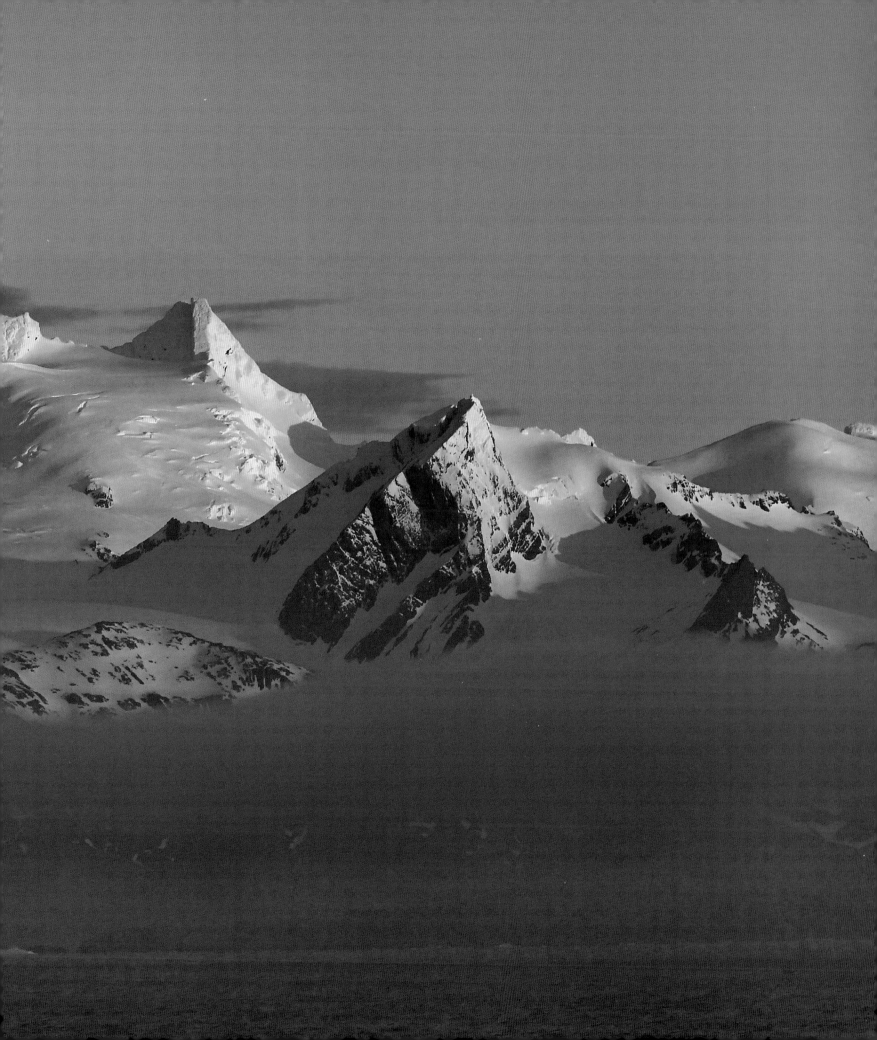

Beach bull, South Georgia. Male southern elephant seals haul up before the females, to sort out who is
top bull. When the females arrive, they aggregate into harems and, within days, give birth.
The king penguins on the island are then forced to make their way to the sea through a mass of seal bodies.

Opposite

Sneaky mating. Males that don't manage to hold a harem hang around in the surf, trying to mate with
females entering the sea. But it is the harem-holders who sire most pups – nearly 90 per cent of them.

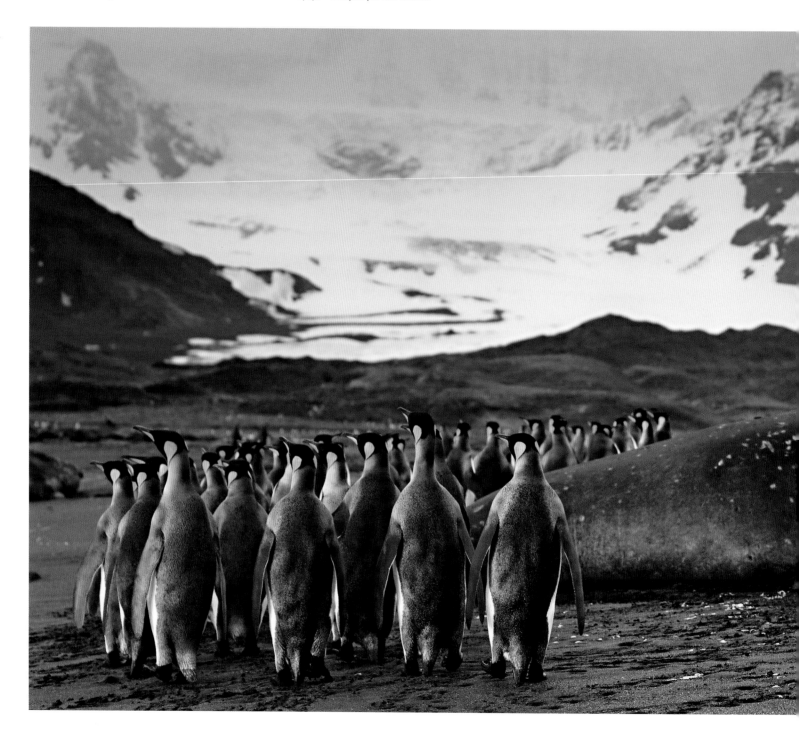

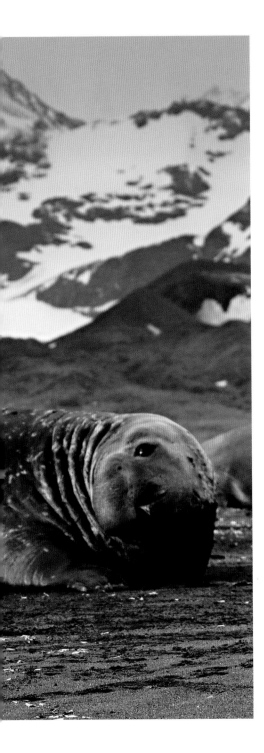

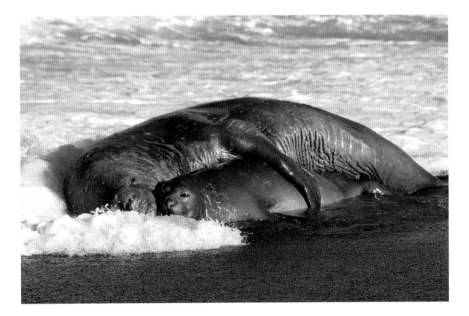

They are followed a few weeks later by the females, which are a third of the size of the 5-metre-long (16-foot) males. Elephant seals spend their lives at sea, except for the few months a year when they breed, and more than half the world's 600,000 elephant seals breed on South Georgia. The beach at St Andrews Bay alone attracts more than 6000 seals, and at the height of spring, in October, it's the stage for a massive spectacle.

THE BEACHMASTERS

The 3km (1.9-mile) beach is a solid wall of blubber, 10–20 seals thick. The males fight to keep control of a harem of females – up to a hundred strong in the case of the most successful males. Rival males challenge each other with loud, deep belching roars that echo down the beach. To enhance the power of the roar, they blow up the large proboscis that gives them their name. The strength of a roar alone may sort out a dispute, but when two equally matched males meet, the contest can escalate into a gladiatorial battle. Roaring all the time, the two rivals pull themselves up to their full height, resting on their tails alone for a moment, before smashing down on each other.

Each seal tries to bite the other, ripping at the proboscis and thick neck blubber. Battles may last as long as 15 minutes before one of the exhausted males backs down.

The females are pregnant when they arrive and give birth as soon as they haul up. By November, most are back in oestrus. Competition for females is intense – only 30 per cent of males manage to copulate. It's a dangerous time for newborn pups. If a harem-holder (beachmaster) spots a rival sneaking around the edge of his harem, he will come crashing through the colony, tossing females out of the way and crushing pups in his path. It's surprising how fast a 4-tonne elephant seal with violence on his mind can move.

Like all polar seals, elephant seal mothers produce rich milk, and her pup grows fast. In just four weeks, she will leave her baby and return to the ocean for the rest of the year. By the end of November, almost all the adult seals will have left, and the beaches return to the gentle rhythm of breaking waves and calling penguins. No longer do the king penguins have to run a gauntlet of fighting bulls to return to their chicks.

COURTSHIP AND LOVE

In October, more of South Georgia's visitors start to arrive. The grey-headed and black-browed albatrosses join the wanderers on the tussock-covered hillsides. Though about half the size of wanderers, these albatrosses are also masters of the wind and nest on steep cliffsides, where they can enjoy the updraughts. They are social birds and often nest close together in large colonies. One of their most spectacular breeding sites, at the very western tip of South Georgia, is the Willis Islands, which stick out of the ocean like jagged grey teeth. In spring, tens of thousands of albatrosses circle the rocky steeples.

Like the wanderers, both species are monogamous and return year after year to the same partner. Courtship is therefore brief but intimate, a pair gently preening the feathers on each other's heads. The two albatrosses do, though, have very different diets. Black-broweds feed on krill, while grey-heads go mainly for squid and, in the case of South Georgia's population, lampreys. Black-broweds breed every year, but grey-heads only manage every other year, possibly because their prey is harder to find.

For many people, the true sign of spring is the haunting call of the last albatross

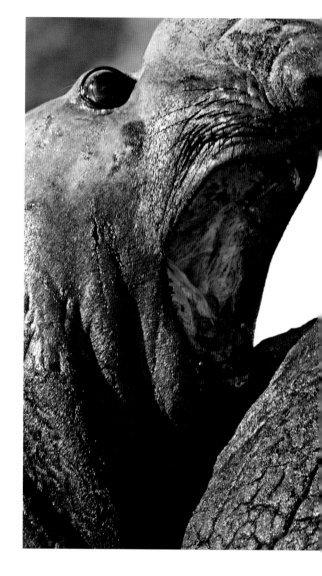

Above

The bloody clash. A male elephant seal's two upper and lower canines can rip an opponent's neck and trunk. But the areas of damage are padded by blubber, and the rips and cuts are seldom mortal.

Opposite

Battling it out. Males can be up to six times the size of females, and size is all when it comes to winning a battle. The power of a harem-holder's roar (amplified by his inflated nose) and his intimidating posture may be enough to drive away a rival male, but if the two males are of near-equal size, they will clash and stab until one gives way.

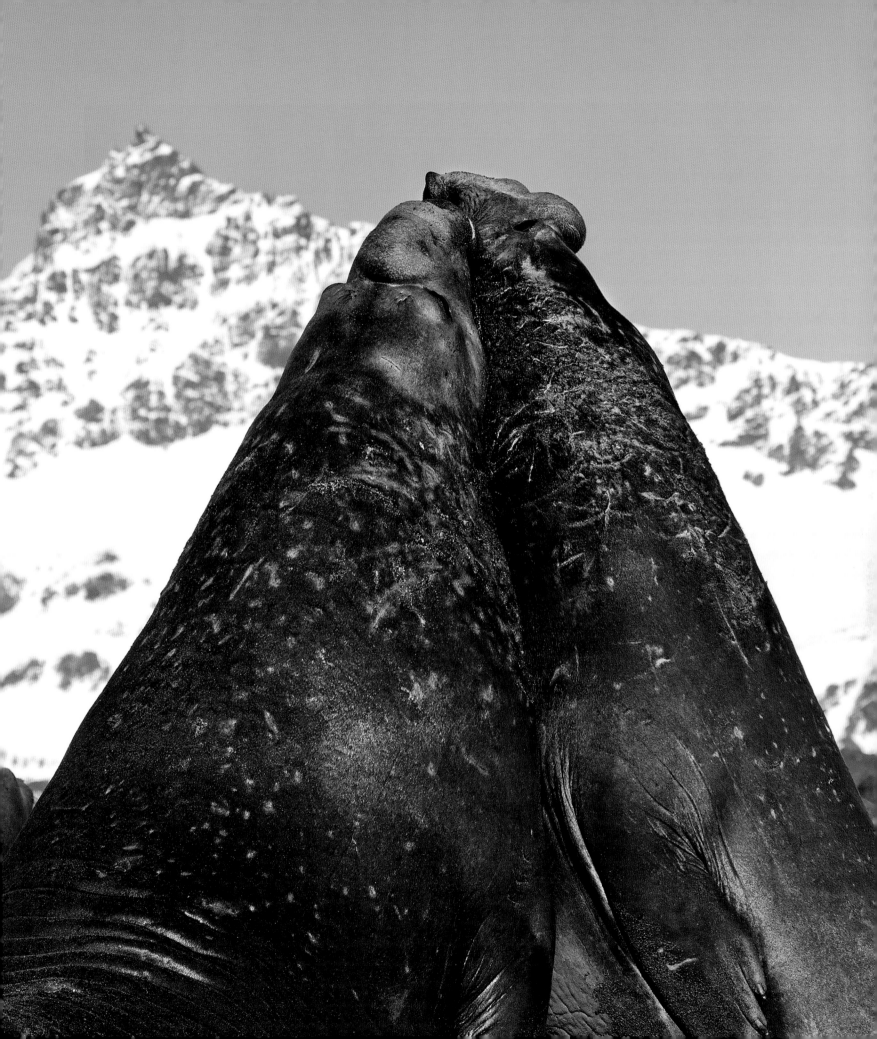

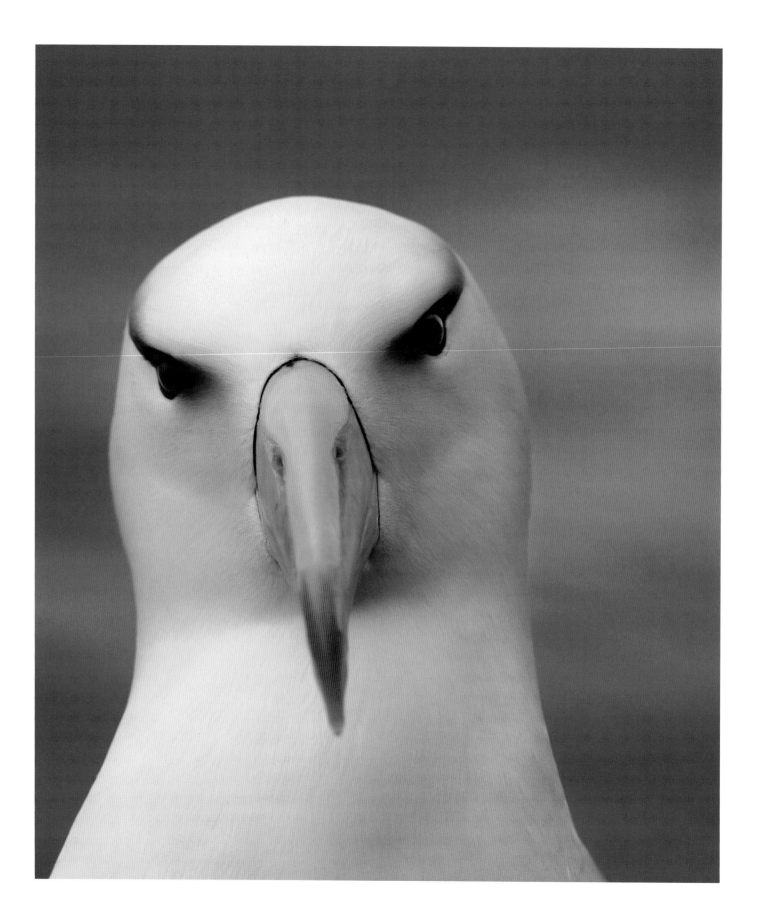

to return, the light-mantled sooty albatross. There are few seabirds with plumage quite so beautiful, and its exceptionally long grey wings give it elegance. Unlike the other nesting albatrosses, sooties are highly territorial and defend lonely nest sites all along the coast of South Georgia. The males come first, trying to attract mates with their two-part calls. A suitor will throw his head up and call, time after time. Eventually his love song will persuade a gliding female to land, when both birds will display to each other, throwing their heads up to the sky and spreading their tail feathers. Finally the couple takes to the air to perform a synchronized courtship display, the male exactly mimicking his circling mate's every move. Played out against South Georgia's spectacular mountain scenery, this has to be one of nature's most beautiful aerial ballets.

AN INFLUX OF MILLIONS

At night, the hillsides are alive with millions of returning seabirds. Walking among the tussock grass can be very dangerous because the ground is honeycombed with burrows that easily collapse. These are home to small petrels that spend most of their lives scouring the Southern Ocean but have to return to land to breed. The ocean is so vast that no one can be sure of the exact size of their combined populations, but 150 million is a conservative estimate. First to return to South Georgia each spring are the blue petrels. They arrive so early that there is a risk of finding their burrows still frozen, and to avoid this problem, they make regular visits throughout the winter to keep them free of snow. They are soon joined by countless tiny diving petrels, 22 million dove prions and 2 million pairs of white-chinned petrels, or shoemakers (their repetitive courtship call reminded whalers of the sound of leather-workers' sewing machines).

Every evening, vast flocks of these small seabirds gather on the sea close to South Georgia. They are waiting for nightfall so they can avoid the predatory skuas that wait for their return. Walk through their colonies in darkness, and fluttering birds are everywhere, calling incessantly and brushing your cheeks with their wings. The sheer density of seabirds, both night and day, is powerful evidence of the richness of the Southern Ocean.

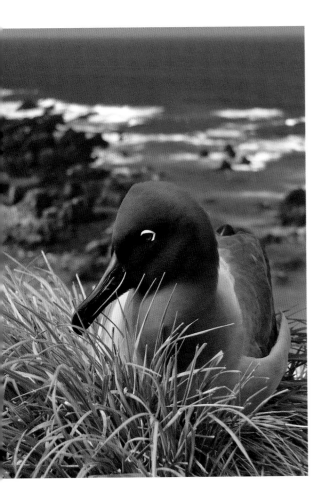

Above
A nesting light-mantled sooty albatross, South Georgia. The eerie cry of a male calling down a female to his solitary nest site signals the arrival of spring.

Opposite
An incubating black-browed albatross. Though it spends most of its life on its own, at sea, it remains faithful to its partner until death and always returns to the same nest site to breed.

A SCRAMBLE OF PENGUINS

The sub-Antarctic islands are also home to the most successful penguin of all, the macaroni. There are thought to be 9 million breeding pairs of macaronis, comprising 50 per cent of all the penguins found south of the Antarctic convergence. Five million of these dandy little penguins nest on South Georgia alone. They get their name from the bright yellow tuft of feathers above each eye, which reminded eighteenth-century explorers of the macaronis – young men who wore extravagant feathers in their hats.

Like all penguins, with the exception of the emperor, macaronis lay their eggs on bare rock. Suitable large areas of rock easily accessible from the coast are in limited supply, and so macaroni colonies are always crowded. The males return first, followed eight days later by the females. Some of the colonies contain tens of thousands of birds, stretching up the cliffside. Established pairs aggressively defend their patches of rock, pecking any penguin in reach, and birds nesting at the top of the colony must run a long and painful gauntlet of beaks.

The other penguin that breeds on South Georgia has an altogether different character. The gentoo is the laid-back representative of the penguin world. It has a population of some 300,000 pairs, about a third of which nest on South Georgia. Like the macaronis, gentoos need bare rock to lay their eggs and will make long journeys up steep hillsides to find it, and when the snow is still on the ground, you see them struggling up the slopes – and tobogganing back down. But their colonies are far more peaceful and less noisy than macaroni ones. Unlike the macaronis, which make long offshore journeys in search of krill, gentoos feed on small fish close to the South Georgia coast. Gentoos nest farther south, too, on the Antarctic Peninsula, but won't lay eggs here until November, a month later than on South Georgia, as they have to wait for the sea ice to retreat.

THE PENINSULA PENGUIN

Antarctica's sea ice starts to retreat on about the spring equinox on 21 September. This is when the sun passes the equator on its journey south. Over the next five months, more than 80 per cent of the sea ice will melt, the Southern Ocean will bloom and the

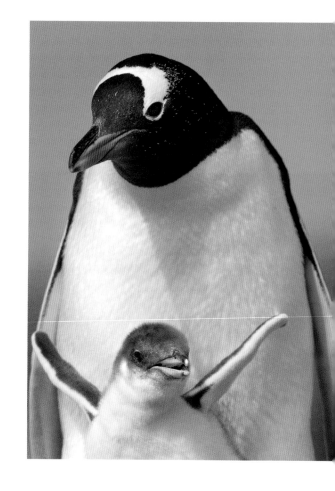

Above
A gentoo penguin and its offspring. Like all the smaller penguins, gentoos need ice-free nest sites. The ones that breed on South Georgia can rear chicks far earlier than those at the Antarctic Peninsula colonies, which have to wait for the ice to retreat before they can lay their eggs.

Opposite
Macaroni penguins skiing down a slope at Cooper Bay, South Georgia. They are on their way to the sea to fish for krill, leaving their partners on duty at the colony, incubating eggs (usually two) or guarding the chicks on nests among the tussock grass.

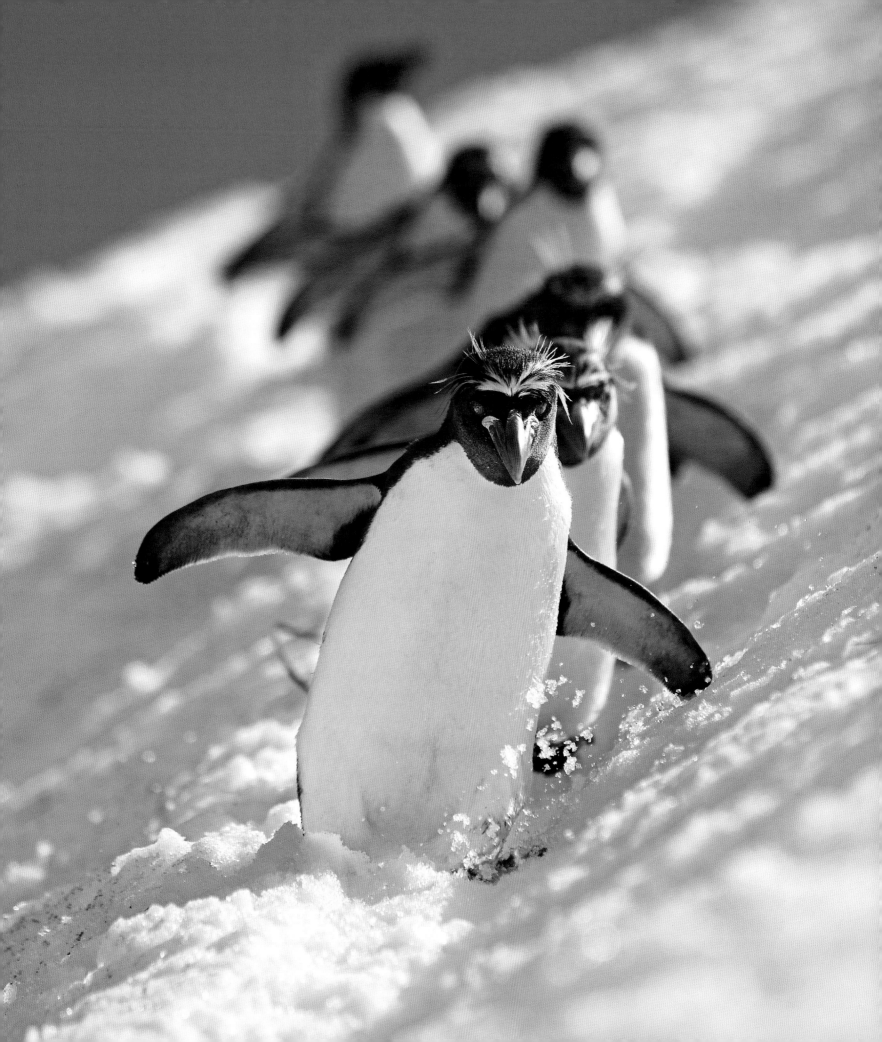

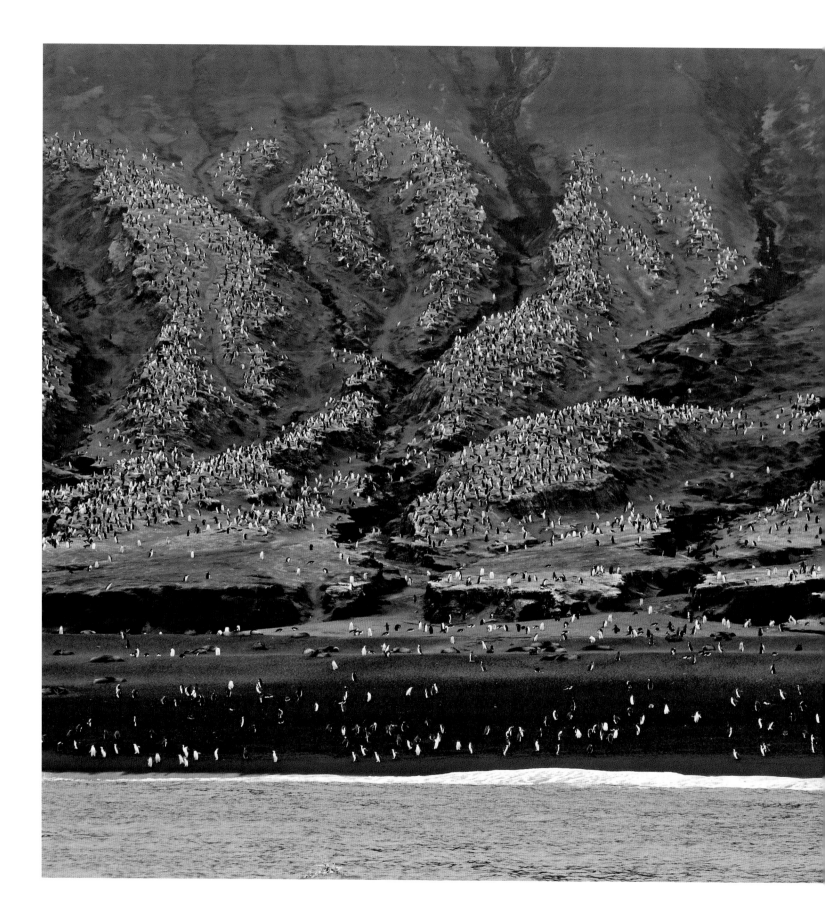

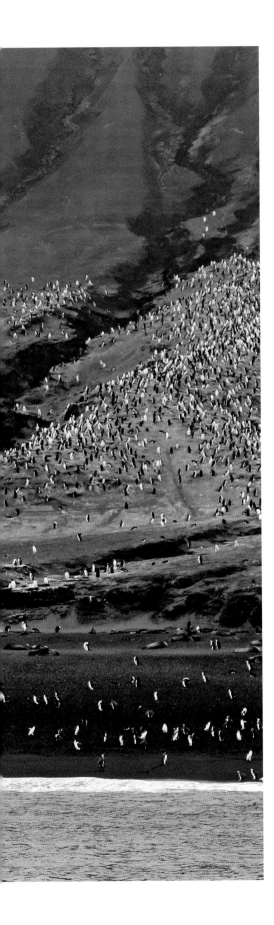

Left

Ash-slope colony. Millions of chinstrap penguins come ashore to nest on the relatively warm, ice-free and volcanic slopes of the South Sandwich Islands, part of the Antarctic Peninsula. Zavodovski alone has a colony of possibly 2 million. Warmer conditions allow a longer breeding season than Adélies have further south.

Below

Chinstrap take-off. Named after the stripe under their chins, these penguins feed mainly on krill and tend to fish close to their colonies, in this case on the volcanic island of Zavodovski.

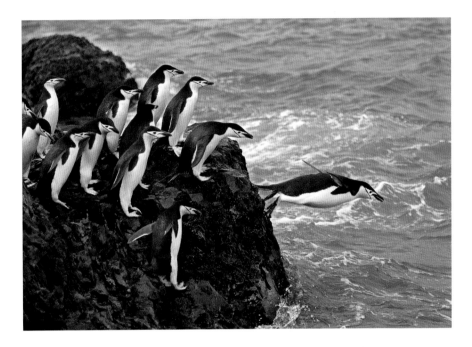

wildlife will follow the diminishing ice south. First to be set free by the retreating ice is the Antarctic Peninsula, a long arm of the continent that projects north like the handle of a frying pan and is fringed by islands. Only 0.32 per cent of the whole of the continent becomes ice-free, and the majority of that bare rock is found here.

Released from the ice in the summer, and with a milder climate than the continent, maritime Antarctica is home to much of Antarctica's wildlife. It also has its own particular penguin, the chinstrap. Almost all the 6.5 million pairs of chinstrap penguins are restricted to this region. The largest colony, on Zavodovski, one of the South Sandwich Islands, is thought to contain about 2 million. The snow melts early on the warm slopes of this volcanic island, and the vast colony stretches for miles up its sides. Chinstraps are the noisiest of all the penguins, with loud, repeated, braying calls, and the sound and smell of the colony are truly overpowering.

Chinstraps feed on krill (shrimp-like crustaceans), and recently both their numbers and their range have decreased. The likely reason for this is the decrease in the numbers of krill, probably linked to shrinking sea ice.

A Weddell seal mother and her pup. She has given birth in spring on an area of ice in the Ross Sea, where the swell of water around a rock means there are cracks in the ice, allowing her permanent access to her pup.

Right
Big Weddell. This seal probably weighs a tonne and is nearly 3 metres (10 feet) long. It will manage to remain south in the winter by staying under the ice and using its teeth to keep breathing holes open.

LIFE ON THE PACK ICE

In spring, the Antarctic continent is still surrounded by ice. Though the ice gradually breaks up as summer approaches, this area remains one of the world's least known and least accessible wildernesses. Even modern icebreakers are challenged by the ever-moving mosaic of broken ice. Only from the air has it been possible to discover that the ice is home to up to 15 million crabeater seals, making them by far the most numerous seal on the planet. They are solitary, and if you fly over the pack ice in October, for mile after mile, you will spot lone females giving birth on the ice.

Crabeaters are perfectly designed for life on the ice. They don't eat crabs (there are none in Antarctic waters), but they feed on another crustacean, krill, which they filter out of the water using their long, interlocking molar teeth as a sieve. Their distribution seems to be related to the ever-changing relationship between the krill and the pack ice.

Farther south, on the permanent ice that fringes the continent, you find Antarctica's equivalent of the ringed seal in the north. The Weddell seal is the most southerly breeding mammal and the only one that remains in the south throughout the winter. It's a large animal with a small, friendly face and a grey coat beautifully patterned with black spots.

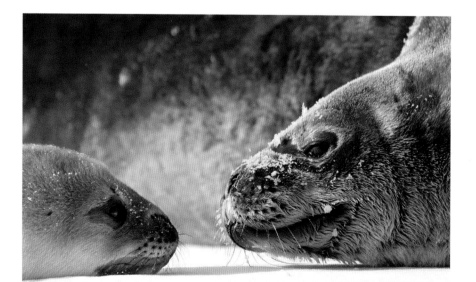

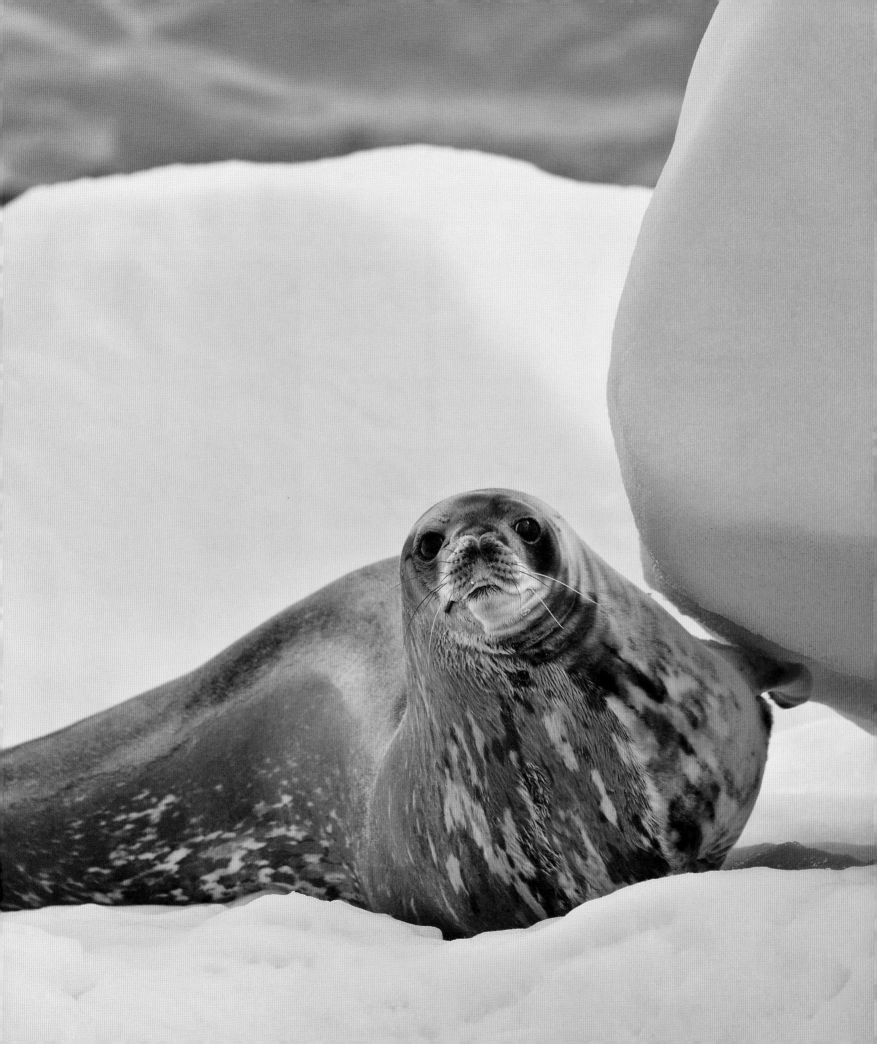

In the depths of winter, when it's too cold to be out on the ice, Weddells spend most of the time under water. But they have to maintain permanent breathing holes, which they do by grinding away at the ice with their teeth. The wearing away of their teeth is thought to be why Weddells only live about 20 years, half the lifespan of most other seals.

Weddells have a fascinating breeding system halfway between that of the solitary crabeaters and the harems of elephant seals. A male defends a large, three-dimensional underwater territory surrounding haul-out and breathing holes and cracks, mating with those females that use the holes. In this way, he can control up to ten females. Only about half the males manage to maintain territories, and competition for holes is intense. Weddells are very vocal seals, and their songs seem to play an important role in territorial battles. Dive under the ice at this time of year, and the seal soundtrack is extraordinary – a weird combination of whistles, buzzes, trills, chirps and groans that can be heard more than 32km (20 miles) away. When song isn't enough to drive away an intruder, a vicious underwater battle will result, and many males bear scars as a result.

The females haul out onto the ice in spring to have their pups. In the north, close to the pack ice, this may happen as early as September. But in the south, where it's still bitterly cold, the females may not give birth until November. It must be a rude shock for a newborn pup to leave the warmth of a womb at 37°C (99°F) and enter a still-frozen world.

The cold is one reason a Weddell mother is keen for her pup to shelter under the ice as soon as possible, and at just a week old, it will make its first swim. The weaning time, though, is longer than that of any other seal – seven weeks. But then Weddell seals, unlike northern ringed seals, don't have to fear being hunted by polar bears.

THE DEEP-SOUTH PENGUIN

Only one penguin ventures to the deep south and breeds around the continent itself. The Adélie may look comical, with its little dinner suit and rolling gait, but it's perfectly adapted to breed farther south than any other penguin. Its most southerly colony is at Cape Royds, just 1300km (808 miles) from the South Pole. Though small, the Adélie has exceptionally dense feathers and a thick layer of subcutaneous fat, which keeps out the

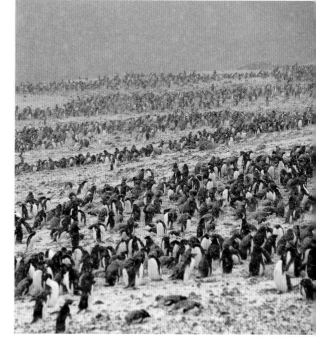

Right
Nest preparation, Cape Crozier. Male Adélie penguins arrive at a colony first, to choose the best site, spending some time gathering stones for their nest piles and stealing from any unguarded piles nearby. The arriving females seem to be impressed by a male's stone-gathering ability and can be won over with stone presents. It may be that a well-built stone nest can protect the eggs and chicks from melting snow and mud.

cold and provides a food reserve in hard times. Its short bill is covered with feathers for half its length, and the external nares (nostrils) are kept tightly closed to reduce loss of body heat. This all combines to make the Adélie a very tough penguin. It needs to be, because it has to survive the briefest of breeding seasons in the harshest of conditions.

The problem with breeding so far south is that, by the time Adélies need to start the journey south, the sea ice still has a long way to retreat. This means an epic trek across the ice, which in bad years, can be as long as 100km (62 miles). The sight of thousands of little black dots approaching across a vast expanse of sea ice is a sign that spring has finally arrived in the deep south. Tobogganing on their bellies or just waddling along, the penguins head for traditional nest sites. Bare rock is in very short supply at the edge of the continent, and so some Adélie colonies are huge, with the largest at Cape Adare containing more than 220,000 pairs.

Adélies are not only faithful to their partners but also always return to almost exactly the same place in the colony where they bred the previous year. For two or three weeks after they arrive at the end of October, Adélie colonies are incredibly busy, noisy places. To impress his mate, the male collects little stones with which he and his partner construct a simple bowl for their nest. But Adélies are kleptomaniacs and steal each other's precious stones.

By the end of November, they will have laid two eggs, but then the deep south often delivers another challenge. As sea temperatures rise, freezing air is drawn down from high on the continent and over the coast, and many Adélies perish in dramatic ice storms. Those that survive have to make long journeys back to the sea to feed. The female sets off as soon as she has laid, leaving the male to do the first shift of incubation. He will have to starve for more than a month before the female returns to relieve him.

Adélies have to choose their breeding sites very carefully. They need strong winds in spring to blow the winter snows away and give them bare rock to lay on. But by the time their chicks start to hatch in December, they need the sea ice to have melted back, giving them a shorter journey to the sea. Each year is different, and only when summer finally arrives in the deep south is it possible to know whether the Adélies have had a successful breeding season.

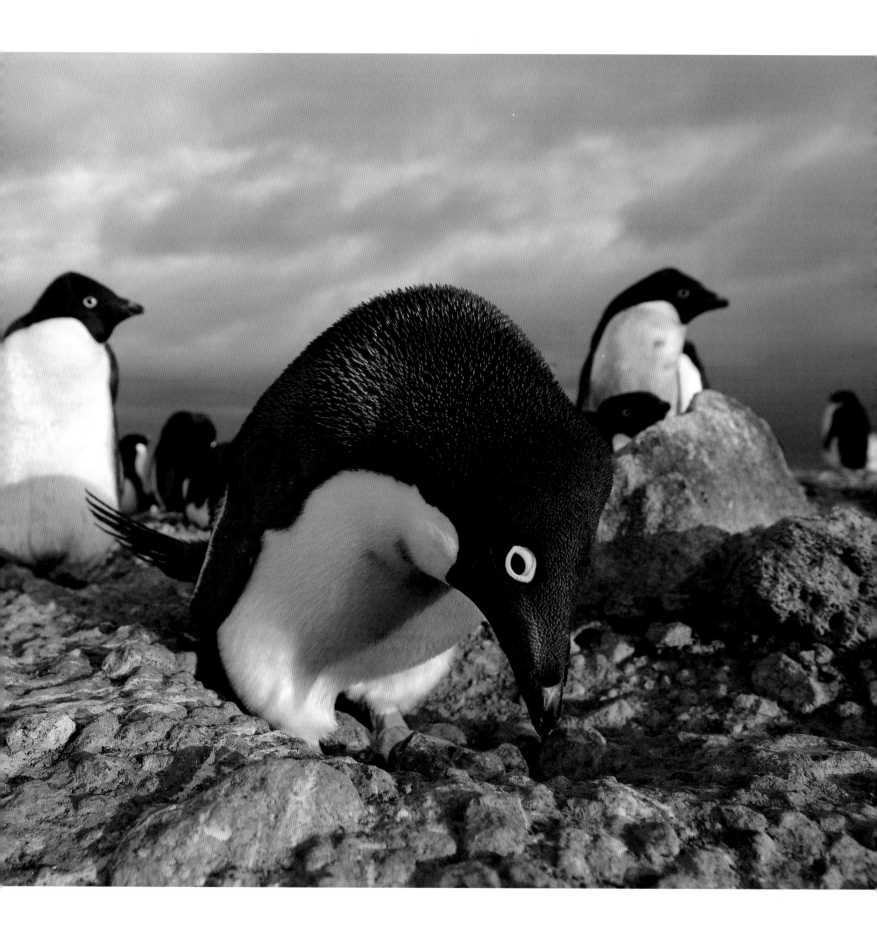

Chapter three | Summer

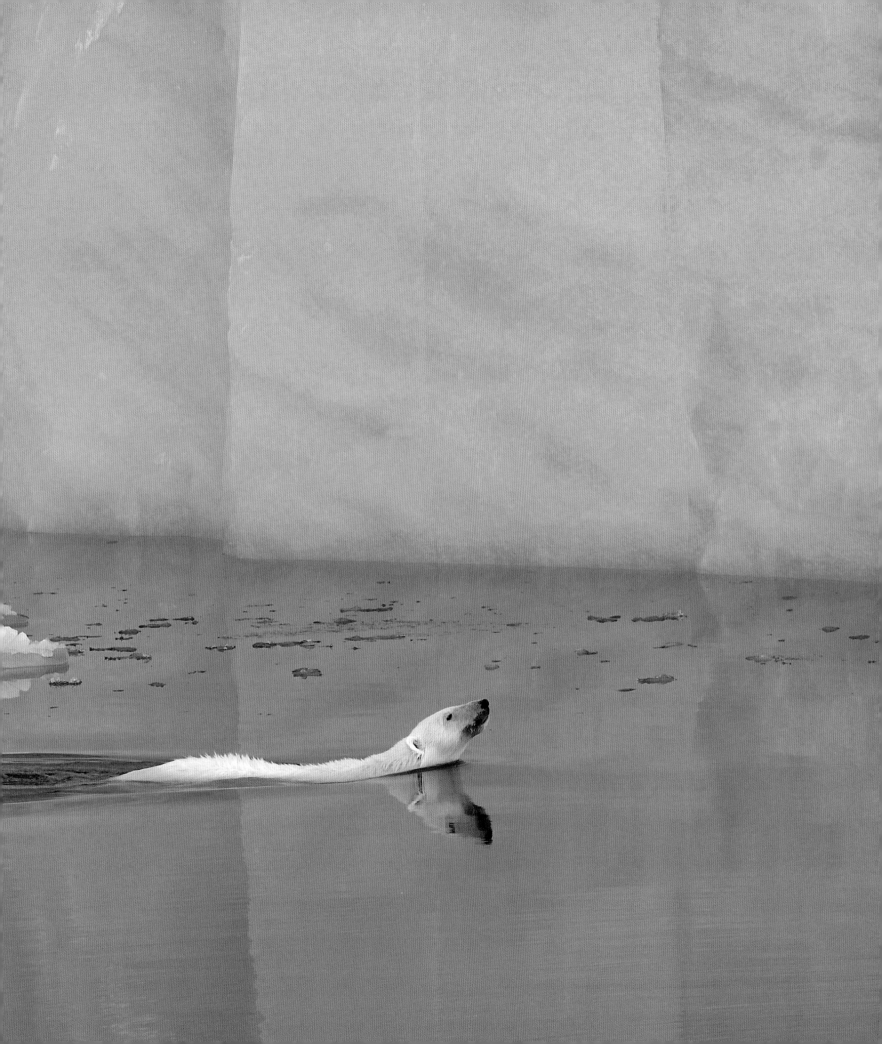

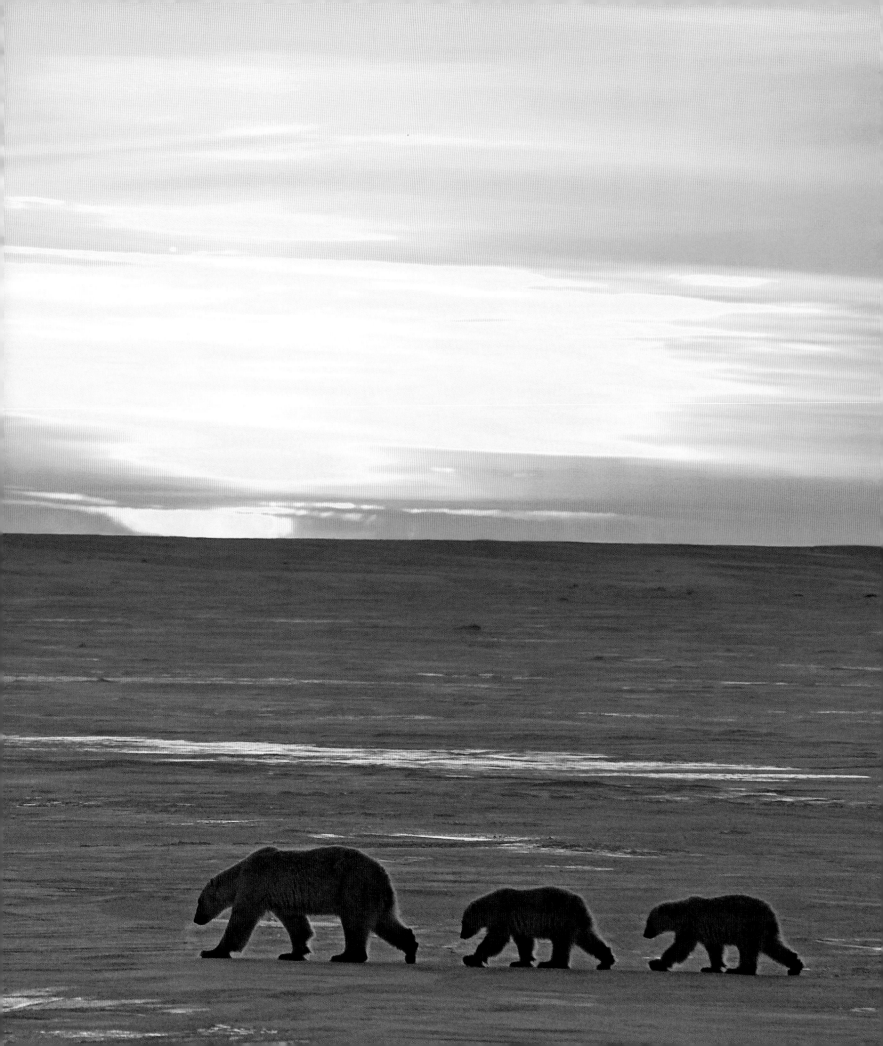

Life multiplies

July brings high summer to the Arctic – 24-hour sunlight and real warmth. For the polar bear mother and her cubs, the once-firm platform of sea ice they relied on melts beneath their feet as the ice breaks up into a patchwork of ever-moving floes.

Though six months old, the cubs have never experienced liquid water before, and wait nervously at the edge of the ice floe as their mother jumps into the near-freezing water. Their hungry mother is desperate to find seal prey. She's a strong swimmer (polar bears have been known to travel as far as 100km/62 miles in one day) and powers herself, doggy style, using her massive front paws. Frightened of being left behind, the cubs eventually leap in. Learning to swim is essential, for much of their lives will be aquatic.

GOING SEAL HUNTING

In early spring, the polar bear had the advantage over her main prey, as the ringed seal pups and their mothers were tied to their sea-ice lairs. But once the pups learnt to swim and the ice began to break up, hunting them became far harder. The bear has now resorted to two different hunting techniques – still-hunting and stalking. Still-hunting involves waiting by the edge of a lead or a melt-hole in the ice, often lying flat, chin close to the edge, in the hope that a seal will emerge to breathe. This is the commonest hunting technique. Otherwise, the polar bear mother resorts to stalking.

Once the seal pups have left their lairs, they haul out onto the remaining ice floes. Their white coats provide camouflage, they have good eyesight, and they are sensitive to vibrations. To approach unseen, a polar bear has to move as stealthily and softly as possible. When it first spots a seal out on the ice, it will freeze while it works out the best approach. What follows is a game of grandmother's footsteps as it lowers its head and stalks its prey. Once the bear gets within 15–30 metres (50–100 feet), it will make a dash to grab the seal before it dives into its breathing hole.

As the ice continues to break up through the summer and the seals become more widely dispersed on isolated floes, some polar bears resort to aquatic stalking. They swim under water for as long as they can, breaking surface only to breathe, exposing just the tops of their noses, hiding behind ice floes.

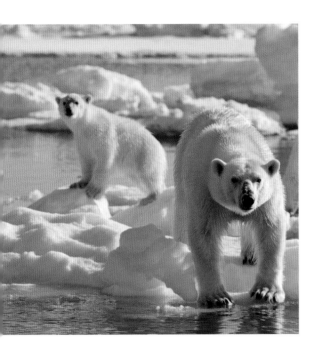

Above
Checking out danger. The cubs are constantly learning from their mother, including why not to disturb her when she is hunting and the best way of stalking potential prey.

Opposite
Sea-ice journey, Wapusk National Park, Manitoba, Canada. The cubs will stay with their mother until they are at least 18 months old and often more than two years old, until they can hunt for themselves.

Previous page
The aquatic mode. Once summer arrives and the ice breaks up, polar bears are forced to follow their seal prey into the water. A long neck helps keep a bear's head above the surface.

Aquatic stalking. This large male is swimming slowly between ice floes in pack ice north of Svalbard, hunting for seals. It is using its huge, partially webbed front feet as paddles and its back legs as a rudder. It can swim under water and is capable of holding its breath for more than five minutes.

Another strategy involves using the water-filled melt channels that appear on the sea ice in the summer. These can be up to 50cm (20 inches) deep and provide good cover for a spread-eagled bear as it slides closer to its prey.

Creeping up on an unsuspecting seal or its pup is a particular challenge for a mother with two six-month-old cubs in tow. They are still being suckled and so don't understand the urgency of a hunt. They want to play and become impatient with their mother as she waits motionless by a seal's breathing hole. But they'll learn. If they disturb her, she gives them a cuff around the ear.

In summer, hunting takes anything between 35 and 50 per cent of her waking day, often taking place at night, when the seals are more active. Sleep accounts for a quarter of the day. Curled up in a ball and with their backs to the wind, the mother and her cubs might sleep for only an hour or two after a good meal, but sometimes that can stretch to eight hours.

A MULTITUDE OF FISH

The long summer days make life more difficult for polar bears, but for most Arctic wildlife, this is a short, rich time of opportunity. As the ice retreats, the warmth and an influx of nutrients from thawing rivers fuel a massive bloom in marine life. Enormous shoals of Arctic cod gather along the shore, which from the air can look like black oil slicks. One huge aggregation was estimated to contain more than 900 million fish.

Exactly why Arctic cod congregate in such enormous numbers isn't clear. They are not spawning (they do this under the ice in late winter), and they don't seem to be feeding – their bellies are usually empty. So perhaps shoaling is a strategy to reduce the chances of any individual being eaten by the enormous number of predators. Certainly, these fish are an extremely important component of Arctic marine food webs.

Sometimes a single shoal will be attacked by hundreds of belugas, narwhals and harp seals. As the mammals plough through the shoal, thousands of kittiwakes and fulmars pick off panicking fish driven to the surface. In just 24 hours, more than half a million fish may be snapped up.

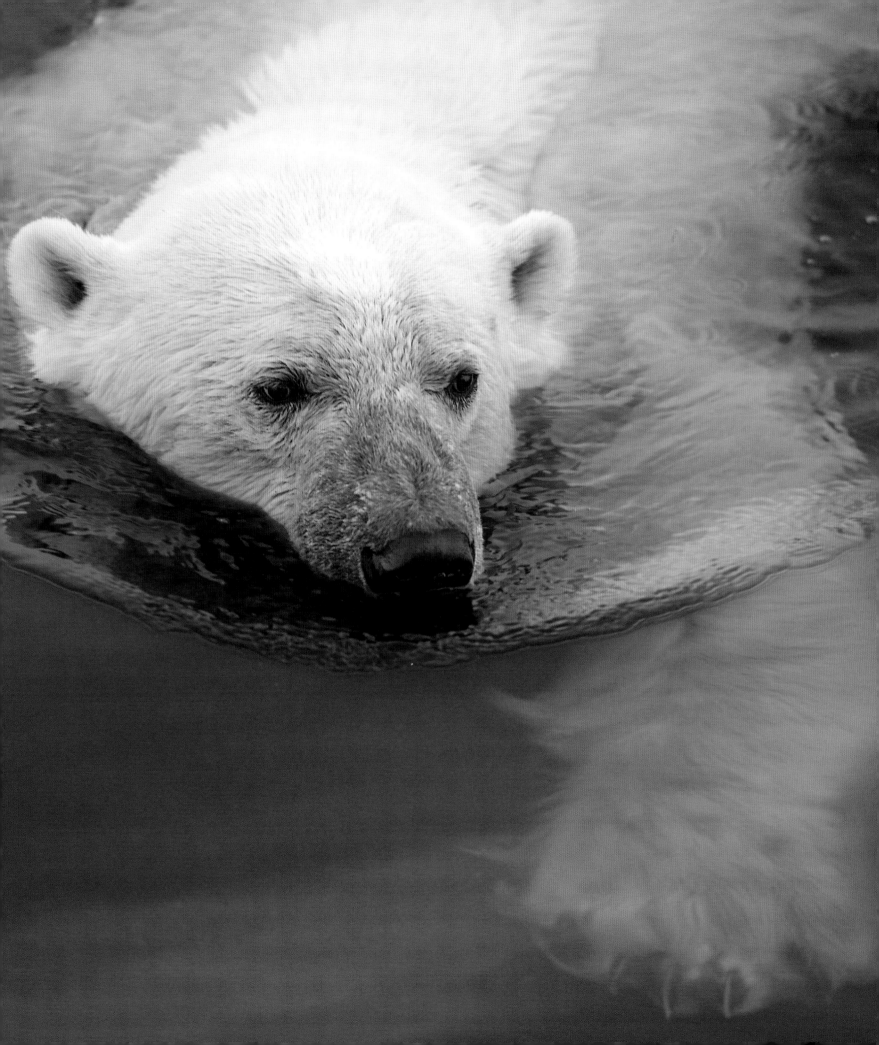

SEABIRD CITIES

By midsummer, the Arctic's huge seabird cities are frantically busy. Towering hundreds of metres out of the sea, the cliff rock-faces are crowded with hundreds of thousands of noisy, squabbling seabirds, and the sky seems permanently full of a swarm of adults returning to feed hungry chicks. These huge colonies are scattered all around the Arctic, bearing witness to the richness of the Arctic Ocean in summer. But the number of species using these avian tenements is surprisingly small. Just guillemots and two Arctic gulls – the black-legged kittiwake and the rarer red-legged kittiwake – dominate most colonies.

Guillemots have two tricks for high-altitude nesting. Their eggs are conical and so tend to roll in a circle around the pointed end, which helps stop them rolling off a ledge. Also, uniquely among seabirds, their eggs are multicoloured, which may help a parent to locate its eggs on a busy cliff-face. Kittiwakes nest on even narrower ledges, sometimes just 10cm (4 inches) wide. To keep their eggs from rolling off, they build an elaborate nest out of plastered mud, seaweed and other vegetation, which can be more than a metre (3 feet) tall. In this way, they avoid competition from guillemots and fulmars, which don't build nests and therefore have to use wider ledges.

ROLE REVERSAL

Most of the rest of the birds that return to breed in the Arctic, including all the other gulls, do not nest on cliffs, and with no trees for refuge, are forced to nest on the ground. They include two phalaropes – the red-necked and the red – which can be seen on ponds, spinning in tight circles, trying to bring insects to the surface. In both species, the normal sexual roles are reversed. The females have bright courtship colours and compete aggressively for mates. And once they have laid their eggs, they head south, leaving the males to do the rest of the work. With the dull plumage normally associated with females, the males are perfectly camouflaged for incubation.

Nesting nearby and equally well camouflaged are often female eider ducks. Four kinds of eiders live in the Arctic, and the males of all of them have beautiful plumage.

Above

Common guillemot eggs. A guillemot lays a single egg on a cliffside ledge, and so only predators that can fly or climb (in this case, humans) can reach it. The egg's conical shape helps prevent it rolling off the ledge, and unique markings help the parents identify it.

Opposite

Brünnich's guillemots nesting on Auk Mountain, Svalbard. Once the chicks are ready to leave (not fledged yet but able to swim), they just parachute down to the ocean below.

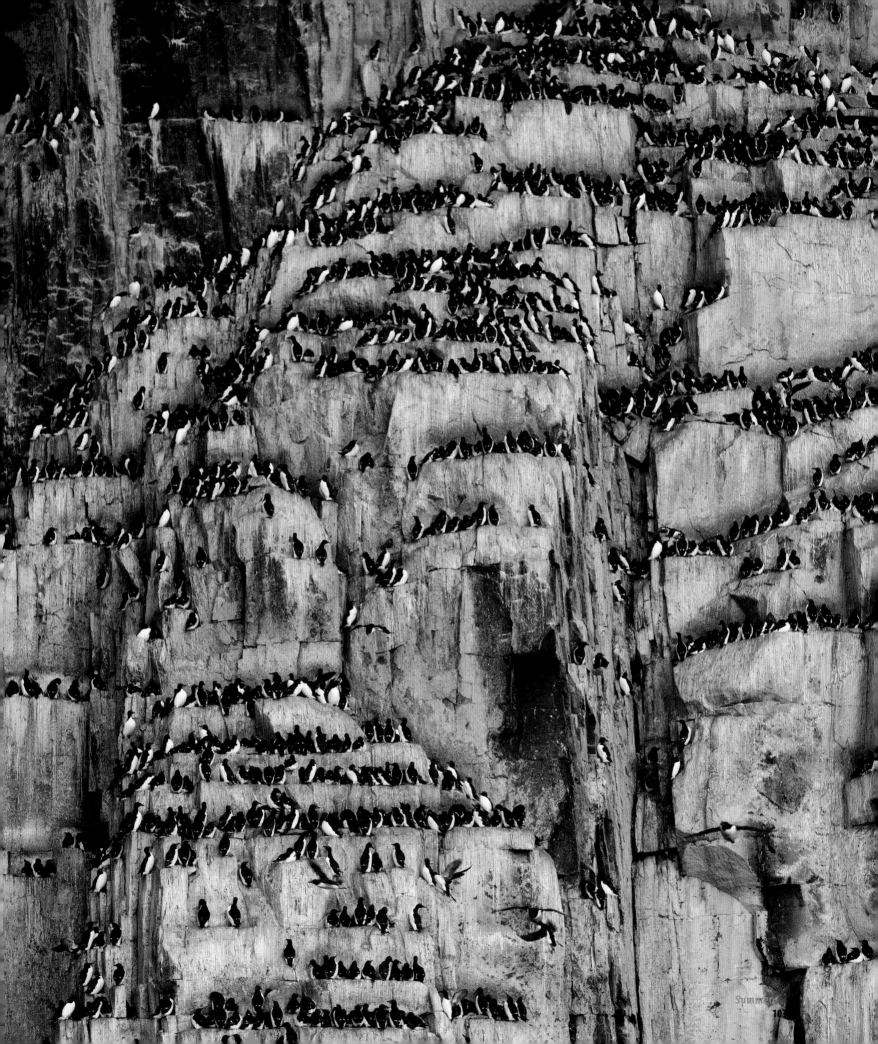

The largest is the common eider, which produces the eiderdown used to fill quilts – it's the soft down that the female plucks from her belly to line her nest and to hide her eggs when she has to take a break from incubation.

Penguins in Antarctica have no land predators, but ground-nesting Arctic birds have to face regular threats from Arctic foxes and even polar bears. A few eider eggs might seem slim pickings for a polar bear, but with seals difficult to catch in summer, bears resort to scavenging whatever they can. One ground-nesting bird species, though, is brave enough to see off the huge carnivore. Arctic terns will repeatedly dive-bomb an invading polar bear, even drawing blood – a surprisingly effective deterrent, providing protection not just for the terns but also the eiders and waders nesting near the terns.

Most Arctic ground-nesting birds nest alone or in small associations, but the impressive exceptions to this rule are the geese, which gather in colonies that can contain more than 100,000 birds. And different parts of the Arctic are dominated by just one or two species. All of the world's red-breasted geese nest in Russia's Taymyr Peninsula; possibly 800,000 Ross's geese concentrate in Canada's Northwest Territories; and all of the world's barnacle geese nest in a swathe from eastern Greenland and Norway's Svalbard east to the Russian island of Novya Zemlya.

The most abundant is the snow goose, which numbers in the millions. On Baffin Island, the largest colony contains 460,000 birds, covering vast areas of the tundra, as far as the eye can see in any direction – a blizzard of white dots. Arctic foxes make a good living stealing the snow goose eggs and chicks, and the geese also have to put up with marauding wolverines, venturing far from their normal taiga home.

THE TUNDRA TURNS GREEN

For a few short weeks at the height of summer, the High Arctic tundra has a real feel of summer. With temperatures as high as 12°C (54°F) in the middle of the day, the upper layers of the permafrost begin to thaw, and with 24-hour sunlight, tundra plants enjoy a short but intense growing season. In wetter parts, stretches of cotton grass swathe

Above
Arctic mouthful of young black-legged kittiwake. It was caught shortly after leaving its high-rise nest in a massive kittiwake colony on Edgeøya Island, Svalbard, Norway, and will be food for the Arctic fox's cubs.

Opposite
Arctic alarm call. An Arctic tern screams a warning. Any intruder into the tern colony, whatever its size, whether fox or polar bear, will be dive-bombed and even stabbed.

the ground with a dancing sea of white fluff, each bunch of plumed seeds designed to disperse in the strong winds. Growing in the drier, rockier parts of the tundra – often called the mesic tundra – are a surprising number of flowering plants. Even at 82 degrees north, there are 90 different species of flowering plants (at a corresponding latitude in Antarctica, you only find lichens).

The plants that flower this far north have developed ways to survive the bitter cold winter and short summer season. All are small and stick close to the ground, out of the way of the bitter Arctic winds. The best example is the Arctic willow, which creeps along the ground, hugging every little bit of shelter. Surviving as far north as 80 degrees, it's the world's toughest shrub and the only tree to grow on the High Arctic tundra. The growing season is just six to eight weeks, which means that 100-year-old willows may be only a few centimetres (an inch or so) high – bonsai trees created by the cold.

Many plants, such as purple saxifrage, form dense clumps. This produces a microclimate that is much warmer than the ambient temperature. Others are covered in a fur coat of fine hairs that trap air warmed by the sun. But perhaps the cleverest trick is to track the sun as it travels around the sky. The yellow Arctic poppies and the white mountain avens have petals arranged in open bowls to catch the sunlight. Throughout the day, they point directly at the sun. This raises the temperature in the flowers' centre by up to 10°C (18°F), which not only allows their seeds to grow faster but also provides a warm shelter for insect visitors.

THE POLLINATORS

Flowers need pollinators, and one of the surprises of an Arctic summer is the number of insects that suddenly appear in the short window of warmth. The largest are the two species of bumblebee that buzz over the High Arctic tundra. They are covered in insulating hair and packed with muscles, which are used not only for flight but also for shivering, generating heat so their bodies are far warmer than the surrounding air. The principal advantage of effectively being warm-blooded is that a bumblebee can feed for longer periods and complete its life cycle quickly in the very short summer.

Above
Sun-follower. Arctic poppy flowers track the sun as it moves across the sky. The temperature inside each flower is warmer than the outside air, incubating the seeds as they develop.

Opposite
Purple saxifrage cushion, Svalbard. Clumping together helps the plants retain warmth and flower early, shortly after the snow melts.

Butterflies are found as far north as there are flowers that bloom. The most northerly, such as the polar fritillary, tend to be circumpolar and stockier, darker and hairier than their southern cousins – all adaptations for keeping warm. Only their wings are the normal size, but these, too, are used to capture warmth, and on sunny days, butterflies can be found basking on tundra flowers. But the season is too short for any of the High Arctic moths and butterflies to complete their breeding cycle. All of their caterpillars overwinter for at least two or three years, feeding frantically in the spring and summer. One caterpillar, the woolly bear caterpillar, can take a record-breaking 14 years to grow large enough to pupate (see pages 75 and 293).

THE HARE AND THE WOLF

Once the winter snow has completely gone, some High Arctic residents become surprisingly obvious. Arctic hares are not only big, weighing in at more than 4kg (9 pounds) – three times larger than their southern relatives – but also remain white, standing out against the grey and green of the tundra. Presumably, the summer season is so short that it's not worth them changing out of their camouflage coats. Instead, they become social, often gathering in herds tens or even hundreds strong, which means there are lots of eyes to watch for predators. If a hare senses danger, it stands up on its back legs, scans for predators and, if it spots one, tucks its front paws to its chest and bounds away, kangaroo fashion. This may be a deliberate way of becoming conspicuous – signalling to a wolf or fox that it has been spotted and has lost any advantage of surprise.

The Arctic wolf also keeps its white colour throughout the year. Though wolves are the only Arctic carnivore not to hunt alone, there isn't enough food to support very large numbers, and so packs are rarely more than seven strong and often comprise just an adult male and female working together to rear cubs.

The permafrost means that they can't dig dens and have to find ready-made caves, and suitable den sites are often re-used year after year by generations. Many High Arctic wolves live in such remote locations that they have never been hunted by people and remain extraordinarily tame. It's possible to sit beside a den in summer as the cubs play

Above
Arctic hare alert, Ellesmere. Once the snow melts and their coat-colour camouflage no longer works, Arctic hares often gather in herds, possibly relying on the advantage of numbers to spot predators. Standing on their hind legs gives height and may also be a way of signalling to a predator that a hare knows it's been seen.

Opposite
Arctic wolf mission, Ellesmere. Unafraid of humans, which he may never have seen before, a young male investigates the cameraman. He and his pack feed mainly on Arctic hares, but muskoxen are also hunted, and the wolves snack on lemmings. Prey numbers determine wolf numbers on their island home.

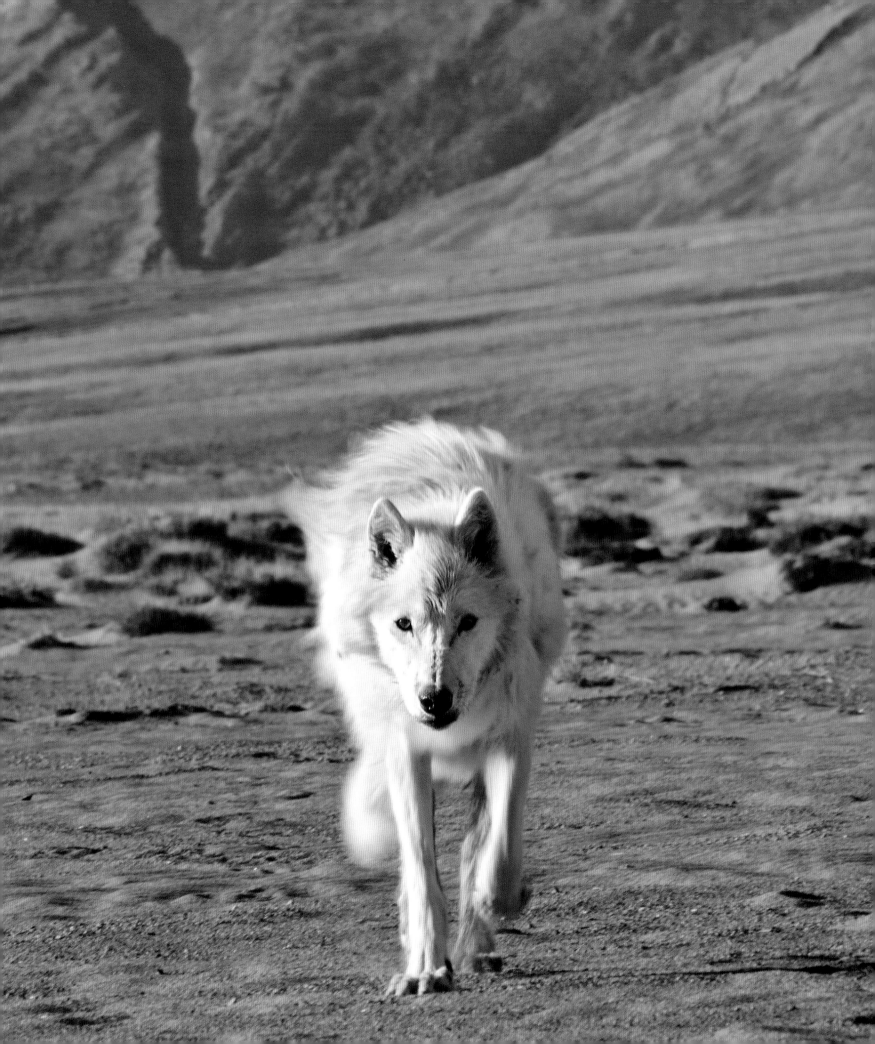

or to walk beside the adults as they head off to hunt. To find enough food for a growing family, the adults may range up to 1600km (1000 miles). Arctic hares are a favourite meal, but wolves are great opportunists and will also go for smaller prey – migrant ducks and waders nesting around tundra pools, and even lemmings.

THE OWL AND THE LEMMING

Lemmings are a vital part of many Arctic-predator diets. The snowy owl, another year-round Arctic resident, is dependent on them to feed its chicks – in just one summer season, one pair of snowy owls may feed their chicks more than 2500 lemmings. Of the three lemming species, the collared lemming reaches the farthest north – to 82 degrees on Ellesmere Island in the Canadian Arctic. Presumably it is the predation pressure that makes it worthwhile to change coat colour, from white in the winter to less conspicuous browns in the summer. The problem for snowy owls is not so much spotting lemmings as coping with fluctuating populations. In some years, there are barely any lemmings on the tundra – in others, they are everywhere, with densities of more than 100 per acre (250 per hectare). So dependent on its prey is the snowy owl that, in poor lemming years, its breeding numbers also decline.

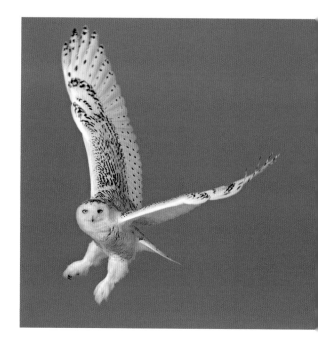

PACKS AND HERDS

Hunting in packs gives wolves the option of taking on larger prey. Farther south, they run down the caribou that migrate north onto the tundra each summer to calve. In the far north, where there aren't any caribou, wolves may resort to attacking muskoxen. These massive animals present a challenge for a small pack, and so the wolves concentrate on the calves. Running at the muskoxen, they try to cause panic in a herd, hoping a calf will get left behind. Even if a wolf succeeds in grabbing a youngster, the adult muskoxen will team up to try to see it off and will encircle their other calves. Standing with their backs together, protecting the calves, the muskoxen present a wall of horns. Even hungry wolves then know the game is up.

Above

Snowy owl hunting. In the High Arctic, the owls prey mainly on lemmings, which in summer, with 24-hour daylight and a lemming population boom, might amount to upwards of five lemming meals a day.

Opposite

Lemming fast food. A male provisions his incubating mate with lemmings. The numbers available determine how successful the pair will be in rearing their chicks.

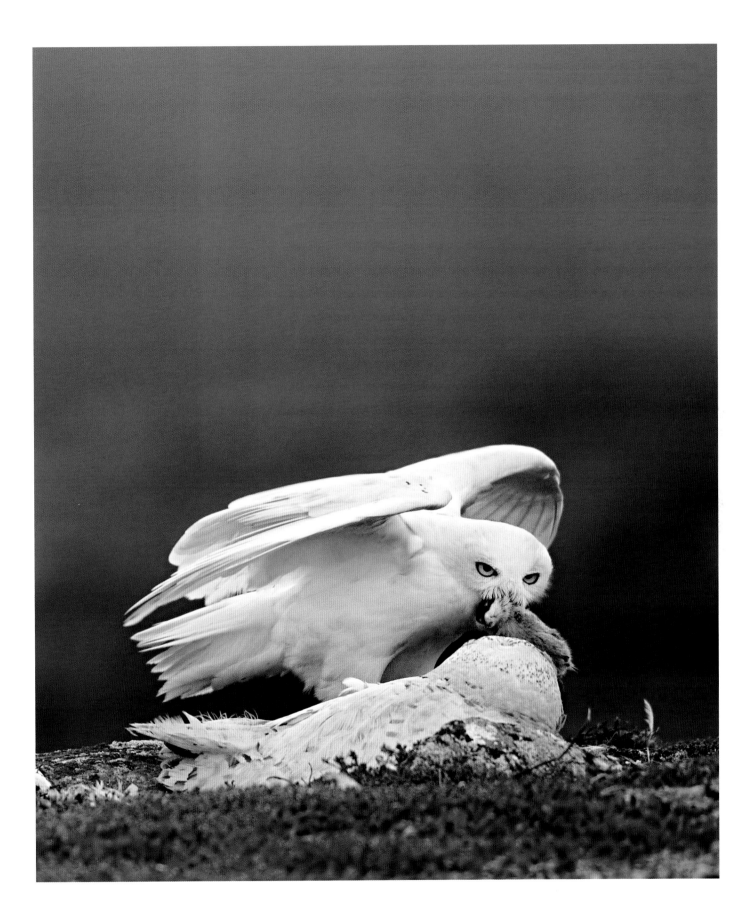

SUMMER IN THE SOUTH

Summer in Antarctica is nowhere near as mild as in the Arctic. At the South Pole, even on a warm summer day, temperatures rarely climb higher than -25°C (-13°F) – colder than many midwinter days at the North Pole. One reason Antarctica is so much colder is its altitude – the continent is the highest on the planet. But it's Antarctica's isolation that makes the real difference. While the Arctic is a frozen ocean surrounded by the warming influence of land masses, Antarctica is a continent surrounded by the Southern Ocean – which separates the continent from warm air and ocean currents from the north.

In the midst of this angry ocean is the chain of sub-Antarctic islands. Free of sea ice throughout the year, they enjoy a relatively mild maritime climate. Walk along the coast of South Georgia on a summer's day, and you can discard your cold-weather gear. The swathes of green tussock grass blow in a gentle wind, and from overhead comes the beautiful song of the only songbird south of the Polar Front, the South Georgia pipit.

But for many visitors, the sub-Antarctic summer is positively uncomfortable. At this time, some colonies of king penguins along South Georgia's mild north coast contain more than 100,000 breeding pairs. While the adults can lie down on their bellies and lose heat through their bare feet or take a cooling bath in the sea, the thousands of last year's chicks are still insulated by a fluffy coat of brown feathers, and they won't fledge until the end of the summer. They can't swim and instead take dips in the glacial streams that run through the colony or they mud-bathe. The elephant seal pups, abandoned by their mothers, are also still moulting and try to keep cool by constantly flicking wet sand onto their backs. They won't go to sea until near the end of summer.

At the height of summer, some of the beaches at the western end of South Georgia are so packed with Antarctic fur seals that it's impossible to walk along the shoreline without an aggressive male, defending his harem, trying to take a chunk out of your leg. These seals are limited to the sub-Antarctic islands, and more than 95 per cent of the population breeds on South Georgia. They feed on krill, and an increase in krill since the mass slaughter of krill-eating whales in the 1930s may have fuelled an increase in their numbers. Today, the population of Antarctic fur seals on South Georgia is at least 2 million and possibly as large as 4 million.

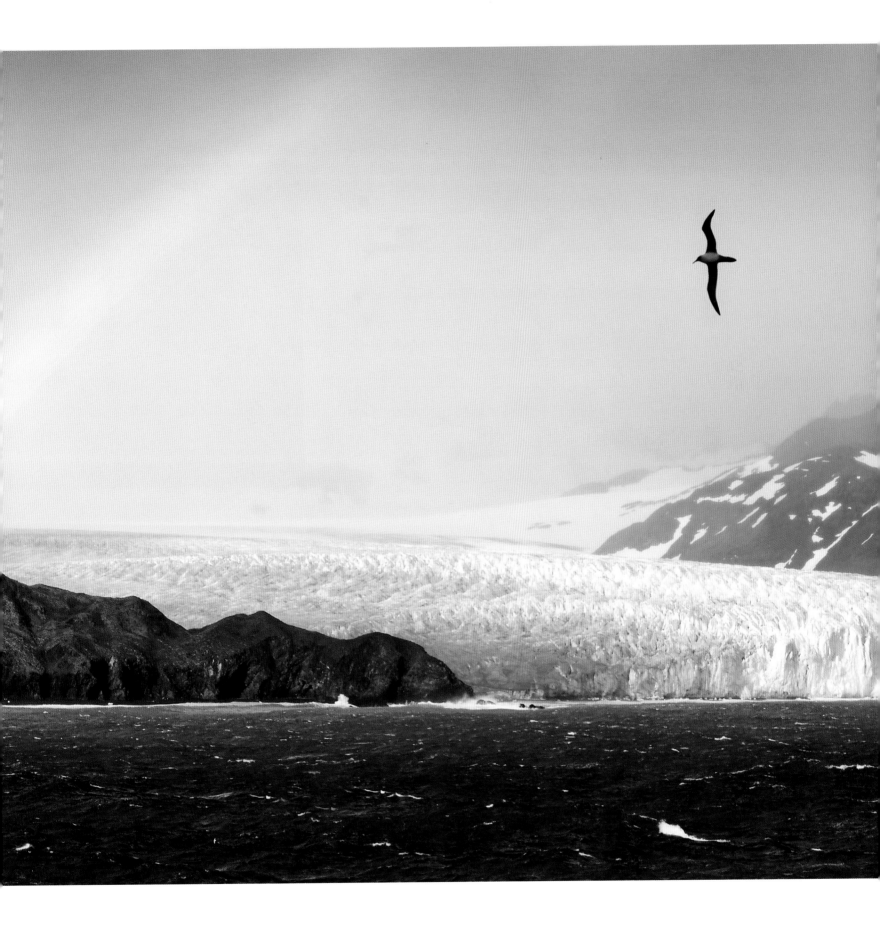

OVERCROWDED BEACHES

The sheer density of life crowding the beaches at the height of summer is spectacular. Competition among male fur seals for a patch of beach and a harem of ten or so females is such that the size of the most prized territories by the water's edge decrease more than half by midsummer. Size is everything for male fur seals, which are at least four times the weight of their mates. Territorial disputes between established males can usually be sorted out by facing up to each other and, with heads held high, staring each other down with sideways looks. True fights usually only break out when newly arrived males rush up from the sea in a desperate attempt to grab territory.

Two days after arriving on the beach, the females give birth – a remarkably synchronized process, with 90 per cent of the pups being delivered in just three weeks. By late December, the mothers move their pups up into the tussock grass behind the beach, away from the battlefields (40 per cent of pups may be crushed by fighting bulls). For the next three months or so, they rely on the summer bloom of krill to boost their milk production. On each foraging trip – swimming up to 90km (56 miles) from the shore – a cow has to capture about 7kg (15 pounds) of krill to keep her milk supply going.

THE FIRST FLIGHTS

By Christmas, most of South Georgia's millions of seabird chicks are just hatching. But the wandering albatross chicks are just about to fledge. After nearly ten months on the nest, they have lost the fluffy white plumage that kept them warm through the winter and have been exercising their 3.5-metre (11.5-foot) wings on every gust of wind. For a bird this size, so perfectly adapted for life on the wing but so badly designed for life on land, taking the first flight is a daunting task. Wanderers nest close to steep cliffs, where strong winds provide the updraughts they need to take off, but they make so many failed attempts that their big webbed feet stamp runways in the tussock grass.

For the next five or six years the young wanderers roam the Southern Ocean before returning to land on South Georgia. It will be another two years before they pair up, and they will stay loyal to their mates for more than 70 years.

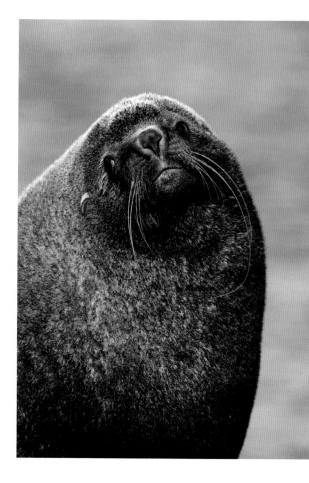

Above
Territory holder, South Georgia. A bull Antarctic fur seal will try to keep as many females as he can defend – usually around ten – on his beach territory, mating with them within a week or so after they've given birth.

Opposite
Cooling off. In summer, the king penguin chicks on South Georgia risk overheating, and so they congregate by the meltwater streams, where they can take a dip in the ice-cold water.

Overleaf
The huge colony of king penguins on Salisbury Plain, South Georgia. Chicks lining the streams form ribbons of brown. At any one time there can be both adults on eggs as well as crèches of chicks, often of various ages.

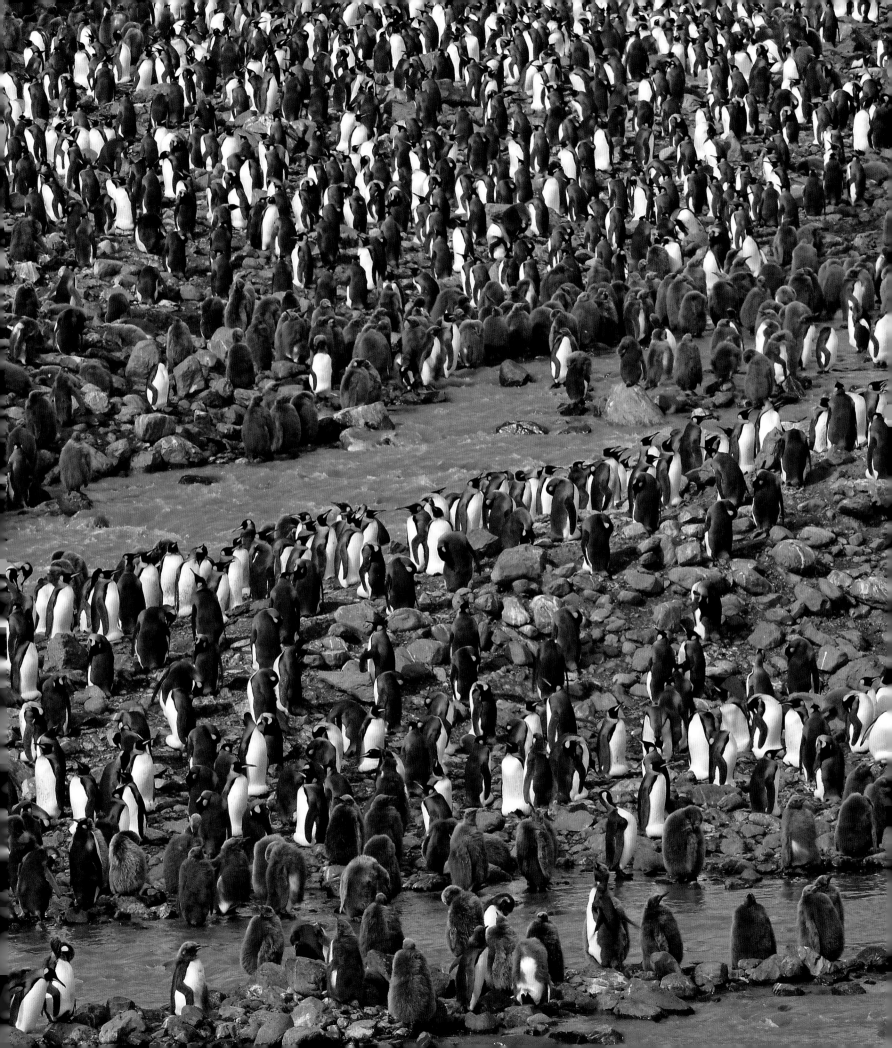

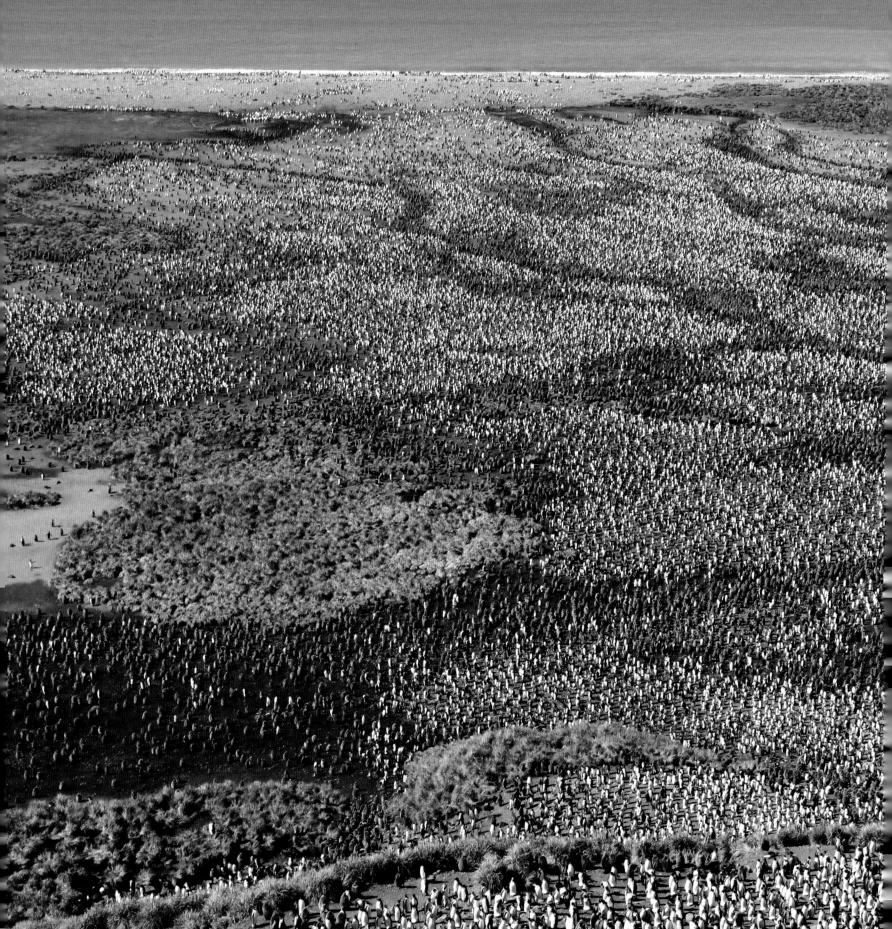

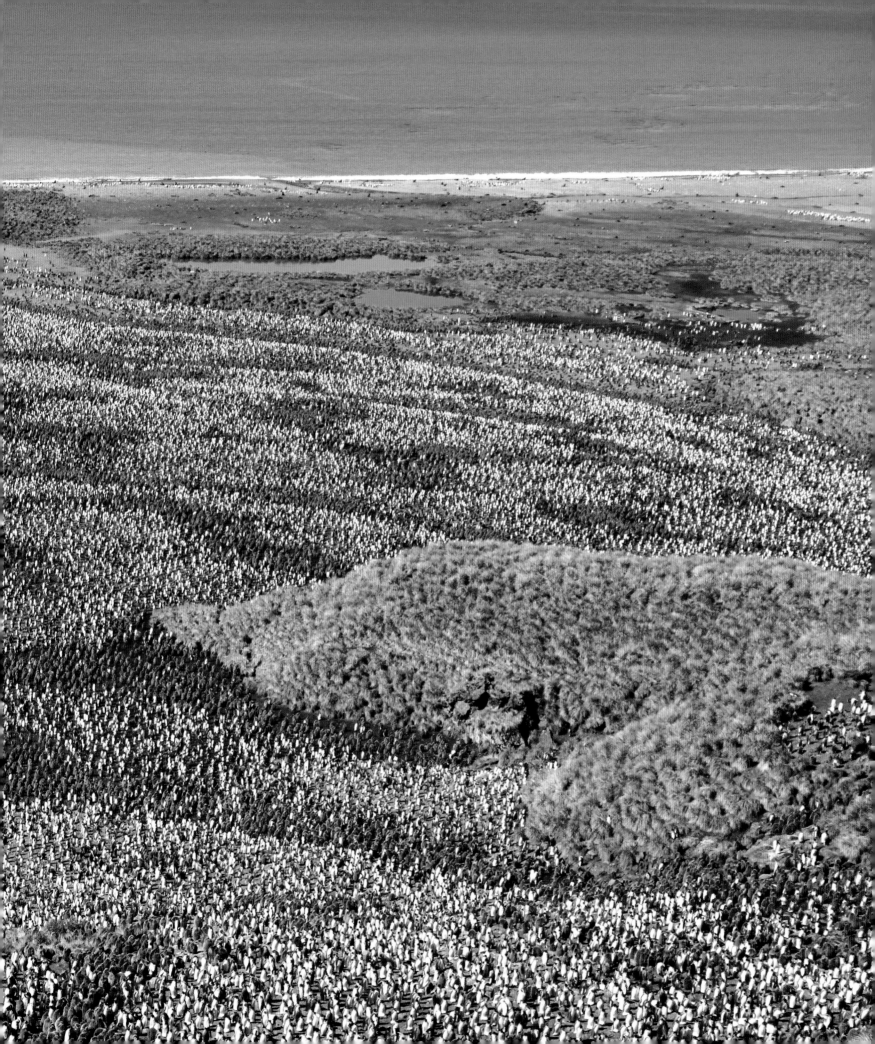

BREEDING IN THE BANANA BELT

The Antarctic Peninsula and its maritime islands are often referred to as the Banana Belt. Extending farther north than the rest of the continent, the peninsula is the first to be released from the sea ice in spring, and summer temperatures often rise above 0°C (32°F), when snow can be replaced with rain. It is not just a comparatively mild climate that makes the peninsula so important for wildlife in summer. Once winter snow is gone, 98 per cent of the continent's bare rock is found here. This resource is so vital to breeding penguins that they occupy almost every accessible patch of it. Gentoos are restricted to the milder northern end; chinstraps dominate the middle ground; and Adélie penguins, better adapted to living where there is pack ice, survive down in the south.

Antarctica's only gull, the kelp gull, nests here, as does the only cormorant found south of the Polar Front, the Antarctic shag. Arctic terns make a 40,000km (24,855-mile) journey from their breeding sites high in the Arctic. This record-breaking migration gives them two polar summers a year and round-the-clock fishing in rich polar waters.

Melting snow and rain in summer provide the fresh water vital for plants, and in some parts there are large areas of moss. Antarctica's only two flowering plants are found here, too – Antarctic hair grass and compact cushions of a tiny pink, Antarctic pearlwort.

THE SOUTHERN OCEAN BLOOM

The greatest seasonal change on the planet is the reduction of the sea ice around Antarctica, from its maximum spring cover of 19 million square kilometres (7.3 million square miles) to just 3 million (1.2 million) by the end of autumn. This great melt dominates the lives of Antarctic animals even more than it does those in the Arctic, kicking off a massive bloom in ocean productivity – the release of a great storehouse of microscopic algae that have been growing under the ice throughout the winter, able to photosynthesize at low light levels. This provides food for the krill, which in turn multiply and fuel the Antarctic marine ecosystem. In summer, these shrimp-like crustaceans, just 5cm (2 inches) long, gather in such massive swarms that they can turn the ocean red over a vast area. The total weight of krill in Antarctica may approach 500 million tonnes.

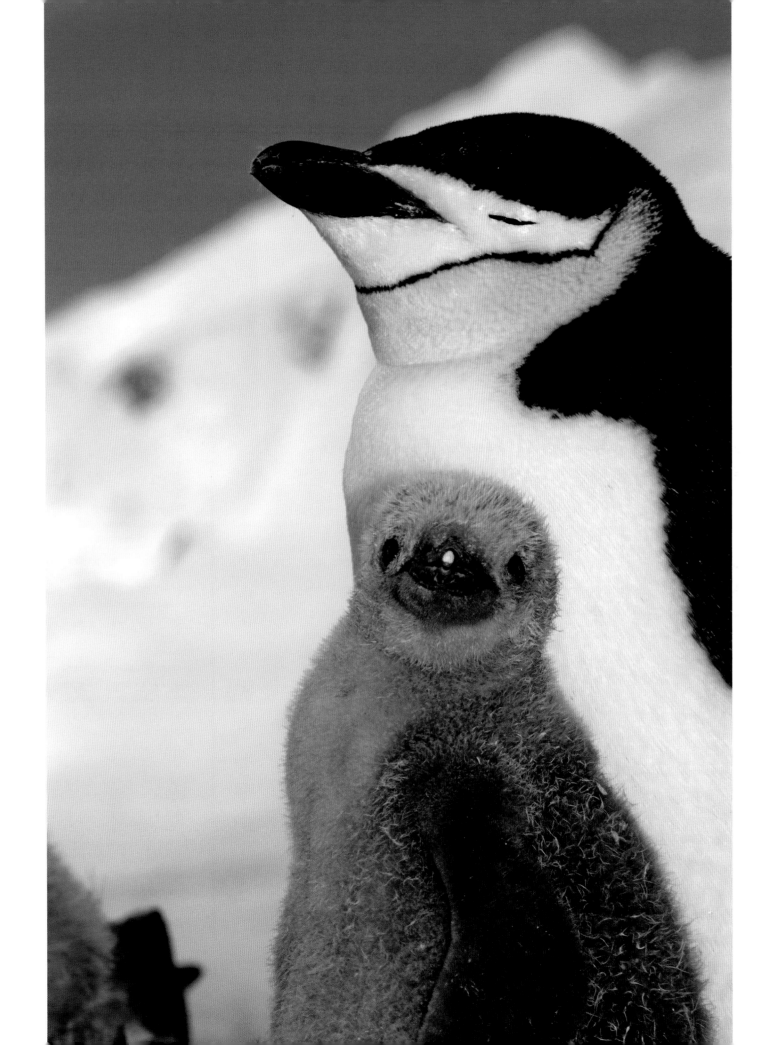

THE ARRIVAL OF THE WHALES

Krill is a vital part of the diet of most of Antarctica's seabirds and many of its seals. In summer, six different whales – humpback, right, blue, fin, sei and minke – journey down from their breeding grounds in the tropics to feed on it, and hundreds of them can be found in the sheltered waters along the peninsula. All are baleen whales, which sieve out the krill using the hanging plates of baleen in their giant mouths.

Different whales have different techniques to catch krill, depending on the depth of a swarm (krill swarms journey up and down the water column on a daily cycle). When krill are at the surface, most whales lunge from below, take a great mouthful of them, snap shut their jaws and force out the water through their baleen sieves. Often whales work together, three or four ploughing the surface like a line of tractors. Moving diagonally to each other, it seems that each benefits from krill driven on by the others. The southern right and sei whales also swim along open-mouthed and skim krill off the surface.

When the swarms are at greater depths, humpbacks adopt a technique they use in Arctic waters to catch fish. Two will dive together into or below a swarm. As they return to the surface, these 30-tonne animals spiral around each other, simultaneously releasing bubbles. The bubbles rise in columns that form two halves of a cylindrical trap. The terrified krill rush into the centre of the ring of bubbles, forming a rich crustacean meal for the whales, which power up through the centre of the trap, mouths agape.

WOLVES OF THE SEA

Though Antarctic seals don't face the threat from polar bears that dominate the lives of their Arctic cousins, they have other predators. Eighty per cent of crabeater seals bear scars from leopard seal teeth. But leopard seals usually only manage to catch pups. The main threat comes from a much more powerful predator, which is pushing south as the ice retreats. Indeed, in the Arctic, too, killer whales are venturing into new areas as the extent of the summer sea ice decreases year on year. Increasingly regular sightings of killer whales have allowed researchers to identify visually and by their behaviour at least three different types (dubbed A, B and C) hunting the Southern Ocean.

Above

Bubblenet fish trap. Emerging up through the trap are two humpback whales, mouths open, scooping up the krill or small fish inside. The net is formed from a stream of bubbles that the whales emit as they circle their prey, which panic and form a tight shoal within the glittering spiral of bubbles.

Opposite

Synchronized bubblenetting. The two humpbacks have lunged through their bubblenet with gullets full of krill. As they close their mouths, the water is forced across the baleen plates – effectively sieves hanging in their mouths that trap the food – and out through the throat pleats.

Overleaf

Spyhopping killer whales in the Ross Sea. These are the most southerly killer whales in the world – type C, the fish-eaters. They are making use of leads in the melting ice to access new hunting grounds, spyhopping both to grab a lungful of air and to see what's ahead and where to take the next breath.

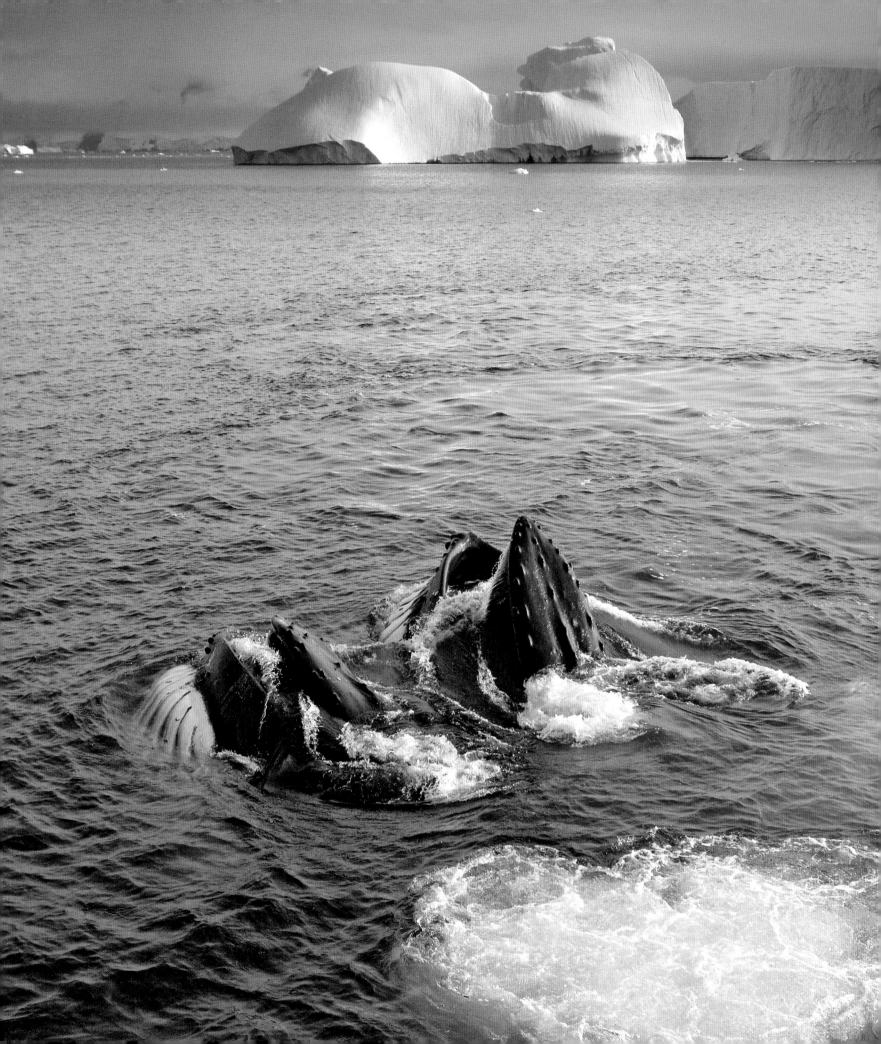

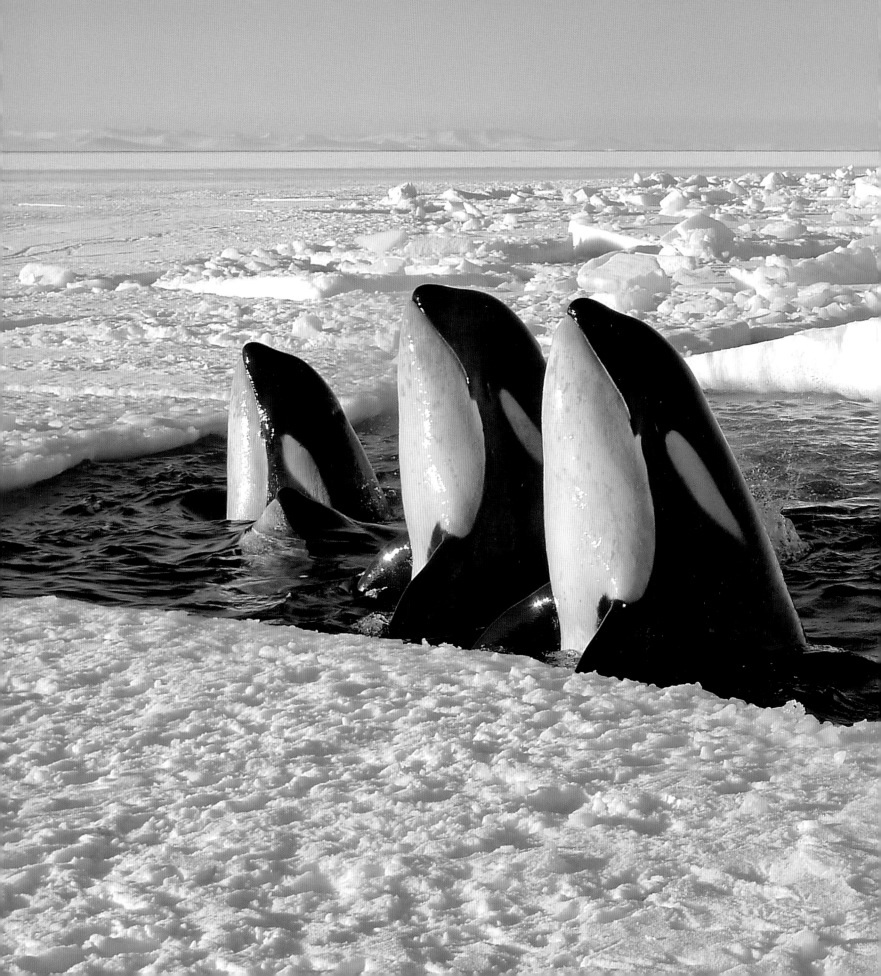

Adélie rest-stop, Adélie Land, East Antarctica. The 24-hour daylight of summer allows non-stop fishing for those penguins feeding chicks. Adélie penguins will go miles offshore in search of krill and fish, leaving their offspring in crèches.

ADÉLIE DEADLINES

By the end of December, the sea ice has started to break up in the deep south. The Adélie penguins nesting down there, along the coast of the continent itself, finally have access to open water right on their doorstep, just as their chicks are hatching. The timing is crucial, as they need to make many fishing trips to feed their growing chicks. Indeed, no Adélies can nest farther south than the minimum extent of sea ice in summer.

All the Antarctic penguins (apart from emperors) have a similar breeding cycle. About Christmas, two tiny chicks hatch from eggs laid seven weeks before. For the first two weeks, the chicks are very susceptible to cold and have to be brooded all the time. Well-fed chicks put on 100g (3.5 ounces) a day and after three weeks are large enough to be left in crèches while their parents head to sea in search of food.

In the morning and evening, there is often a rush hour as hundreds of adults come and go from or to foraging trips that can last up to 24 hours. Penguins are visual hunters, and so the rush hour is much more noticeable in the more northerly chinstrap and gentoo penguin colonies, compared to those of the Adélies in the deep south, where 24 hours of daylight means the penguins can keep coming and going around the clock.

Gentoos go shorter distances, specializing in small fish found in shallow water near the colony. Chinstraps concentrate largely on krill, while Adélies go for both krill and small fish, depending on the time of year. Typically, Adélie and chinstrap foraging journeys take them 30–40km (19–25 miles) from the colony. When they have to go as far as 70km (44 miles) for food, the chicks begin to suffer.

Early in the year, when Adélie chicks are small and there is still a lot of sea ice about, the parents make longer journeys to find krill out on the continental slope. But later in the season, when the chicks are larger and the ice has gone, they catch more fish nearby on the continental shelf. Each dive for krill takes about three minutes, and though a dive is normally less than 50 metres (164 feet), it may be as deep as 170 metres (558 feet). An Adélie can catch 25g (0.9 ounces) of krill per dive, which works out at 1.3 krill per minute, but the race is on, because it takes 23–33kg (50–73 pounds) of krill to raise a single chick. The Antarctic summer is short, and before the autumn is through, 50 per cent of the Adélie chicks will have perished.

Chapter four | **Autumn**

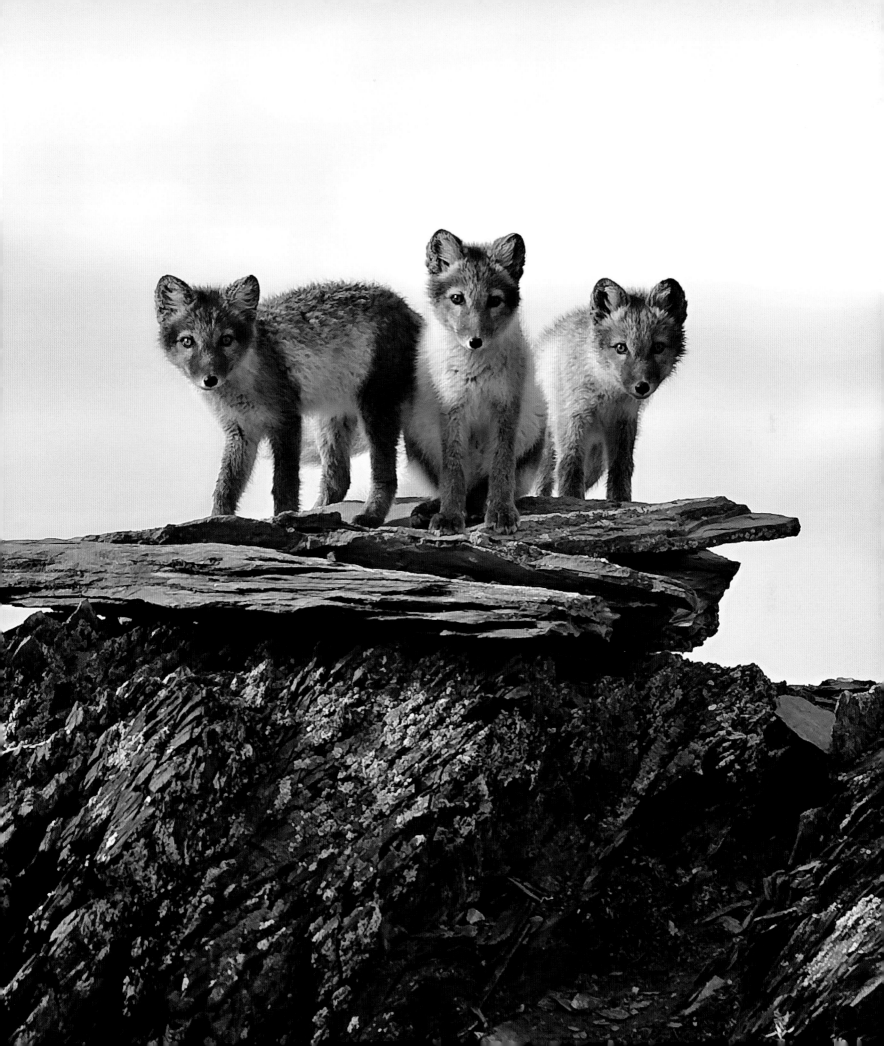

Life retreats

Autumn comes quickly to the polar regions and doesn't last long. The sun's warming influence in summer is brief, particularly at high latitudes, and the cold of winter soon takes hold. Temperatures plummet, new snow covers the bare rock or Arctic tundra and the sea begins to freeze. Seasonal change is more intense in the polar regions than anywhere else on the planet, and with the arrival of autumn, the animals adopt one of three strategies. A few such as the muskox, Arctic fox or emperor penguin sit out the winter. Others such as lemmings or the Weddell seal survive by living beneath the snow or ice. Most, however, flee the darkness of the polar winter and head for lower latitudes.

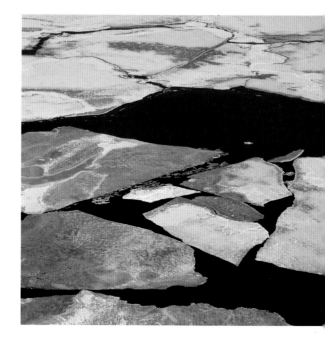

GATHERINGS AT THE ICE EDGE

For polar bears, autumn is the hardest time of year. By September, 50 per cent of the Arctic sea ice has melted away. From a maximum extent of around 15 million square kilometres (5.8 million square miles) of ice at the end of winter, just about 5 million square kilometres (1.9 million square miles) remain. With the loss of their ice platforms for hunting, many polar bears are forced onto land.

Along the shores of Canada's Hudson Bay, the normally solitary polar bears gather in surprising numbers. It is not unusual to see 10–20 bears sharing the same strip of coastline. Unable to catch seals, they are forced to scavenge. Some delicately pick crowberries off the bushes. Others make do with old bones, seaweed or even grass. But for the most part, they just fast, waiting for the sea to freeze over again in November or, more recently, even as late as early December.

To save energy, the bears rest as much as possible, but these autumn assemblies also provide a chance for males to assess each other's strength. Two 600kg (1320-pound) males rearing right up to their full height on their hind legs is an impressive sight. Sometimes they seem to shadow-box each other, their heads at an angle and their mouths open. Or they may hold each other by the shoulders and wrestle back and forth until one loses his balance. But even though the bears are capable of inflicting terrible damage on each other, there rarely is any. Bites are gentle, on the neck or shoulder. Usually such play-fights last just a few minutes and are between closely matched

Above

Sea-ice formation. Once the seas freeze, polar bears can start hunting again for seals. Warmer than normal autumn and winter temperatures over the past few years have led to late formation of ice.

Opposite

Warning. Until the seas freeze, polar bears are stranded along the coasts. Here, a large male on Wrangel Island warns off another with a snarl. His size gives him dominance.

Previous page

A new generation of Arctic fox cubs in early autumn on Wrangel Island. They will stay with their parents into winter. Opportunists, their survival will depend on scavenging as well as hunting and their ability to cache any spare food.

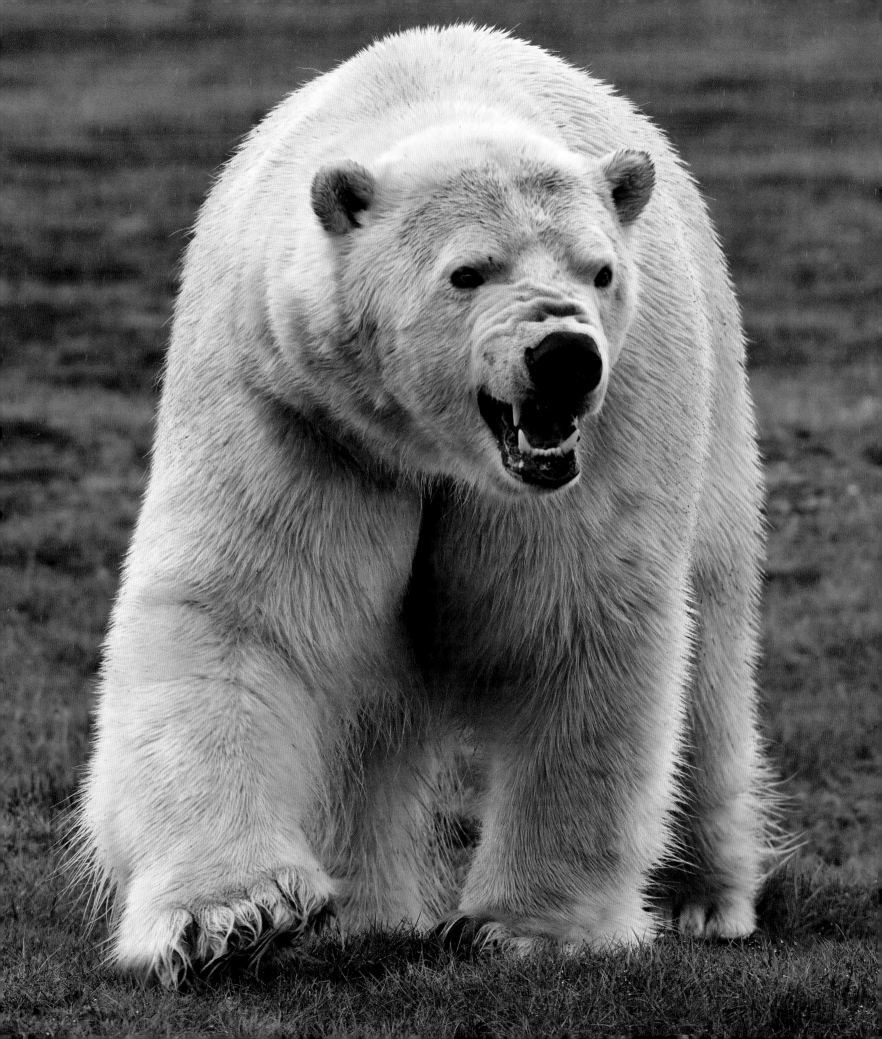

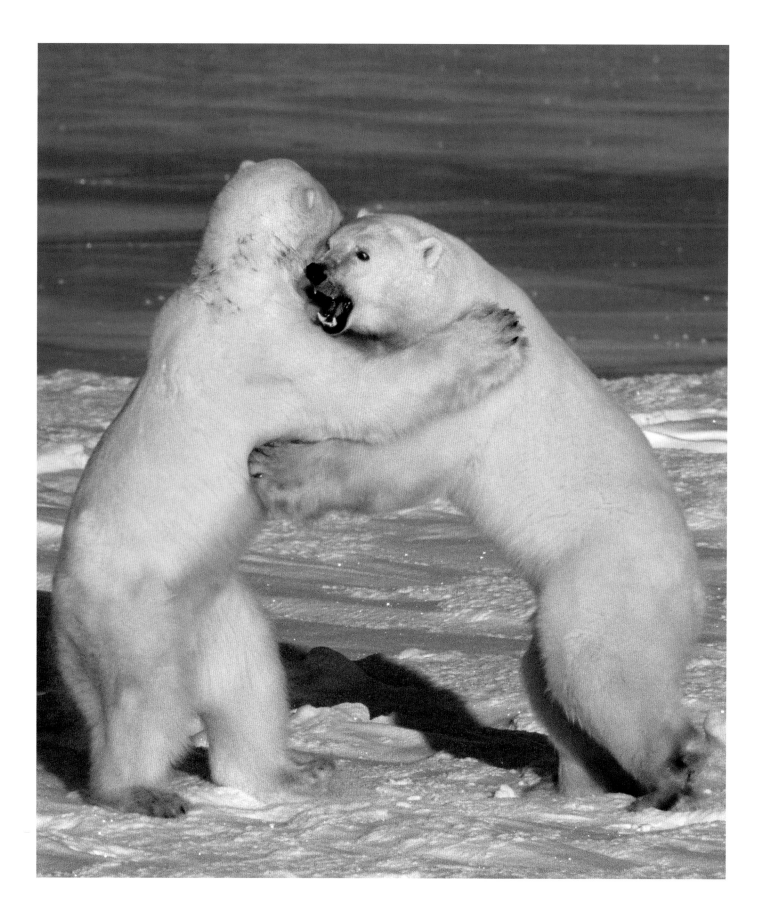

opponents – a test of strength before the real battles of spring, when competition for fertile females is at its peak. Then the battles are vicious and may even result in death. For the moment, though, while they wait for the arrival of winter, the bears tolerate each other.

MOULT TIME

The end of summer sees impressive gatherings of whales along the Arctic coast. While still free of ice, the mouths of certain rivers attract large numbers of beluga whales. Following traditional migration routes, the whales head for the shallow estuaries they have used for centuries.

At Cunningham Inlet in the Canadian Arctic, more than 2000 belugas gather every July and August. Riding on their mothers' slipstreams are newborn calves just a month old. They are still pinky-grey and will not turn white for another five years. These spectacular gatherings are not for food or sex. Rather, the whales come together to moult off the year's skin.

Rubbing and twisting against the stony bottom of the estuary, the belugas scrape off the slightly yellowed skin of summer to reveal new white skin. They choose these particular river mouths for two reasons. First, they are the correct depth for rubbing and have just the right type of gravel to provide the perfect scrub. Second, the fresh water coming down the river is probably gentler on their skin than salty seawater.

The belugas can't linger long. As autumn arrives, the sea starts to freeze along the coast. Every day, 52,000 square kilometres (20,000 square miles) of ocean turn to ice as the cold spreads, driving the whales south. Bowheads travel the farthest to find open water, often swimming up to 8000km (5000 miles) to the south. Narwhals and belugas stay farther north, tracking along the advancing edge of the pack ice. They seem to be skilled at finding breathing spots under the ice even where there is 90 per cent pack-ice cover. Staying under without breathing for up to 20 minutes, they may travel as far as 3km (2 miles) in search of open water. Their highly sensitive echolocation system, used for feeding, allows them to find even the smallest breathing hole.

Opposite

Sparring session. These male polar bears are play-fighting on newly formed sea ice on the coast of Hudson Bay at the end of November. Such sparring may help sort out dominance in advance of spring, when males fight in earnest.

Overleaf

Beluga spa. Before the sea starts to freeze, beluga whales in some regions gather in estuaries with relatively warm fresh water and stony bottoms (here in Cunningham Inlet, Canada) where they rub off their summer skins. As the sea starts to freeze with the approach of winter, they will be forced south, following the ice edge.

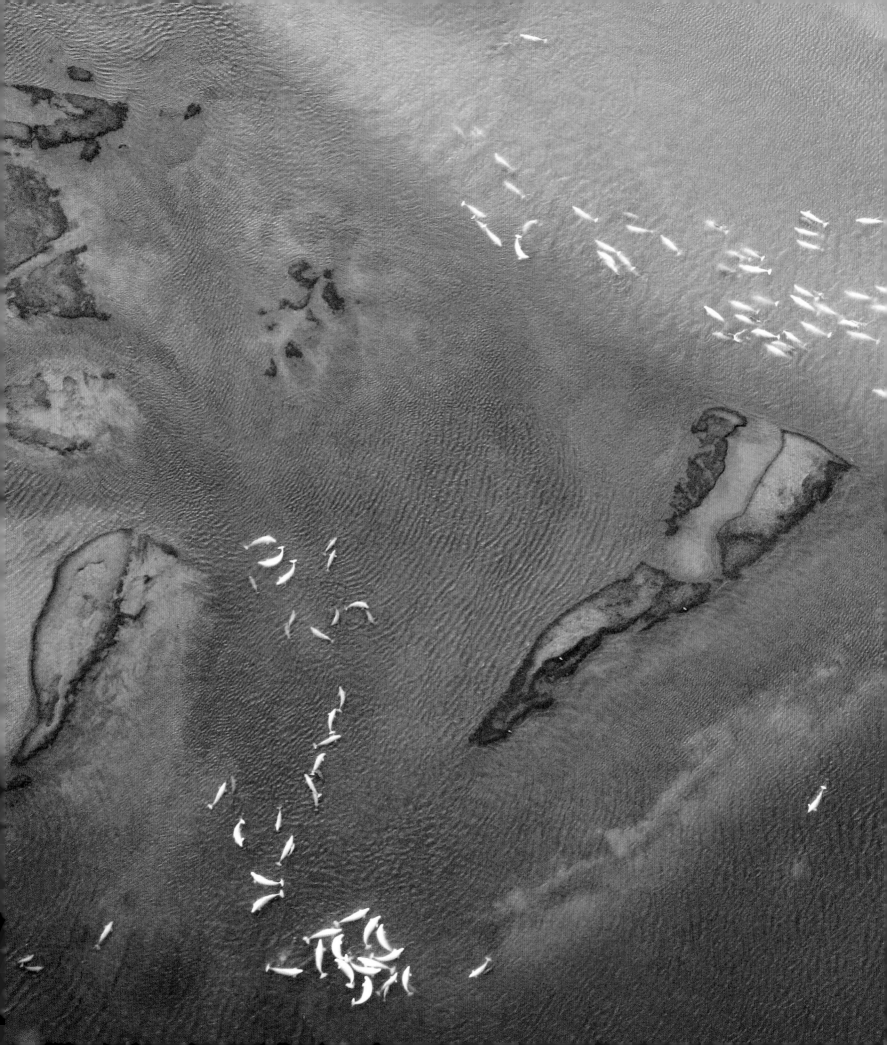

Above
Mouthful of snow geese chicks.
The Arctic fox may bury some of them
as a store for the dark days of winter.

Opposite
Autumn tundra view on Wrangel
Island. Berries and insects, as well as
lemmings, birds and carcasses, are food
for Arctic foxes in autumn as they build
up fat reserves in advance of winter.

Overleaf
Muskoxen head-on. Both sexes have
broad, sharp-tipped, upturned horns
as weapons against predators, mainly
wolves, but males also use them for
threatening and fighting rivals. The
enlarged base of a male's horns acts as
a shock-absorber for a head-on charge.

THE MIGRATION SOUTH

Of the 180 species of bird that breed in the Arctic each summer, less than a dozen stay through the winter. It's the young that face the greatest challenge in the race to head south before both the land and ocean freeze up. Up on the seabird cliffs, the guillemot chicks have all their feathers, but their stubby wings are still too short for proper flight. Yet they still have to make it to the ocean far below. Encouraged by their parents, the chicks plummet down with wings outstretched, not so much flying as gliding. The lucky ones reach the water, but most fall short, bouncing on the beaches beneath the cliffs. Waiting for them are hungry Arctic foxes, which grab as many chicks as they can, hoarding the ones they can't eat as a winter store. Great flocks of adults and chicks gather on the water. As the chicks are flightless, the families have no option but to swim slowly south to avoid the approaching ice.

It's not the cold so much as the lack of food that determines how far the birds go in autumn. Some, ptarmigans and ravens, don't leave the High Arctic at all. Ptarmigans benefit from a close association with the overwintering muskoxen, which use their massive heads and powerful feet to dig under the snow for lichens and other vegetation, leaving little clearings where the ptarmigans can also feed.

Snowy owls and gyrfalcons travel relatively short distances south to avoid the harshest period of winter, but most Arctic birds escape winter altogether. Snow geese choose the warmth of the southern states of the US, while many shorebirds such as sanderlings and white-rumped sandpipers travel all the way to the southern hemisphere. Such massive migrations mean that these birds spend most of their lives in the long days of both southern and northern summers, feeding around the clock.

THE TUNDRA TURNS RED

As autumn advances and the days start to get shorter, the willows, dwarf birches, blueberries and other plants of the shrub tundra undergo a colour change as spectacular as any seen in the deciduous forests of the south. They stop producing the green pigment of photosynthesis, and red and yellow pigments are built up instead.

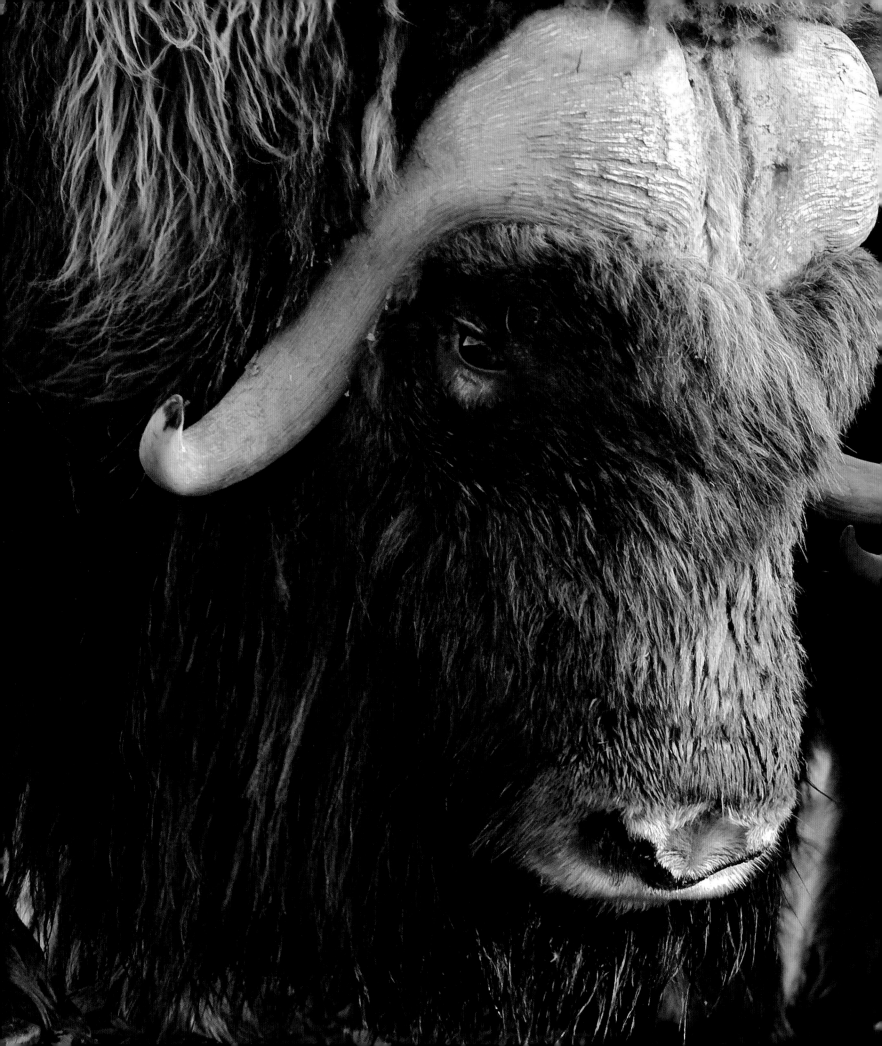

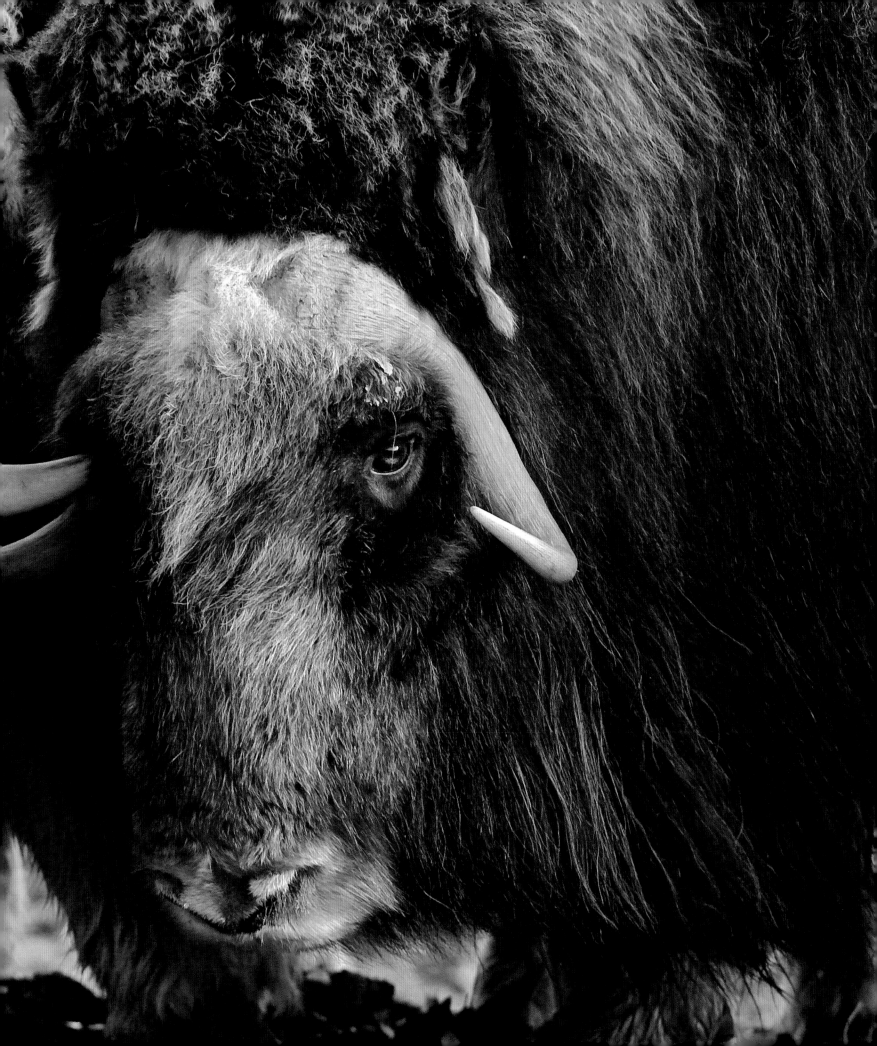

Vast areas of the tundra become a multicoloured backdrop for one of nature's most impressive battles.

For muskoxen, late summer and early autumn is the rutting season. Every bull wants to control a harem of females – up to 20 – and the action starts when the females come into heat. Curling his lip, a bull will sniff his cows' urine to see if they are ovulating. He also marks the bushes in his territory with scent from glands on his face. It is from this musk that these oxen get their name.

A deep bellowing sound is the first sign of an approaching rival. The harem owner bellows back and starts to dig up the tundra with his horns. The exchange of bellows may continue for a while until, eventually, the rival males parade to compare each other's size and strength. A couple of head butts test the intentions of the rival before the battle begins. Slowly the two of them back away, swinging their heads from side to side. Then they charge at full gallop, reaching speeds of up to 50kph (30mph). Their massive heads collide with a loud crack, and shock waves ripple through their hairy coats. That they survive such a collision is because their horns and skulls are thickest over their foreheads. Usually the battle is decided after just a few such brain-bashing bouts.

Above
Hunting practice, September, on Wrangel Island. The young owls are learning to catch voles and lemmings but will continue to be provisioned by their parents until they can hunt for themselves.

Opposite
Family rendezvous. After a hunt, adult Arctic wolves meet up with the pack's fast-growing youngsters at a rendezvous site on Ellesmere Island, Canada. By the start of winter, the youngsters will be joining the adults on their nomadic movements around the pack territory in search of prey, mainly Arctic hares and muskoxen.

Chapter four

THE CLASH OF CARIBOU

By mid-September, caribou (North American reindeer) are ready for their rut. For five months the bulls have been growing the most impressive set of antlers in the animal world. Moose grow a heavier set, but relative to body weight, caribou antlers are the larger. A unique feature of the caribou's antlers is the so-called shovel – a single, flat, palm-shaped branch that sticks forward over its owner's muzzle. It's used for defence in the vicious battles of the rut, protecting the caribou's eyes from the sharp points of a rival's antlers.

The size of a bull caribou's antlers is a reflection of the age, strength and health of its owner. The set of antlers is shed every year, and each season, new antlers grow, bigger than before, reaching their maximum extent after five or six years. With the arrival of autumn, the bulls' appearance and behaviour changes as their necks swell and they become aggressive. They size each other up with brief sparring sessions, lasting just 30 seconds or so. Rival bulls carefully lock their antlers together before pushing and turning to try out each other's strength. But the real battles don't start until October or early November and the breeding season.

A dominant bull aggressively defends his females from other bulls, and only males that are equally matched will challenge him and risk injury. Bulls may, however, be badly injured and even killed, and the rut is so strenuous that many bulls become too weak to survive the winter. Once the rut is over, the bulls shed their antlers, but the female caribou, which also have antlers (the only female deer that do), keep them until they give birth in spring. It seems that antlers are useful for settling disputes in winter over the best feeding sites.

Each autumn, the 2 million or so caribou that journey north across the tundra of Canada's Barren Lands head back south for the winter, forced to do so by the arrival of the snow. This is the Arctic's greatest migration, but on the southward journey – less urgent than the movement north in spring to calf – the herds move slowly. Most travel a maximum of 65km (40 miles) a day on an 800km (500-mile) trek to the edge of the treeline, where they spend the winter. They find shelter here from the worst of the winds and feed on meagre pickings of lichens under the snow and willow twigs.

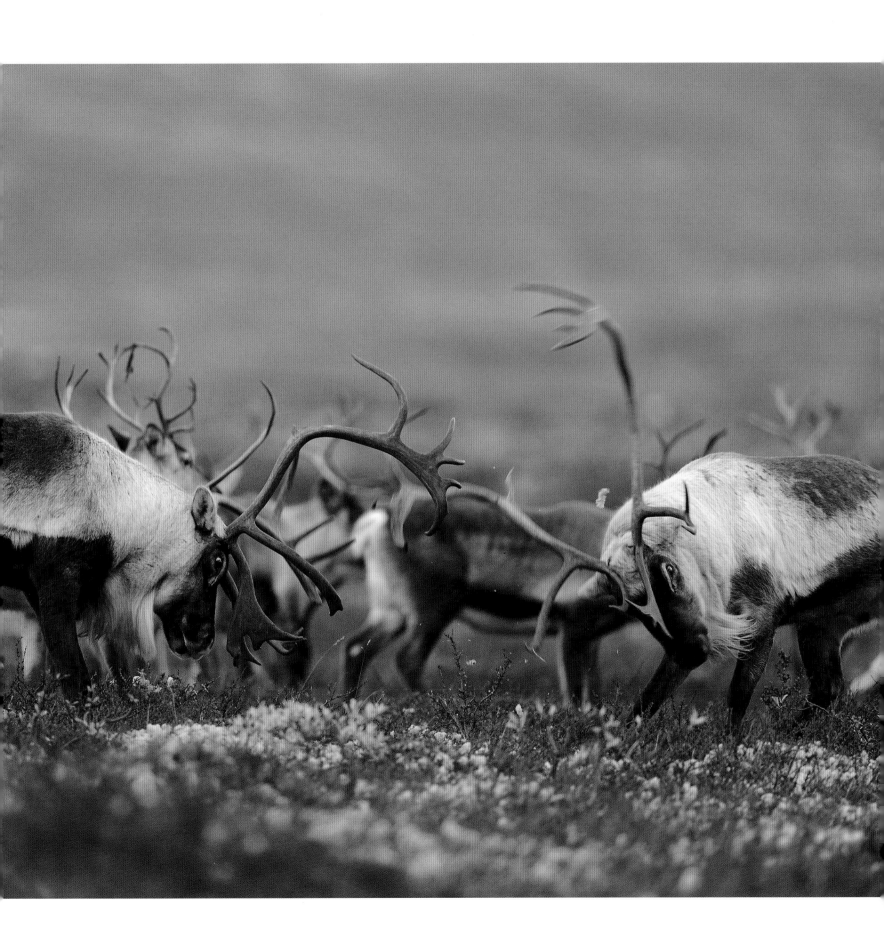

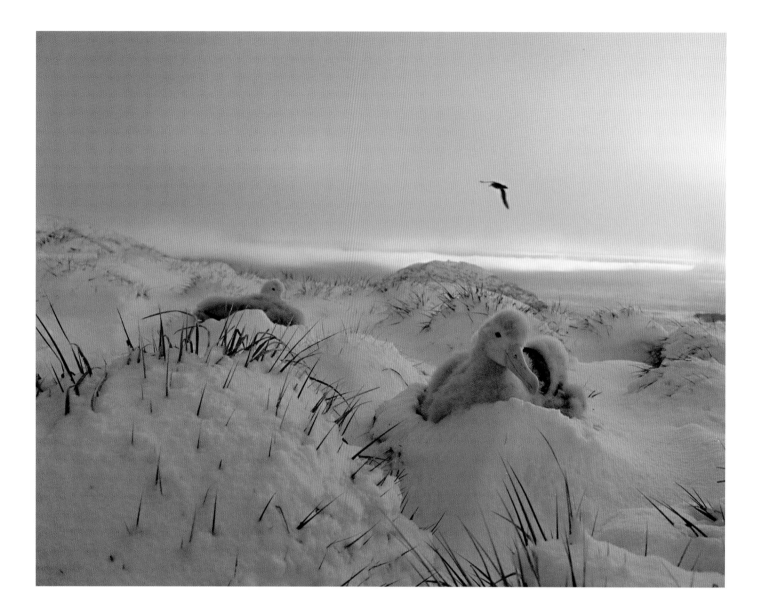

DESERTED BATTLEFIELDS

The islands that are dotted along the northern fringes of Antarctica never get caught in the frozen sea ice of winter. But lying in the midst of the Southern Ocean, the roughest on our planet, these lonely islands are battered by the worst of the autumn storms. Snow soon covers the tussock grass, temperatures plummet and massive rollers crash against the shore. The fur seal beaches that were so busy at the height of summer are very different now. Only the females and their pups remain.

The Antarctic fur seal, the only fur seal found south of the polar front, takes about four months to wean its pup, and so it will be early March (the end of summer) before the mothers are ready to leave their pups to hunt for themselves. The males left way back at the end of December, once the battles for females were over. All that remains

Above
Overwintering youngsters,
South Georgia. Wandering albatross
chicks sit out the storms of autumn
and winter. In fact, once the seals
and sealions leave, South Georgia
belongs to the birds.

of them now are the carcasses of the ones that lost those fights. The beaches are like deserted battlefields, scattered with the corpses of the losers.

These carcasses provide a rich autumn bounty for Antarctica's vultures, the southern giant petrels – large, impressive birds with 2-metre (6.5-foot) wingspans and powerful, hooked beaks. Like Africa's vultures, the giant petrels squabble noisily with each other for the spoils. Their beaks can break through a fur seal's hide, and soon they are tucking in, emerging from the carcass with their heads and necks covered in blood. Once the carcass is properly opened, another scavenger joins in – one that seems totally

Below

Arrival of the vultures. Though southern giant petrels catch birds and other prey, they are also the scavengers and waste-removers of the Southern Ocean, feeding on carcasses (here, an elephant seal) and offal. Autumn is bonanza time, when there are plenty of dead seals and penguins. They have a good sense of smell and a hooked beak that can rip a hole in a hide.

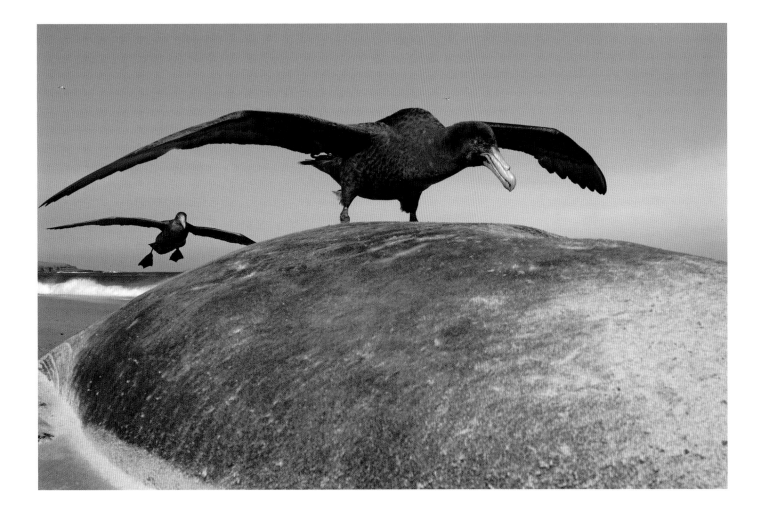

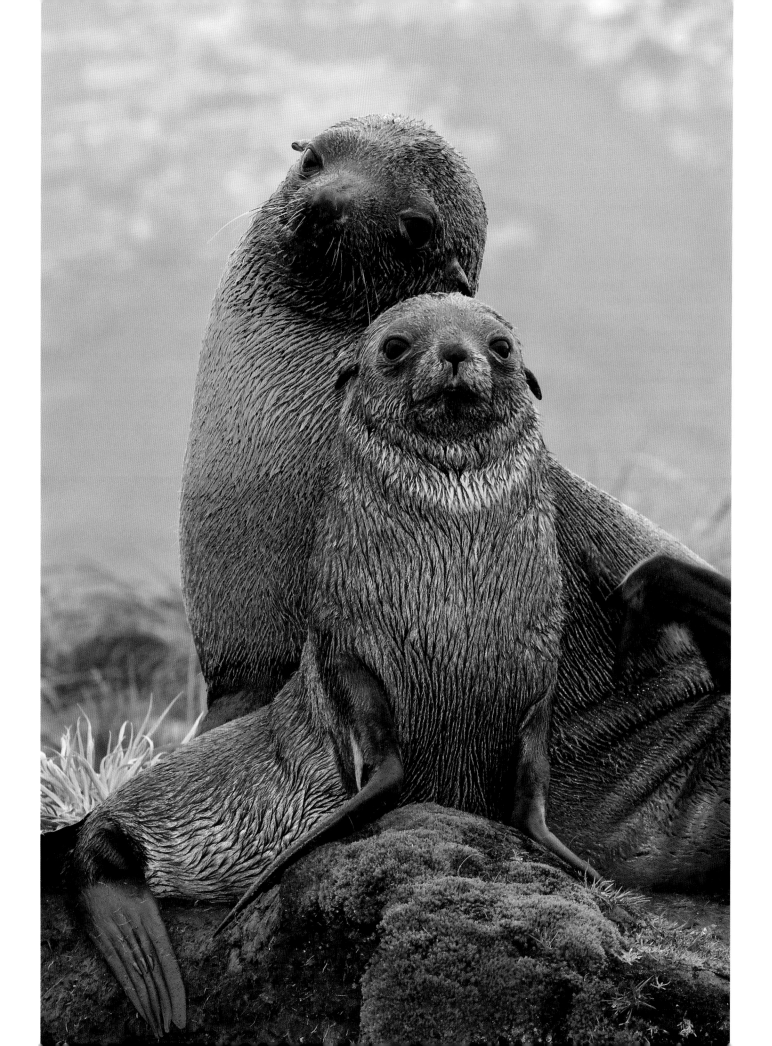

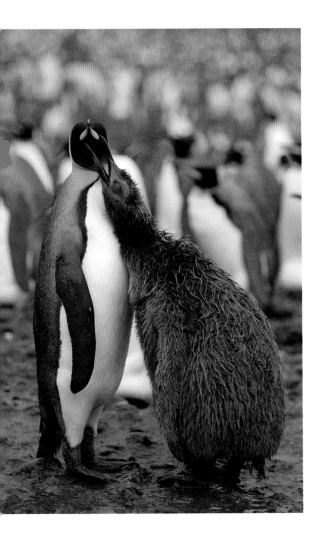

out of place. The South Georgia pintail is an elegant little duck with a bright yellow beak, the sort of duck you might expect to find on a village pond. It has a taste for meat, though, and happily steals scraps from under the beaks of the squabbling petrels.

The elephant seal beaches that were so noisy with the roars of battling males in the spring are much quieter now. It takes just 27 days for an elephant seal mother to wean her pups, and so all the adults were back at sea by midsummer, the end of December. Now, in autumn, they return to moult.

Behind the beaches, the seals churn up deep wallows in the mud, allowing a massive bull elephant seal to be submerged completely, with only an encrusted eye or nostril poking through the mud. All through the cold days of autumn, the hollows steam with heat from the seals and echo with their belches. Their old skin gradually comes off in strips, and by the end of May, the seals will have returned to the ocean.

ISLAND OF THE KINGS

King penguins, which are often forced to share their beaches with elephant seals, are surely pleased to see them go. Now their journeys to the ocean are no longer through a wall of elephant seal blubber. The sea never freezes around these sub-Antarctic islands, and so the king penguins can stay throughout the winter – in fact, they are resident the whole year round.

It takes 10–13 months to raise a king penguin chick, and so a pair rears only two chicks every three years. At any one time in the colony, there are birds at different stages of their breeding cycle. In autumn there are the fluffy well-grown chicks – the offspring of the first wave of breeders that laid their eggs back in the spring. Weighing 10–12kg (22–27 pounds) and almost the size of their parents, most of these chicks will remain over the winter and leave for the ocean in January of the following year. But the colony also has much smaller chicks at this time of year. These have been hatched by parents that saw their first broods fledge successfully at the height of summer and then laid eggs again late in the season. Come autumn, these newly hatched chicks are very small, and not many will survive the winter storms.

Above
Demanding chick. On South Georgia, it can take a year or more to rear a king penguin chick, which means that most chicks continue to be fed through autumn and winter and are not ready to go to sea until the following summer, when feeding conditions are good.

Opposite
Summer's end, South Georgia. An Antarctic fur seal pup stays with its mother until March or early April, by which time it must be weaned and able to fish for itself if it is to survive the winter.

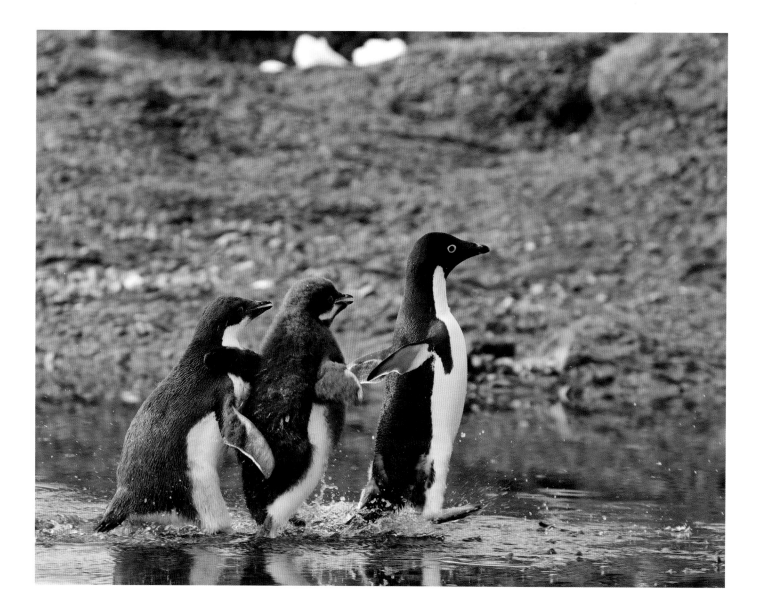

CHICKS TO REAR

As autumn takes hold in the south, penguin colonies have a very different look. The ground is now stained pink with the spilt krill and penguin droppings of the busy summer. The colony seems quieter, with both parents fishing out at sea rather than taking turns. Left alone, the fast-growing chicks huddle together in crèches – 10 to 20 fluffy bundles squeezed together for warmth and protection from predators. What returning parents need to do is make sure they feed only their own chicks, and to do so, they have a test.

Returning to the crèche, an adult calls. Its hungry chick recognizes the call and runs towards it, only to find its parent running away. What follows is a crazy chase across the colony, the chick tumbling and tripping as it follows. Eventually, well away from the confusion of the crèche, the parent feeds the chick. These food chases occur more

Above

TThe test. Adélie penguins collecting their chicks from the crèche make them run for their food. Where there are two offspring, the stronger and most likely to survive gets fed.

Opposite

Last of the fluff – an Adélie chick nearly fledged but without an adult's eye ring.

Overleaf

Year end. By autumn, a chinstrap colony is full of faeces and spilt krill. And as the climate warms and it rains more, many mud-covered chicks get chilled and die.

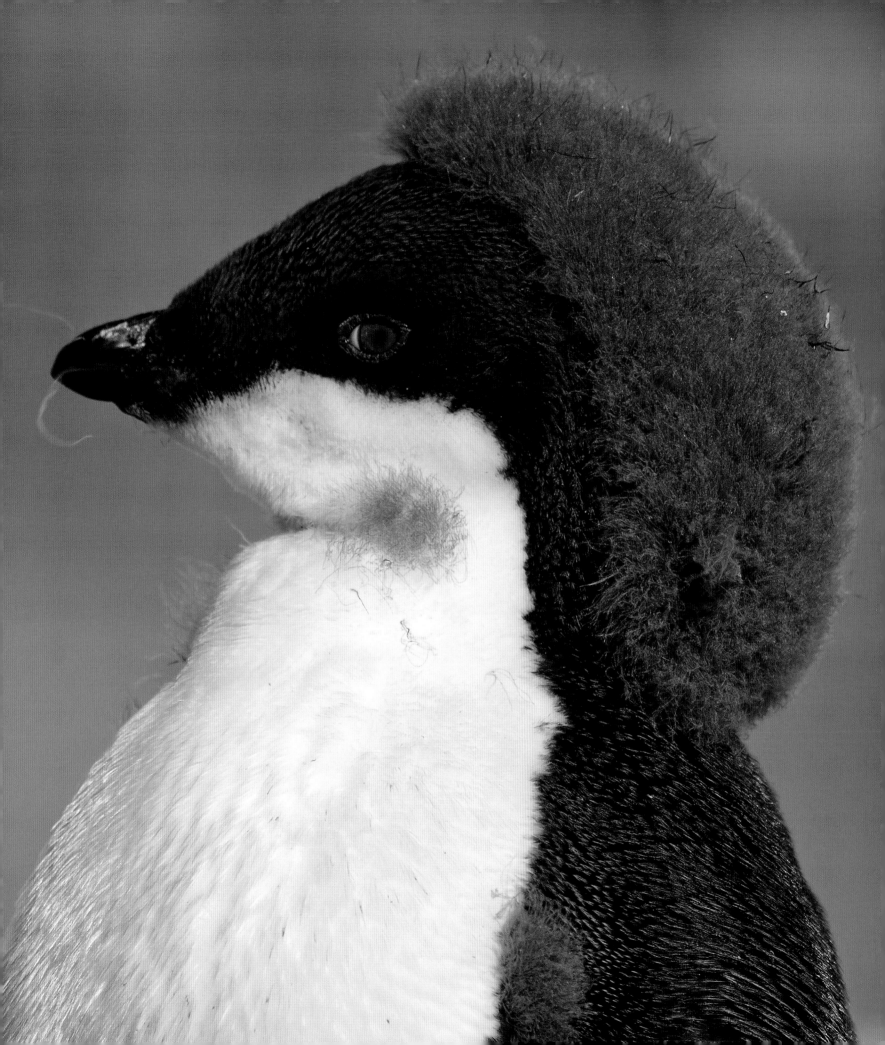

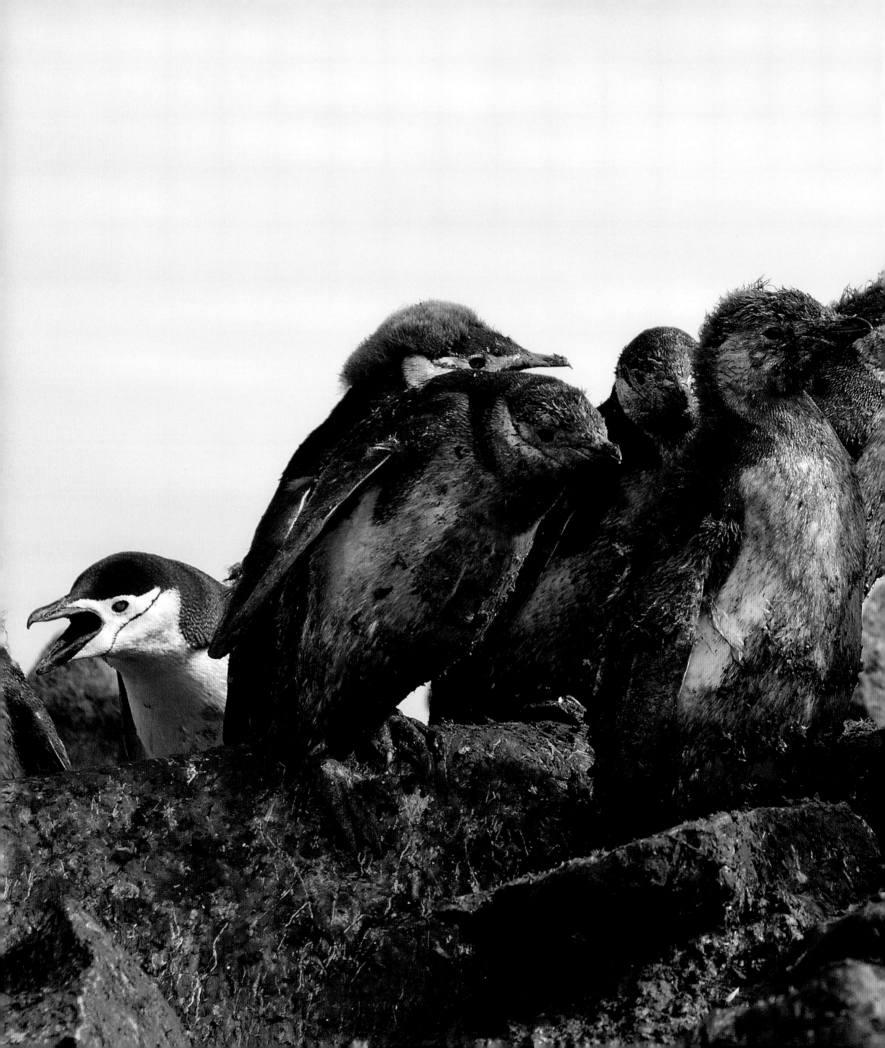

often when there are still two chicks to be fed, which suggests it's probably a way of ensuring that the strongest chick – the one that wins the race – gets most of a limited supply of food. It may also be a useful way of feeding a chick away from the eager eyes of predators and scavengers.

The race to finish breeding is particularly intense in the south, where the sea freezes first. Adélie penguins, which breed farthest south, around the continent itself, usually take 50–60 days to get a chick from hatching to fledging. Gentoos by comparison need 70–90 days, depending on how far north they nest.

By mid-February, Adélie chicks are ready to go to sea, but first they have to shed the fluffy down that has kept them warm through the summer. It comes off in chunks, leaving many of the chicks looking like Mohicans, with a tuft of down still on their heads. Over a two-week period, the adults encourage the chicks down to the water by feeding them only at the shore. Gradually the numbers build up, as nervous chicks consider their first swim. Eventually, a few chicks take the plunge, splashing about on the surface like clockwork toys, and the others follow. They are too buoyant at first, and it takes some time and practice before they are confident in the medium they are designed for.

CHICKS TO HUNT

All this action on the shore doesn't go unnoticed. The autumn is a particularly productive time for Antarctica's most fearsome seals, leopard seals. These large mammals (2.8–3.8 metres/9.2–12.5 feet long) have sinuous snake-like necks and mouths set in what looks like an evil grin. They get their name from the spots that pattern their throats, and like their feline namesake, they hunt alone.

Using the broken ice for shelter and keeping most of its head below the water, a leopard seal cautiously approaches the unsuspecting chicks floundering on the surface. Once it has caught one, the seal plays a macabre game of cat and mouse with it. Time after time, it lets the chick go before chasing after it again. Eventually, the seal decides it is time to eat and repeatedly thrashes the chick against the water's surface to remove its skin and feathers. Leopard seals are highly efficient predators, but because so many chicks

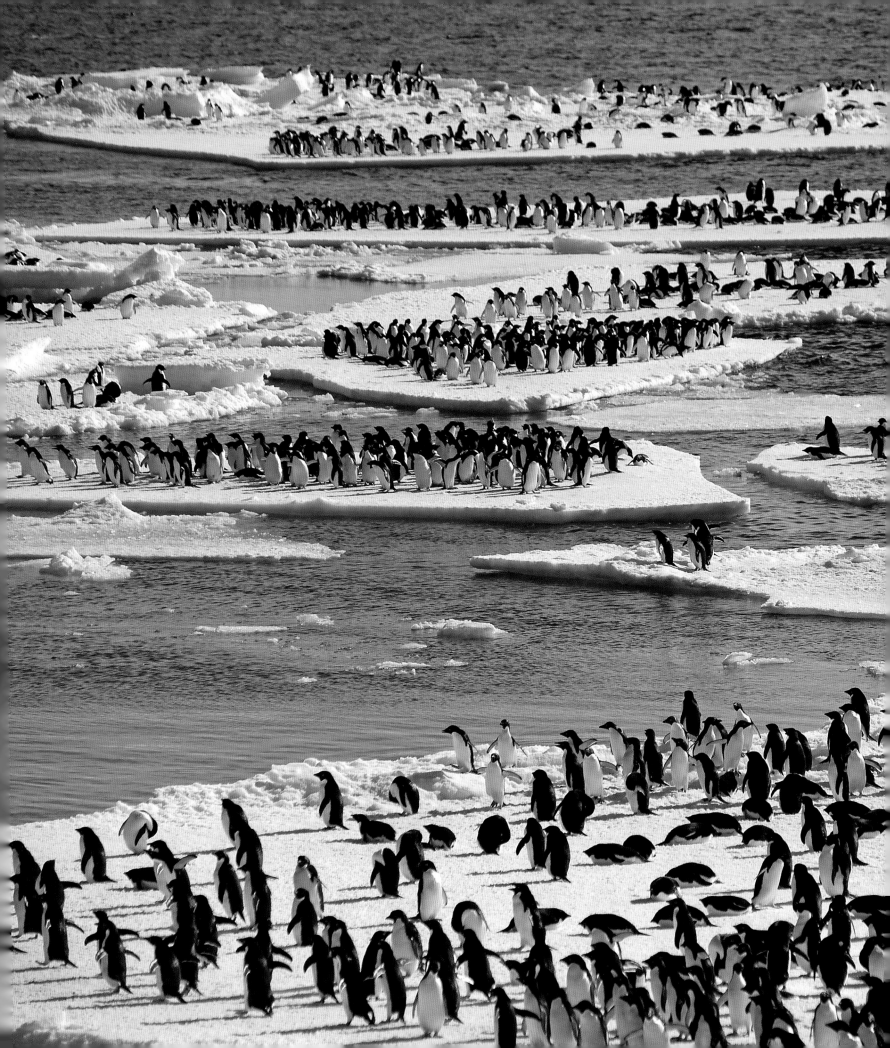

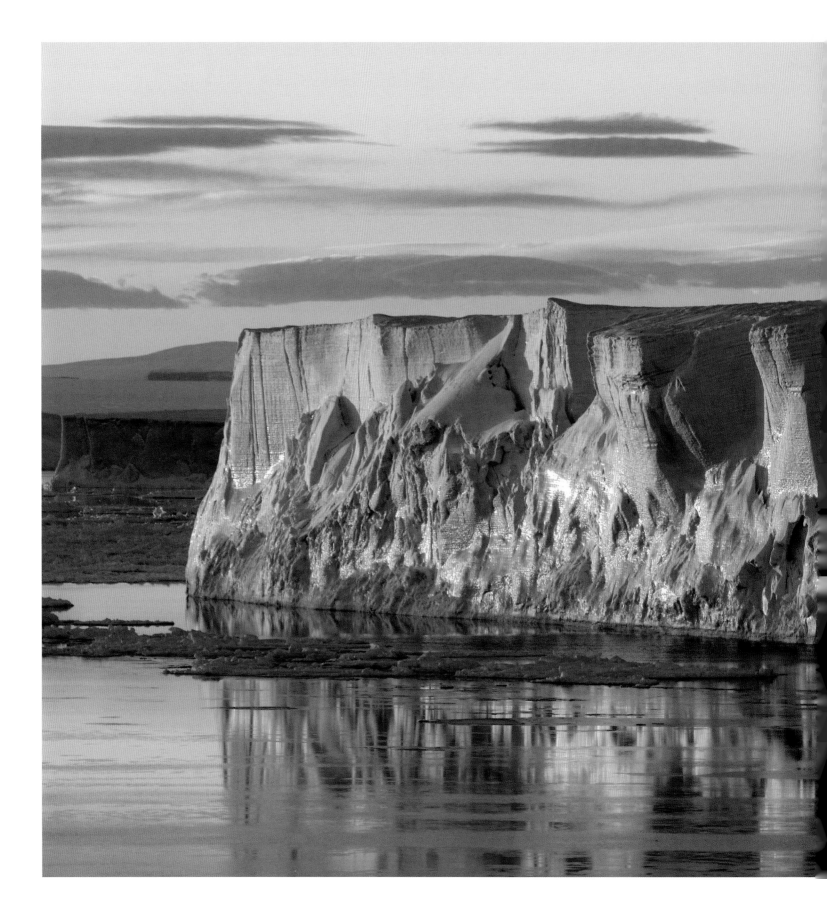

Return of the ice. Great tabular icebergs, here in the Weddell Sea, will have come from the Antarctic ice cap and are therefore made of fresh water. They may drift far north, but they can also ground and become frozen into the newly forming sea ice as winter approaches.

fledge at the same time, the vast majority get away. One study at the large Cape Crozier colony estimated that only 630 of 100,000 fledging chicks were taken by leopard seals.

THE CHANGE OF FEATHERS

Once the chicks have fledged, the adult penguins have one last vital task in preparation for the winter. Penguins have the densest plumage of any bird. They need to moult the feathers that have served them through the summer and grow a new set for the tough times ahead. Moulting is so energetically demanding that the birds must first put on weight, and so they feed up at sea for about three weeks. When they return, the colony is a very different place. No longer is there the cacophony of the summer months. Instead, there's an eerie silence. Standing just the right distance apart, the penguins stay motionless and quiet for up to three weeks. Slowly the old feathers are shed and new ones grow through, and the colony blows with a snowstorm of feathers. The whole process demands so much of penguins that they can lose up to half their body weight during the moult. And those Adélies that nest in the far south where the ocean is already freezing are forced to complete the process on the pack ice.

DEPARTURE

By the end of March, when practically all the penguins have completed their moult, they head north towards the open water, where they will spend the winter. We still have much to learn about exactly where the different penguins go, but all remain in the Southern Ocean. The ice-loving Adélies remain close to the edge of the pack ice throughout the winter, but the chinstraps prefer to avoid the pack itself and stay farther north.

Soon after the penguins leave, the sea begins to freeze. Starting in the deep south and heading north, the ice edge advances 4km (2.5 miles) a day. From a minimum in February of 3 million square kilometres (1.2 million square miles), the sea ice increases to 19 million square kilometres (7.3 million square miles), and the Antarctic continent effectively doubles in size. Almost all life is driven north by this relentless force.

THE EMPEROR'S CHOICE

At the end of April, just as almost all Antarctic life is escaping north, one penguin heads south. Emperors arrive at the ice edge with style. To avoid any hungry leopard seals lurking by the ice, they torpedo out of the water at high speed, landing on their bellies on the ice with resounding thuds. More than a metre (3 feet) tall and weighing up to 40kg (88 pounds), twice as much as kings, emperors are by far the largest penguin. They also return fat, ready for the ordeal ahead.

From the ice edge, the emperors walk long distances to reach their traditional nesting sites on the ice. There are thought to be about 220,000 pairs of emperor penguins breeding in more than 40 locations between 66 and 78 degrees south. Many of these colonies are extremely remote, and new ones are being discovered every year. The emperor penguins choose the locations carefully, making sure they are not too far from the sea and food but also on ice that stays firm all year round (rearing a chick can take up to 10–12 months from hatching to fledging), preferably surrounded by an amphitheatre of ice cliffs or by icebergs frozen in the ice that will shelter them from the worst of the winter weather to come.

On their return, they search for their long-term partners, whom they remain faithful to until one of them fails to return to the colony. Courtship is a noisy but graceful affair. Walking in synchrony and holding elegant poses with their necks, each bird exactly mimics the movement of the other. They call to each other all the time, a bonding process that will prove vital in the future. It will be the only way they will find each other when they are reunited at the end of winter.

Emperors are the only Antarctic bird to 'nest' on ice. In May, the female lays a single egg that she quickly passes to her mate before it freezes. Both birds have a brood pouch just above their feet. The egg is held on a highly vascularized patch of bare skin and encased by a loose flap. The temperature inside the pouch can be 80°C (176°F) warmer than outside.

Once she has handed over her precious egg, a few hours after it has been laid, the female heads for the ocean and won't be back for at least 65 days – when the egg hatches – leaving her mate to face the toughest winter on the planet.

Above
Return of the emperors. When they make the long walk across the sea ice back to the colony, they are fat and healthy, ready for the fast.

Opposite
The Snow Hill trek. A trail of male emperor penguins toboggan and walk from the ice edge to their colony on Snow Hill Island in the Weddell Sea, many kilometres away and sheltered by ice cliffs. The colony site needs to be on firm ice that won't break up before spring. Once the eggs are laid, the females go back to sea, and it will be a couple of months before the incubating overwintering males will be relieved by the females and can themselves walk back to the sea.

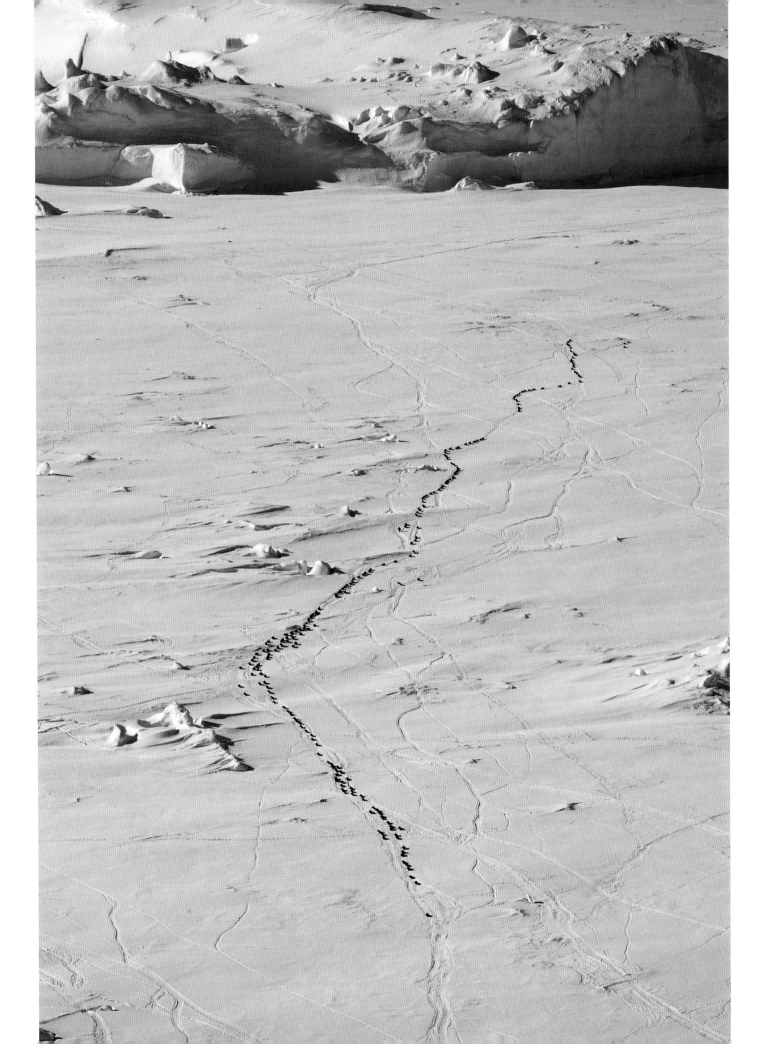

A flurry of snow crystals

1

4

A selection of snowflakes, illuminated to reveal their individual structures. Each one is a unique, complex, symmetrical crystal of water, which started life thousands of metres above the Earth, when ice formed around a nucleus of dust.

1 The most familiar design is the multibranched snow star, usually with six main branches. 2 Some have scores of side branches, giving them a fern-like appearance. 3–6 Others may have side branches decorated with thin, patterned ice plates. The most basic form is a simple hexagonal column of ice, similar to the shape of a wooden pencil. Often the columns are hollow. Or they may grow into assemblies of thin ice needles. Snowflakes include many variations on these simple themes – plates, columns, branched, hollow, six-sided and twelve-sided. Whatever their form, all are symmetrical.

2

3

5

6

Chapter five | Winter

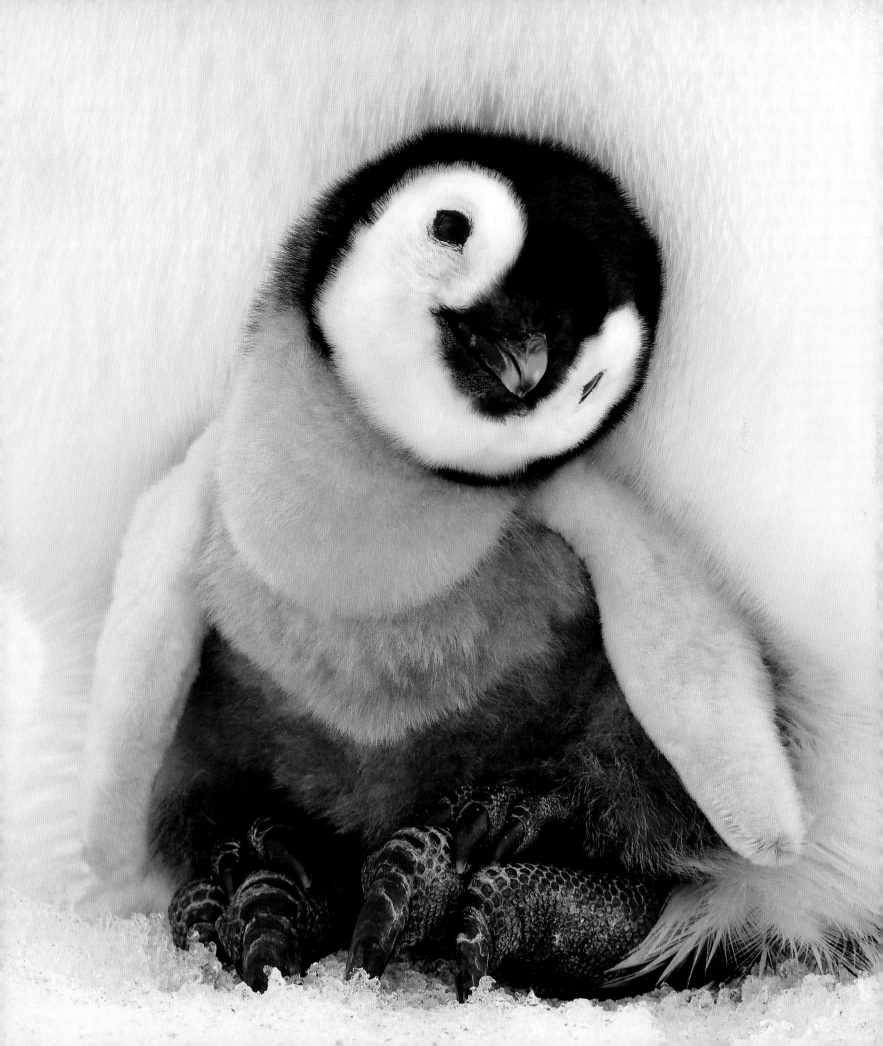

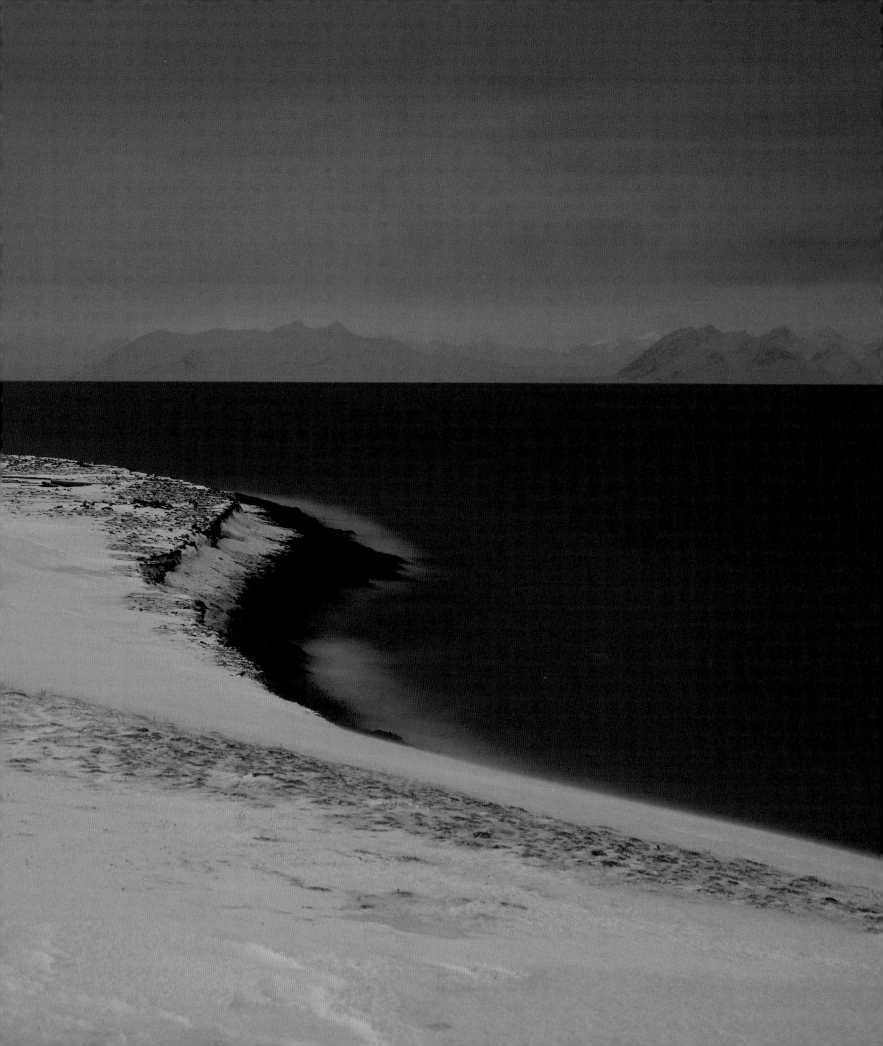

Life closes down

In the twilight of midday, it's just possible to see the outline of the dead cub. The little bear was a year old when he died, though he is now curled up as if in his mother's womb. The tracks around the body tell a sad tale. The mother stopped frequently to wait as her weak and underweight cub struggled to keep up. His brother gambolled back and forth, encouraging him to join in one last game. Large and small tracks mingle, showing where the mother encouraged her surviving cub to abandon his then lifeless brother and continue the relentless search for food.

In the Arctic, more than half of polar bear cubs do not survive their first autumn. But the death of a weaker cub will give the survivor an advantage in the dark winter months ahead: whatever meagre food is found will be split one less way.

THE LONGEST OF NIGHTS

If you stand at the North Pole at the winter solstice – 21 December – you will experience true polar night. On this day, the pole is at its maximum tilt away from the sun as the Earth circles it, and so the stars neither rise nor set. A long-exposure photograph of the night sky reveals the stars as a series of concentric rings, the radius of each getting smaller until Polaris, the North Star, is reached. The North Star itself has a very small ring, sitting almost (but not quite) above the North Pole, and the blackness in this circle on this day is the most truly dark place visible from Earth. On this one day only in the Arctic Circle, the sun does not rise above the horizon.

The length of the night increases as you head towards the poles until, at the poles themselves, night effectively lasts for six months. Arctic residents call the winter the Dark Period. But it is not a winter of total darkness. Even when the sun is below the horizon, it has a presence, and people talk of a twilight that is still bright enough to work by. The stars also become bright enough for seafarers to navigate by. But when the sun is more than 18 degrees below the horizon, it has no influence. This is when the moon takes over, and in periods around the full moon, it casts an eerie bluish light across the ice. At the onset of winter, at both poles, the moon does not set at all for the two weeks closest to full moon. It then disappears below the horizon for the next fortnight.

Above
A time exposure of star trails around the north celestial pole, formed as the Earth rotates. At the centre is the North Star.

Opposite
Daytime darkness, November, on the west coast of Svalbard. On the east coast, the sea is frozen by November, but here, an increasingly warm North Atlantic current now keeps the coast ice-free.

Previous page
A newly hatched emperor penguin chick, in October – the end of winter. Its parents take turns to hold it on their feet, where it will stay until the weather warms up. While one broods it, the other goes to sea to feed.

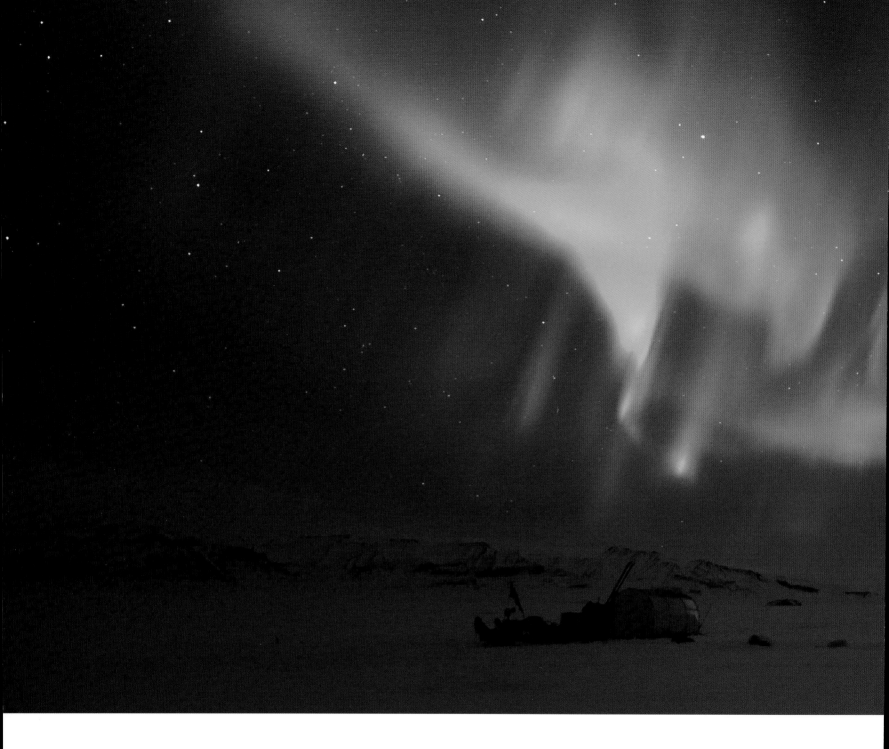

LIGHT FANTASTIC

During the long polar nights, an aurora (named after the Roman goddess of dawn) is a dramatic reminder of the sun's presence. It's a natural phenomenon that creates swirling and pulsating curtains of green, red and violet, which light up the sky and even the landscape. In the north, it's called the aurora borealis, or northern lights, and is steeped in myth and legend. For some Inuit, torches held by ravens are lighting the path of the dead to Heaven. The Sami reindeer herders speak of a 'fire fox' racing across the sky, his coat sparking each time he clips a mountain. For the Chukchi of Siberia, the

Above
Northern lights, Greenland. These occur
most days, depending on the amount
of solar activity, but are visible with
the naked eye only when it's dark.
Displays include rippling curtains,
pulsating shapes, travelling pulses
and steady glows. Altitude affects the
colours. This bright green display is the
most common, occurring 100–240km
(60–150 miles) up in the atmosphere.

spirits of those who have died a violent death are kicking and hurling a walrus skull around the sky. In the south, the aurora australis (the southern lights) captivated the early explorers and is still one of the highlights of a winter stay at an Antarctic base.

Scientists now understand that an aurora is caused by charged particles in the sun's powerful solar wind entering the Earth's atmosphere and interacting with the magnetic field to cause enormous electrical storms. The auroras occur in two belts around the polar regions, and as the solar wind bathes the Earth symmetrically, auroras occur simultaneously at both poles but are only visible at the pole that is experiencing night.

ICE BEARS

Through the Arctic winter, polar bears continue to be active, their coats taking on the vibrant colours of the night skies, whether the yellow-orange hues of twilight, the purplish blues of moonlight or the greens of the aurora. A polar bear's fur is transparent in the visible spectrum, though the skin underneath is uniformly black, hinting at its evolution from brown bears less than a quarter of a million years ago. It has a double layer of fur (growing longer in winter) covering it up to the tip of its nose. Even the pads of its large feet are covered in fur, giving it both protection and a better grip on ice. Each outer hair is hollow, the air inside providing added insulation, and a thick layer of blubber helps to keep the bear warm even at temperatures below -35°C (-31°F). Also key to survival in a place where the weather is so extreme and so unpredictable is the polar bear's ability to drop its metabolism to stretch its fat reserves even further.

Female polar bears stay with their cubs throughout their first two winters, teaching them where and how to hunt out on the frozen ocean. In periods of calm weather, they may walk up to 50km (31 miles) a day, taking refuge behind ridges or in snow-holes when storms set in. But a pregnant female will head for land. On a mountain slope close to the coast, she scrapes out a shallow bed in a snowdrift. Here she lies until covered in snow. Then she starts to hollow out a cocoon, with ice-smooth walls – her refuge and birthing den for the next five months.

Now her metabolism drops and she becomes dormant, a way of stretching her fat reserves until the spring. Though she mated in the previous spring, her body has waited until now for the young she is carrying to continue their development. She gives birth to them just a few months after entering the den, around the solstice. The young are tiny – effectively premature. It's a necessary strategy, because while torpid, she would not be able to give birth to larger young.

The clucking calls of the deaf and blind newborns induce their mother's milk to flow, and once they start to suckle, their calls assume an almost mechanical rhythm. Polar bear milk is so rich in fat and protein (nine times more than human milk) that the cubs double in size every two weeks. But they won't be strong enough to venture outside their womb in the snow until they are three months old.

Opposite

A pregnant female polar bear on her denning slope. She will usually create a den on land, near the coast, but may also do so on pack ice. Her key requirement is a place that will accumulate snow in early winter so she can excavate a snow cave. Den sites tend to be concentrated in one area, which females will return to over a number of years.

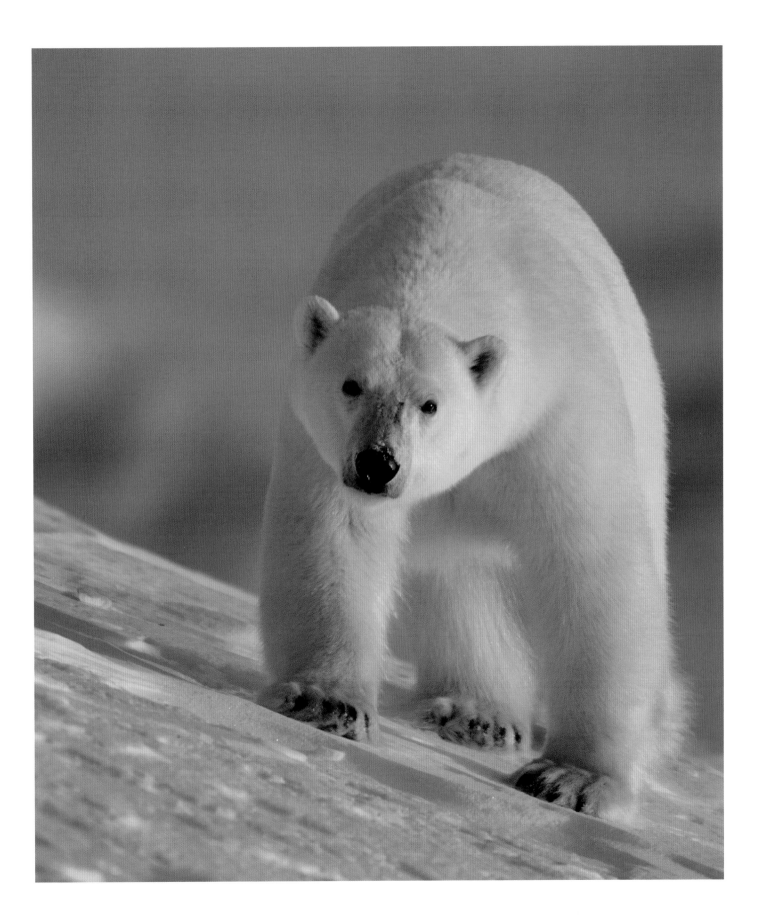

The birthing den

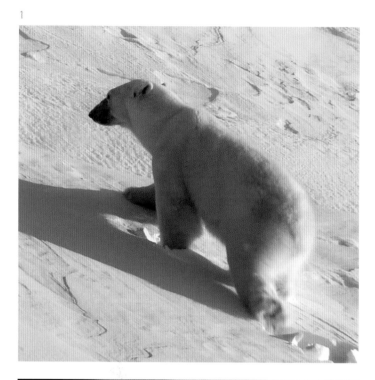

1

4

Top row

Preparing to make the birthing den, Svalbard, late October.
1 The pregnant polar bear climbs her chosen slope, which is protected from the prevailing winds. 2 She makes a scrape and lies down in it.
3 She then curls up and waits for snow to drift across her up to a depth of 3 metres (7 feet). Once covered, she digs out a den tunnel several metres long with an oval chamber, where she gives birth.

Bottom row

4 A two-day-old blind cub suckles. The milk it gets is closer to that of seals than to the milk of most land mammals.
5 The cubs will spend the first three months of their lives with their mother in the den (here in a captive situation – to film newborns in the wild would involve too much risk to the family).
The mother is effectively dormant and doesn't eat, drink, urinate or defecate during her time in the den.
6 A second cub shows itself a day later. Two cubs is the norm.

2

3

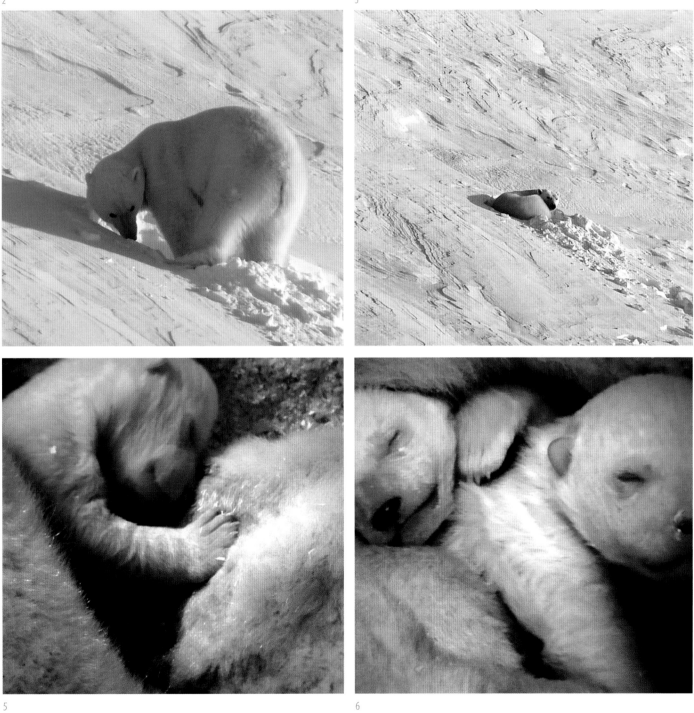

5

6

OASES IN THE ICE

At its peak in winter, the Arctic Ocean is covered by about 15 million square kilometres (5.8 million square miles) of ice. The Arctic seals, whales and birds that get their food from the ocean have no option but to head south in search of open water. At least, that's the theory. Recently, it was discovered that almost half a million spectacled eiders, virtually the world's entire population, overwinter in one area of open water in the pack ice off the coast of Alaska. Such oases in the ice are known as polynyas – the Russian word for forest clearings – and were first observed by native American hunters. They are kept free of ice by strong winds and tidal currents and recur in the same location year after year, attracting marine mammals and seabirds, which use them for breeding and feeding. Spectacled eiders have recently been discovered using the polynyas as arenas for mass courtship displays – and walruses have been seen taking advantage of the congregations, hunting the ducks from below and impaling them on their tusks.

In winter, the 100,000 common eider ducks that live in Canada's Hudson Bay use the small polynyas that fringe the Bay's Belcher Islands, diving as deep as 10 metres (33 feet) to harvest sea urchins and mussels from the seafloor. These polynyas are too small to hold the whole group, and so the adults spend most of the time offshore, returning to the polynyas for short periods at dusk and dawn to join the young birds, who shelter there through the winter. Occasionally a polynya will freeze over, and the young birds will become immobilized by ice freezing to their backs. Soon the opening is too small for either the currents or the ducks to keep it open. And so a whole generation of young Hudson Bay eiders disappears under the ice.

Colonies of other seabirds are often located close to polynyas, so avoiding costly migrations. And now archaeological evidence has shown that early humans also settled near them. Polynyas are also vital to the overwinter survival of many marine mammals, including narwhal and beluga whales, which feed under the ice.

Such giant holes in the ice have a vital physical role, too. Heat is lost rapidly from their unfrozen surfaces, resulting in large amounts of ice being generated below. This cools the ocean and adds salt to the remaining water, both of which are processes vital to the functioning of the Arctic oceanic system.

Opposite
Aerial view of hundreds of thousands of spectacled eiders resting in a polynya – an area of open water surrounded by sea ice. The entire world population of spectacled eiders is thought to overwinter here, in the St Lawrence Island polynya region of the Bering Sea, Alaska. But the refuge is threatened by climate change, as fish moving into the gradually warming water compete with the ducks for the limited winter food source of bottom-dwelling molluscs and crustaceans.

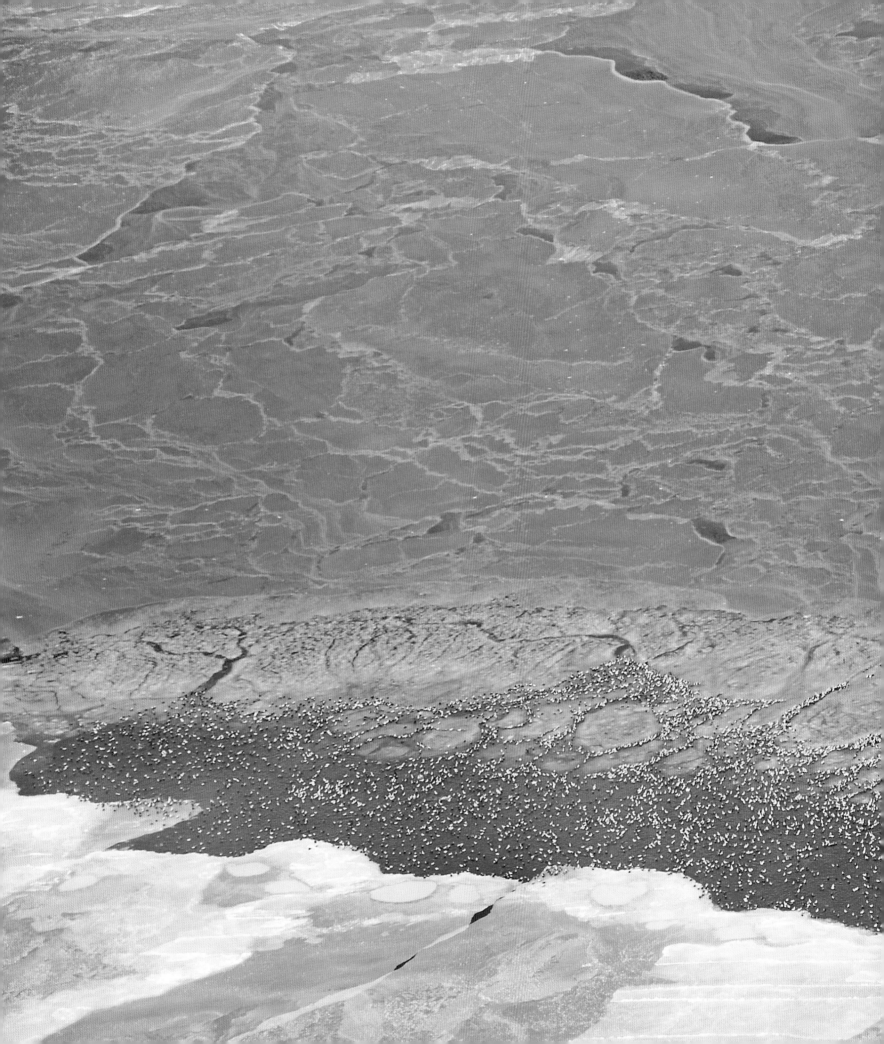

FROZEN EARTH

The winter freeze spreads over a fifth of the Earth's land mass. Intense cold also penetrates deep into the ground, freezing any water that it holds. The resulting permafrost is ever-present in places that are on average colder than -6°C (21°F) throughout the year, extending far to the south into China and Asian Russia. Nearly a quarter of the Earth's land is propped up on permafrost. In parts of Siberia, the permafrost layer is almost 1500 metres (4922 feet) thick, a relic of previous ice ages. In the High Arctic, the scree slopes result from frost shattering the rock. Some areas are patterned with polygons, often ringed by larger stones, and look man-made but are in fact formed by frost-heaving of stones in the soil over cycles of freeze followed by thaw.

FROZEN FORESTS

Winter in the northern forests is brutal. Temperatures can drop to -50°C (-58°F), and for seven months, all water is locked up in snow and ice, leaving the area as dry as a desert. The northernmost forest is in Siberia, made up almost entirely of the Dahurian larch, possibly the most cold-hardy tree in the world. Like all conifers, its needles have a small surface area and a waxy covering that helps reduce water loss. When temperatures drop, water is expelled to prevent ice crystals forming inside and destroying the cells. And as winter takes a grip, it simply drops its needles.

Frost forms from water vapour in the air and can coat an entire forest overnight. The crystals are intricate. When large, like elaborate, lacy snowflakes, they are called hoar frost. 'Frost flowers', like delicate clumps of downy feathers, are sometimes found on waterlogged wood on the forest floor or at the edge of puddles. Rime, formed when super-cooled fog water droplets freeze on contact, sometimes covers trees with outlandish, wind-driven shapes. Further south, where the air is milder and moister, the freeze takes the form of heavy falls of snow. The taiga (the coniferous-forest band) becomes a fairytale land of snow-laden Christmas trees. Smaller conifers become overwhelmed by the snow, looking like stooped figures dressed in white, but the snow tends to slide off the branches of the larger, cone-shaped ones, and even if it builds

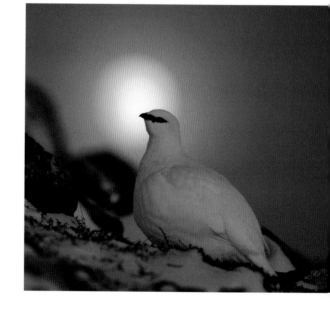

Above
Ptarmigan, Greenland, midwinter. It survives the dark months scratching a living from vegetation under the snow. Feathers on its feet act as snowshoes, allowing it to walk on soft snow.

Opposite
A frozen forest, Finland. It's a silent world, with tracks revealing the presence of a few hardy animals. Those trees that keep their leaves continue to photosynthesize, using light filtering through the snow – a vital adaptation, as snow cover can last for months.

Overleaf
The taiga, early winter, western Siberia, Russia. For several months, the sun will barely rise, and for seven months, all the water will be locked up in snow and ice, leaving the forest as dry as a desert.

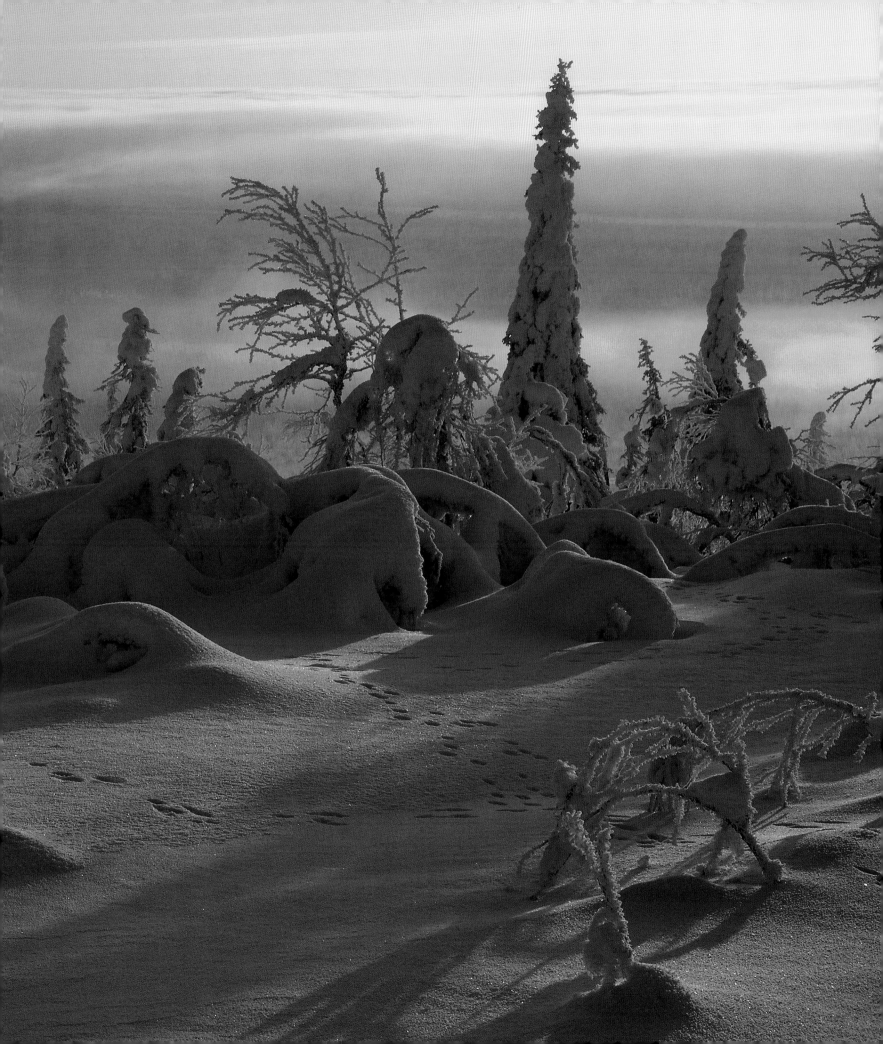

up, these trees can carry a surprising weight before they buckle and break. In northern Finland, where winter storms are fed by moisture from the Baltic Sea, a tree 12 metres (39 feet) high can carry a mass of snow weighing 3000kg (6615 pounds).

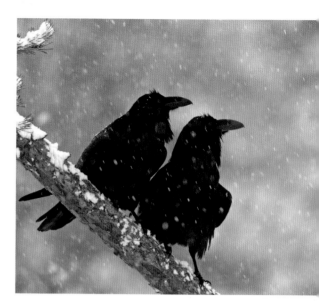

FOREST GIANTS

As winter advances, the snow builds, blanketing the vegetation. The forest becomes eerily quiet. Animals are scarce, but for some larger species, the winter forest is a place to shelter from the wind on the open tundra. Being big helps to reduce the effects of the extreme cold – the larger an animal is, the less surface area it will have relative to its body and so the less heat it will lose. It explains why the Siberian tiger is easily the largest cat alive, dwarfing those on tropical islands such as Sumatra, and the fact that moose of the northern forests of America and Europe (where it's called elk) are the world's largest deer.

The wolverine is no exception to this trend for giants. The size of a small bear, it is by far the largest weasel. Its extra body weight enables it to roam vast distances in search of food. Females may range over 300 square kilometres (116 square miles), and males nearly twice that. The wolverine is well suited to life here – its fur is long and dense and doesn't hold water, making it highly frost-resistant, which is why traditional Arctic hunters favour it as a lining for their parkas. The wolverine is also a scavenger – a sensible strategy in a place where food is scarce – searching out animals that have died from the cold or even driving wolves or bears off their kills. It has also learnt to make use of ravens. With their exceptional sense of smell and an aerial view of the forest, ravens are often the first to find a dead animal. This works for both parties. A raven cannot penetrate a frozen carcass with only its beak, but the wolverine, with its exceptionally powerful jaws, hook-like molars and sharp claws, is able to rip apart a deep-frozen carcass that a human would struggle to cut with a chainsaw. The raven can then move in for scraps.

Wolverines are also hunters, capable of catching a surprising range of mammals. In summer, a reindeer can easily outrun a wolverine, but in winter, the wolverine's large, snowshoe-like feet give it the advantage. In Denali National Park, Alaska, in winter, when

Above

Ravens on the lookout for carrion, in February, Finland. They are highly opportunistic birds, but in winter they are dependent on kills made by wolves and even polar bears. As aerial scavengers, they are often first at a kill and so make valuable guides for ground scavengers such as wolverines.

Opposite

A wolverine, eyeing potential carrion. It has powerful jaws capable of crushing frozen meat and bones.

Overleaf

The pack of 25, midwinter at -40°C (-40°F). The wolves of Wood Buffalo National Park, Canada, are the largest, most powerful wolves in the world. They have developed the stamina and strength to pull down bison, with most success in winter, when the bison are weakened and snow makes them easy to track. Big, plentiful prey leads to record-breaking pack sizes.

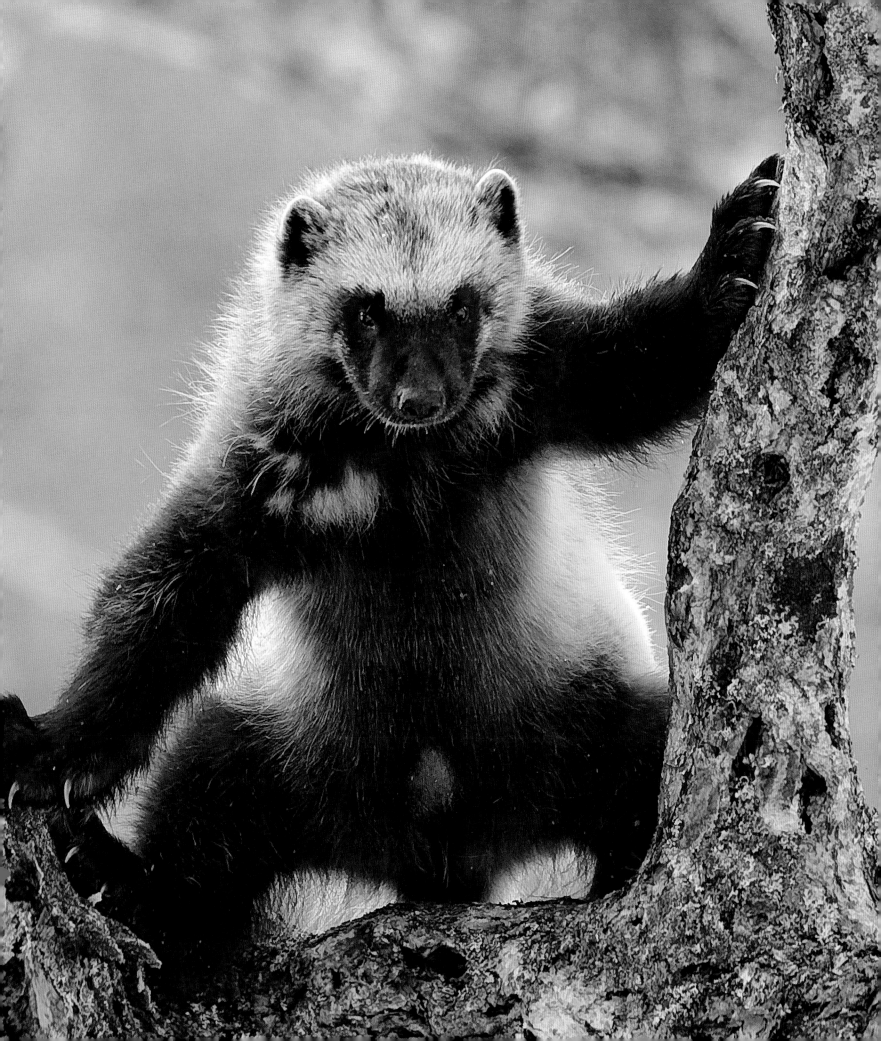

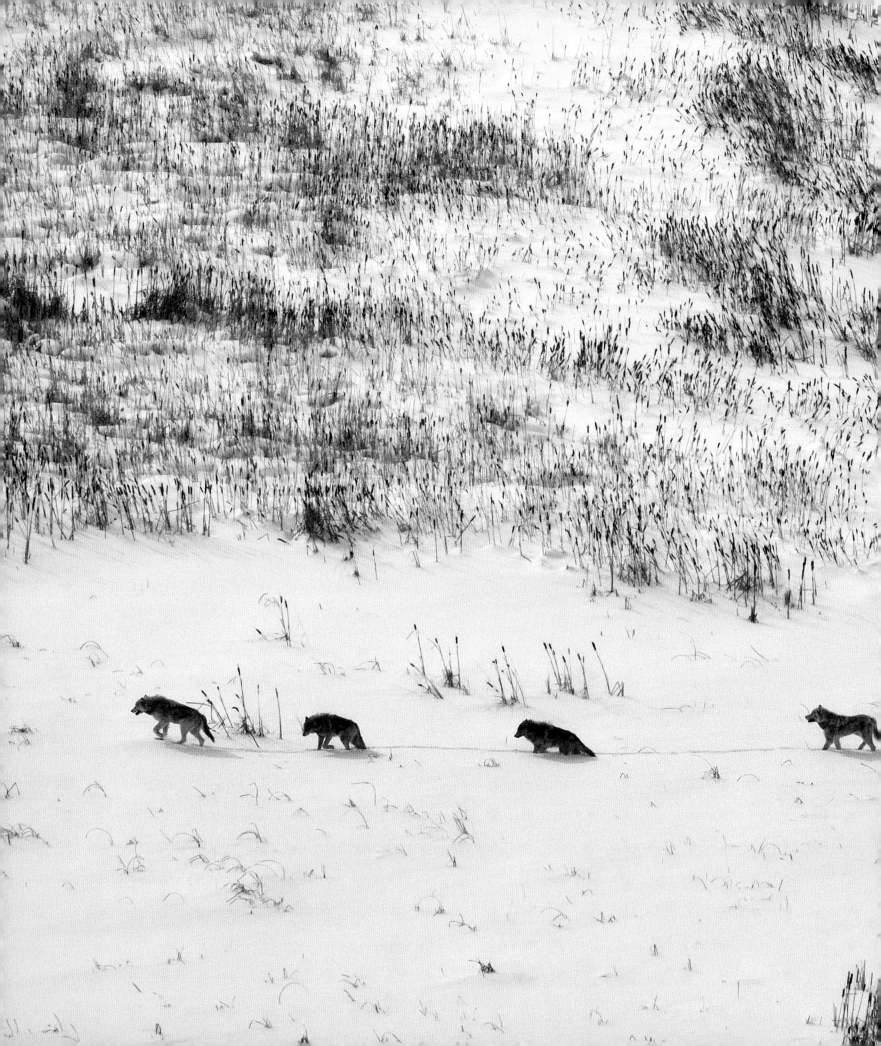

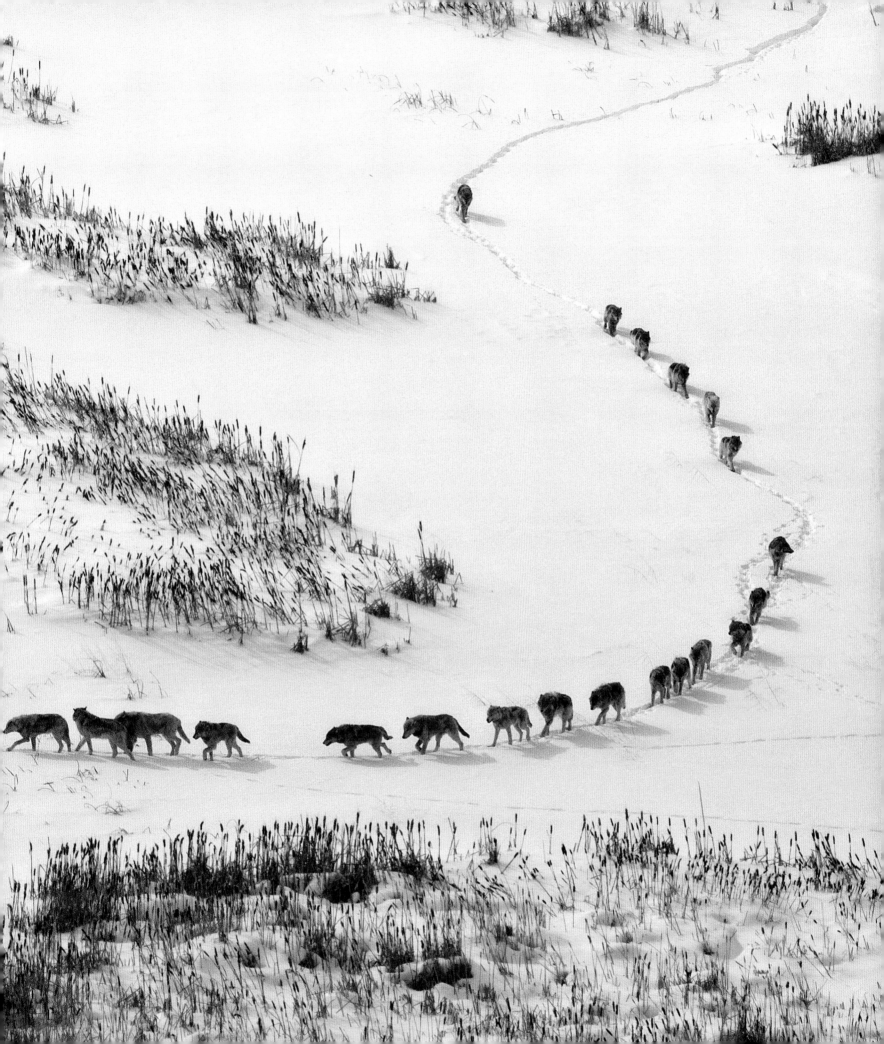

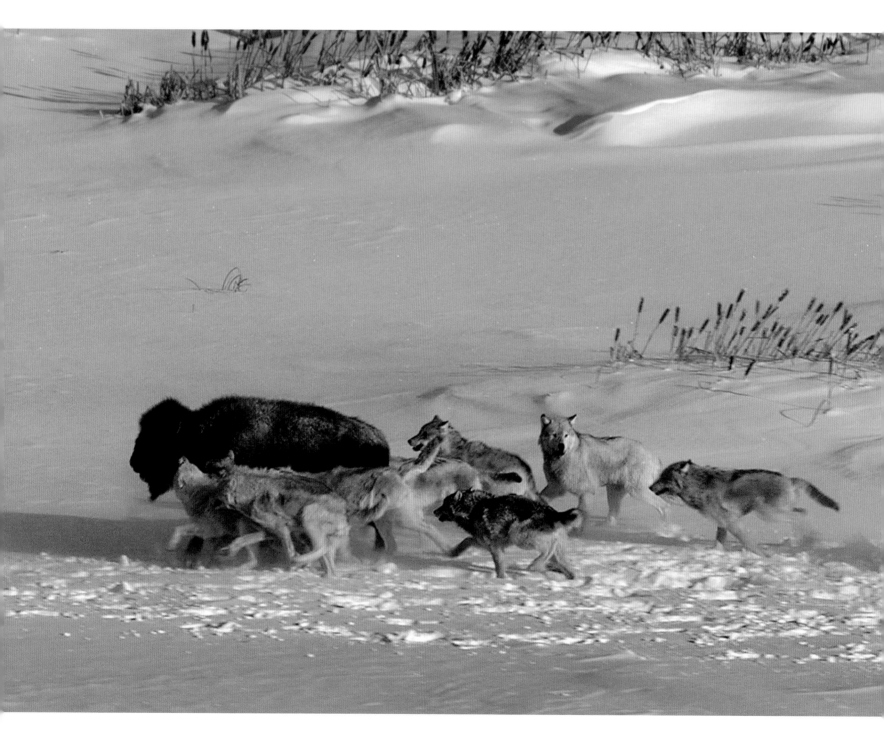

there is thick snow, wolverines have been observed taking down caribou five times their size, jumping onto the caribou's back and killing it with a swift bite to the neck.

A wolverine consumes a large amount of meat in one sitting, which has led to its nickname of 'glutton'. But greed makes perfect sense in the frozen forest, when it may be a long time before the next meal. Any leftover food is hidden in caches, to be used in lean times. A female wolverine has been known to return to a cache six months later to feed herself and her kits on meat that, effectively, has been stored in a deep-freeze.

BATTLE OF THE TITANS

Wood Buffalo National Park lies on the edge of the Arctic Circle in northern Canada. As its name suggests, it's home to the wood buffalo, or bison. These giants – heavier and taller than their cousins on the plain – are the largest land mammals in North America. Their hides are thick, their neck muscles are incredibly powerful, and their heads are protected by sharp horns. What's more, they can sprint, approaching speeds of up to 60kph (37mph). They need to be able to, as the park is also home to the largest and most powerful wolves in the world, weighing up to 60kg (132 pounds) – twice the size of a German shepherd dog. In winter, the wolves feed exclusively on bison, the last place in the world where this happens, and the never-ending struggle between predator and prey is what has shaped each species into the most impressive examples of its kind.

In winter, snow is a serious obstacle for bison; their heavy bodies and small hooves cause them to sink deep into the snow, making it hard for them move around. And where they go, they leave a trail that makes it easy for a pack of wolves – often 25 strong – to follow. But bison are so dangerous that wolves will only attempt to kill if the situation looks favourable.

Once a herd is in sight, the wolves make a critical decision: use the element of surprise and attack immediately or bide their time. If the bison are settled, the advantage lies with them. They can group around their calves, presenting an impenetrable wall of horns and making it harder to distinguish sickly adults. But if the herd can be made to panic, the wolves can pick off the calves and weaker adults.

Opposite
Bison prey – ten times the size of a wolf but the only prey on offer in winter. Here some of the pack try to pull down a yearling. They are successful only when another bison thundering down the track accidentally head-butts the yearling from behind as it tries to knock the wolves out of the way.

The long hunt

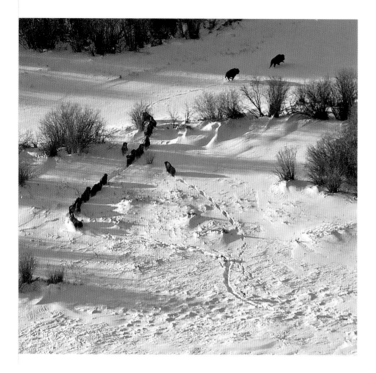

1

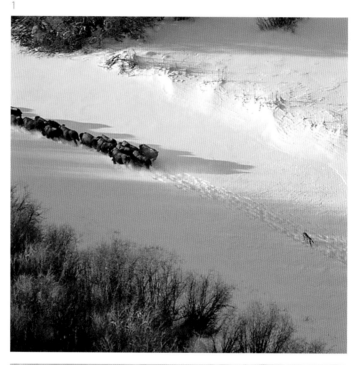

The hunt. Just one pair of wolves – the alpha male and female – pursue the bison herd. It's a chase that can last 12 hours.

1 The wolf tries to close the gap by running at top speed (56kph/35 mph). Though wolves have incredible stamina, they can only run fast for a maximum of 20 minutes.
2 The bison are slowed down by having to trailblaze through deep snow, and the ready-made trail allows the wolves to catch up.
3 The female singles out a yearling at the back of the herd.
4 She goes for its belly, where the hide is thinner.
5 The male wolf attacks from the rear. Even though the bison is still young, it's many times the weight of the wolf and capable of killing it.
6 The male backs off leaving the female to attempt to bring down the bison – a battle that will last for hours and leave the contestants covered in each other's blood. As the female continues to attack the bison's underbelly, the bison repeatedly tosses her into its path and attempts to gore her. But eventually the exhausted bison collapses.

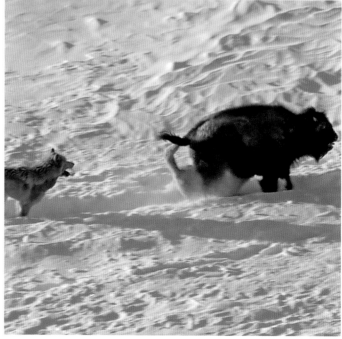

4

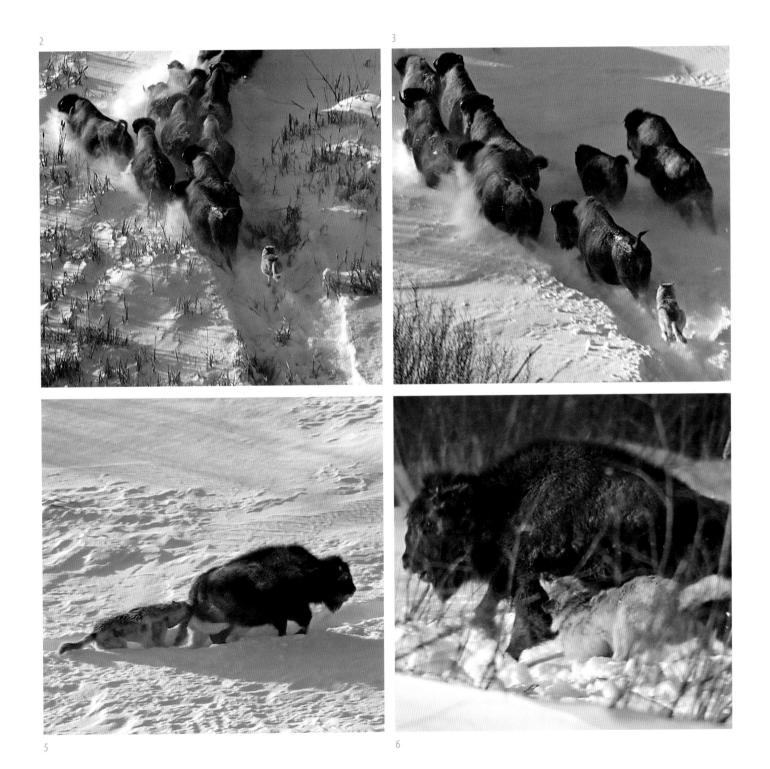

Most often, the wolves find the bison in a cautious mode and are forced to follow the herd for days. They will harry the bison relentlessly, but as long as they hold their ground and continue to present a united front of horns, hide and brawn, the pack doesn't stand a chance. Sooner or later, though, an animal will panic and trigger a stampede.

Once the herd starts to run, the hunt is on. Wolves and bison can both run fast, but if the bison are running over virgin snow, they will tire first. On the other hand, the wolves can only maintain a fast pace for 20 minutes or so and therefore cannot afford to delay the final stage of the attack. Either they can divert the bison into a forested area, where the trees will make it harder for the bison to group together and protect their calves, or they can try to single out a yearling.

Even a young bison can do serious damage with its horns, and so the lead wolf will only attack from behind, hanging onto the hindquarters with its teeth. The bison will attempt to toss the wolf over its head and into its path, where it can gore it. A battle may last for up to 12 hours, when the struggle becomes a matter of life or death for the predator as well as the prey.

If the hunt is successful, the dominant male and female feed first, packing their stomachs until they've eaten a quarter of their total body weight. They will then sleep for up to five hours, digesting their meal, but they do this beside the carcass – protecting it against the gathering mob of scavengers. Some leftovers are taken to the den, others buried in caches, which the pack will return to when the snow gets too deep for them to hunt.

LIFE UNDER THE SNOW

There's a hidden world beneath the snow. Many small animals inhabit the layer between the ground and the snow that forms in autumn, when the ground continues to radiate heat, melting some of the snow and creating a cavity between the two – the subnivean space. Water vapour condenses and freezes under the bottom layer of snow, creating a crisp ceiling that prevents the roof from falling in. Some plants continue to grow here, using the small amount of sunlight that filters down. And the snow around this vegetation also melts, leading to a network of spaces and tunnels.

Above
A taiga vole, food for many overwintering Arctic predators. It survives under the snow in runways, feeding on refrigerated stashes of grass, lichens, horsetails and berries.

These air pockets support whole communities – lemmings, voles, mice, shrews and weasels. Such small mammals are at grave risk of losing too much heat from their relatively large surface areas, but the blanket of snow is superb insulation, and so long as it is at least half a metre (18 inches) deep, the temperature in the subnivean space will never fall much below 0°C (32°F), unaffected by the massive fluctuations in the world above.

Many small mammal species also build communal nests to conserve heat. Shared by up to ten individuals, the nest of the taiga vole is 25 degrees warmer than the air above the snow. A huddle makes a single 'supervole', which has a relatively smaller surface area than lone individuals would have. And when voles go out foraging, one stays behind, keeping the nest warm. Like many subnivean mammals, voles are so effective at reducing heat loss that they can continue breeding right through the winter. The snow blanket may help keep the voles warm, but it doesn't always keep them safe.

Airborne predators such as the great grey owl have learnt to take advantage of the abundance of prey under the snow, and voles are their favourite food. Their large facial disks focus sound, and the asymmetrical placement of their ears helps them to pinpoint their prey. Great grey owls can actually hear the voles moving in their tunnels 60cm (24 inches) beneath the snow and will punch through the crust with their talons.

An even more formidable predator – the world's smallest mammal predator – hunts under the snow. Along with its slightly larger cousin the stoat, the least weasel follows voles into their own world. Its long, slender body and short legs make it ideally suited for running through vole burrows. But this is a terrible shape for staying warm, and the least weasel loses so much heat through its surface that it has to eat almost a third of its body weight every day to maintain its temperature.

Voles can smell weasels, and when they do, they retreat deep into their burrows and move around as little as possible. Female voles may even suppress their breeding cycles if they detect weasel odour. But the weasels themselves can smell out different types of vole, allowing them to select the best prey, such as female voles that have just given birth, with their bonus of juicy pups. In a macabre twist, the weasels take over old vole nests, making them extra cosy by lining them with fur plucked from dead voles.

THE WINTER BONANZA

At its peak, the Arctic winter extends as far south as the mountainous, volcanic peninsula of Kamchatka in the Russian Far East. Though Kamchatka is on the edge of the Arctic Circle, it receives polar winds from the north, and mountain ranges cut off the warming influence of the sea. The result is a truly polar winter.

In the coldest months, there is little visible life. But Lake Kuril, a crater lake in southern Kamchatka, is an oasis in this frozen world. Underwater springs and raging winds keep the lake from freezing over, allowing sockeye salmon to spawn until March and sometimes until the start of April, creating one of the largest spawning sites for sockeye salmon in the world. Up to a thousand eagles gather here to dine on this winter bonanza, staying in peak condition through even the harshest months.

Opposite
A great grey owl – one of the most well-insulated of birds. It hunts from a perch, both watching and listening for prey. It can pick up the sound of a vole (its favourite prey) moving under the snow, and it has acute binocular vision, adapted to hunting by both day and night. In winter, though, it hunts mainly in the early morning and late afternoon.

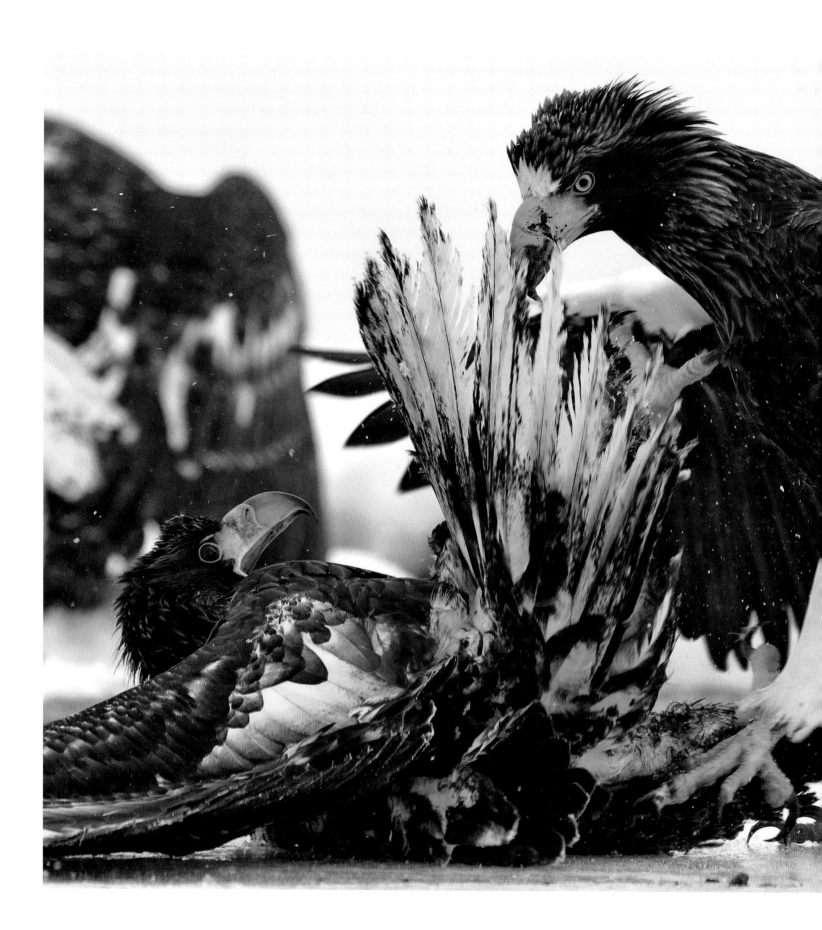

Below

A Steller's sea eagle walking on ice, handicapped by its huge wings, designed for soaring. Along with hundreds of other eagles, it is feeding on sockeye salmon spawning in Lake Kuril, Kamchatka, Russia.

Opposite

An adult Steller's sea eagle battling with a juvenile that has attempted to snatch its fish.

Steller's sea eagles make up the majority of raptors overwintering around Lake Kuril, with up to 750 visiting in years with a heavy salmon run. This heavyweight eagle, with a 2.5-metre (8-foot) wingspan, can carry the reserves and insulation needed to survive an Arctic winter. Seabirds make up the majority of its summer diet, but in winter, the Steller's sea eagle will hunt mammals including red foxes, river otters, young snow sheep and even reindeer. Sometimes it scavenges on the remains of large animals such as bears. But fish, especially salmon, are its preference, and large numbers of eagles will gather wherever salmon are abundant.

It uses its massive, curved bill to kill and drag salmon almost half its own body weight from the water. Steller's sea eagle is also a pirate, stealing from the white-tailed sea eagles and golden eagles. In good years, when the spawning grounds are packed with fish, the other eagles keep their distance, but when stocks are low, golden eagles will take on the larger Steller's sea eagles in dramatic battles. For all of them, the salmon are vital to their survival through the winter.

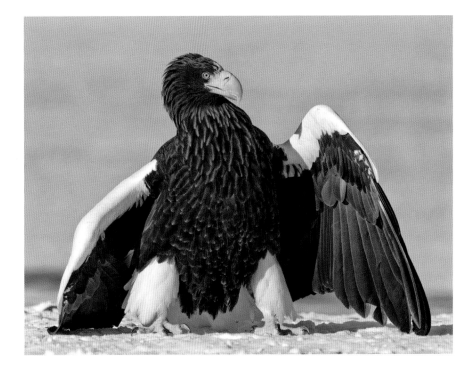

UNDER THE ANTARCTIC ICE

In winter, the dark, calm waters below the Antarctic ice are a sanctuary from the ferocious storms that rage overhead. Here the water stays at a constant -2°C (28°F) – right on the freezing point of salt water. Ice crystals drift past, but the sea never freezes solid because the sea ice that forms on the surface acts as insulation against the cold air above, and the massive body of seawater below is constantly moving. Neither the temperature nor the wildlife down here has changed in millions of years.

A wet nose sticking up above the surface of the ice is usually that of a Weddell seal taking a breath before a dive that may last more than 70 minutes and take the seal up to 12km (8 miles) from the hole. The Weddell is the supreme diver among seals, spending most of its time under water, which is why it is the only mammal that can survive the Antarctic winter. It regularly dives down to 400 metres (1312 feet) looking for squid, octopus and fish, and will dive more than 700 metres (2297 feet) in search of Antarctic cod. A Weddell seal doesn't get 'the bends' as a human diver would when it ascends, as its ribcage is flexible and collapses at about 40–80 metres (130–262 feet), ridding the lungs of air so that nitrogen can't dissolve in its blood during the remainder of the ascent.

The ice is several metres thick, but it's honeycombed with pockets and channels that teem with life. Algae and bacteria inside the ice support a wealth of crustacean grazers (relatives of crabs and shrimps), including krill, which shelter here in winter. Coating the underside of the ice ceiling is a layer of ice platelets. This layer is patrolled by borchs – white ice fish, with four different forms of antifreeze in their bodies, which hunt algae-grazers in among the ice. Cameras mounted to Weddell seals have captured footage of the seals blowing bubbles into the ice to flush out the borchs.

Occasionally, the ice platelets form pendulous structures that hang down from the ceiling like giant chandeliers. These become the nurseries for borchs, which can be seen in their hundreds feeding on the bacteria on the surfaces of the ice platelets.

On the seabed are animals so strange you would think they came from the abyss. In fact, they have. Creatures from the deep ocean have similar cold, dark and stable conditions and are thought to have been the first to colonize Antarctica's seabed. Many here are giants. The isopod *Glyptonotus antarcticus*, which looks like a huge woodlouse,

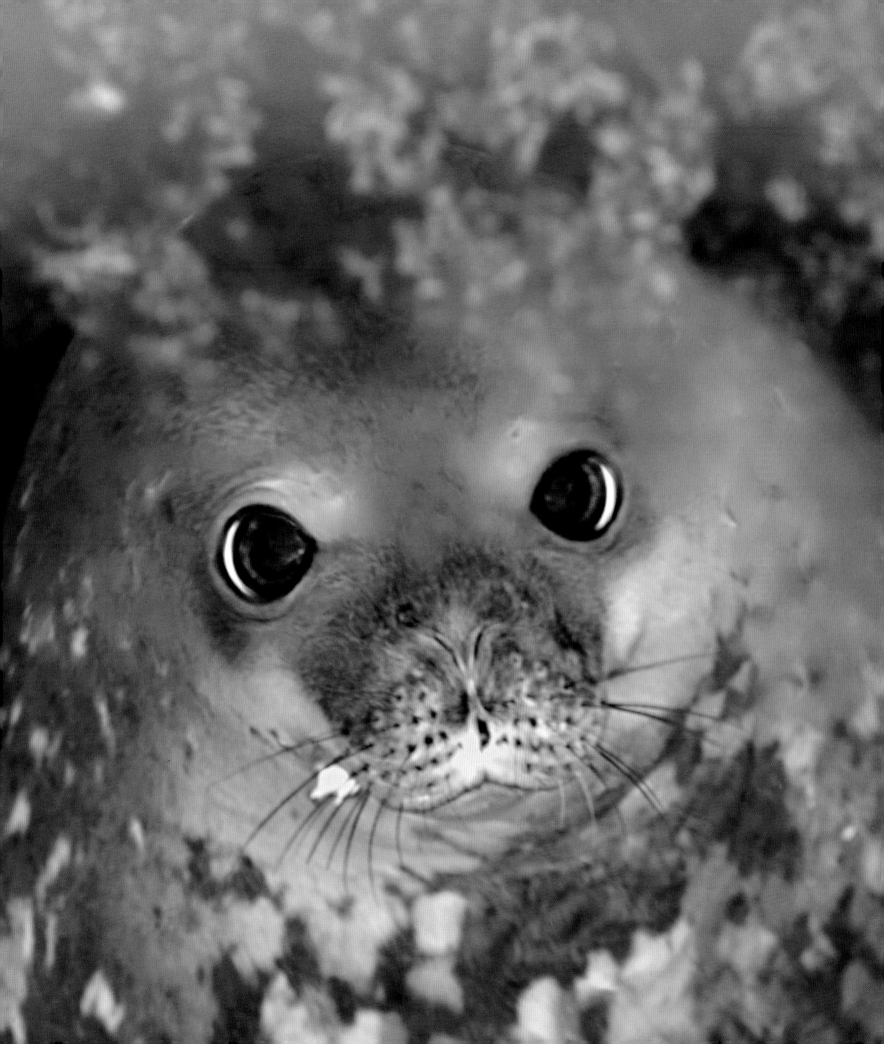

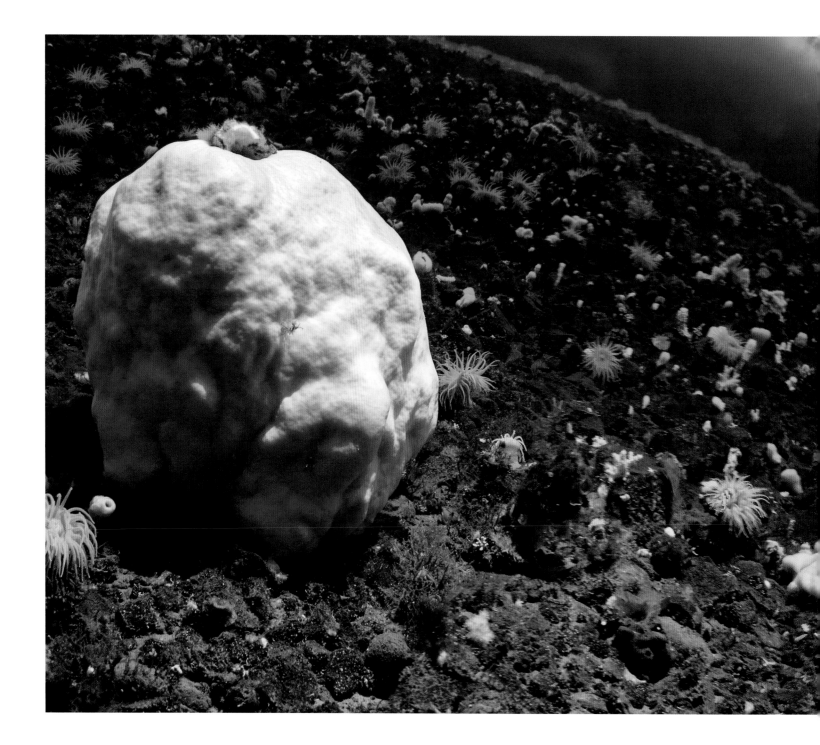

grows up to 20cm (8 inches) in length and takes the place of crabs. The most alien-looking creature is the giant sea spider, which is not a spider but part of a very ancient group with no other survivors. Down here, animals grow very slowly and live for a long time. One limpet is known to have lived for half a century, and some of the sponges are suspected to be more than a thousand years old. It may be this longevity that allows the animals here to grow to such enormous sizes. Slow growth can also go

Above

A proliferation of life under the ice in McMurdo Sound, Antarctica. Here, at more than 60 metres (197 feet) down, safe from the scouring action of 'anchor ice', are giant sponges that can be up to 2 metres (6.6 feet) high and as much as 1000 years old.

Chapter five

hand in hand with restricted diet – there are creatures living under the breathing holes of Weddell seals that survive on nothing but seal faeces.

The cold affects the creatures of the seabed in other ways. They tend to produce fewer, larger eggs than their relatives in warmer seas and also care for them more diligently. They lay their eggs in the winter months so that the juveniles can hatch in spring and benefit from the bloom in plankton, which is fuelled by the returning sun.

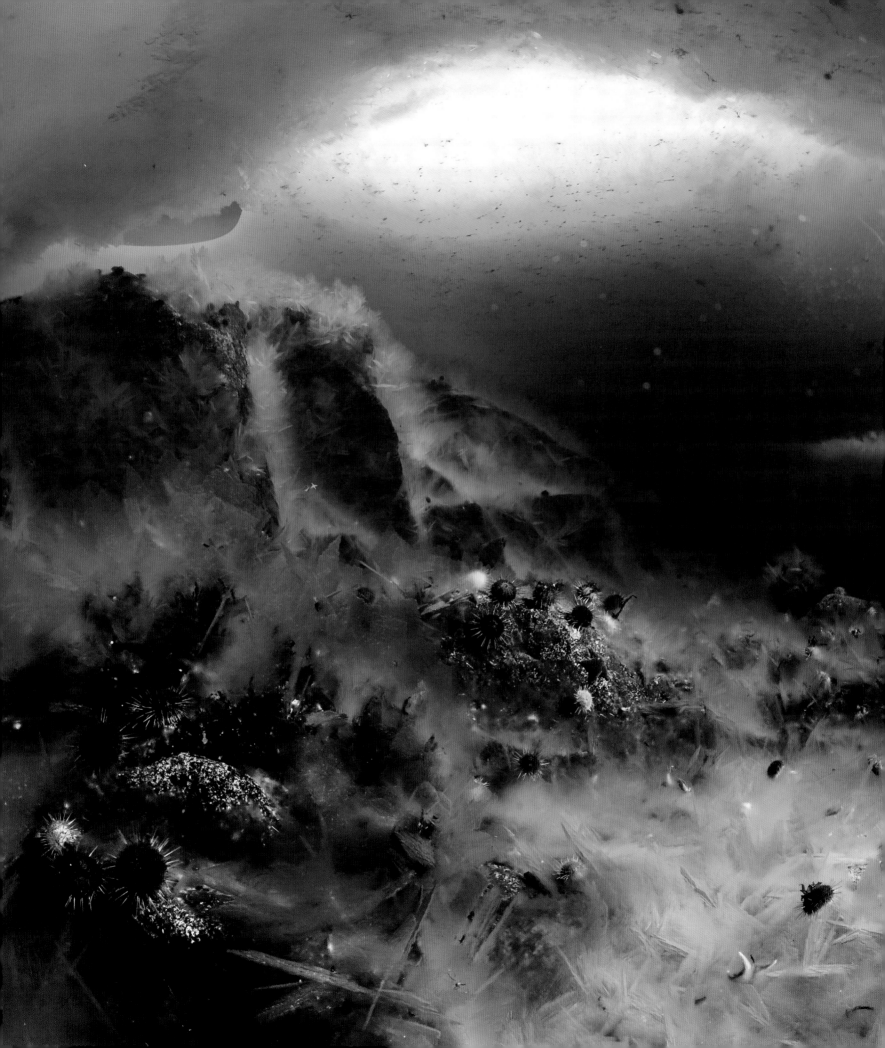

Between 15 and 30 metres down (50–98 feet), fast-growing soft corals and brightly coloured sea stars dominate. And below 30 metres, seabed life gets noticeably richer. Here is an incredible abundance of sponges, sometimes so densely packed that they obscure the seafloor. The largest are shaped like volcanoes and grow to more than 2 metres (6.6 feet) tall and 1.5 metres (5 feet) wide. Some sponges support themselves with skeletons made of silica fibres – spicules. These spicules also act as optical fibres, funnelling light to algae that live deep in the sponge. Sheltering beneath these immobile sponge giants is a community of shrimp-like amphipods, sea spiders, isopods and molluscs. Mobile scavengers such as red starfish and brittlestars gather on the seabed in their millions in what has been described as one of the richest marine habitats on Earth.

But why does life only thrive at 30 metres (98 feet) or deeper, rather than in shallower water as it does elsewhere on the planet? In McMurdo Sound in western Antarctica, ecologists have unravelled this mystery. Each spring, a layer of 'anchor ice' forms on the rocks of the seafloor down to a depth of 15–30 metres (50–98 feet). The ice can be up to a metre deep and is made up of large, randomly oriented ice crystals. It acts as a scourer, ripping rocks and animals from the seafloor, and then drifts upwards, carrying its victims with it before freezing them to the underside of the ceiling of fast ice. This annual scour prevents stationary organisms such as sponges from becoming established. Even relatively mobile animals such as sea urchins get trapped by the ice and lifted away.

In shallower waters, there is still a threat from the ice, but this time it comes from above. At very cold temperatures, seawater starts to freeze. The process releases salt into the surrounding seawater, producing highly concentrated brine that drains through channels in the newly formed sea ice and enters the seawater below. The brine is much denser than the surrounding water, and so it sinks. It is also much colder, and as the brine stream falls, the seawater freezes around it, forming a hollow ice stalactite, or 'brinicle'. The brine continues to pour from the tip, and the stalactite continues to grow, extending several metres towards the seafloor. Travelling at a rate of one metre per minute, this 'finger of death' is devastating to any life in its path. Creatures are first poisoned by the super-salty brine and are then encased by the advancing ice.

Opposite
A deathly carpet of anchor ice on the seabed of the Ross Sea. The ice crystals kill all life in their path, here including sea urchins and starfish, and scour the rocks as the currents move them.

The icicle of death

1

The icy finger of death. This phenomenon occurred over 12 hours. Even in the protected waters beneath the permanent ice ceiling, life is never completely safe from the ice's destructive power.

1 Dense brine drains from the tip of an ice stalactite or brinicle.
2 Extending to the seafloor, the brinicle grows as the surrounding seawater freezes around the sinking stream of brine.
3 The tip of the brinicle makes contact with the seabed 3 metres (9.9 feet) below the ice ceiling. Starfish in its path try to escape but can't move fast enough and are poisoned by the super-salty brine.
4 The advancing ice entombs all animals in its path.
5 and 6 The trail stretches 5 metres (16.4 feet) along the seabed.

4

2

3

5

6

A fat female emperor penguin rocketing out of a hole in the ice, revealing her bullet-like streamlined shape and skintight feathers – a design for a life at sea. Her belly is full of fish, and she is on her way to relieve her partner from chick-care duty. He has incubated their egg on his own through the harsh winter.

THE ULTIMATE ANTARCTIC SURVIVOR

The polar regions are the most seasonal places on Earth. In summer, the sun never sets and most animals are busy round the clock gathering food and rearing young – in many ways, summer is like a single hectic day. The opposite is true of winter. Some animals deal with the extreme cold by leaving – indeed, most birds are forced to be 'summer tourists'. Those that stay adopt special measures. A few hibernate or shelter beneath an insulating roof of snow. Others gain protection by living in the sea, which stays at a constant -2°C (28°F). But a few tackle winter full on, relying on exceptional insulation and teamwork to beat the cold. It is these animals that are the ultimate polar survivors. In the Antarctic, only one animal can endure the extremes of winter above the ice – the emperor penguin.

In May, which is autumn in the far south, the female passes her single egg to her mate and then returns to the sea to feed. The male is left to incubate the egg alone, spending much of his time in total darkness, battered by ferocious winter storms.

By July, temperatures regularly fall to -60°C (-76°F). Fortunately, the emperors are equipped with some of the best cold-weather gear on the planet: a four-feather-thick outer layer overlying an inner layer of blubber combine to make excellent insulation. To reduce heat loss, the exposed feet and bill are especially small. That the emperor is the largest of all penguins – twice as heavy as the king penguin – also helps it to conserve heat, having relatively less surface area from which to lose it. In fact emperors are so good at staying warm that they overheat in summer. Despite this, in the depths of winter, they cannot rely on their own bodies alone to keep warm and have to cooperate.

Emperors are the only adult penguins that overcome their aggressive and territorial tendencies and huddle together for warmth. In large colonies, up to 5000 birds will huddle, their backs to the wind, taking turns to occupy the coldest, most exposed position on the windward side of the group. This reduces heat loss by 50 per cent. The penguins may spend days of total darkness in temperatures that few humans could endure, even with their specialist equipment. Occasionally they are illuminated by the southern lights, which dance across the Antarctic skies, but this light show is just a tease, as it generates no warmth.

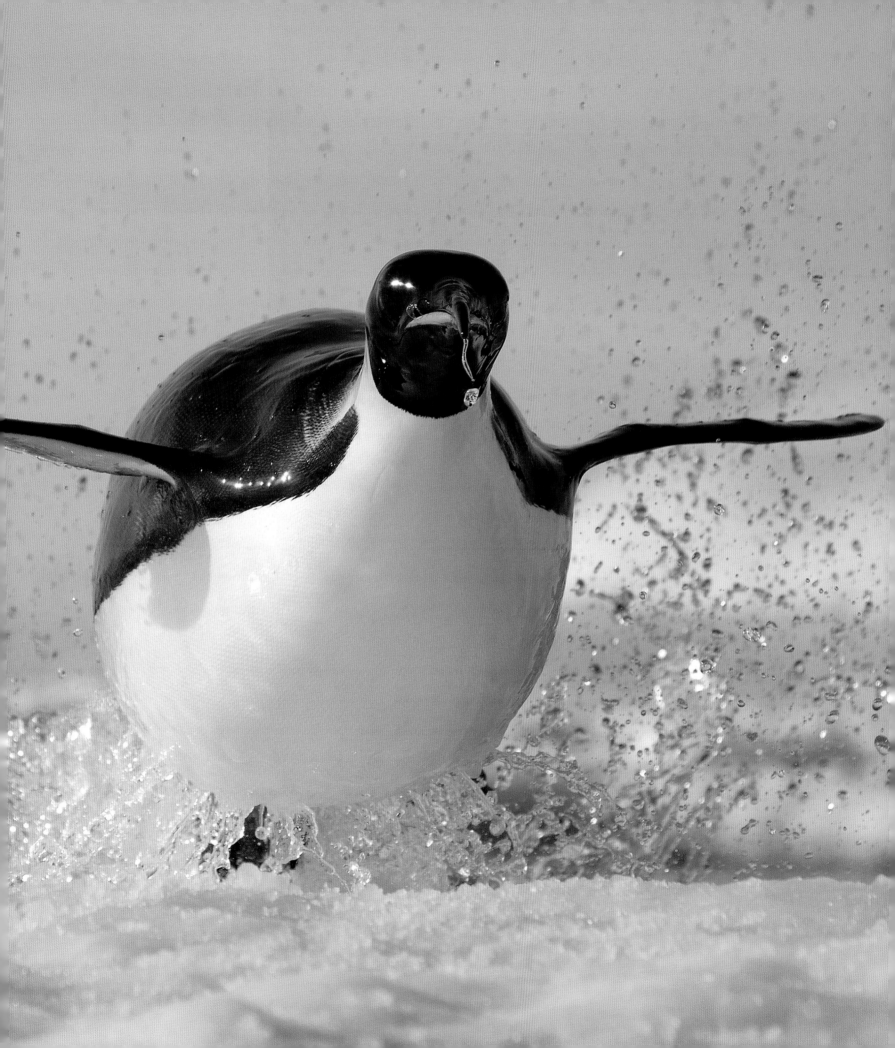

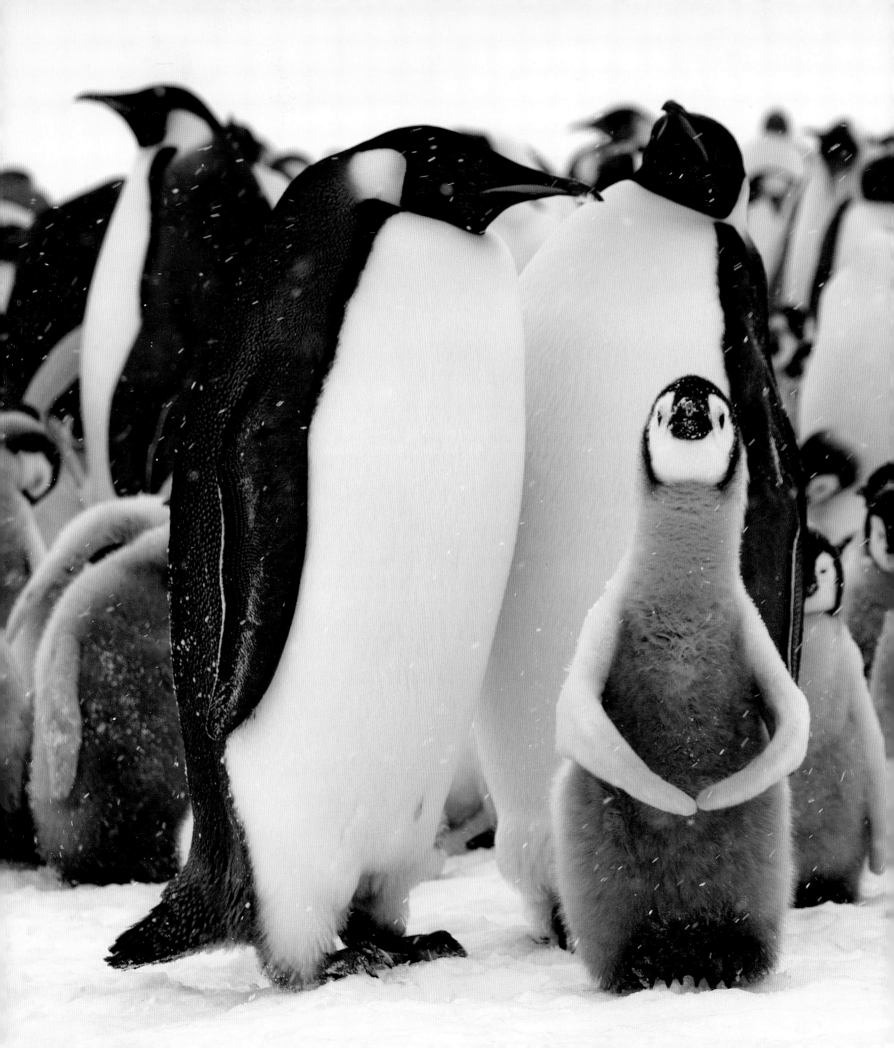

Left
A 50-day-old emperor penguin chick. It is independent enough to be left alone while both its parents head off to feed out at sea. It will join a crèche, huddling together with other chicks for warmth and protection.

Overleaf
Midwinter at the Auster emperor penguin colony, East Antarctica, illuminated by moonlight and the southern lights. Male emperor penguins are the only animals that can endure the Antarctic winter above the ice.

THE FEMALES RETURN

In mid-July, the male penguins are near starvation. Now the eggs in their 'brood pouches' hatch, and the new chicks shelter inside the feathery fold. The males can sustain their chicks with a milk-like secretion for about ten days, while they wait for the females. Any longer and they are forced to abandon their chicks and head to the sea to feed.

The females may have to trek 100km (62 miles) or more over the sea ice to reach the males – the ice has more than doubled in area in the winter, and it is now much farther back to the colony they left in the autumn. The journey can be hazardous, as the females are forced to navigate large cracks and ice boulders the size of houses.

They arrive back to claim their chicks not long after the sun returns to the far south. Their bellies are full of fish, but the males have not eaten since arriving at the colony four months ago and are now on the verge of collapse. The sight of a stream of female emperors arriving back among their mates is one of the most heart-warming in nature. How the penguins feel we will never know, but it is clearly no ordinary day for them.

Initially a male is reluctant to hand over the chick and needs gentle coercion from the female. The exchange is fast – if the chick is exposed for more than a couple of minutes, it could freeze to death. A female whose chick has not survived has such a strong maternal instinct that she will adopt any stray or orphaned chick she encounters. But if the reason that her own chick has died is that her male has died, too, she will never be relieved from chick-duty and will eventually be forced to abandon the youngster and return to the sea.

For most of the penguins, the next seven weeks are an extremely busy time as the parents take turns providing for their growing chicks. After that, the chick needs more food than a single parent can provide, so the chicks huddle together for warmth in the spring storms, while both parents go to sea to fish. Eventually, as the chicks near the age at which they will fledge, the parents head out to the open ocean for good. The chicks follow a week or so later, driven by hunger to find the ice edge.

The emperor parents endure the worst winter conditions on Earth to ensure that their chicks hatch early in the spring and have the whole summer to grow to maturity. Now, just five months after hatching, the chicks are ready to take their first swim in the Southern Ocean.

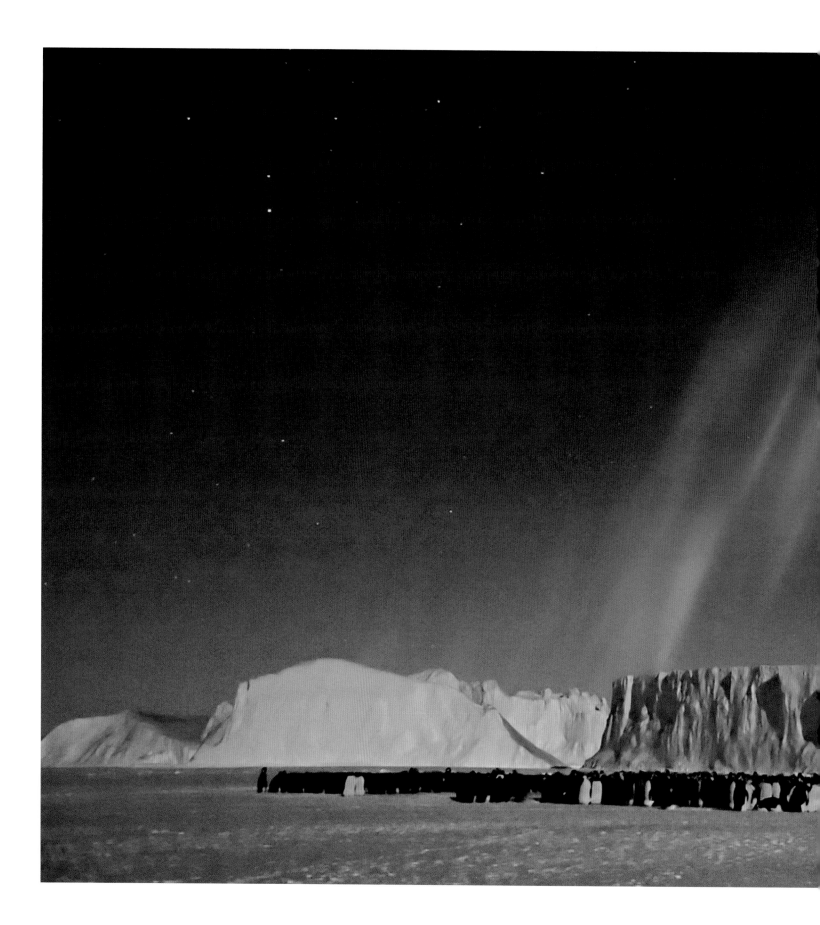

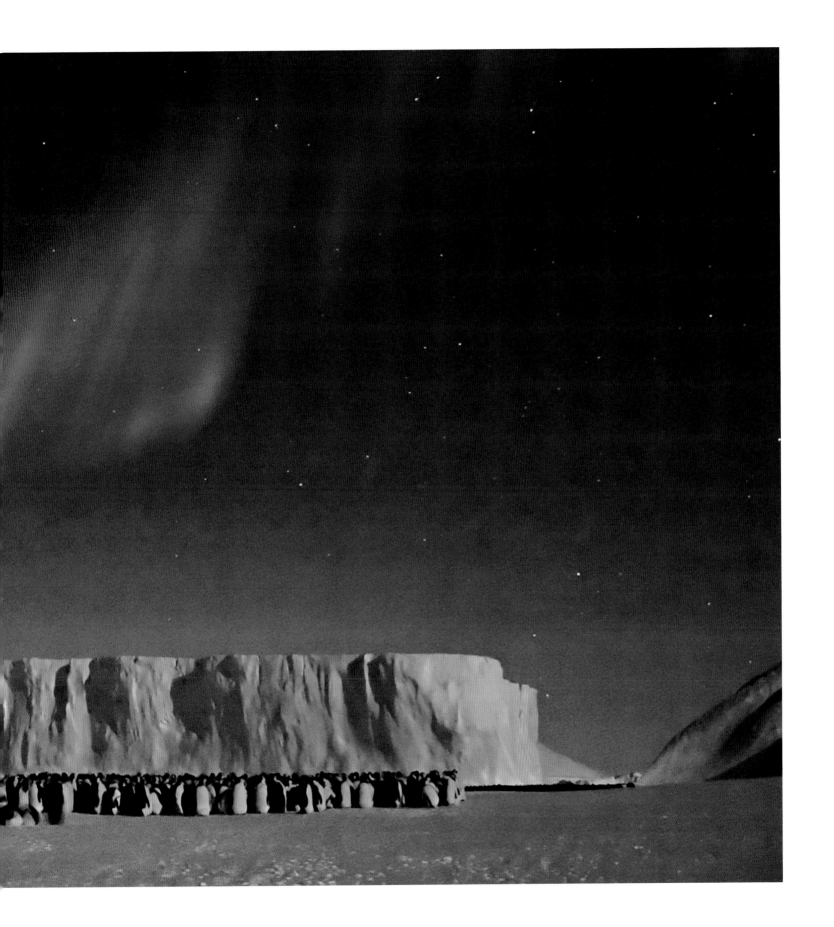

Chapter six | On thin ice

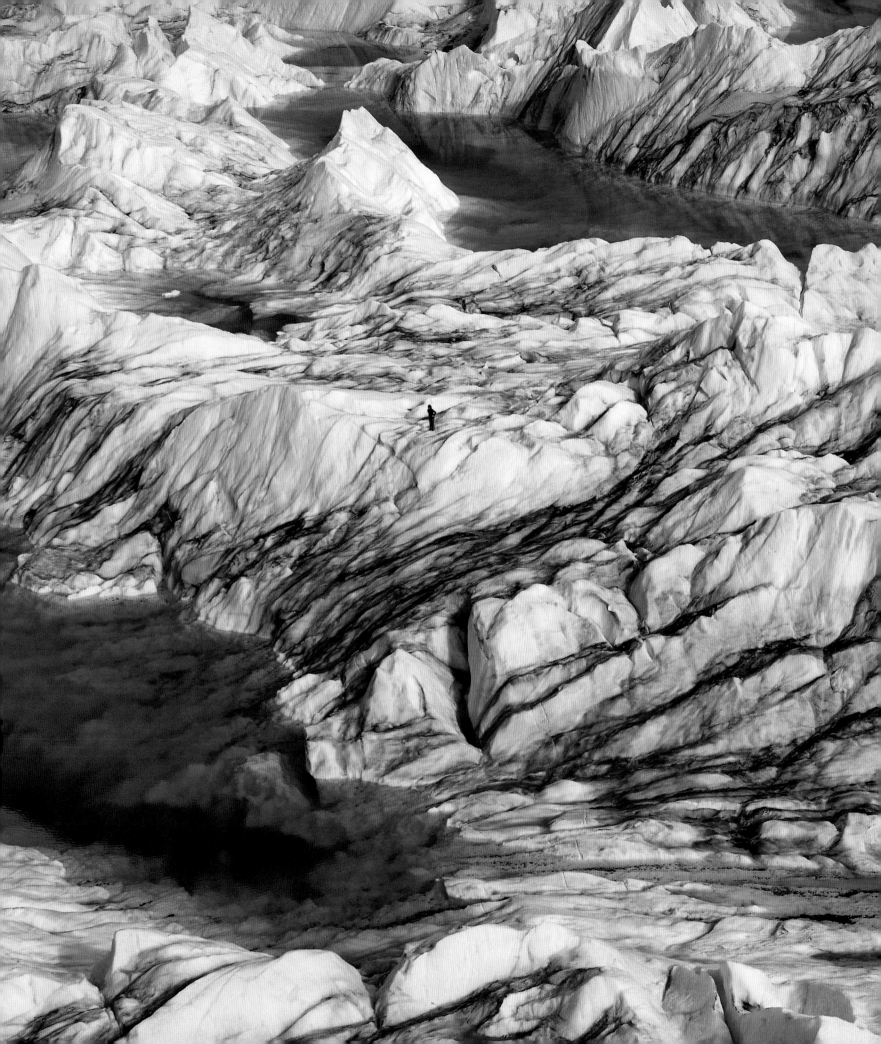

People at the poles – a story of change

In 1972, two brothers were out hunting on the west coast of Greenland when they noticed some strange piles of rocks. They turned over a few stones and, much to their surprise, discovered two burial pits containing eight perfectly preserved bodies – six women, a boy and a baby. Life-size images of the antique mummies can be seen today in a small museum in the town of Uummannaq, close to where they were discovered.

Most striking is their clothing. Beneath an outer layer of fur, mainly sealskins beautifully tailored into hooded anoraks, trousers and boots, the women and children wore intricate, flexible undergarments sewn from hundreds of bird skins, worn inside out with the feathers against the skin. Lacking the necessary insulation, these colonizers had acquired it from the polar animals. It makes you realize how key the invention of the needle must have been to the early people of the Arctic. Even today, traditional Arctic people still favour the double layer of animal-skin clothing similar to that worn more than 500 years ago. Indeed, an Inuit hunter's most valuable item of clothing is often his lined polar-bear-skin trousers, which he will wear on top of sealskin leggings in really extreme winters.

THE MAMMOTH-EATERS

Humans colonized the Arctic about 40,000 years ago, first moving into the Russian Arctic during a relatively mild period of the ice age, when large areas were free of ice. Piles of animal bones found along the Usa River in northern Russia reveal that these early people ate mammoths, wild horses, reindeer and wolves and used stone tools to chop them up. It was a hard life – winters were severe, and summers rarely got much above freezing. To survive, they are likely to have lived communally in large groups, so they could share the meagre spoils of summer and perhaps plan ahead for the lean months.

Today there are approximately 4 million people in the Arctic, with the indigenous population ranging from 80 per cent in Greenland to as low as 3–4 per cent in Arctic Russia. Despite tremendous social, demographic and technological change in the twentieth century, Arctic cultures remain vital and resilient, with many communities still closely linked, both economically and spiritually, to the pioneering lifestyle of their ancestors.

Above
A melt-lake hole on the Petermann Glacier, Greenland. At the bottom is silt – cryoconite – a combination of dust and industrial soot blown onto the ice from around the world. Being dark, it absorbs more of the sun's light and a lot more of its energy, and so the sun effectively drills down into the ice.

Opposite
Ice floes, forming as sea ice breaks up in summer off northwest Greenland.

Previous page
The Greenland Ice Sheet. In summer, the surface is riven with crevasses and meltwater lakes, which are a vivid blue, partly because of the lack of impurities and the absence of salt in the water.

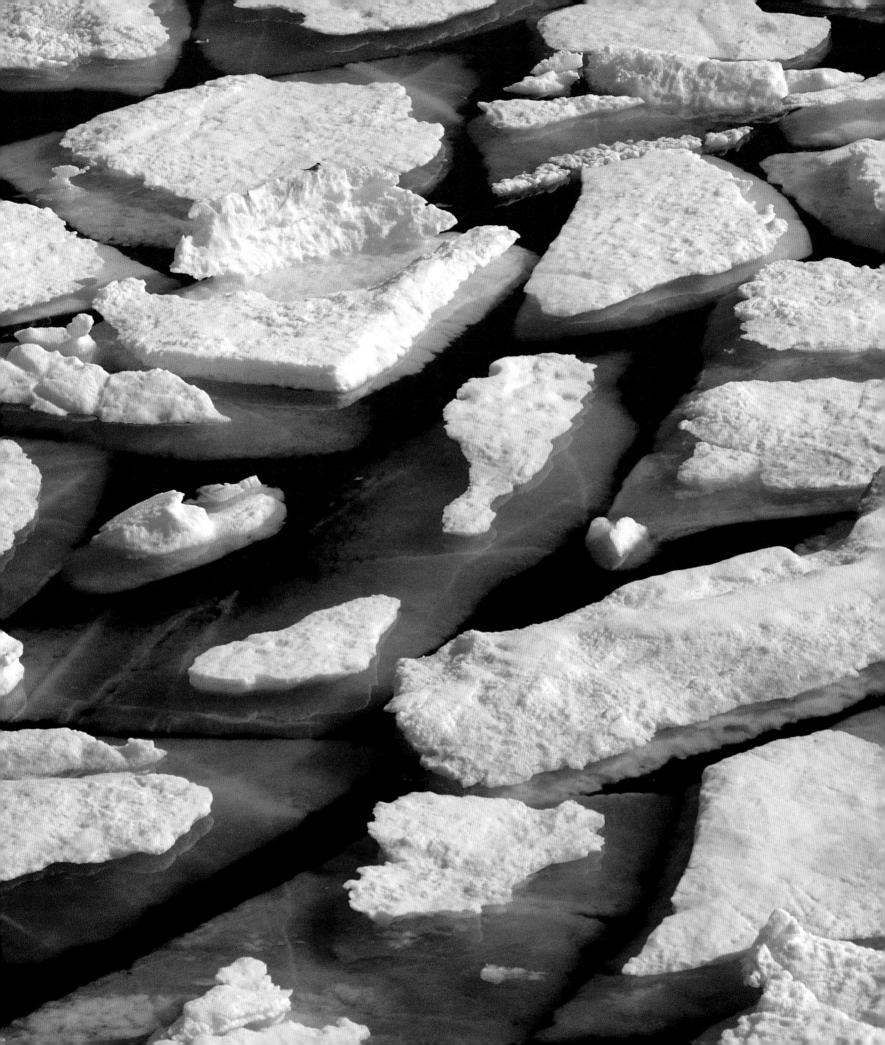

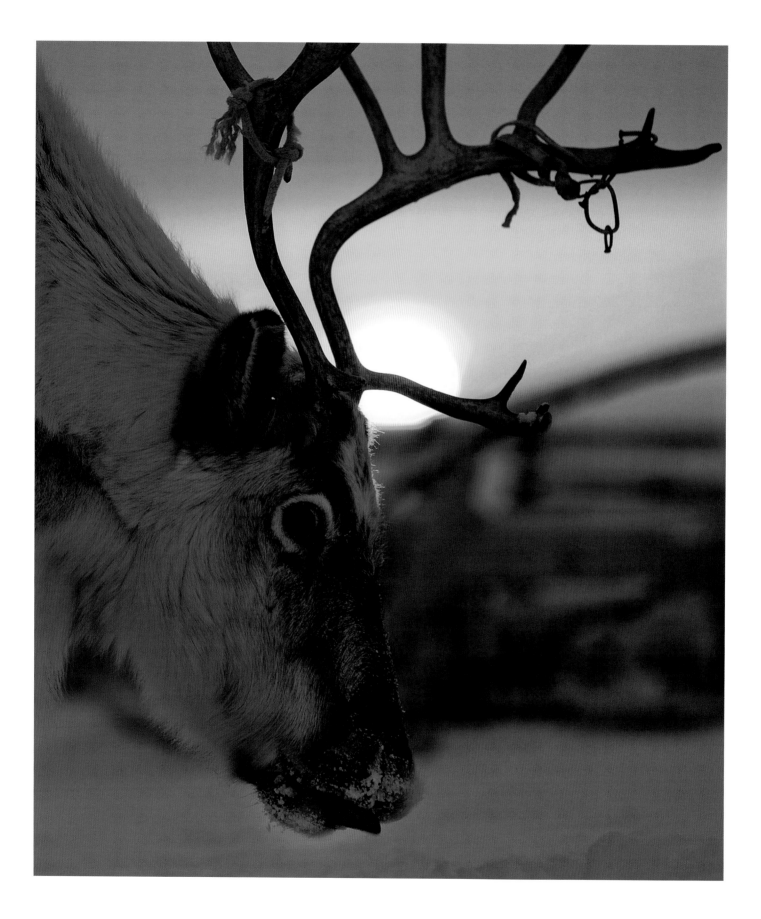

Above
A Dolgan herder chipping ice for drinking water. It has been collected from a frozen river – the reindeer herders' source of fresh water for nine months of the year.

Opposite
One of the herd. Domesticated reindeer are key to the nomadic Dolgan people's survival. When one dies, nothing is wasted. The skin is used both to make clothing and to insulate their baloks – wooden huts resting on sled runners.

Overleaf
Moving home. In winter, when the reindeer move to find new lichen to graze on, the Dolgan follow, breaking camp every week or two and using teams of reindeer to pull their baloks.

PEOPLE OF THE REINDEER

It is hard to imagine a more hostile place for humans than the extreme northern part of Siberia. In winter, temperatures regularly drop to -60°C (-76°F), but the Dolgan people somehow manage to eke out a living. Their survival is dependent on one thing – their reindeer. Reindeer can withstand the extreme cold, surviving the winter by eating lichens living under the snow.

By following and hunting wild reindeer, early people were able to move farther north and eventually colonize the High Arctic. Herding of reindeer began only relatively recently, initially as a way of transporting belongings while following the herd. Nobody has ever managed to fully domesticate reindeer, but today's animals are tame enough to be driven across the tundra in herds of several thousand.

For nine months of the year, the only way to get water in the Siberian wilderness is to melt ice from the frozen rivers. Food is less of a problem as the Dolgan preserve a supply of river fish in their deep freeze – the outside. They eat the fish frozen, shaving it into wafer-thin strips that melt in the mouth. Reindeer is seldom on their menu, unless they get a chance to hunt one from the truly wild herds that still roam the tundra. Their own animals are simply too valuable and are killed only when they come to the ends of their lives.

The Dolgan wardrobe comes from these reindeer, whose skins make extraordinarily warm clothes. Even so, small children have to be sewn into their jackets – to lose a glove would mean almost instant frostbite. Reindeer skins are also used to line the Dolgan's huts, which stay a toasty 20°C (68°F), even when it is -60°C (-76°F) outside. Staying warm here is more important than privacy, and a single hut just a few metres square can shelter an entire extended family. This is living at its most communal, where good relations with the in-laws are a necessity.

Every week, the families have to travel to find new pasture for their herds. First, they round up their strongest animals using lassos – an ancient skill that came north from Central Asia with their ancestors. Then they move house, quite literally, as their huts are built on sledges. These fur-lined mobile homes are a clever solution to a nomadic lifestyle and allow an entire village to move in just a few hours, dragged along by reindeer. Over the year, the people and their herds travel vast distances across the Siberian tundra.

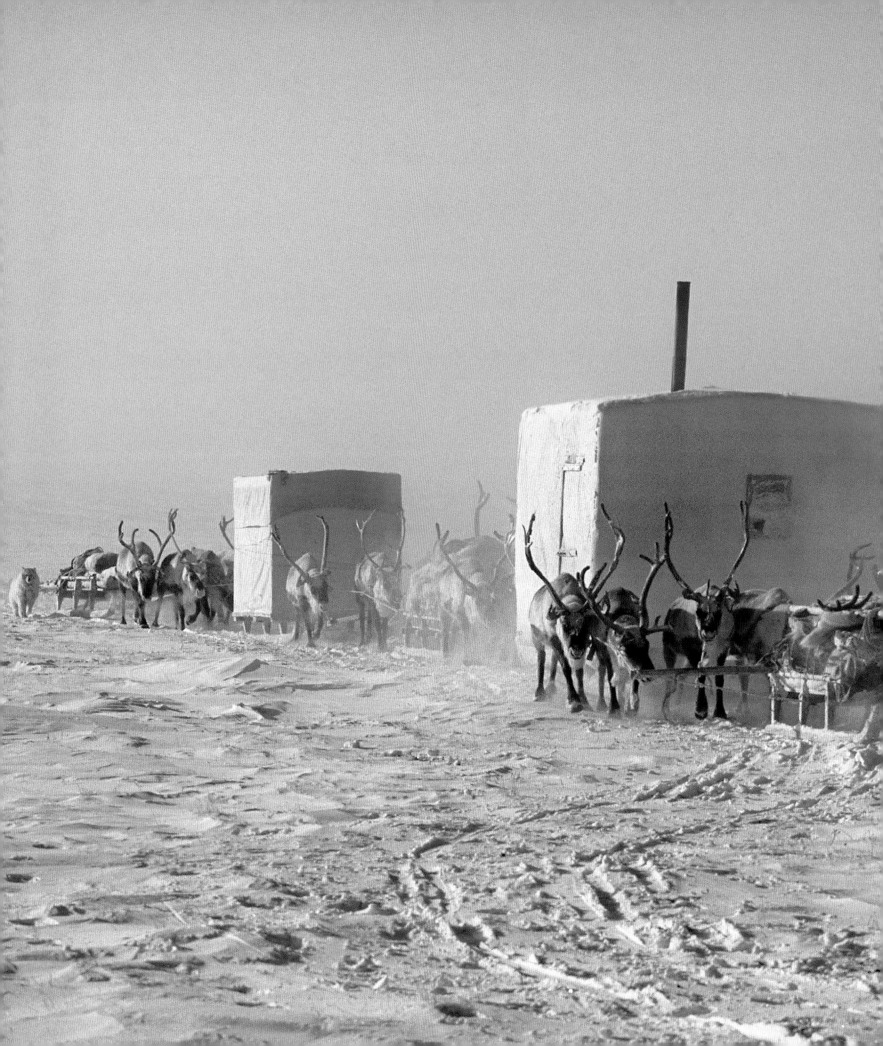

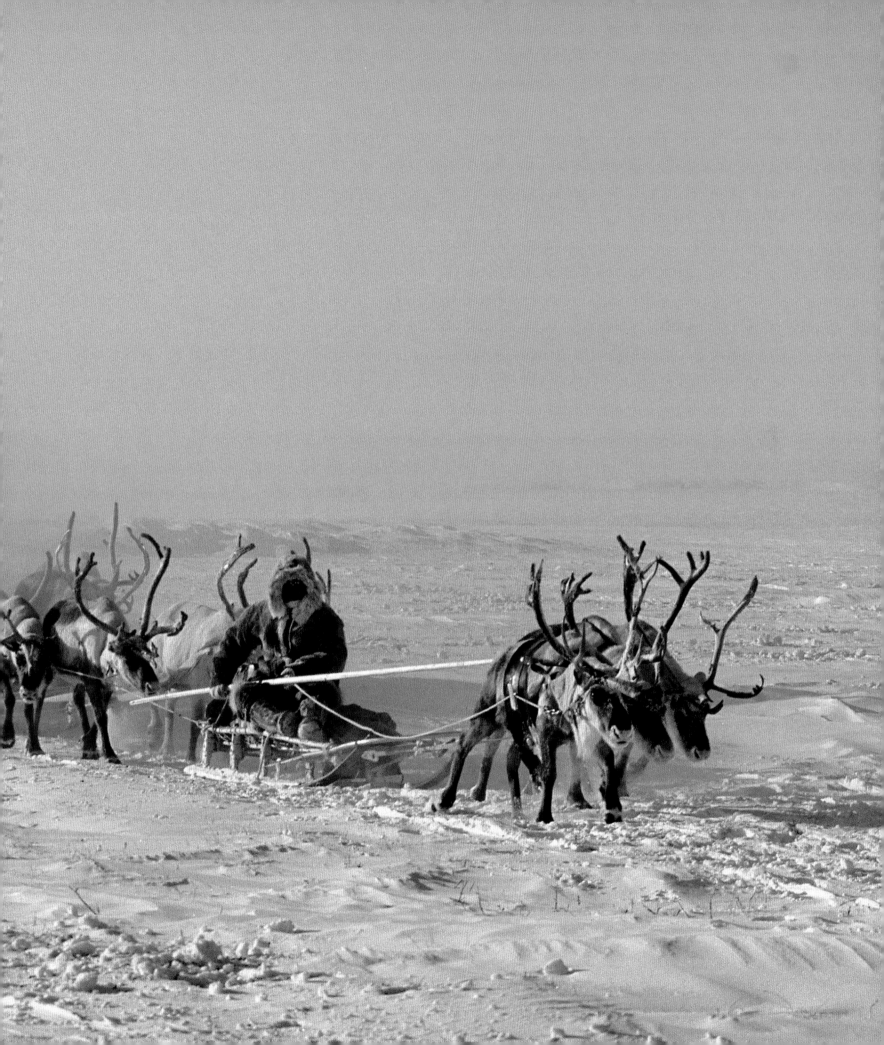

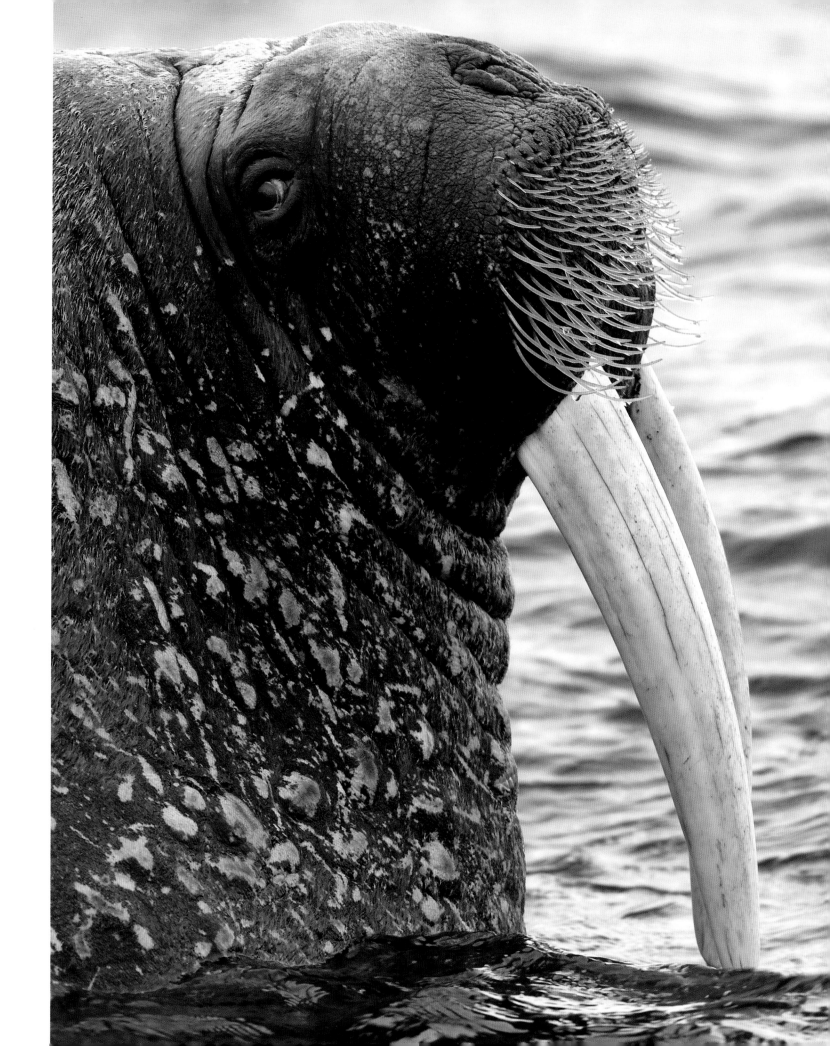

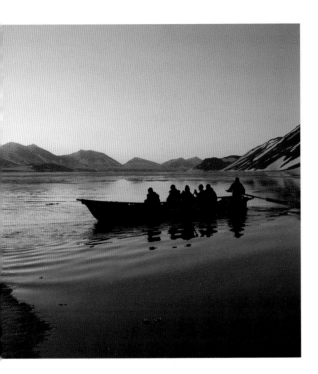

HUNTERS ON THE FROZEN SEA

As the ancestors of the Dolgan were conquering the frozen land, other groups were finding ingenious ways to make a living on the Arctic Ocean. One of the challenges of hunting sea mammals is their tendency to dive at the first sign of trouble. The first hunters solved this problem by inventing the harpoon – a spear with a barbed head and a detachable handle; when the handle drops away, the barbed head stays attached to a rope, which in turn is attached to a float made from an inflated seal bladder or skin. When the harpooned prey tries to dive, the float keeps pulling it back. Each time it surfaces to breathe or struggles against the float, it can be struck again, until it finally dies.

Hunters in the northern Bering Sea became so adept with the harpoon that they would even take on a bowhead whale, which can weigh more than 60 tonnes – only the blue whale is heavier. Their key invention from at least 1500 years ago was the kayak, a simple boat made by stretching skins over a wooden frame – a vessel light enough to carry and easy to right if capsized. A major breakthrough, probably by AD 500, was the development of a cover with a drawstring around the paddler's waist, making the kayak watertight and offering much greater security than an open boat.

By AD1000, a group of people known as the Thule people had become established in coastal Alaska. They are thought to be the ancestors of the modern Inuit, a group of indigenous peoples that number 150,000 and are spread throughout the High Arctic. Today, many Inuit are struggling to maintain their traditional lifestyles in the face of change imposed from the outside. Even so, there are people who still live from the land in much the same way as their ancestors. One such group inhabits Chukotka, the most easterly part of Russia.

Each May, small hunting parties head out onto the pack ice, navigating between huge ice blocks that could crush their small metal boats like tinfoil. They travel in silence, in search of walruses – seals larger than many Arctic whales. A walrus can weigh up to 2 tonnes, have metre-long (3-foot) tusks and be aggressive when cornered. The hunters aim to ambush one before it heads to open water and dives. The harpoon is only fired when the hunters are almost on the walrus. It's a scene that hasn't changed for hundreds, even thousands, of years, except that the final blow is now delivered by a bullet.

When the hunt is over, it takes the men all night to butcher the walrus, taking every scrap back to feed and clothe their families. Survival is marginal for these communities. They depend on a successful hunting season to get them through the year. But spring is short, and when the sea ice goes, so do the seals, as they, too, rely on the ice – as a platform on which to digest meals and give birth.

In summer, food becomes even less reliable, and the Inuit head to the bird cliffs, where they can scavenge for eggs. The extreme seasonality of the Arctic is nothing new to the Inuit – it's something they've observed keenly and adapted to over the centuries. But in recent decades, it's been getting harder to make ends meet. Their home is changing.

ROTTEN ICE AND OPEN WATER

Each spring, the Inuit of Alaska's most northerly town, Barrow, come together to celebrate their hunting traditions with a ceremonial 'blanket toss', launching their youth, trampoline-like, up to 6 metres (20 feet) into the air. In the past, this was the way hunters would spot whales blowing in the distance, in a sea that was frozen solid to the horizon until August. Today, the view the young men get when flying in the air has changed considerably: since 2002, there's been open water offshore by June.

Throughout the Arctic, Inuit are observing and responding to change. They name their seasons according to the ice, and now they tell of the 'rotten ice' of June being seen in May. This early melt brings many problems. Hunters report that sealskins are of poor quality, because the early melt forces the seals into the water before they have completed their moult. The Inuit used to be able to use the sea ice to travel across Greenland in summer. Now, from May onwards, there's a ban on doing this because the ice has become too dangerous. The Inuit are also finding the weather harder to predict and have abandoned ancient techniques of reading wind and cloud patterns. The elders say, 'This isn't our weather. It belongs to someone else.'

Scientist Dr Shari Gearheard believes the best way to monitor the changing Arctic is through the eyes of the people who understand it. Many of these changes are subtle but visible to those with generations of accumulated experience of their environment.

Below

An egg-collector at work in the midst of a guillemot colony in the Russian Arctic. In summer, the Inuit are prepared to risk their lives to harvest seabird eggs, using just a rope and sure-footedness. Few other land predators are able to reach the precarious nesting ledges.

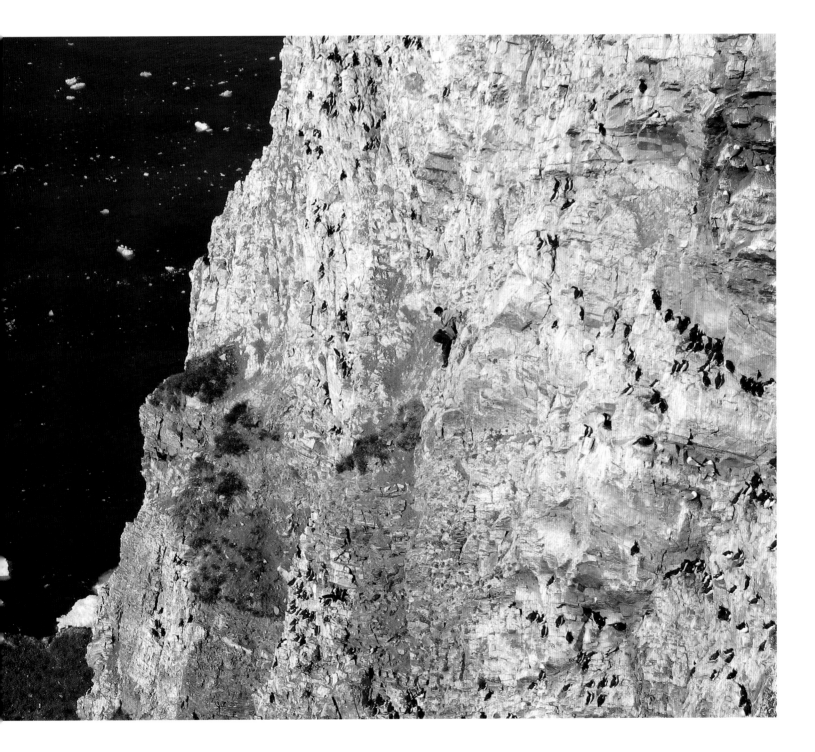

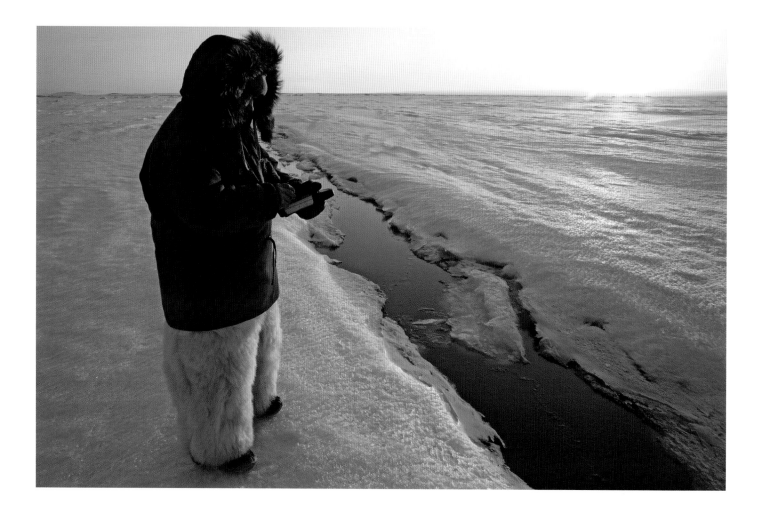

Dr Gearheard has started a pilot project – Igliniit – working initially with the Clyde River Inuit community in the Canadian Arctic. It involves six hunters – two using dog teams and four on snowmobiles – charting features of the ice as well as the wildlife. They use bespoke GPS units to mark the position of cracks, weak ice, open water, seals and bears. Weather data is also entered so that complex maps of the changing environment can be created by Dr Gearheard and her team. Such detail at ground level can then be added to the picture of change that is also emerging from satellite imagery. In essence, the Inuit are seeing with their eyes what scientists have been seeing from space.

THE GREAT MELT

For more than 30 years, scientists from Colorado's National Snow and Ice Data Center (NSIDC) have been collecting satellite data about the extent of the Arctic-summer sea ice. This shows a decline from more than 7 million square kilometres (2.7 million square miles) to 4.3 million square kilometres (1.7 million square miles) in 2007. What's more, since 1979,

Above

Marking the positions of newly formed ice leads using a specialized GPS unit. This Inuit hunter working on Baffin Island in the Canadian Arctic is part of the Igliniit project, which combines traditional knowledge with science to produce a more accurate picture of change in the Arctic.

Opposite

Ice-research camp. Dr Alun Hubbard and his team of 15 from Aberystwyth and Swansea universities (UK) are camped on the Greenland Ice Sheet, where they are taking a range of readings to monitor the rapid changes in the ice mass.

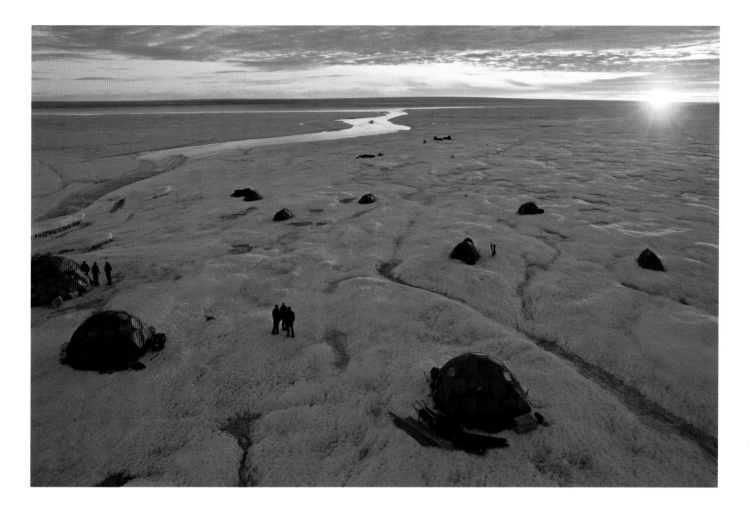

the three records of ice cover less than 5 million square kilometres (1.93 million square miles) come from 2007, 2008, 2010 and 2011. The area of ice cover is clearly changing, but evidence that it is also thinning has come from an unexpected source.

From the 1960s and throughout the Cold War, British, US and Russian submarines patrolled the Arctic Ocean – an area of military significance, being the shortest route between North America and Russia. Both the US Navy and the British Navy kept records of the thickness of the ice – critical when looking for a place to surface. Forty years' worth of these records have revealed the Arctic sea ice to be 40 per cent thinner than it was in the 1980s – down to 2 metres (6.6 feet) thick.

SLOWDOWN AT THE ICE FACTORY

Another crucial factor is the age of the ice, which varies in different parts of the Arctic. Each year, sea ice forms along the Siberian and Alaskan coasts in what is called the 'sea ice factory'. It starts out as thin ice floes, which are slowly blown across the Arctic Ocean

by strong winds. The ice takes years to reach Greenland and Canada, steadily thickening each winter. While the new ice along the Siberian coast is thin and responds quickly to the annual melt, the older ice along the coasts of northern Greenland and the Canadian archipelago is thicker and more resistant to change.

In 2007, NASA scientists combined data from satellites with data from ice buoys to generate a computer-based map of ice age across the whole Arctic. The revelation was that the percentage of ice more than seven years old had shrunk from 21 per cent to

Chapter six

A visualization of the Arctic sea ice in September 2007. By the end of summer the sea ice had shrunk to just 4.3 million square kilometres (1.6 million square miles) – the lowest since satellite sea-ice records began. The extent of the summer ice has remained close to this low level, opening up new areas of the Arctic to exploration.

5 per cent in just 20 years. So it's official: Arctic sea ice is becoming thinner and younger, which is why it's so vulnerable to the summer melt.

In recent years, the ice over much of the ocean has been so thin that it's been at risk of melting entirely by the end of summer. If current trends continue during the next few decades, there will be open water at the North Pole at summer's end. In 2010, Mark Serreze, director of the National Snow and Ice Data Center, made a statement that puts this in context: 'Arctic summer sea-ice cover is in a death spiral. It's not going to recover.'

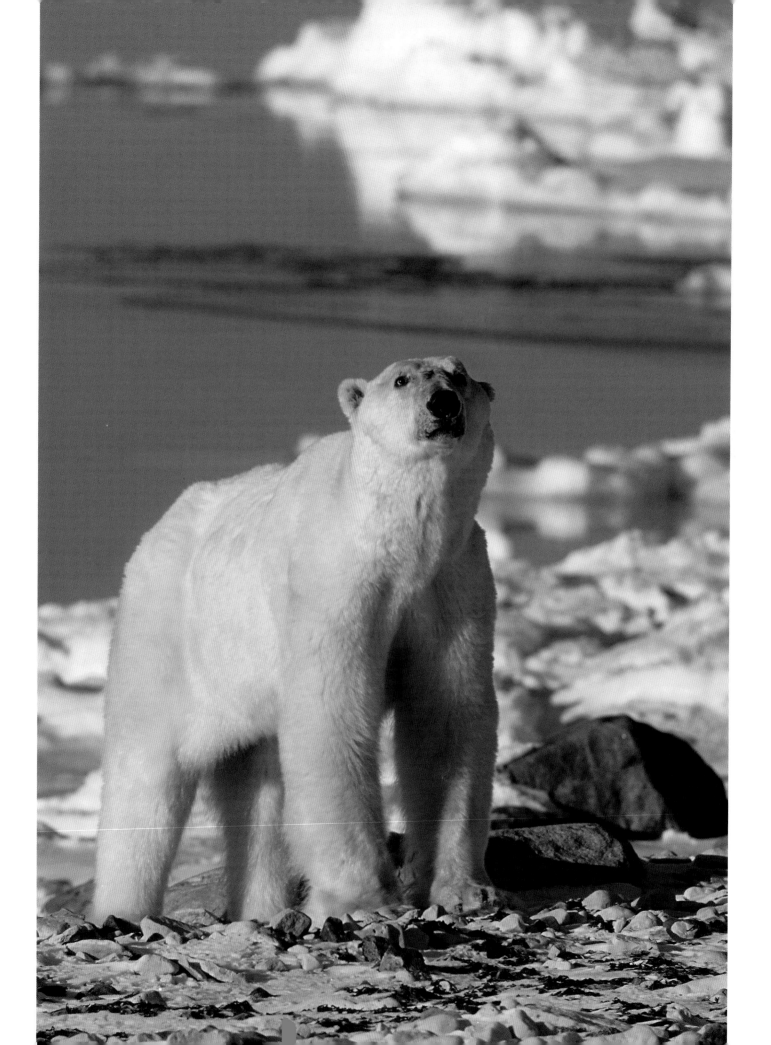

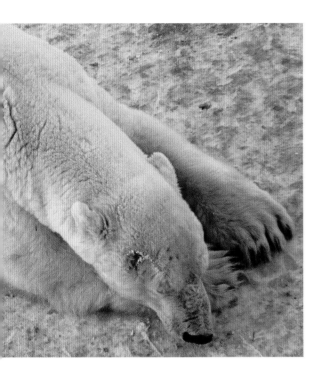

THE ALBEDO EFFECT

The loss of sea ice isn't just an issue for the Arctic; it's a global issue. A frozen ocean acts as a giant reflector, bouncing 85 per cent of the sun's heat back into space – the albedo effect. This keeps the polar regions cool and moderates the Earth's climate. Seawater is dark, and so rather than reflect the sun's energy, it absorbs 93 per cent of it. The more ice that melts in the Arctic summer, the more heat is absorbed by the ocean. That heat is spread around the world by ocean currents, leading to an overall rise in ocean temperatures. The melting of sea ice also disrupts the current system known as the 'global conveyor belt'. Warm water from the equator moves north to the Arctic, where it is cooled. Cold water is denser than warm water, sinks and then is returned to the equator to be warmed again, completing the conveyor cycle. When sea ice melts, it forms a layer of fresh water that is less dense than seawater and floats, disrupting the conveyor belt and therefore the world's climate, which is partly controlled by ocean currents.

THE AILING ICE BEAR

It's not just humans who are struggling to cope with the melting sea ice. Polar bears depend on it as the platform for travelling and hunting for seals. They favour coastal sea ice, which climate models predict is most at risk. The implications are serious. The global polar bear population was last estimated at fewer than 25,000 individuals, and in 2007, the US Geological Survey warned that the population would drop by two thirds as early as 2050. It predicts that the polar bears' last refuge will be the High Arctic regions of Canada and western Greenland, but that by 2080, they will have gone from there, too, leaving dwindling numbers in the interior of the Arctic archipelago. Other factors such as hunting and poisoning from toxic chemicals accumulating in the seals they eat are accelerating their demise. Put simply, most polar bear populations are in dramatic decline.

In Svalbard, a Norwegian team has been giving their bears an annual health check for more than 20 years, over which time, they've noticed a steady deterioration in the condition of the female bears. This has serious implications, as underweight females give birth to underweight cubs, which are less likely to make it through their first year.

Morning light on the edge of the Austfonna ice cap over the island of Nordaustlandet in Svalbard. With a surface area of 8120 square kilometres (3135 square miles), this is one of the largest Arctic ice caps outside Greenland. But while the ice in its interior remains thick, its edges are thinning and retreating.

Bear families are forced to make longer swims each year to reach areas where there is still some ice. In 2011, a radio-collared female bear swam continuously for nine days, covering 687km (427 miles) before finally reaching an icy platform where she could rest and hunt. This epic journey came at a high cost – she lost her yearling cub along the way. Smaller cubs can't swim very far, and so some mothers keep them on land. Unfortunately, their chances of finding quality food on land are slim. Scientists think that the resulting higher mortality of cubs may be the principal reason that polar bears are in decline.

THE SHIFTING ICE EDGE

Historically, the melting edges of the frozen ocean have always been a major draw for wildlife. Birds and whales migrate thousands of miles from all over the globe to feed on the explosion of life that occurs at the edge every spring. Humans come, too. Arctic fisheries, including those in the Barents Sea and the Bering Sea, are among the most productive in the world, accounting for 10 per cent of the world catch. Alaskan fisheries alone provide more than half of the fish caught in US waters. The leftovers from the spring algae bloom rain down on the seafloor, supporting a whole community of bottom-dwellers. These clams, crustaceans and marine worms provide food for divers such as bearded and ringed seals, walruses, eider ducks and even grey whales, which every year travel more than 10,000km (6200 miles) from the Mexican coast to feed on them.

But all this is changing, and fast. As the overall sea-ice cover shrinks, the ice edge is shifting north, so areas such as the Bering Sea are now farther south of the melting edge than they were and are generally less productive. Native fish and seals are getting harder to find – a problem both for commercial fisheries and for the local Inuit, who depend on them. Many animals are forced to range farther north following the ice. Grey whales are starting to overlap with belugas, narwhals and bowheads in northern waters and will end up competing for food. Killer whales are invading the north. Their tall dorsal fins make it difficult for them to travel among the ice, and so they used to be rare in the Arctic. With less ice they are able to move in and exploit the rich Arctic waters. In recent years, there have been reports of increased attacks by killer whales on narwhals.

THE OIL RUSH

There is a wealth of resources in the far north – a quarter of the world's remaining oil and gas reserves are thought to lie under the Arctic Ocean, enough to sustain global demand for oil and gas for three and fourteen years respectively.

In the past, prospecting was limited by the extreme weather and remoteness of the locations, but as the ice has retreated, an Arctic oil rush has begun. Whether it is desirable is another matter: an oil spill like that of the 2010 Deepwater Horizon spill in the Gulf of Mexico would be almost impossible to clean up in the icy water. But with increasing political problems in the Middle East, Arctic oil and gas are being regarded as a credible alternative.

The retreating ice is also opening up shipping routes. A shortcut between Europe and Asia, the legendary Northwest Passage Arctic route was sought for centuries by explorers such as Sir John Franklin, who found only ice-blocked passages. The first successful transit, by Roald Amundsen in 1904, was via the southernmost route. The journey took more than two years and was not repeated until 1944. In August 2010, for the third year out of four and for the fourth time in recorded history, this passage was completely free of ice for several weeks. The potential benefits for shipping could be enormous, shortening the journey between the Atlantic and the Pacific by up to 4000km (2500 miles).

As thinning sea ice provides openings for development, the Arctic Five – the nations that control coastlines in the Arctic: Canada, Russia, the US, Norway and Denmark (through its sovereignty over Greenland) – are keen to stake their claims and extend their control to large areas of the continental shelf off their coastlines. The planting of the Russian flag on the seafloor at the North Pole and Canada's decision to open new Arctic bases in 2007 herald a new era in the commercial and strategic importance of the far north.

ICE CAP ON A BANANA SKIN

Ice is also melting on the land. If you want to witness this first hand, go to Greenland. It's covered with a giant sheet of ice that accounts for the majority of the Arctic's terrestrial ice. Standing with glaciologist Dr Alun Hubbard and his team, as they struggle to lower

Above

Sea-ice highway. Trucks making use of the frozen Beaufort Sea in the Yukon, Canada, to supply an oil camp. Locked under the sea itself lie more oil and gas reserves that will become accessible when the ice cover eventually melts.

Opposite

An oil-drilling platform in the Beaufort Sea off the Alaskan coast, where a gradually greater area is becoming ice-free in summer. Shell forecasts that within 20 years Arctic oil production could constitute a quarter of the world's production, as long as the technical, political and environmental challenges can be met.

Overleaf

A rest break for huskies pulling one of the six two-man teams that maintain Denmark's claim to northeast Greenland. These Sirius Patrol teams from the Danish Special Forces cover an uninhabited area larger than France and Great Britain combined – a potential gold mine of precious metals and oil.

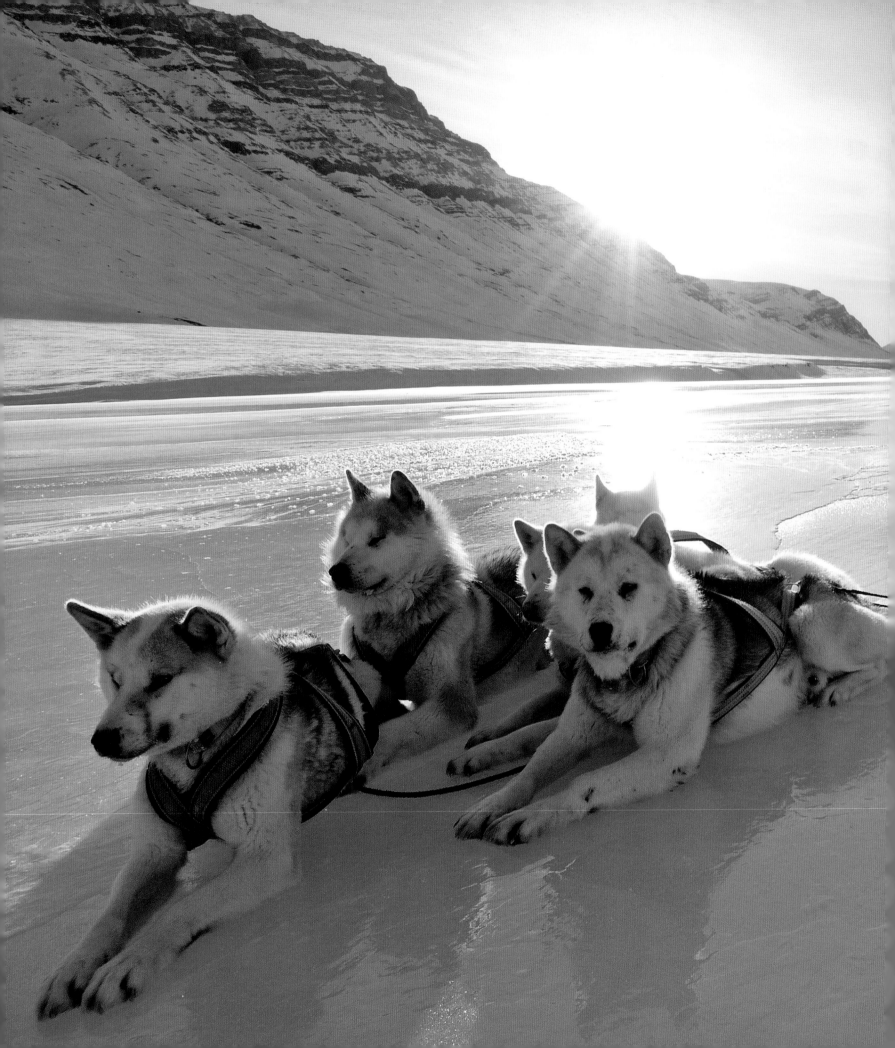

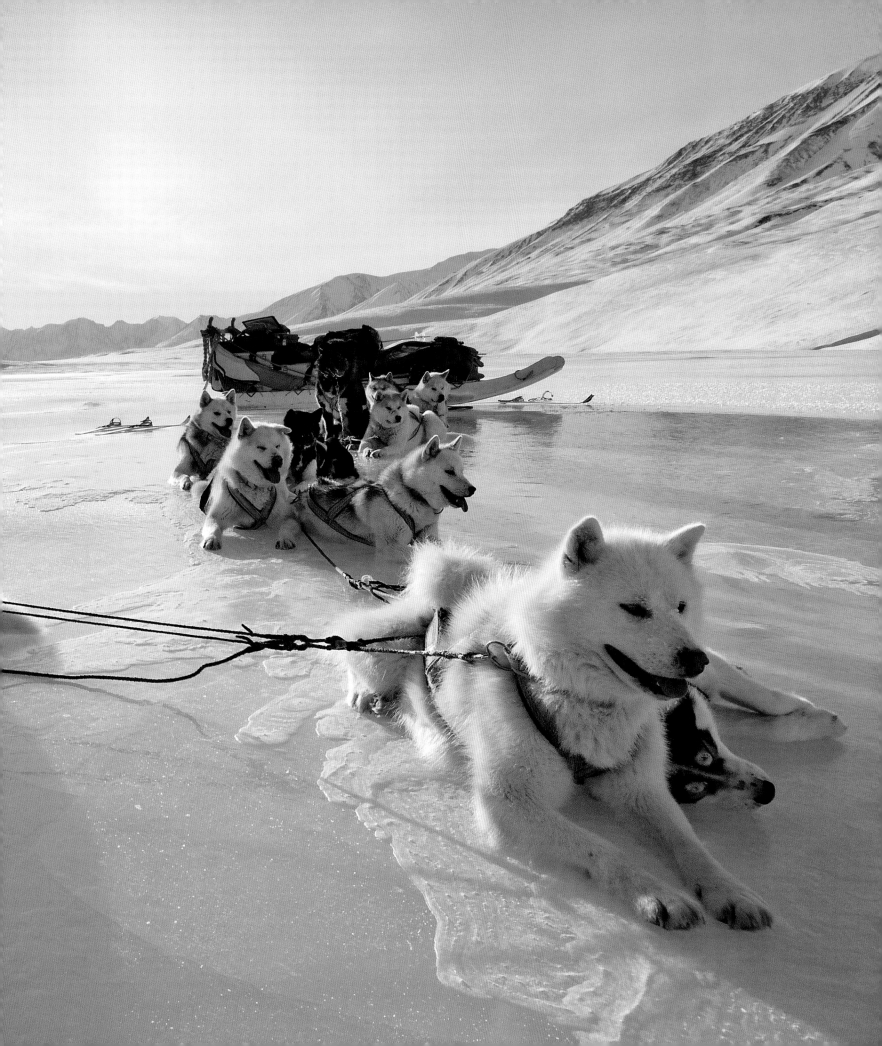

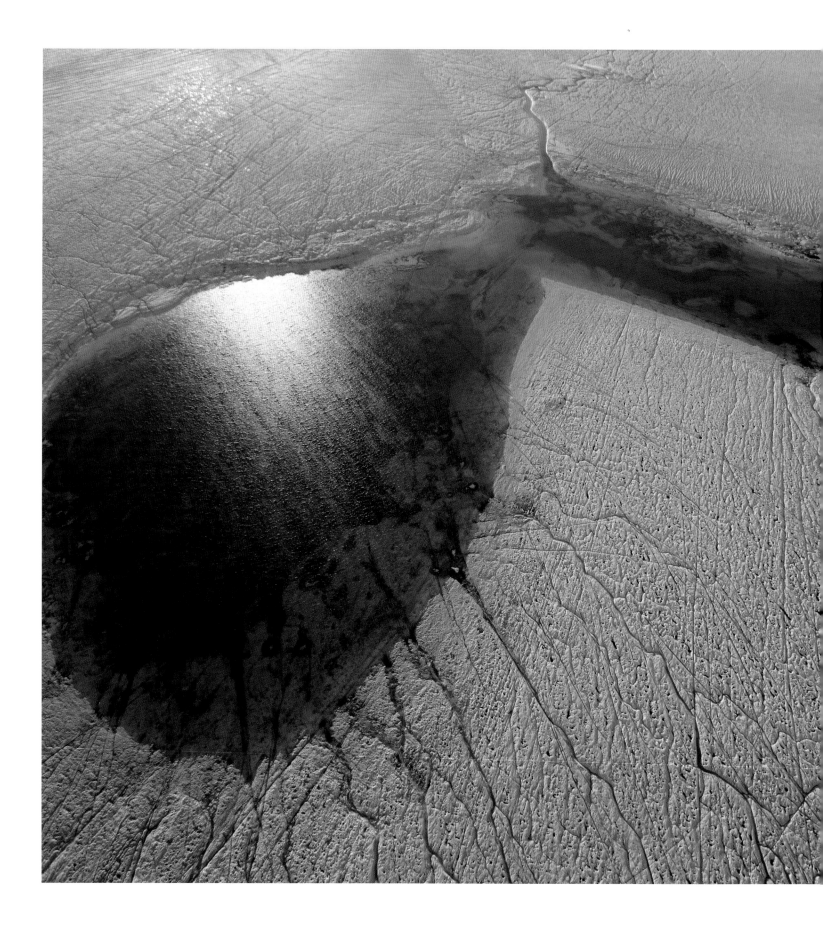

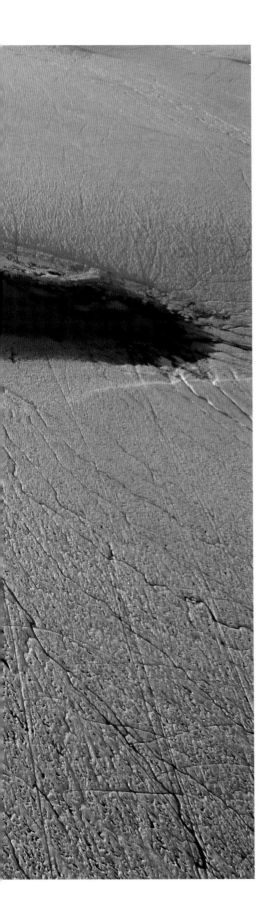

A melt lake on the Equip Sermia Glacier near Disko Bay in southwest Greenland. It measures 300 metres (985 feet) across and is draining out through a ravine at the top. These lakes can be up to 8km (5 miles) wide and are forming higher up and farther north on the ice sheet as the air above Greenland continues to warm.

a camera into a Niagara-style waterfall plummeting into the Greenland Ice Sheet, it's clear that science here can be dynamic and risky. The team utilizes every moment of the near-24-hour daylight to monitor change happening all around them. In a matter of weeks, giant meltwater lakes form on the ice cap, some up to 8km (5 miles) across, which then vanish overnight as millions of tonnes of water drain into the ice sheet below. One of the scientists was working close to a lake when it drained. He described the sound as being 'like an atomic bomb'.

The change being studied is the result of a dramatic rise in temperature over Greenland: 5°C (41°F) in the past 30 years. Quite simply, the warmer air is rapidly melting the ice sheet. In 2010, Dr Hubbard and his team found that new northern and upper parts of the ice sheet were melting, generating at least double the amount of meltwater compared to the year before. This extra meltwater eventually drains to the bedrock and acts as a lubricant for the ice cap above.

'It's much like the ice is suddenly aquaplaning or slipping on a banana skin,' says Dr Hubbard.

In the past decade, the flow rate of many of Greenland's glaciers has doubled or even tripled – Kangerdlugssuaq Glacier in east Greenland reached speeds of up to 14km (8 miles) per year. To put this in context, in a year, most glaciers move anywhere from a few centimetres to, at most, a few hundred metres.

SHRINKING GLACIERS, RISING SEAS

Scientists now believe there is another factor undermining Greenland's ice. Seawater that originated far to the south, in warmer parts of the Atlantic Ocean, is flushing into Greenland's fjords at a brisk pace. This starts to melt the floating ice tongues where the glaciers meet the sea, loosening their connection to the land. These floating ice tongues act like plugs to the land ice behind, and once they've gone, the ice can flow more easily into the sea.

This is of major concern, following the spectacular calving of the Petermann Glacier in August 2010, which produced the largest iceberg seen in the Arctic since 1962.

This giant piece of ice – 251 square kilometres (97 square miles) – is four times the size of Manhattan Island in the US. There are fears that the vast expanse of open water left in its place could help melt the remaining ice tongues, setting off a chain of major calving events.

All across the Arctic, glaciers and ice fields are melting. Alaska's glaciers have experienced some of the most dramatic change: an aerial survey of 2000 glaciers showed that 98 per cent of low-altitude ones are thinning or in retreat. In the past 25 years, the Columbia Glacier has retreated 15km (9.3 miles).

The melting of this land ice is important not only to the Arctic but also to the rest of the world. When ice and meltwater are transferred from land to sea, they raise the sea level. Scientists such as Dr Alun Hubbard predict that Greenland alone could contribute up to half a metre (1.6 feet) to sea-level rise by the end of the century.

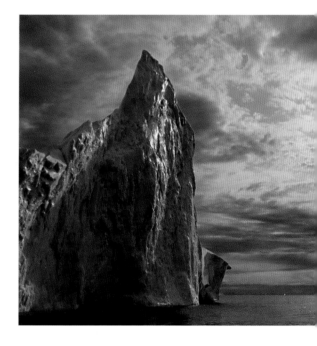

THE GREENING OF GREENLAND

In 2007, Greenland's four oldest trees (named Rosenvinge's trees after the Dutch botanist who planted them in a mad experiment in 1893) began to grow again. These pines are part of a small, cultivated forest that is one of only nine forests in the whole of Greenland. In the past, most of anything else that was green was imported from Denmark. But now that the climate is warming, supermarkets are stocking Greenland-grown cauliflower, broccoli and cabbage. Potatoes are also grown commercially, and there are reports of successful strawberry crops in gardens. Hans Gronborg, a Danish horticulturalist who is cultivating grasses, strains of potatoes and, for the first time, annual flowers such as chrysanthemums, violas and petunias in a small agricultural research station, tells how locals still come to stare at his plants as they would exotic animals in a zoo.

For the people of southern Greenland, climate change is a good thing. With winter arriving later and departing earlier, there is more time to leave sheep in the mountains, grow crops and travel by boat. Ewes are having more and fatter lambs. The growing season has extended by three weeks, and cod, which prefer warmer waters, have started appearing off the coast again.

Above
A giant iceberg from the Jakobshavn Isbrae Glacier in Greenland, which puts more ice into the oceans than any other glacier in the northern hemisphere. The icebergs it calves float through Disko Bay and then gradually melt into the North Atlantic.

Opposite
A network of meltwater channels on the surface of the Greenland Ice Sheet in summer. This water plunges to the base of the ice through vertical shafts known as moulins, where it acts as a lubricant for the ice above before it finally drains into the ocean. Dr Alun Hubbard's team recently demonstrated that the quantity of meltwater coming off the Greenland Ice Sheet doubled between the summers of 2009 and 2010.

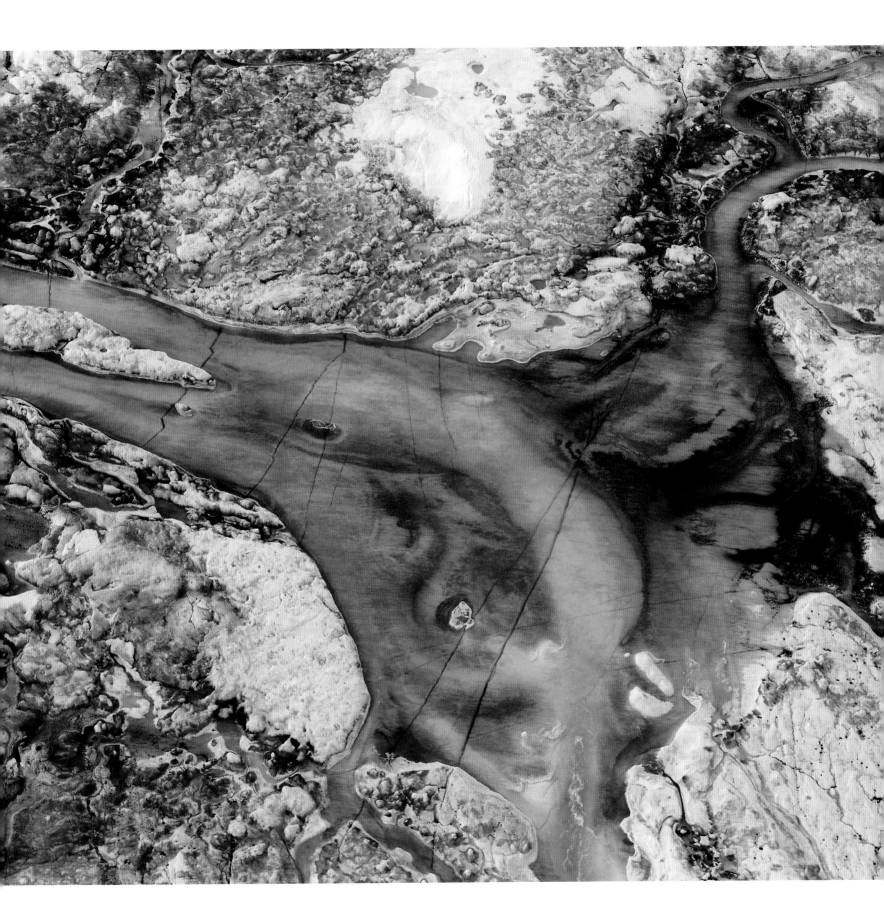

THE DRUNKEN FOREST SYNDROME

The same view is not shared by the 600 Inupiaq Eskimo who are on the verge of abandoning their tiny island of Shishmaref in the north of Alaska, after the houses that had sheltered generations of their people began to buckle and slide into the sea.

Shishmaref is an extreme example, but the phenomenon that caused it is becoming widespread. The frozen soil, or permafrost, that underlies 25 per cent of land in the northern hemisphere is thawing, causing soil to become looser and to crumble away. Slopes that were frozen become prone to landslides and rockfalls. Trees that were anchored by the ice become destabilized and tilt at precarious angles, resulting in so-called drunken forests. Forests that grow on extensive ground-ice die and turn into bogs and wetlands, and this harms caribou (reindeer) and other wildlife that depend on the forest habitat. For humans, the thawing of the permafrost spells disaster: homes, industrial and sanitation facilities, pipelines, power lines, roads, railways and airport landing strips are all undermined.

Above

Buildings in the Alaskan town of Shishmaref collapsing into the sea. Here the coast is eroding at more than 20 metres (60 feet) a year, caused by a combination of melting permafrost and sea-ice retreat that exposes the destabilized soils to increased ocean-wave activity. It's considered one of the most dramatic examples of the impact of climate change.

GAS HEATING

There are also global consequences. When the permafrost begins to thaw, bacteria are able to access carbon from dead organic matter that was previously deep-frozen and can start to break it down. If this happens in air, it produces carbon dioxide, but if it takes place in swamps or bogs, it produces methane – an even more powerful greenhouse gas. And this is now happening on an unprecedented scale. In Siberia, a million square kilometres (386,100 square miles) of land that was previously frozen peat bog is now filled with lakes and melt pools, from which methane bubbles continuously.

Permafrost is also found under the Arctic Ocean, and this, too, is melting rapidly. In 2008, Dr Natalia Shakhova of the International Arctic Research Centre concluded that the amount of methane beneath the submarine permafrost with the potential to be released would increase the methane content of the planet's atmosphere by a factor of 12. The scale of this potential time-bomb is hard to comprehend.

BACK TO SHACKLETON

Antarctica has ten times more freshwater ice than the Arctic. This frozen continent is so remote and inhospitable that it has never had an indigenous population. No human had even seen it until 1820. Today, a number of governments support permanent science bases on the mainland and nearby islands, but even in summer, the number of people on the mainland rarely exceeds 5000. Yet this doesn't mean that humans don't influence the continent: even in this remote wilderness, rising temperatures are having a major impact.

One of the most famous Antarctic expeditions unwittingly began the study of ice. In 1916, Ernest Shackleton set off with two companions in a tiny boat to summon help after their expedition ship was crushed by the ice and sank. They navigated through rough and stormy seas before reaching the sub-Antarctic island of South Georgia. Starving and in rags, the three men were forced to traverse the island's ice sheet before reaching the safety of Grytviken, a whaling station on the opposite coast.

Every few years the Royal Marines try to recreate Shackleton's journey, but they cannot truly emulate this epic feat of endurance, because the ice has melted. We know

Above

Researcher Katey Walter igniting methane released from a frozen Arctic lake. Bacterial decomposition of organic matter from the melting permafrost continues even when the overlying lake is frozen over. The resulting methane – a powerful greenhouse gas – collects below the ice ceiling.

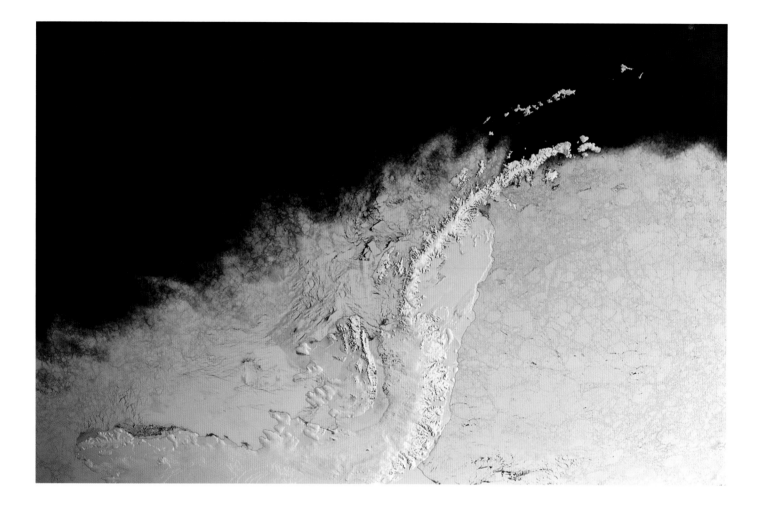

this because Shackleton's photographer, Frank Hurley, documented a number of South Georgia's glaciers. Nearly a century later, a crew from the *Frozen Planet* production went back to the same glaciers and found that many of them had retreated significantly.

Farther to the south, the change is even more dramatic. In 2010, the US Geological Survey announced that every single ice front on the southern part of the Antarctic Peninsula is in retreat, with the most dramatic change occurring since 1990. This is a result of intense atmospheric warming: 2.8°C (37°F) within the past 50 years, making the Antarctic Peninsula the most rapidly warming region in the southern hemisphere.

SHIFTING PENGUINS

The Adélie nests farther south than any other penguin, and like the polar bear in the Arctic, it spends most of its life out at sea. It only comes to land for a few months in spring to breed. Adélies are still the most common penguin on the Antarctic Peninsula, their colonies taking up every available inch of bare rock. Today, though, many of these

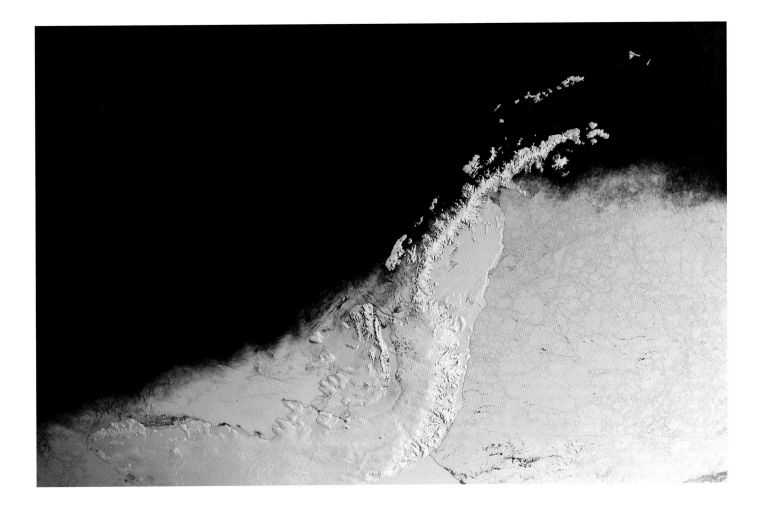

colonies lie deserted. It's likely that warmer temperatures around the peninsula have reduced the amount of the ice-loving krill that the Adélies rely on for food. An increase in the frequency of spring blizzards may also be contributing to their decline. These storms hit the colony at peak breeding time and create havoc, particularly when the snow melts, floods nests and kills hundreds of eggs and chicks. What no one knows is if the numbers of Adélies on the peninsula are in general decline or simply heading south to colder climes.

But some animals find these new conditions to their liking. The orange beaks of gentoo penguins are becoming a more familiar sight on the peninsula. Gentoos tend to avoid ice, preferring the warmer islands to the north of the Antarctic. The new warmer peninsula suits them perfectly, and their numbers here have increased 23 per cent in just under 30 years. So why are they succeeding here when the Adélies are in decline?

The Adélies rely on ice, whereas gentoos are less specialist and thrive in ice-free water where currents or upwellings prevent ice from forming. The spring blizzards are less likely to affect them: they breed three weeks later than the Adélies, by which time the worst of the storms are over.

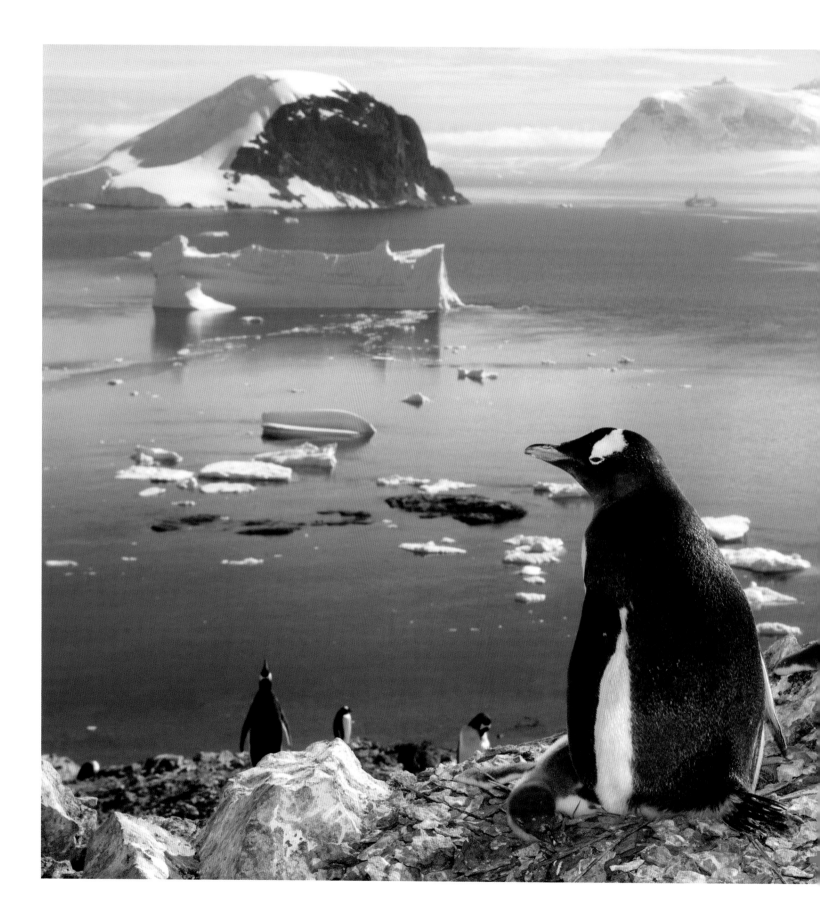

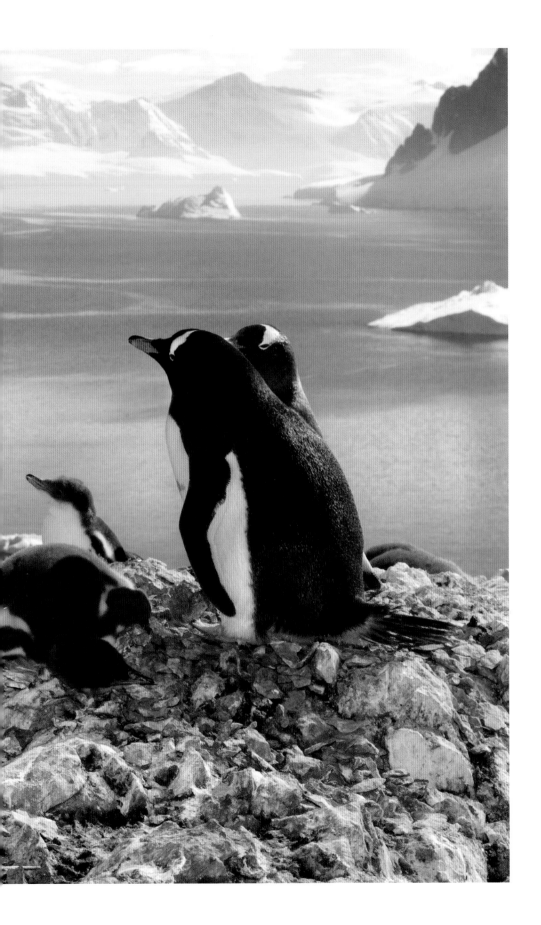

A gentoo penguin colony on
Danco Island, the Antarctic Peninsula.
Historically, gentoos have preferred the
warmer islands to the north,
but in recent decades, they have been
colonizing the newly warmer peninsula
as the retreating glacial ice exposes
more rocky sites.

COLLAPSING ICE SHELVES

The Antarctic Peninsula's long arm reaches farther north than any other part of the continent, and so it's not surprising that this is the first place to experience ice-free conditions as the climate warms. But what of the vast ice mass farther south – the great Antarctic ice sheet. Surely this is immune to melting? After all, the average summer temperature on the ice cap is still -20°C (-4°F), and even the worst predictions don't suggest the temperature could ever rise to zero.

But what scientists, such as Dr Andy Smith of the British Antarctic Survey (BAS), are concerned about is rising sea temperature. His work is focused on the places where the ice sheet extends into the sea in giant masses of freshwater ice called ice shelves. He uses explosives to send shockwaves to the bottom of the ice, recording the echoes that bounce back. From this data, Dr Smith is able to generate a map of the underside of the ice shelves to see how much rising sea temperatures are melting the ice from below.

Melting from below is now thought to be the main cause of some of the most dramatic changes that ice has undergone in recorded history – the collapse of entire ice shelves.

In 2002, the Larsen B Ice Shelf in the north of the peninsula collapsed when 3250 square kilometres (1255 square miles) of ice broke off the ice sheet. The ice had been thinned to breaking point by warm seawater below, combined with melting of the surface by warm air, creating melt ponds that penetrated crevasses and helped to wedge the ice shelf apart. Within just 35 days, 40 per cent of the ice shelf disintegrated into thousands of icebergs. This was the largest ice collapse recorded in the past 30 years of monitoring.

THE DOMINO EFFECT

The fresh water contained within the Larsen B Ice Shelf may have been considerable, but this is not the problem. It's what happened in the aftermath that's important – and of considerable concern. The Larsen B Ice Shelf had been acting as a dam, holding back the glaciers that fed into it. Without the ice shelf to check their flow, these glaciers began pouring into the ocean at rates up to eight times faster than previously recorded.

Above and Opposite
Satellite time-study images of the break-up of the Larsen B Ice Shelf on the east of the Antarctic Peninsula. They were taken at intervals over a 35-day period that began on 31 January 2002 and resulted in an area of ice the size of the state of Rhode Island disintegrating.
1 and 2 Unusual melt ponds can be seen (top) on the surface, caused by intense atmospheric warming. Collapses are also spilling ice into the ocean.
3 Here the majority of the collapse has happened, resulting in enormous icebergs. 4 This is the region after much of the broken ice has melted or dispersed. Land-based glaciers that fed ice into the shelf were now no longer dammed and reached speeds eight times faster than before.

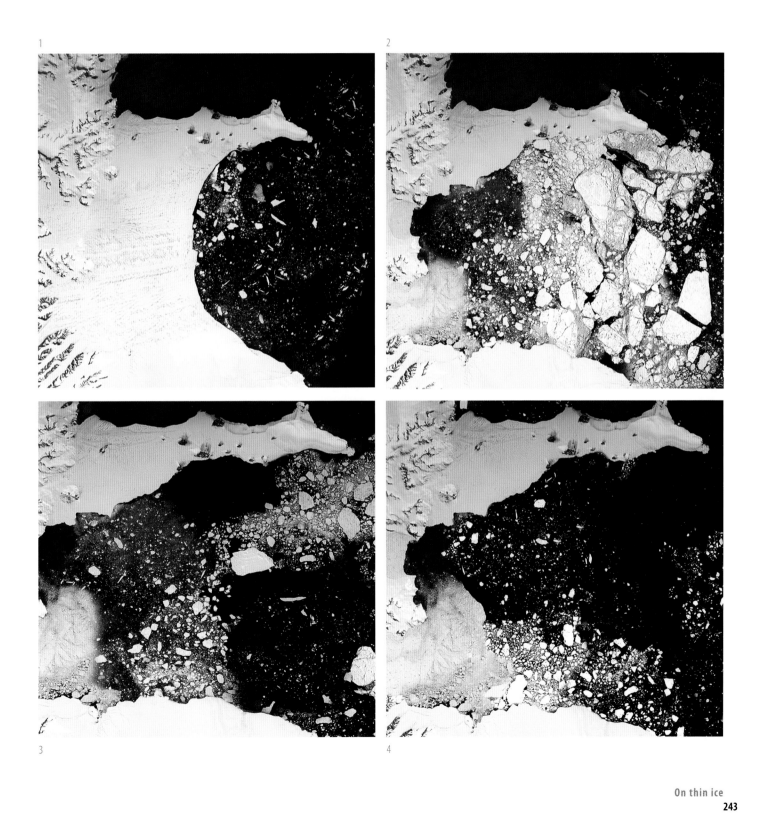

It is the ice that slides from the land when ice shelves collapse that has the potential to raise sea levels around the globe.

In 2008, data from satellites showed that an even larger ice shelf, the Wilkins, at the southern end of the Antarctic Peninsula, was also beginning to collapse. A year later, a chunk of ice the size of New York City had detached and shattered into a mass of icebergs. In 2010, Dr Andy Smith and his team set off with a *Frozen Planet* crew to document the collapse from the ground. After an epic journey from the BAS research station at Rothera, the team arrived to discover that the break-up was even more extensive than they had imagined: giant icebergs, many miles wide, were all that was left of an ice shelf larger than Jamaica (see page 296).

Dr Smith went on to position instruments on one of the newly formed giant icebergs so that he could continue to monitor the break-up remotely. The Wilkins break-up is the latest in a wave of ice-shelf collapses that have been travelling southwards down the peninsula, and Dr Smith's concern is that the next ice shelves likely to break are ones that act as plugs for the massive body of ice on the continent.

ICE, OCEAN AND ATMOSPHERE

Antarctica's ice sheet is divided in two by the Transantarctic Mountains. The West Antarctic Ice Sheet (WAIS) is smaller than the East Antarctic one, but each has the potential to raise sea levels by several metres if the ice shelves surrounding them collapse. Scientists are particularly concerned about the WAIS: it feeds into the continent's two largest ice shelves – the Ross Ice Shelf and the Ronne-Filchner Ice Shelf. The ice that they hold back sits on land that has been pushed 500 metres (1640 feet) below sea level by its own weight. This means it's possible for ocean water to penetrate beneath the ice sheet and speed up its flow. If this ice sheet collapses, large amounts of inland ice and meltwater will slide into the sea, causing a significant rise in sea level. By exactly how much and by when are difficult to estimate, as there is still much to learn about the complex interplay between land ice and the warming of ocean and atmosphere. The real question is whether this is a risk we can afford to ignore.

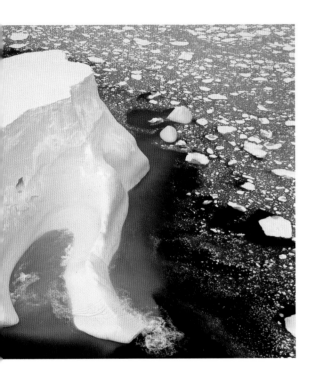

Above
A large iceberg calved off the Ross Ice Shelf, which has produced some of the largest in recorded history. Scientists believe these large bergs are part of the natural cycle of the shelf and, unlike the collapse of the Larsen B Ice Shelf on the other side of the continent, are probably not due to rising ocean temperatures.

Opposite
A British Antarctic Survey plane flying over the remnants of the Wilkins Ice Shelf in 2010. This ice shelf, larger than the Larsen B and roughly the size of Jamaica, is the latest to collapse, in a wave travelling southwards down the peninsula. Next in line are the giant shelves that act as plugs for the massive body of ice on the continent itself.

RISING SEAS

Coastal areas host many of the world's biggest cities – including London, New York and Bangkok – and are home to about 70 per cent of the world's population. Many coastal people are already struggling to cope with rising sea levels, at great financial cost to governments as well as individuals. So there is an enormous incentive to provide a reliable prediction.

In its last big report, in 2007, the Intergovernmental Panel on Climate Change (IPCC) said that sea levels might rise as much as 0.59 metres (1.9 feet) by 2100. But none of the models they used took account of the impact of methane or the release of glaciers following the collapse of ice shelves.

In 2009, the Scientific Committee on Antarctic Research (SCAR), a partnership of 35 of the world's leading climate-research institutions, revised this figure to 1.4 metres (4.6 feet) – more than double that predicted two years before. The developing consensus of climate scientists puts this figure closer to a metre (3 feet), which is still enough to inundate low-lying lands in many countries, rendering large areas uninhabitable.

A rise of a metre would cause coastal flooding of the sort that now happens once or twice a century to occur every few years. Beaches, marshes and barrier islands will be eroded much more quickly, and freshwater supplies will be in danger of being contaminated by salt.

In the United States, parts of the east coast and the Gulf coast would be hit hard. In New York, coastal flooding could become routine. About 15 per cent of the urban land around Miami in Florida could be inundated, and the ocean could encroach more than a mile inland in parts of North Carolina. Defences can, of course, be built to keep out the sea, such as the levees of the New Orleans region, the famed dykes of the Netherlands and the Thames Barrier in London. But the expense is likely to soar as the ocean rises, and anyway, such defences are not foolproof, as Hurricane Katrina proved. Storm surges that batter the world's coastlines every few years would almost certainly force people to flee inland. But it is hard to see where the displaced could go, especially in Asia, where huge cities – even entire countries, in the case of Bangladesh – are at risk.

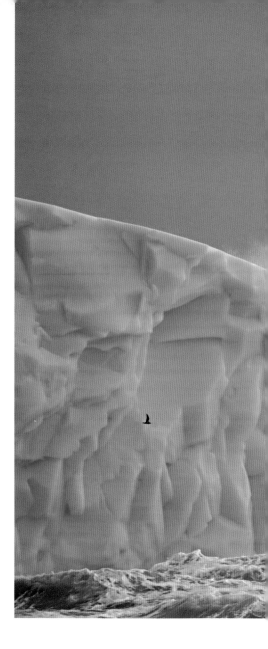

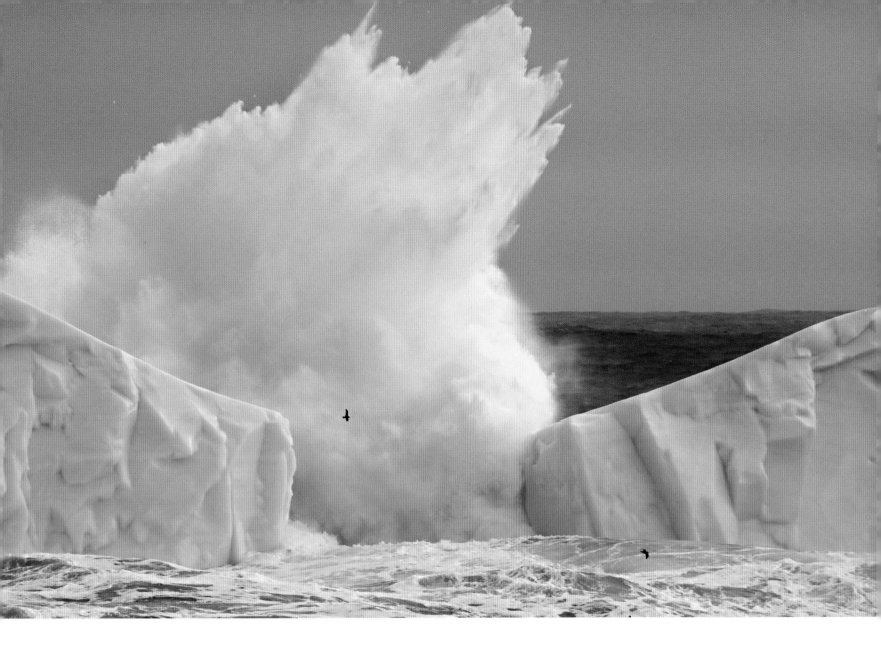

THE ICE PIONEERS

More than a third of the planet is frozen during the course of a year, and no human has ever witnessed it any other way. Our own evolutionary journey started nearly 2 million years ago, at the beginning of the last ice age, and since then, the poles have always been capped by ice. We first colonized the Arctic just 40,000 years ago, using our ingenuity to make up for our lack of fur or feathers. Those early pioneers prospered and spread, discovering that a reasonable living could be made from the frozen north, something their descendants continue to find today.

At the other end of the planet, the first person to set eyes on Antarctica did so less than 200 years ago. The intrepid sailors that braved the Southern Ocean came for the same reason that the first people went to the Arctic – to find new hunting grounds. These whale and seal hunters were content to stay on Antarctica's fringes, harvesting its rich waters, and they never set foot on the continent.

Above

An Antarctic iceberg battered by giant waves in the Southern Ocean. As more land-ice slides from the continent into the sea, the number of icebergs like this will rise. The impact of this will be felt across the globe with rising sea levels.

A century later, all this changed. Teams of men arrived to conquer Antarctica's frigid interior, but they did so not for exploitation but for exploration. Expeditions such as the one led by Captain Scott became a symbol of human endurance and a source of great national pride. Scott and his team died on the ice, but their intention was to reach the South Pole, while taking only photographs and leaving only footprints.

To this day, there has been no human exploitation of Antarctica, and nor will there be. This was ensured by a unique international treaty established in 1959, in which the nations of the world agreed that no country can claim Antarctica or exploit it for minerals or oil. Instead, the continent has been dedicated to science – for the common good of mankind. And today the science being undertaken in the Antarctic is proving more important to our species than the signatories of that treaty could ever have imagined, for we've come to realize that what happens at the poles affects us all.

TURNING OFF THE AIR-CONDITIONING

The polar regions are the Earth's air-conditioning units, helping to keep the planet cool; but a rise in global temperatures, generated far from the poles and warming air and seawater, is disrupting their ability to regulate the climate. The resulting loss of snow and ice cover is reducing the Earth's ability to reflect energy from the sun back into space; frozen soils are thawing and releasing powerful greenhouse gases into the atmosphere; and land-ice is melting on a scale that will raise sea levels across the globe. Not only are the temperatures in large areas of the poles rising fast, but they are also doing so at twice the rate of anywhere else. For this reason, the poles can be considered an early-warning system – a 'canary' for the planet.

In a coal mine, the canary warns the miner of approaching danger. Will the global community heed the polar warning and attempt to slow the changes, and does it matter if we don't? Humans are nothing if not adaptable. Even if the worst climate predictions come true, the likelihood is that our species will survive. But populations will be decimated and huge numbers of people will suffer untold misery. What's certain is that, without the frozen poles, our home will be a very different place.

Opposite
A grounded iceberg frozen into fast ice near the Mawston Station in the Australian Antarctic Territory. Ice can be a major destructive force in the poles, but it can also be essential to life. Icebergs like this provide shelter from the worst of the winter winds for the breeding emperor penguins and their chicks at their Auster rookery.

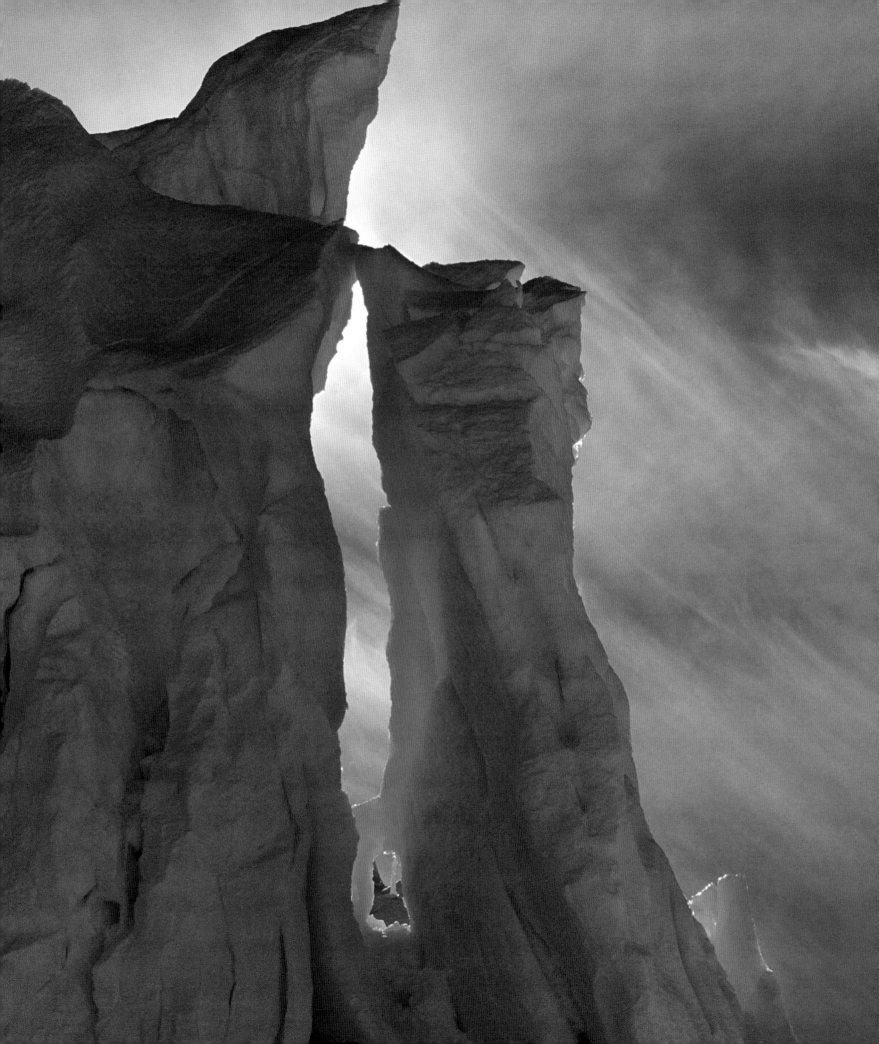

Chapter seven | Tales from the poles

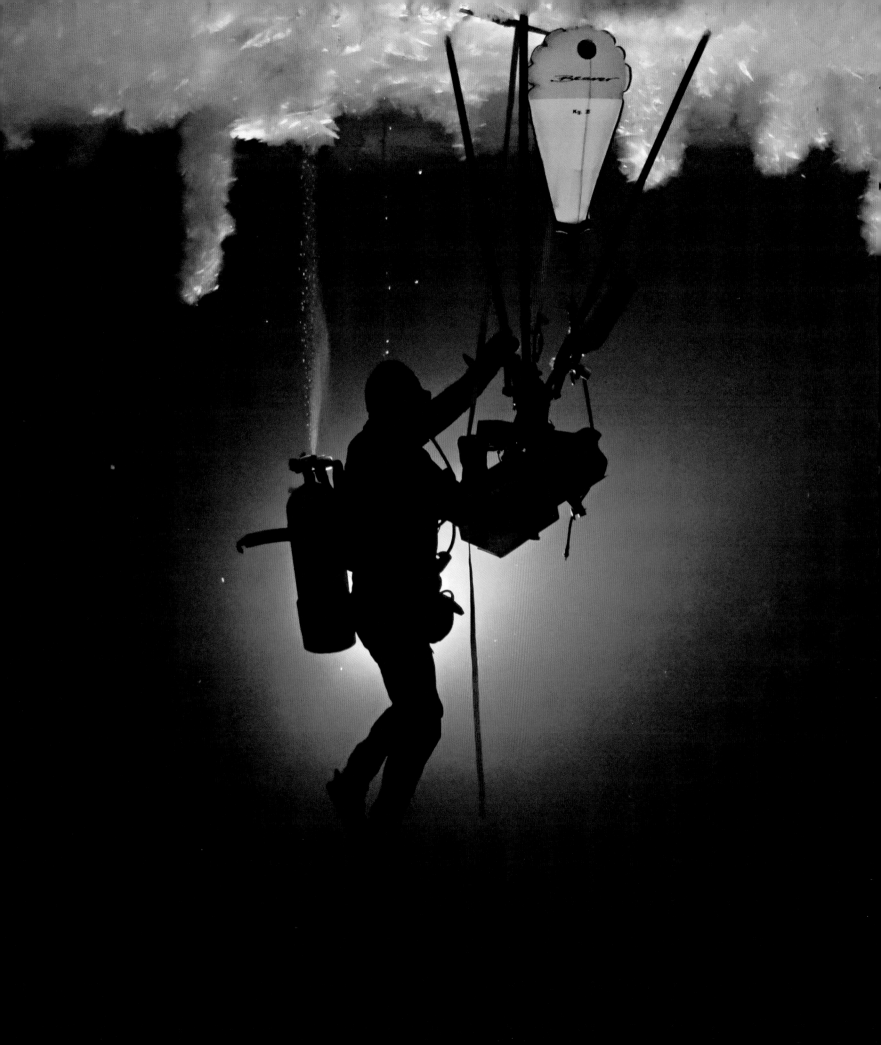

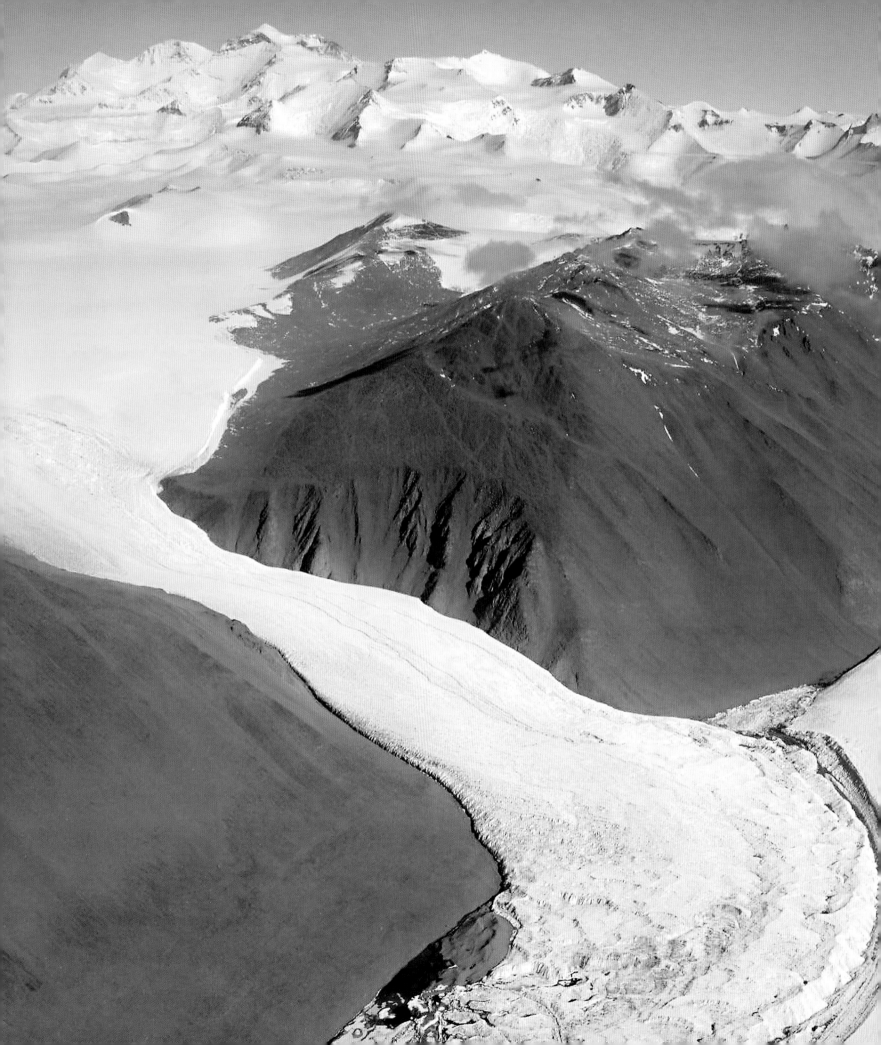

The making of a polar epic

There will never be another series like *Frozen Planet*. The reason is not the scale or the
logistical challenge of such a multimedia expedition, involving some of the world's most
experienced wildlife film-makers, polar scientists and technical experts, but the fact that
the Arctic and Antarctic are melting. The aim of the series was to reveal the marvel
of the poles, the planet's last great wilderness areas, before global warming changes
them for ever, and to do so using feature-film techniques: storytelling, drama and epic
cinematography. It cast principal characters, the polar bear in the north and the Adélie
penguin in the south, with a secondary cast of Arctic wolves and killer whales, together
with the ruler, the Sun, and the ever-present forces of snow and ice.

Conceived by executive producer Alastair Fothergill, *Frozen Planet*. was born out
of the experience gained from making *Life in the Freezer*, *Blue Planet* and *Planet Earth*.
The breakthrough on *Planet Earth* had been the use of high-definition filming, adding
ever more clarity, and the breathtaking aerial imagery obtained using a gyro-stabilized
camera controlled by a joystick that can attach to a helicopter or plane, turn 360
degrees and give a steady image from a great height. When work started on *Frozen
Planet*, technology had given rise to ever more high-powered computers, even better
high-definition and high-speed cameras, together with new time-lapse and motion-
control techniques and therefore even greater possibilities for getting breakthrough
footage. Yet, as with all ambitious projects, it was teamwork, planning and nerve rather
than just technology that brought about success.

The team faced major problems: the extreme cold and unpredictable weather, the
shortness of the polar seasons during which filming could be done, the huge expense
of transporting crews to the poles and keeping them there, and the relatively unknown
nature of the behaviour of many of the animals. But surmounting big problems can
bring big payoffs as well as frustrating failures. And that was how it turned out to be.

THE MEGASHOOT

The team had just four years to make the series, which meant just two chances to film in
the Antarctic. So when the 2009/2010 Antarctic summer melt began, the team moved

south, as did the wildlife. With just a five-month window for filming, a megashoot was the only option, meaning the deployment of seven crews around the continent, whether tracking killer whales at the ice edge, following the penguins on land, diving under the ice or flying into the vast interior.

The only way to travel beyond the Drake Passage was by ship, whether on a Russian ice-breaker, with the Royal Navy or on the *Golden Fleece* – the first yacht to penetrate the far south, skippered by Antarctic veteran Jérôme Poncet. The other imperative was the help of the international science bases, in particular the US McMurdo base and the British Antarctic Survey bases. And when the Antarctic season was over, the teams would, like the Arctic animals, follow the arrival of spring at the North Pole.

Opposite

The *Golden Fleece* at anchor in Charcot Bay, Graham Land, Antarctic Peninsula. This was the yacht that made much of the Antarctic filming possible, whether of killer whales or, as here, penguins.

Below

Wheelhouse view from the *Golden Fleece*. The four-cabin yacht became home to *Frozen Planet* crews for up to nine weeks at a time. A steel hull and experienced skipper Jérôme Poncet made navigation south through the pack ice possible.

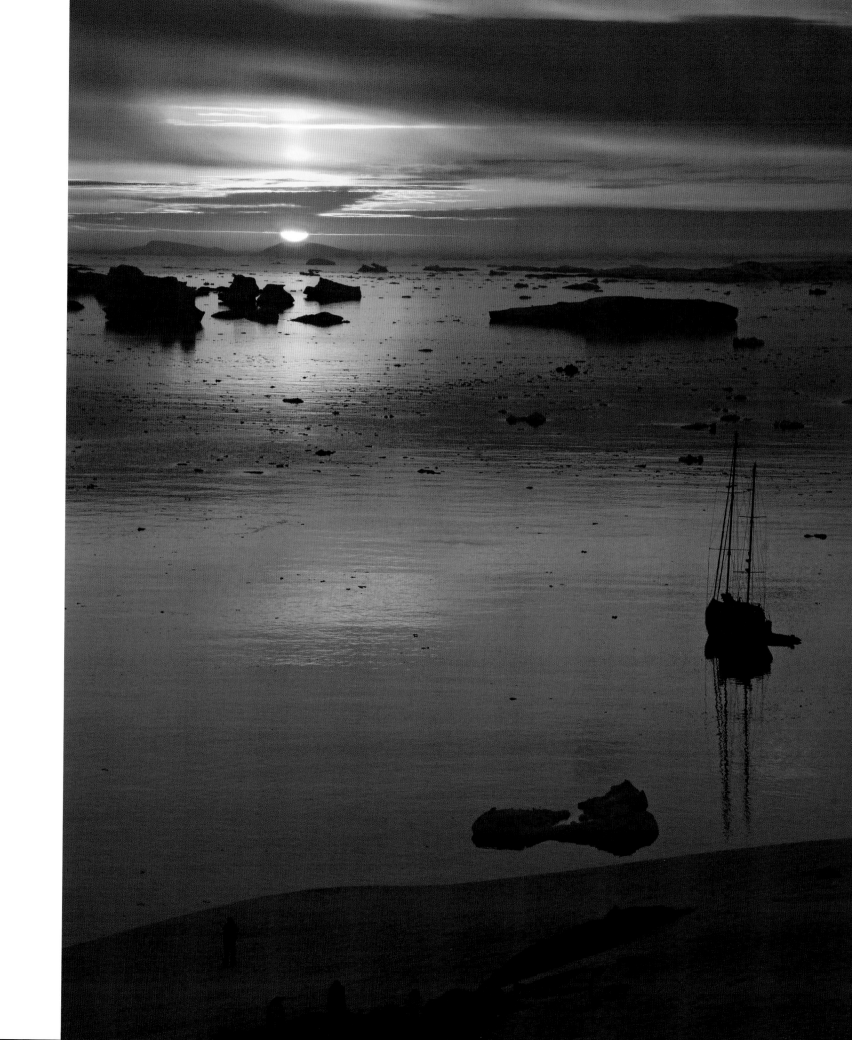

Flying high

'It's been like a difficult marriage,' says series producer Vanessa Berlowitz about her relationship with the Cineflex. 'We've been all over the world together, but the biggest headache was taking it to Antarctica.' Without it, there was no way to shoot aerials that would convey the scale of the frozen continent. But would it work at -35°C (-31°F)?

Key was luring Cineflex cameraman Michael Kelem away from the comforts of Hollywood. But harder was the planning. The US National Science Foundation had given *Frozen Planet* 120 hours flying time from McMurdo, and so it was crucial to work out how long it would take to fly where. 'But there were few pictures of the places, and I had very little concept of the scale,' says Vanessa.

The first flight was over Mt Erebus, Antarctica's live volcano. 'The view of the summit defied all expectations,' says Vanessa. But high winds and a huge plume of volcanic smoke meant it was achieved only after 15 aborted attempts, when pilot Paul Murphy risked just aiming for a hole in the cloud. 'This was dangerous flying. It meant negotiating high winds and dodging the volcanic plume.'

Shooting into the bubbling crater, 'Mike would zoom in, hoping that the helicopter could hold steady, but then Paul would be forced to pull away and circle round again. Coming round for the fourth time, we got it. Below were the scientists waving on the rim, and Mike was able to pull back to show them on the extreme drop doing extreme science.' Suddenly, the helicopter began 'dropping so fast my eardrums felt they were going to burst.' The hole in the clouds was about to close. 'We'd pushed it enough.'

Flying inland to the Dry Valleys involved reading 'maps that hadn't changed for a hundred years, working out how many hours it was from one fuel dump to another,' says Vanessa. 'But only from the air was it possible to grasp the true scale of the interior.'

At the point where you see the ice creeping back into the valleys, where the mountains are no longer able to restrain the ice cap, you realize this truly is geology in action – a constant battle between ice and rock … The valleys were so dry that the pilot had to gain altitude. They looked so incongruous – Grand Canyons dropped into Antarctica, canyons only a handful of people have ever seen … Rounding one valley, we found the Gargoyle Rocks, sculptures eroded by wind over the millennia … I kept thinking how on Earth were we going to distil this specialness into just a few shots.'

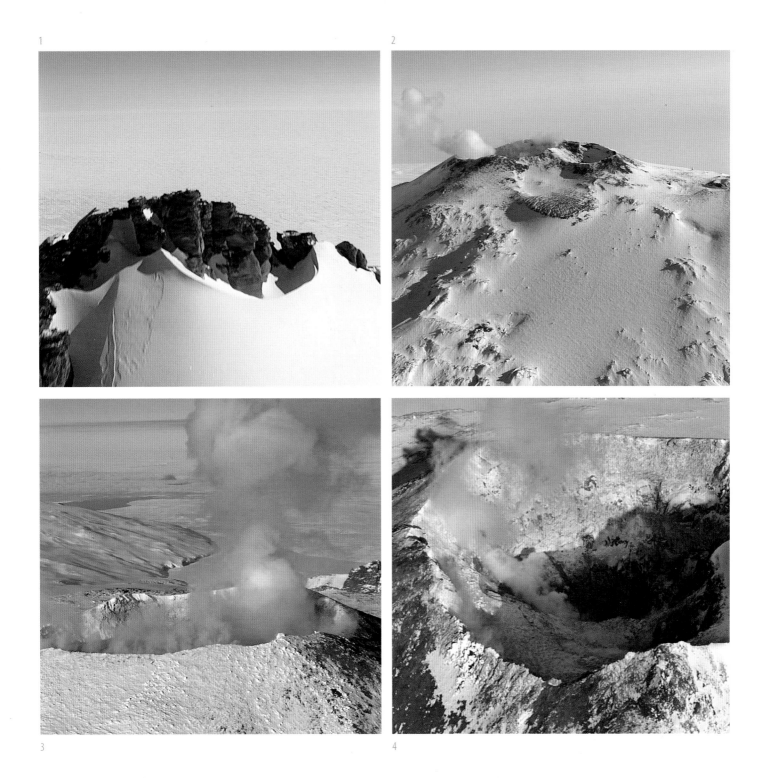

1

2

3

4

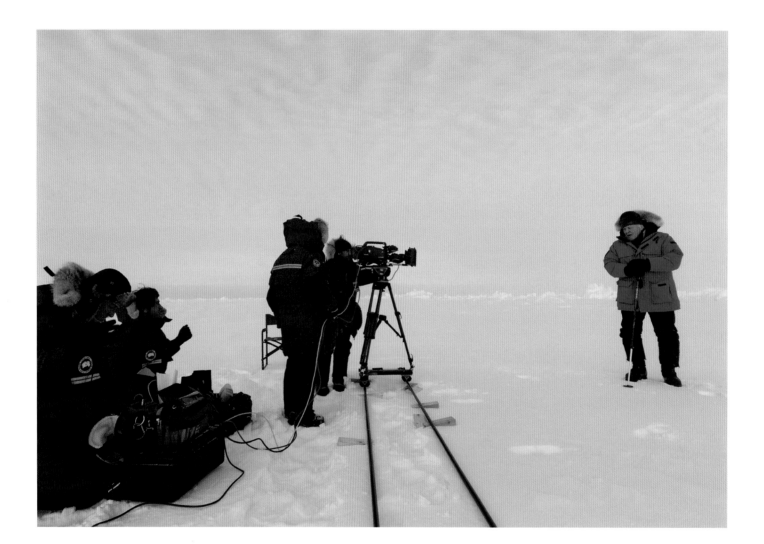

The final challenge was to fly along the coast and then inland to the South Pole to meet up with David Attenborough, following the route of Scott's ill-fated expedition. The only way to travel that distance was in a Twin Otter plane. It meant building a special mount for the Cineflex, rigging it in freezing weather – and then unrigging when the forecast worsened. In fact it was eight weeks before the weather cleared enough for take-off.

'Everything in Antarctica is on a mind-boggling scale,' says Vanessa. 'On the way down the coast, I wanted to film the famous Drygalski Ice Tongue, which flows off the

Above
David on the pole. Getting the film crew, equipment and David Attenborough to the actual North Pole involved a Russian plane, black plastic bags and nerve.

ice cap, but I couldn't see the end of it, even flying at 20,000 feet [6056 metres].' The aerial view of the coast also made it obvious why the Cape Hallett Adélie penguin rookery was where it was: 'It was the only wind-blown spit free of ice along this vast coastline.'

'Suddenly we were in the Transantarctic range – the Himalayas of the Antarctic, bisected by huge glaciers. As we flew up the Beardmore Glacier, like an undulating sea, I kept saying, "Oh my God, it's massive" – and this was just one outlet for the ice cap … On the ground, Scott would have had no idea of the scale of the journey.'

The ice cap itself was 'the most negating landscape I've ever seen – six hours of flying over nothing … until we saw the black speck of the South Pole station on the horizon, where David and the rest of the crew were waiting for us.'

Planes don't have the manoeuvrability needed for aerials. 'Every time we took off, the window and lens would ice up, and I thought we would never get the shot,' says Vanessa. 'We went round and round, ten times, with David waiting below at -35°C [-31°F]. Every time, something would go wrong. Michael's fingers were so cold that he was struggling with the focus. Meanwhile, David's knees were seizing up. But we just *had* to get that pull-away, with David on the ice where Amundsen and Scott had stood.'

Filming David at the North Pole was quite a different undertaking. They went in very early spring, which meant flying with the Russians and camping on the ice – ice that was constantly moving. 'Our landing place was marked with lines of black plastic bags – the Russian way – and once all the gear was unloaded, we watched the plane disappear and the bad weather roll in,' says Vanessa.

For six days they were marooned on the ice until the ancient helicopter hired for filming could take off. Directing the aerials, Vanessa had to shout instructions to the pilot via a translator and share a headphone with cameraman Gavin Thurston. There was also a matter of finding where the actual pole was.

David was finally dropped off to do his piece to camera. 'He delivered straight, still an absolute pro at 84.' Then the helicopter circled to film him as a dot on the sea ice. Fifteen minutes later, the ice had moved, and he was no longer standing at the North Pole. And within hours of leaving their base, great cracks opened up, and the ice floated away.

Under the ice

If the Antarctic could be described as land surrounded by ocean and covered by ice, then the Arctic is for the most part ice-covered ocean encircled by land. 'In fact most of the Arctic stories are filmed on ice and not land,' says director Elizabeth White. 'On a snowmobile, you forget that it's not tundra underneath you but frozen ocean. Under the ice – that's another world.' They managed to access it, cutting dive holes through the ice in spring – 'the surprise was how colourful it was,' says Liz – but working under water is 'a race against time and creeping cold in an alien environment'.

The underwater world of Antarctica's Ross Sea is not only cold but also hugely difficult to access. The only way to film there was with the help of the US scientific base at McMurdo.

Above
Beneath the Arctic ice. Under the ice-covered White Sea, the team filmed a colourful garden of soft corals, sponges and sea anemones.

Opposite
Hanging out the camera, lights and monitor under the Ross Sea ice. Cameraman Doug Anderson is a technical wizard, but practising the art in the near-freezing water of McMurdo Bay was a physical feat.

1–2 The big drill. With equipment from the US McMurdo base, dive holes were drilled through the metre-thick (3-foot) Ross Sea ice. Huts were then placed over the holes. 3 The descent. Cameramen Hugh Miller and Doug Anderson descend under the ice, assisted by producer Kathryn Jeffs. With heated vests, they could stay down up to 60 minutes before they lost sensation in their bodies. 4 Hanging out. Weddell seals used the dive holes in the warm huts as breathing holes. The problem came when the divers wanted to exit up through a hole blocked by a seal. The only thing to do was to behave like another seal wanting to use the hole and exhale a blast of bubbles.

Focusing on the big sponges. Setting up lighting and a shade (on top of the camera) could take Doug Anderson several dives. But luckily nothing moves fast under the ice, and above it was 24-hour summer light. So the challenges were the cold and finishing the shoot within the allotted days.

1

2

3

4

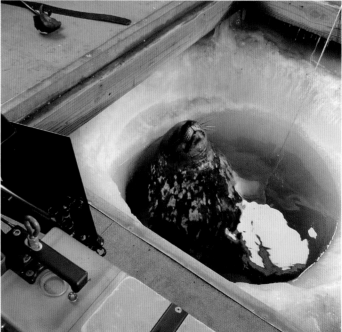

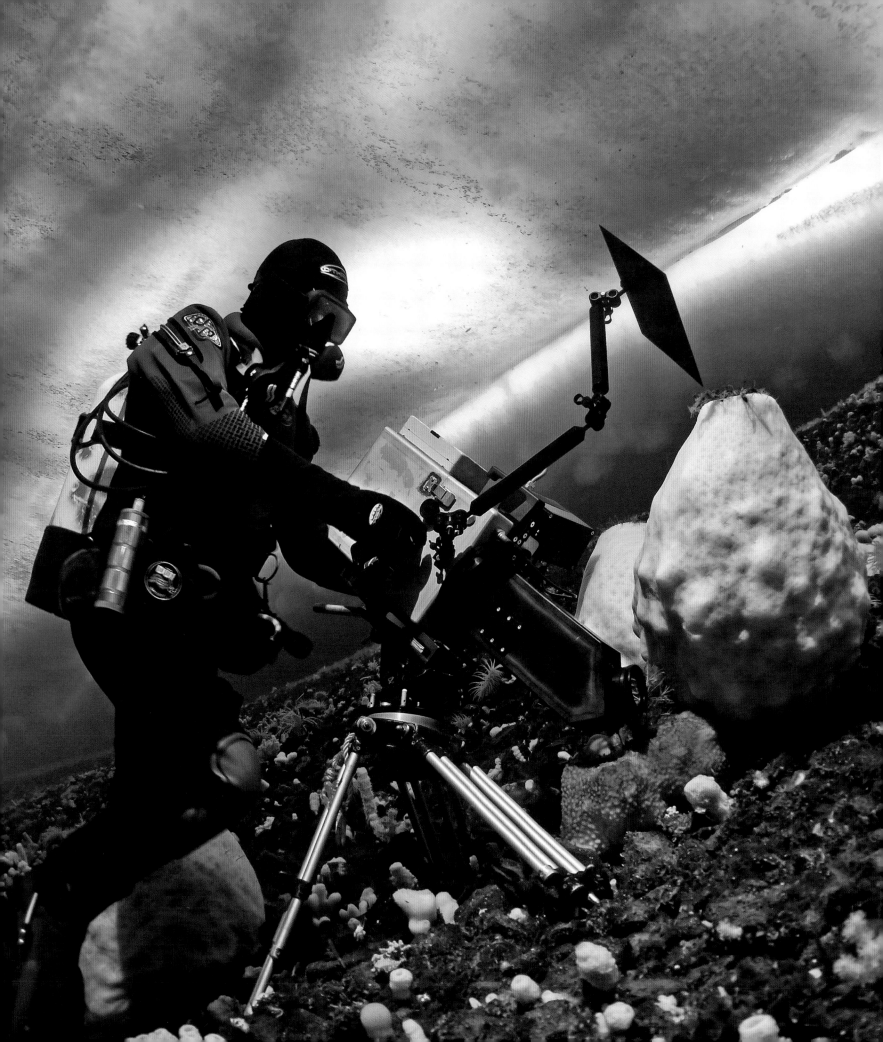

As well as providing transport, accommodation and a workshop – and drilling a hole through the ice for them – the scientists gave invaluable advice about the strange sea ice. It was the ice as well as the marine life that the team wanted to film, using time-lapse (a picture a minute) to show how dynamic it can be and how it both nurtures and kills.

After perfecting the electrical circuitry and building special housings so the time-lapse cameras would work under water at -2C° (28°F), cameraman Hugh Miller, together with Doug Anderson, dived down with all the kit to a creature-covered spot 25 metres (82 feet) under the ice. They spent the first dive setting it all up. But in just that time, something grew behind them – what Doug was to describe as 'the creeping finger of death'. It was what they had hoped for – a brinicle: a flow of brine encased in a needle of ice that creeps down and kills whatever it touches, enveloping it in ice and then melting away.

The elation didn't last long. A Weddell seal smashed the brinicle. Gambling that another brinicle might appear in roughly the same place, Hugh set up the three cameras, each at a different angle (so the shots could be cut into a sequence) and left them clicking away for eight hours. 'So many things could have gone wrong,' says producer Kathryn Jeffs. 'The exposure could have been out, the batteries could have died in the cold, a housing might have flooded, some invertebrate might have sat on the lens …' But Hugh's calculations had been perfect, and when he retrieved the cameras and downloaded the files, they found they had indeed recorded the finger of death in action, spearing and enveloping a starfish.

OVER THE EDGE

For director Chadden Hunter and cameramen John Aitchison and Didier Noiret, the challenge was to find open water. The sequence they were after was simple enough: emperor penguins jumping from the sea onto the ice edge. But as they flew from McMurdo to Cape Washington over the crumpled sea ice, the challenge of finding a route to open water dawned on them.

Setting up the tents on fast ice (permanent ice), they started the laborious job of chiselling a route through the ice. They knew there was open water ahead because

Opposite
1 Preparing to dive. Cameraman Didier Noiret gets ready to put his hugely heavy HD camera and its specially designed housing under water, having lugged it miles across the ice. Once launched into the water, it is weightless. Meanwhile, the emperor penguins get ready to dive, getting their heart rate up to 200 beats a minute so they can absorb as much oxygen as possible.
2 Poised, ready to dive. Holding his camera under the water, Didier would keep one eye on the viewfinder. He had just seconds to start recording once a penguin launched itself. Most often, though, that moment would come only after he and Chadden had waited hours at a time by an ice hole, fingers freezing despite layers of gloves.
3 The exit. An emperor would rocket out of the sea at 400kph (250mph) onto the ice. Luckily, emperors are both streamlined and bouncy, cushioned by blubber. Filming a flying penguin was a challenge, not only because of the unpredictability of an exit but also because emperors (despite their size) are terrified of leopard seals, and humans in wetsuits look like seals.

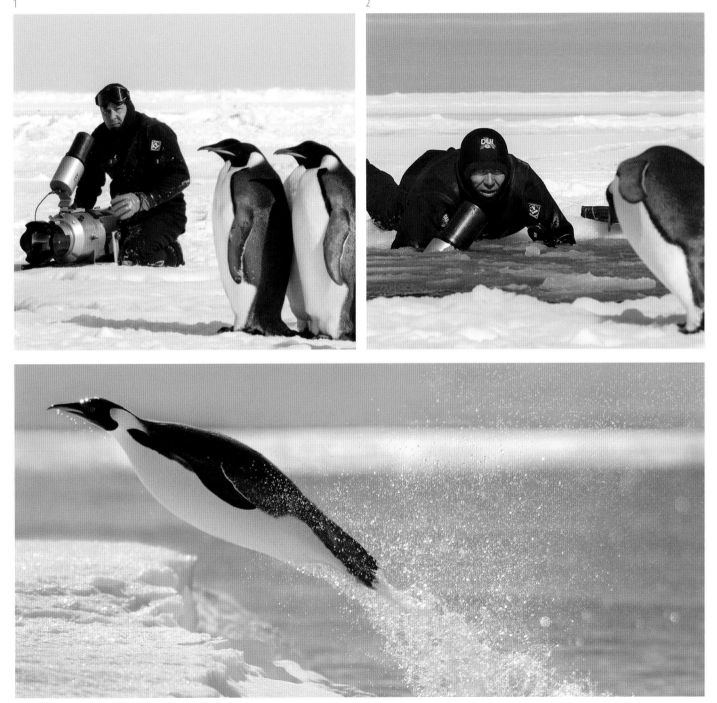

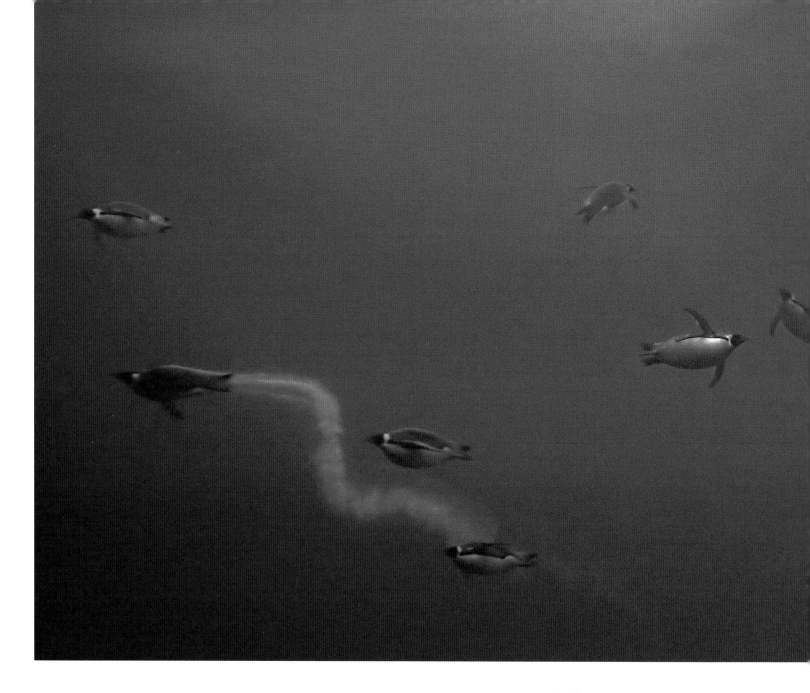

they'd meet penguins coming back to the colony. After days of blistering work, they finally located a hole in the ice – 'like finding an oasis in the Sahara,' says Chadden. But no penguins were using it. What with storms and setbacks and the fact that the moving sea ice was too dangerous to camp on – meaning that they had to travel up to 5km (3 miles) back to camp to sleep, hoping that no major fissure had opened up in the meantime – it was ten days before they located open water where they could film emperors rocketing out.

The last challenge was to film in slow motion the emperors shooting to the surface, leaving jet streams of bubbles behind them. That meant diving in blue water, untethered (a rope could get tangled up with the camera), and filming with a high-speed (super-slow-motion) camera that they had never used under water. The only way

Above
Above
Didier in action. Under water, his massive camera is weightless, allowing him to track the emperors. Those that have swum up from the depths are circling around the exit point, waiting for their heart rates to increase to normal. They then jet-propel themselves upwards, leaving a rocket trail of bubbles in their wake as all the air is forced out of their feathers. With no limbs to pull themselves onto the ice, this is the only way to exit. But it means they can't see what's on the surface, and beak-breaking collisions with ice blocks can happen.

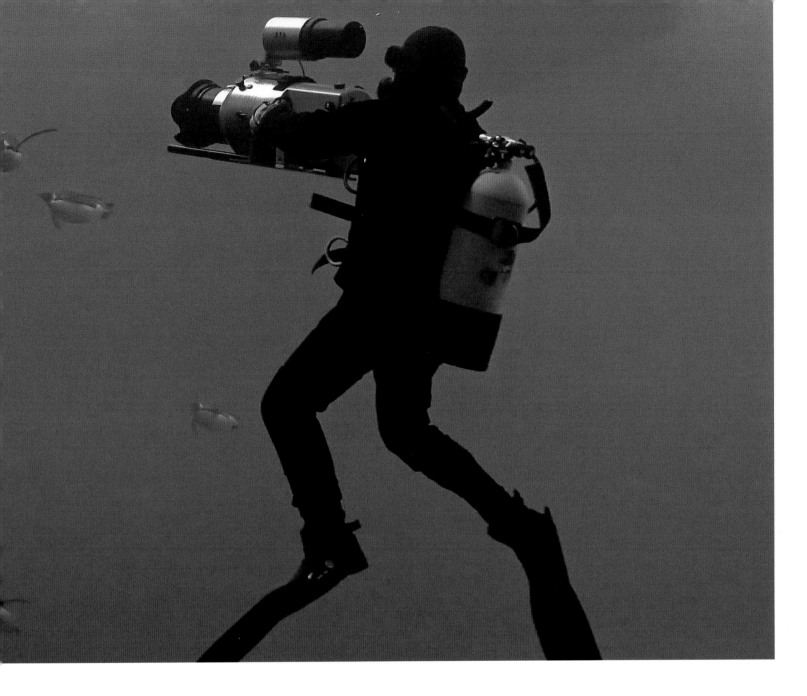

to control buoyancy was to let air into the drysuit from the tank, and if anything went wrong with that, 'you would just descend to the bottom of the ocean,' says Chadden. Also, at -2°C (28°F), any freshwater moisture in the breathing tubes could freeze up. There was no safety net other than top-notch equipment and their skills as ice-divers.

The water clarity was so great that it played tricks on their minds. 'The specks in the water that you first thought were plankton would turn out to be metre-long penguins a hundred metres away, circling like spaceships as they prepared to jettison themselves out of the hole,' says Chadden. 'You were mesmerized. Then suddenly you would check the depth gauge and realize that you were hurtling down at great speed and would frantically press the button to get air into the drysuit.' It was, he says, 'like space walking, untethered from the space station, while being circled by aliens'.

Whales at the edge

As the ice recedes in spring, many of the polar whales follow it in their search for food. In the Antarctic, the ones that penetrate the farthest south are the killer whales. They patrol the edge, looking for cracks big enough to swim up so they can feed on the riches under the sea ice. Chadden Hunter and cameraman Jamie McPherson made use of a McMurdo-base helicopter to hunt for them at the edge of the Ross Ice Shelf.

When a pod was spotted swimming up an ice lead, they would fly ahead of it, land, set up the Varicam (the camera that can shoot in both slow motion and real time) and the polecam (a pole-mounted underwater camera) and wait.

'They usually caught us off guard with a great whoosh as they shot up,' says Chadden. 'The blow would cover you in an oily mist that smelt like puppy-dog breath' – a mist that would also oil up the camera lens. The killer whales were spyhopping – to breathe (in an ice lead, it isn't possible to breathe by making the normal dorsal roll). But they would also spyhop to get a good look at the human animals on the ice.

'Being eyeballed was an incredible experience,' says Chadden. 'The eye would move up and down as it checked you out. The young ones would squeak as they made a beeline for us, getting very excited, pushing each other around and throwing ice, until their mothers called them away. Being curious is in their make-up.'

In the Arctic, as the ice starts to melt, the narwhals that congregate off Canada's Baffin Island are so desperate to get into the Eclipse Sound to feed on flatfish that they line up at the ice edge waiting for leads to open up. At this point they are relatively unafraid. So after filming them from the air, producer Mark Linfield would drop cameraman Tom Fitz onto the ice to shoot them from the edge.

It was while the narwhals waited for the ice to melt that the males, the ones with the 'unicorn' tusks (though occasionally females have them, too), started doing something very seldom seen and never properly filmed before: fencing.

'I had an image in my mind of what it would be like – a clashing of sabres,' says Mark. 'In reality, it was gentle, almost as if they were stroking each other, certainly not fighting, though it could have been that they were establishing a hierarchy.'

When ice finally broke and narwhals came pouring into the sound, it was, says Mark, 'like rush hour'. They entered from different points and spyhopped as they

A mother killer whale and her calf emerging from a crack in the ice to breathe. The shock for them was to see cameraman Jamie McPherson on the ice. The shock for Jamie was the fishy spray they exhaled. The killer whales were using cracks in the ice (leads) as highways and breathing points as they hunted for toothfish under the Ross Ice Shelf. The ice was too thin for them to be tracked by snowmobile, and so the team had to search for them by helicopter, following the leads in the ice. Once a tell-tale spray of surfacing killer whales was spotted, the team would land far enough ahead of the whales to allow time to get the cameras ready. The water was so clear that they could see the killer whales lining up, waiting their turn to surface and breathe.

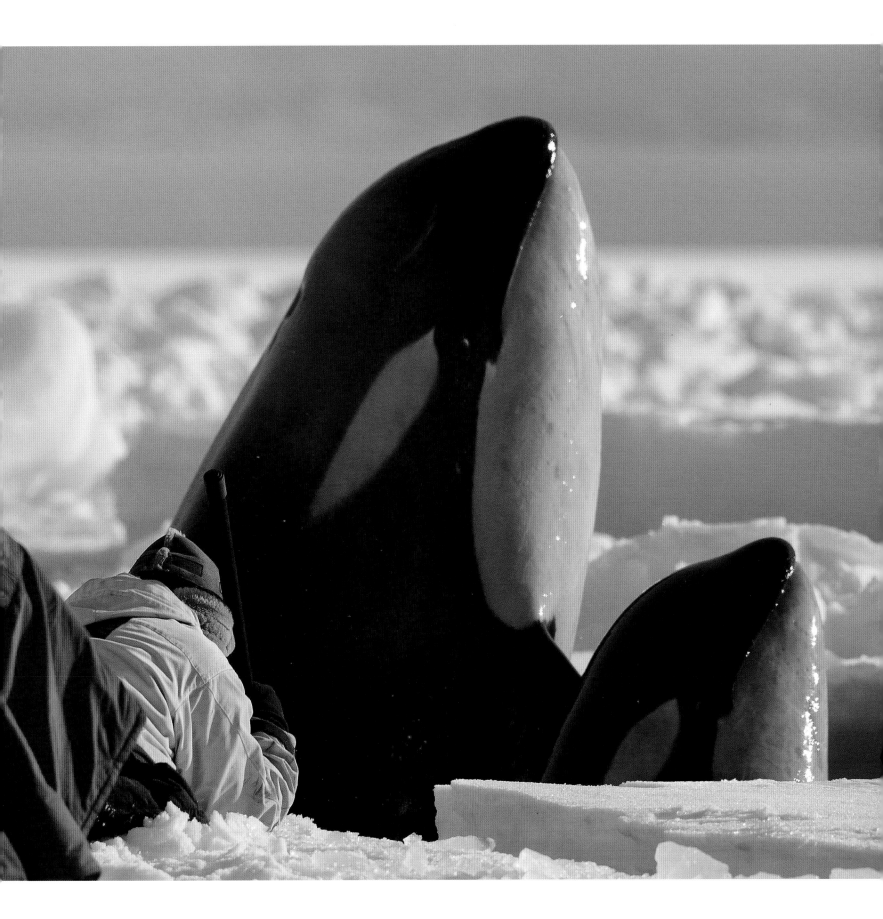

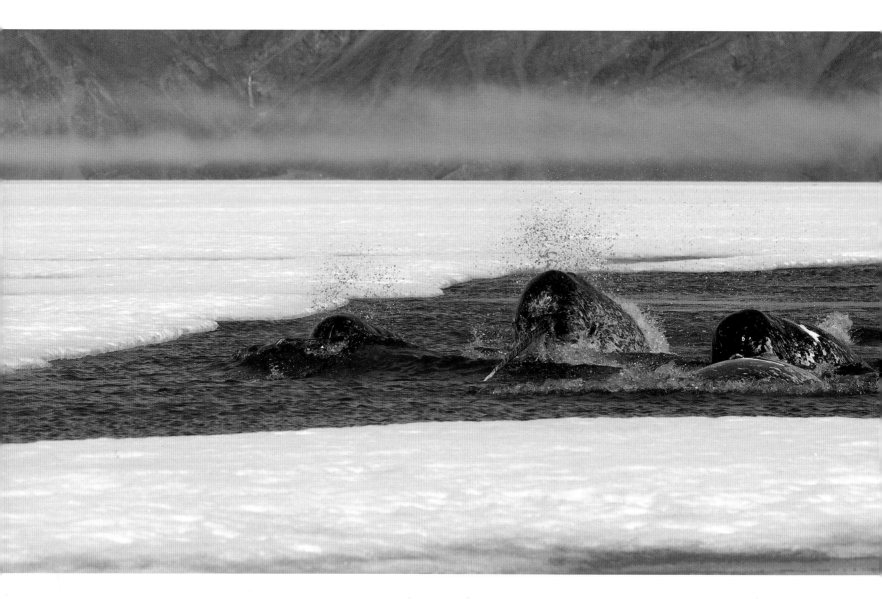

porpoised down the leads, almost looking like hummingbirds with their beaks poking ahead. Where two whales travelling in opposite directions met, there'd be a stand-off – something Tim filmed on the last morning. It had to be the last morning, not just because it was the last one on the schedule but because that was when the ice broke. 'The next day, the ice was all gone – blown out – and there wasn't a narwhal in sight.'

Above
Spring rush hour. As soon as the ice started to break up, the waiting narwhals charged up the leads in search of new fishing grounds.

The penguins of madness

The daily haul home. Mark and Jeff had to camp 2.5km (1.5 miles) from the colony, which meant dragging the camera gear up and down every day for four months. The one thing it made them aware of, though – at least, when they were away from the colony and there wasn't a storm blowing – was the silence. The only sound was the wind.

The plan was to spend the whole season with the Adélies, the Antarctic stars of the show, from their arrival in October until the chicks fledged in February. Of course, it would be tough going. For cameraman Mark Smith and director Jeff Wilson it would mean nearly four months working on their own at Cape Crozier, weathering storms and extreme cold with no transport and just a satellite phone for contact. But then they were among the toughest in the team, and penguins hardly pose a threat. What they weren't prepared for, though, was the wind, the noise and a landscape of death and desolation.

'The first thing we saw were dead penguins, everywhere,' says Jeff. In the extreme dryness and cold and without bacteria, bodies don't rot but become a ghoulish frozen soil of penguin poo. The live Adélies were still far away, making their way south over the Ross Ice Shelf. So the only noise was that of the wind. In fact, the wind was to become the most terrifying aspect of the trip.

'In the Arctic, the risk had been polar bears, and it took a while to stop looking for them, but we soon realized that it was the wind we had to fear. We would hear it coming, like the low roar of a jet. Then it was a race to get back to the emergency hut-shelter.'

Within a few days, males began to arrive, one by one, to stake their territories 'like guests arriving early for a party'. They would stand around, shuffling, with no females to impress or rivals to ward off, mildly curious about the two giants already in residence.

But then came the first big snowstorm. 'We were both used to extreme conditions, and so when it started, it was just exciting,' recounts Jeff. 'We filmed each other playing around and getting thrown down the slope by the wind, but as the strength increased, the fear set in.' First the tents went. 'The big worry was then that we might never find our gear stashed in the colony, tied to rocks.' As the howling wind increased to nearly 240kph (150mph), they feared that the roof of the hut would come off. What played on their minds was what happened to Scott and his men a century before – and the thought that their teeth had shattered in the cold.

After four days, the two emerged. Not only had the penguins weathered the storm (by just hunkering down) but also the colony had doubled in size. 'We came down the hill, remarking on how many there were, and then we saw it – a long column of penguins, backlit against the snow. We were so thrilled that there was a chance of the epic shot we were after that we ran down the hill to the ice.'

Upwards of 800 males arrived every day, to be followed by thousands of females. As they paired up, the territorial aggression increased – and so did the noise. Six weeks later, there were more than 300,000 Adélies and a continuous, near-deafening screaming.

The descent into madness was inevitable. 'With 24-hour daylight, we were never sure what meal we were making, and the lack of sleep and routine, coupled with anxiety about the wind, began to get to us,' Jeff remembers. 'On top of the screaming, I began to hear voices. It started with a penguin squawking my name "Jee-ee-f, Jee-ee-f." Luckily, I could talk to Mark about it. If I'd been on my own, I would have been terrified.'

Adélies make up for their lack of size with aggression. A large number in the colony means that competition for nest space is intense, and intruders will be seen off with a flipper bashing. Adélie pectoral muscles are incredibly strong, designed for a life at sea,

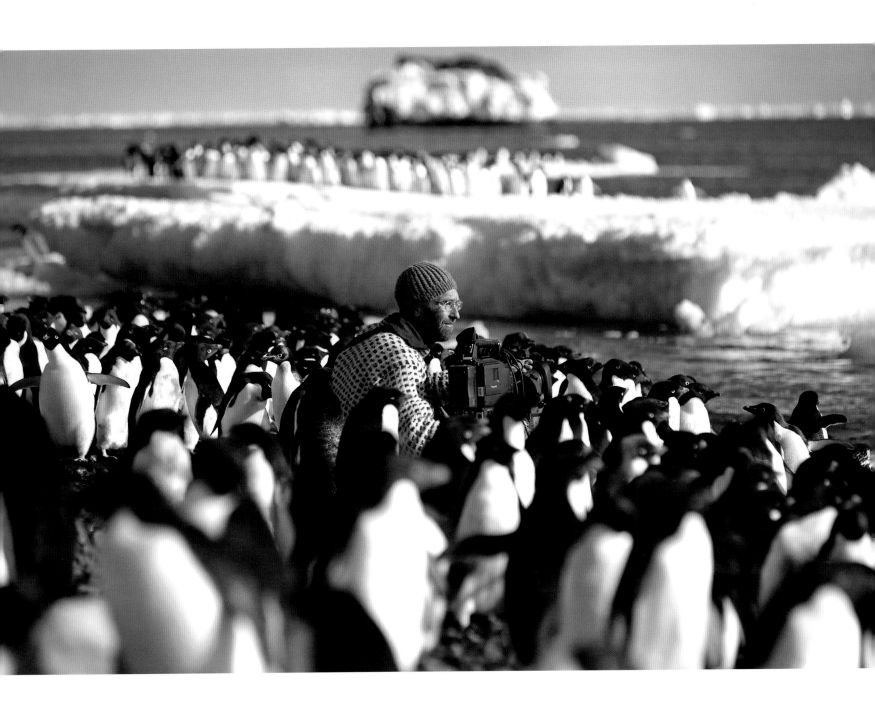

and a whack from a flipper is like being hit by a paddle. 'Our shins were literally blue for months,' recalls Jeff. It was comical to begin with, but very soon, the duo found it difficult not to feel animosity towards their attackers. Indeed, the sighting of a leopard seal – eater of penguins – became a moment for rejoicing. It was only when the Adélies settled down to incubate their eggs that Jeff and Mark had a three-week breather.

The chicks were different. It was difficult not to get attached to them, which was fatal, as usually only one chick of a pair survived. Either its sibling would get feeding preference, or it would be pecked to death by neighbouring penguins or eaten alive by

predatory skuas. 'Humour became macabre, and we got deadened and brutalized by the daily carnage,' recalls Mark.

By now it was summer, and after temperatures of -30°C (-22°F), the warmth should have been welcome. But as the ground melted, there were mudslides of dung, and rivers of urine and dead penguins. 'Worst was the smell,' says Mark. When the parents return from their feeding trips at sea, they disgorge pink krill and fish for their chicks, a good proportion of which doesn't make it into their beaks. 'Fishy puke and penguin poo on top of the stench of death is a potent combination.' The odour impregnated everything and stayed with the equipment for months after their return. 'At first,' recalls Jeff, 'it was possible to take off our dung-covered clothes and escape into our sleeping bags, but then the poo got in there, too.'

The last phase was when both adults left to feed and the chicks crèched together – a time of maximum predation by the skuas, thousands of which hung around the colony (less than two thirds of chicks make it even to the crèche stage). Being territorial, the skuas also took to jabbing Mark and Jeff on their heads, which was even more painful than a flipper-bashing.

As the chicks matured, so the cacophony died down, and day-to-day life for Mark and Jeff became more manageable. Having watched the chicks grow up and seen the journeys of the parents, their admiration for the spunky Adélies had grown, and they realized that the experience had affected them profoundly, emotionally as well as physically.

The extraordinary thing was that Jeff and Mark survived as firm colleagues. 'I think one of the skills of film-making is being laid back,' says Jeff, 'accepting each other's characters.' A saving grace was that they also spent long periods apart in different parts of the colony, Jeff tending to the time-lapse camera and diary filming and Mark filming behaviour. And, of course, they came well prepared with good gear and chests of food. 'As David Attenborough says,' recalls Jeff, 'any fool can be uncomfortable,' and there is nothing like boil-in-the-bag curry for cheering you up.

Their abiding memory, though, is how incredibly hard it was to survive in the Adélies' environment. 'It made us realize that this place is true wilderness,' says Jeff. 'Humans don't figure in the lives of these penguins. So we were observers in the truest sense.'

Hunted by polar bears

Opposite

Checking what's for supper. Visiting polar bears were a worry for the crews filming them. As much as they enjoyed the experience of seeing bears at the window, constant visits from bears led to insomnia.

Below

Checking out the boat. The smell of cooking from the galley was another attraction for bears, which could be a problem when the boat was anchored to the ice, giving a bear access.

'Polar bears are in their element in the pack ice, and you're not,' says producer Miles Barton, 'one reason to keep a 15-foot moat of water between you and a bear.' So to film bears in Svalbard, the team used a boat – an ice-strengthened trawler that they would live on and a speedboat that could keep up with a bear (and reverse fast). Fixed onto the speedboat was a jib arm for the Cineflex, so it could swing smoothly up and down.

Three weeks in, after another bear-less day, Miles was attempting to sleep (24-hour daylight and the captain's way to anchor by ramming the trawler into the ice didn't help), when the shout went up 'beer on the bow'. It turned out not to be cameramen Ted Giffords and John Aitchison calling him up for a drink but the Norwegian first mate alerting them to a bear. It had just stared in at the cook through a porthole and, given a chance, would

On the scent of man. Polar bears have an acute sense of smell, needed for finding food, and can locate a camera operative from a huge distance away, especially if he has been out on the ice for a while (washing is not an option when camping). Scent is probably the chief way that polar bears communicate with each other, and some biologists believe that they communicate by leaving scent marks on the ice and snow.

have climbed onto the boat. The male bear was quite unconcerned when the speedboat was lowered and allowed itself to be filmed for 30 minutes as it searched the ice for seals. Then, at 3am, just as it headed away, they saw what they had been hoping for, a female with cubs in tow, and she was coming determinedly towards them.

'The weird thing about the Cineflex is that the cameraman operates it with a joystick and has his head in a hood to avoid glare. If you lift your head up, you're blinded. As director, I also had my head in a hood looking at the bear in the monitor, getting rather excited, losing all sense of distance. As she came straight at us, I remember saying to Jason, who was operating the boat, "You are keeping an eye on her, aren't you?" when the boat suddenly went into reverse.' She'd been about to climb into it. 'That', says Miles, 'was my first experience of being hunted.' The mother bear paced up and down at the edge of the ice, providing us with great shots, and then went off and gave the cubs a swimming lesson. 'Magical and totally on her terms.'

Jeff Wilson's encounter was a little different. He was on Svalbard to film the first appearance of the sun on 14 February, camping out with field assistant Lisa Ström in an old trappers' hut overlooking the sea ice. They'd ringed it with a tripwire linked to explosives on poles to discourage bears (at this time, the bears are very hungry and will eat anything organic, even snowmobile seats). One stormy night, he was woken by banging. He assumed it was the wind, and Lisa was already up, about to exit for a pee. 'But something didn't feel right,' says Jeff. 'Then at the window appeared an enormous head.' This in itself wasn't unusual – though the fact that the tripwire hadn't worked was. 'In fact, at 4am, it was all a bit of a bore to have to put on our clothes in the dark and load the bear-scaring flare guns', he says. 'We were just getting down the arms from above the door when, without any warning, the door caved in, and suddenly there was a polar bear in the hut. Lisa instantly let off a flare, and we must have thrown quite a few more in our panic, as my overriding memory is of flashes of polar bear face in the darkness.' Slowly, the bear backed off into the night, leaving them without a door and no sleep for many nights.

Miles Barton's next encounter with a polar bear was again in Svalbard, but on an island, with a secure cabin and 24-hour daylight. He was with John Aitchison to film

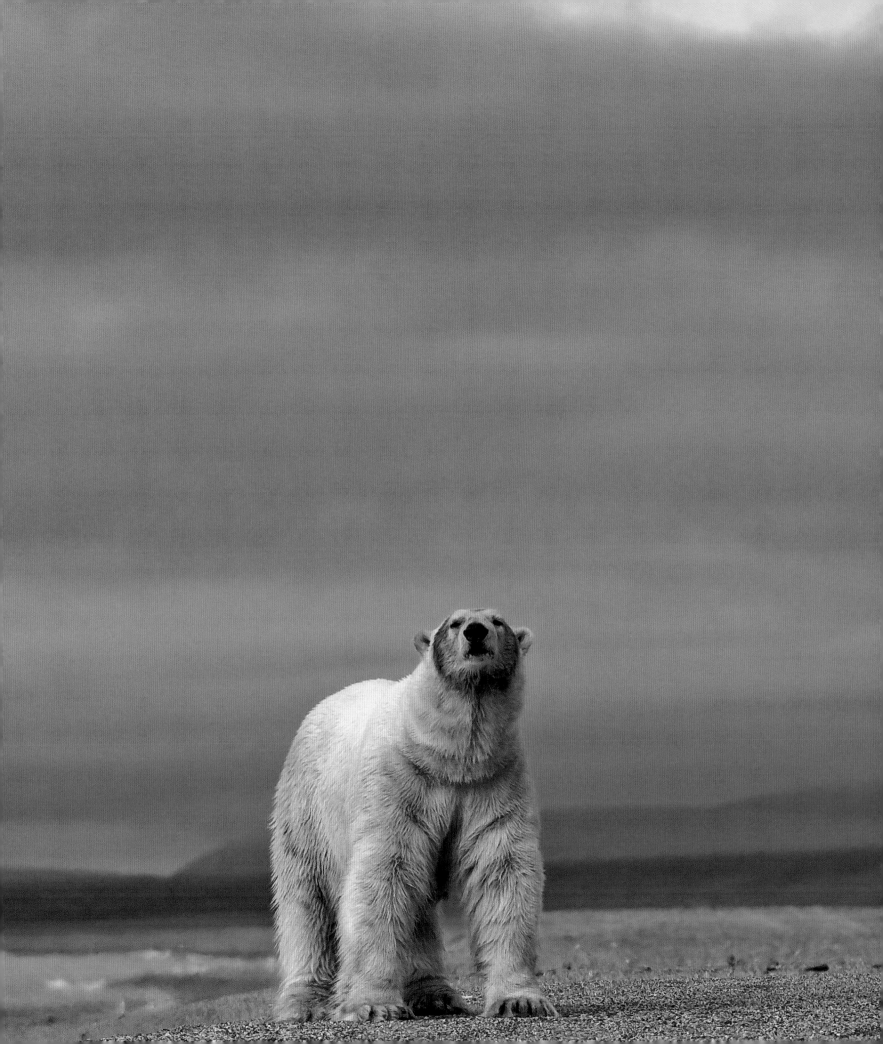

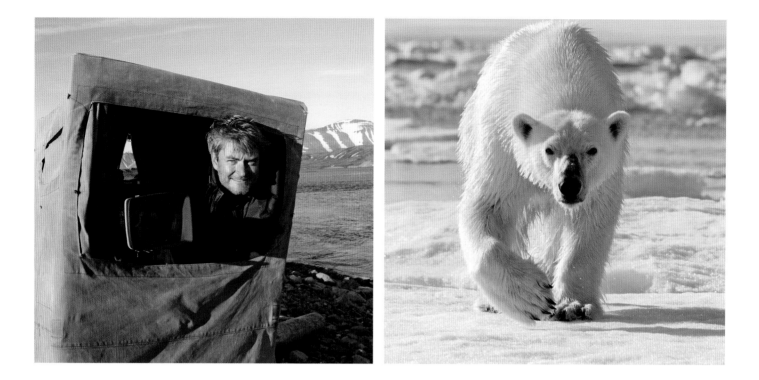

hatching eider ducks as well as bears. 'We had a lovely position on a hillside, only ten minutes from the cabin,' says Miles. 'I could just put John in the hide for the day and watch from a ridge in case of bears. But what we miscalculated was that from the first pipping of the egg until the chicks hatch can be a very long time.'

It was a cold, miserable day, and John had already been in the hide for 16 hours. He needed to be taken out, warmed up and fed. 'When I opened the hide, he fell out like a beetle,' says Miles, 'onto his back, and needed to be straightened out before he could stand.' When they returned to the hide, the inevitable had happened: the ducklings had hatched and were walking down the beach. There were other nests but none near hatching, which meant more days in the hide for John. And then the polar bear arrived.

They had already watched the bear on a neighbouring island, chasing a flock of barnacle geese and then eating the goslings 'like ice-cream cones'. Now the bear had swum across and started to work its way up the beach, 'munching its way through all the eider nests we'd lined up to film,' says Miles. They filmed it dining on eggs – an illustration of what may happen as more and more ice melts and bears get stranded on land, causing havoc to bird colonies. One eider duck mother planned well, though. She had chosen to nest in the middle of a tern colony – terns are great aerial bombers of predators including bears – and next to the cabin, a combination that probably protected her nest. So her ducklings became the stars, filmed on the very last evening, looking cute as they waddled down to the water and swam away into the sunset.

Above, left
John Aitchison on one of his last appearances in his 17-year-old hide. While he was intent on filming eider duck eggs hatching, a polar bear was intent on eating them. When the male bear found the hide, he stood up, put his paws on the top and squashed it. It was just luck that John wasn't inside.

Above
A mother bear not happy to smell Miles Barton. She had two cubs to protect, and Miles, with the shot of the family in mind, had his head under a hood viewing her on the scanner. Lesson: distances while viewing down a lens or on a scanner can be deceptive.

The seal-killers

'Don't worry if you fail,' had been the reassuring words of executive producer Alastair Fothergill before the team set sail on what was to be the most expensive gamble of the series: filming killer whales wave-washing seals off the ice. In fact, the eight-week expedition aboard the *Golden Fleece,* skippered by the legendary Jérôme Poncet, was to come back with footage of behaviour that had hardly been seen before, let alone filmed.

There had been sporadic reports of seal-washing over the years, and a tourist had shot a shaky video of killer whales washing a seal off ice. But was that a one-off or did the behaviour occur regularly? Two years earlier, a BBC crew had tried to film seal-hunting whales but had failed to keep up with them in the ice. This time, though, producer Kathryn Jeffs was relying on four pairs of expert eyes to watch for killer whales – those of veteran polar cameramen Doug Allan and Doug Anderson, and NOAA (National Oceanic and Atmospheric Administration) whale biologists Bob Pitman and John Durban – the

Below

Whale-spotters: from left to right, cameraman Doug Allan and whale biologists Bob Pitman and John Durban. In the first week they had no luck. The only option was to risk taking the *Golden Fleece* much farther south and into the pack ice, where the killer whales might be hunting.

use of satellite tags to keep track of the whales and an earlier start in January (summer).

The first hurdle turned out not to be the stormy crossing over the Drake Passage but the technology. The Cineflex camera and the linked computer technology – their chance of getting steady shots – had never been used on a boat before. So when the system went down on the very first try, fear set in. Then there was a matter of finding killer whales, specifically, the ones that hunted seals rather than fish or other whales.

Sailing south past the South Shetland Islands, it wasn't long before they located the first pod of killer whales. But though the Cineflex was now working and the whales were playful, there were few seals, little ice and no hunting. So the only option was to head south for the infamous Gullet – an iceberg-choked passage between Adelaide Island and the mainland Antarctic Peninsula and the shortest way south.

Above

Underwater view. While the huge male, dubbed Fat Boy by the team, inspected the Zodiac, he was filmed under water by Doug Anderson using a camera on a pole. Kathryn directed, keeping the light off the monitor with a towel, so she could see what was being filmed.

The hunt for the hunt. When the *Golden Fleece* entered Marguerite Bay and the brash ice, the light was bad, but seals and killer whales were plentiful. And when the action started, the Cineflex camera mounted on the prow enabled them to take steady-enough shots.

By January, the ice should have been broken up enough for the boat to get through, but it wasn't. After unsuccessfully trying to squeeze through the huge chunks of ice, Jérôme took the risky decision to sail back out and around the outside of the islands, exposing them to a possible stormy run with no shelter and going farther south than an ordinary little yacht with an ordinary skipper would ever dare go.

They were lucky. The weather held, and as they entered Marguerite Bay, their excitement grew. The feel of the place was completely different. Tennis-court-sized sheets of ice surrounded them – perfect resting places for seals – and in the distance were the killer whales. 'There was a chance for the scientists to tag a whale and for us to film something,' says Kathryn, 'even if it wasn't the behaviour we were after.' Doug Anderson describes the pack-ice killers as 'very different to others I had seen – very big, and very confident.' They were also curious and unafraid of the boat, and very soon John, an expert shot (at $3000 a satellite tag, he had to be), had tagged one of a pod of ten whales.

The next morning, they followed the pod, now behaving very differently, moving around the pack ice with intent and spyhopping – coming vertically out of the water to look around. But the light was poor, and so they didn't try filming with the Cineflex. 'I was on the wheelhouse cleaning the lens when I heard the yell "wave, wave",' says Kathryn. 'I looked down, and there was a strange, glassy dip in the sea. Then a great wave smashed down onto an ice floe, throwing the seal into the sea. There was a roar of excitement from the boat. Everyone went wild. Suddenly the holy grail was in front of us. Then the shout went up: "Move the boat, now, now." Another great wave had broken the ice raft, and the whales were again charging in formation, pushing the raft away from the rest of the ice. On the fifth wave, the seal came off. And we'd filmed it.'

Says Doug Anderson, 'If nothing else had happened on the trip, we had behaviour that would blow people's minds. But then it just got better and better.' The pod kept on hunting, and the team was also able to film from the Zodiac.

Over the next two weeks, the team discovered that the killer whales weren't eating crabeaters, as everyone thought they would be. The whales would spyhop to see what kind of seal it was and attack only if it was a Weddell. The wave-washing technique also involved different waves. 'The first was to break the raft,' says Kathryn.

Line-up. A group of killer whales lined up to take one last look at a Weddell seal before creating a wave to wash it off the ice floe. The entire family was involved in the attack, including a young calf and a large male.

Last gasp. After being wave-washed into the water several times, the exhausted Weddell seal got back onto the ice but left its hind flippers hanging over the edge. It's about to be dragged under water and drowned.

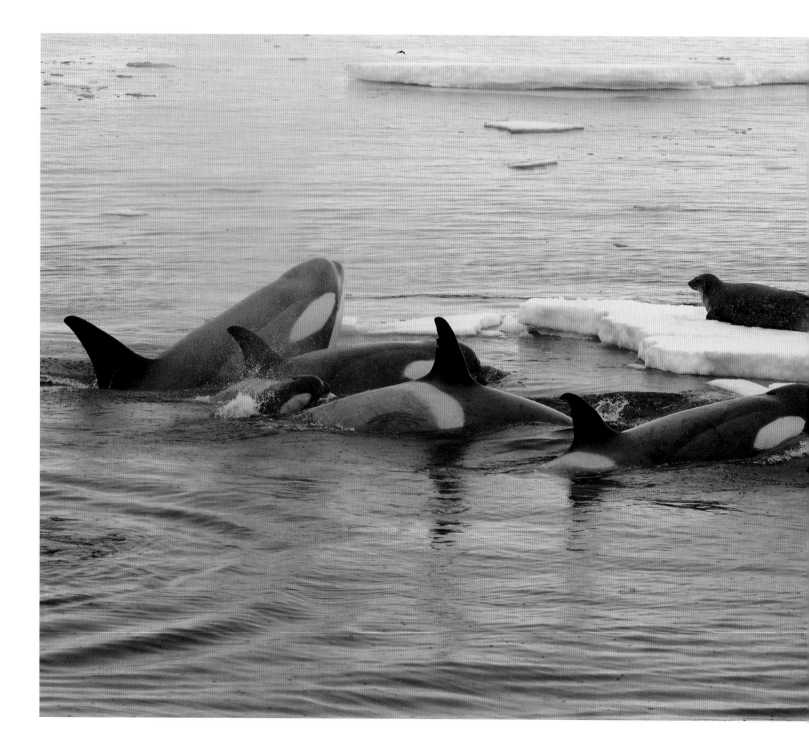

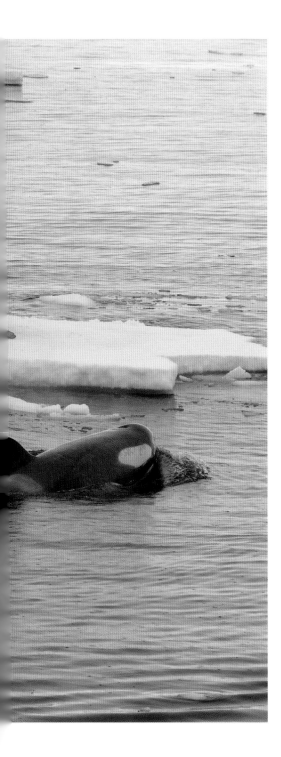

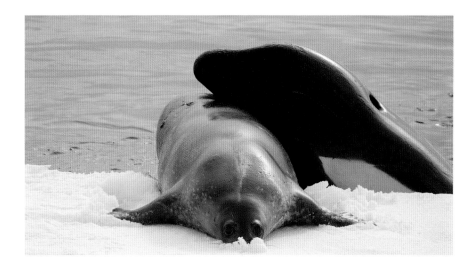

'The whales would charge as one under the raft. The following wave shattered the ice, leaving the seal on a fragment. The whales would re-form, this time aiming a wave to crash onto the ice, washing the seal off, often to a whale waiting just below.'

They got to know different pods and their different strategies. The entire pod would take part in creating the waves. 'Once in the water, a seal would fight back for up to half an hour,' says Doug Anderson, 'but the killer whales didn't take risks.' With the polecam (a pole-mounted camera), he was able to film the seals under water, tucking in their tails and trying to face their killers. Eventually the killers would gather in a semicircle, looking directly at the seal. 'You'd see the seal gasping for breath and the stress in its eyes.' Then they would rise as one and pull back, creating suction that would turn the seal topsy-turvy so they could grab it.

Then came the humpback incident. On several occasions humpbacks stopped a hunt, with their bellowing and thrashing, preventing the killer whales from getting to the seal. 'We first thought this was the equivalent of songbirds mobbing birds of prey,' says Bob. 'But a week later, we witnessed behaviour that suggested something else.' When an escaping seal approached one of the intervening humpbacks, the huge whale rolled on its back, allowing the seal to be swept up onto its chest and between its flippers. 'As the killer whales moved in, the humpback arched its chest, lifting the

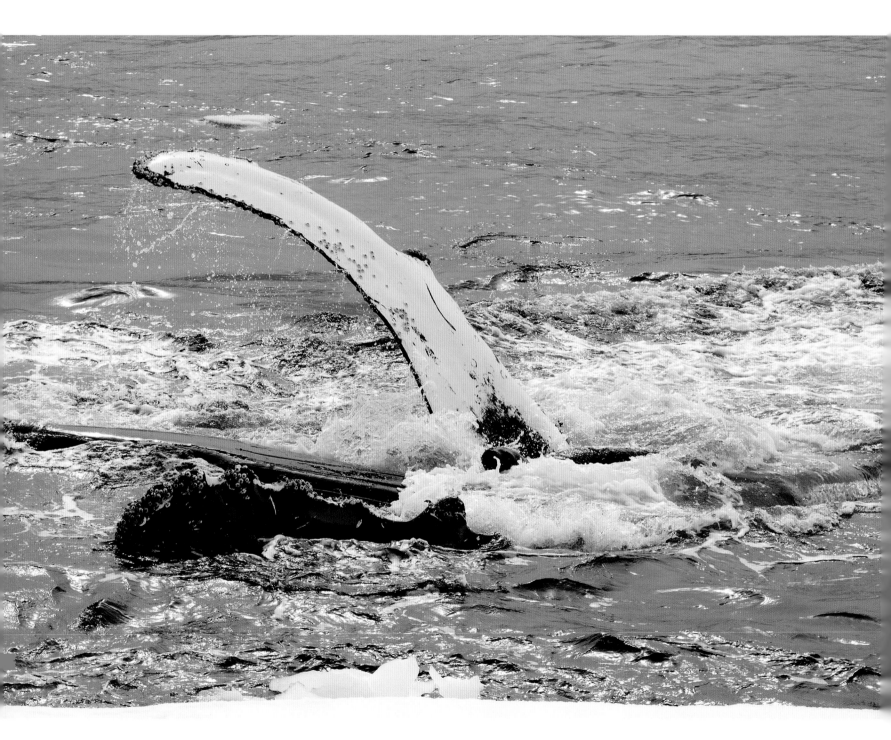

seal out of the water,' and when it was nearly washed off, 'nudged the seal gently with its flipper back onto the middle of its chest. None of us guessed we would be the first to witness, let alone film, such extraordinary behaviour,' says Kathryn.

THE MINKE KILLERS

'It was like a wolf hunt,' says Elizabeth White, who led another trip aboard the *Golden Fleece* with Bob and John, this time to film whale-hunting killers. 'The day we got the kill, we were hanging out with a massive pod of 30 or so of the largest type A killer whales, all chilled out and socializing,' says Liz. 'Suddenly they fell silent and spread out across the strait. Then out of the water lunged a massive minke whale, headed straight for us with the killer whale pod hot on its tail.' The minke had the greater size and stamina, but the killers had strength in numbers. 'One large killer moved in on either side to flank it, stopping it fleeing into the brash ice, while a tag-team swam close behind.

'The minke broke away with the killers on it and us flat out trying to keep up. After more than 2 hours and 25 miles [40km], it finally began to tire and the killers surrounded it. Each time it lifted its head, they'd push it under. The final blow came from the largest female, who put her giant body weight onto it, and the minke sank below the surface.

'We also came across a pod working as a team eating chinstrap and gentoo penguins' says Liz. 'They would chase them round and round in circles to catch them. Then it looked as if one would hold the head while another would bite out the breast meat. We were surrounded by little carcasses of legs and flippers floating on the surface.' It was behaviour the scientists had never seen before.

Bob and John have been documenting the different societies of killer whales, which are not only genetically different and look different but also display different behaviour and food preferences. They believe there are at least three different forms. The minke killers (type A, see page 125) have the classic black-and-white look, while the seal killers (type B) – which also take penguins – are two-tone grey and white, with a darker cape on their backs. Type C (see pages 122 and 268) also have a cape but are smaller, with a slanted eye-patch. They are the toothfish-eaters, living mainly in the pack ice off East Antarctica.

Above
Remains of the day. Whale-biologist Bob Pitman displays the head of a chinstrap penguin flayed by a killer whale. The remains of many other penguins were floating around – in every case, the whales had eaten only the breast muscles.

Opposite
Saving the seal. Having rolled onto its back, the humpback whale has used its flipper to nudge the terrified Weddell seal onto its chest [visible in front of the far flipper, its head in the whale's 'armpit'], preventing the killer whale pack from catching it. Was this maternal instinct at work? One thing was certain – the humpback effectively stopped the hunt.

The great wolf hunt

Wood Buffalo National Park is huge – it's Canada's largest national park. With winter temperatures of -41°C (-42°F), it was also the coldest Arctic Circle film location. 'Physically, it was my worst experience of the series,' says director Chadden Hunter. 'The pain in our fingers and feet was excruciating, our eyes froze shut, and the liquid in our noses turned to super-glue. Making decisions about team safety became a nightmare.'

The goal was a sequence for the winter programme of a pack of wolves bringing down a bison. In winter, when the bison's energy levels are low and they are reduced to feeding on dead grass under thick snow, a wolf pack's chances of a successful hunt are high. These wolves are also the biggest, most powerful in the world. Their stamina, strength and strategy have been honed by hunting bison over hundreds of thousands of years, and the exceptionally large sizes of their packs prove that specialism has been a very successful strategy. They are also used to the extreme conditions, unlike the humans on their trail.

Every morning Chadden and Canadian film-maker and wolf expert Jeff Turner would fly over the park scouting for wolves. If they spotted a pack, they'd photograph the place for reference, return to base and, with a local native guide, ride back to the location on snowmobiles – sometimes a two-hour journey. But the wolves are hunted and are extremely nervous. So the team would have to dismount a kilometre or so away and then track them on skis or snowshoes, downwind, carrying heavy gear in deep powder snow. 'If they got any hint of us, we wouldn't see them for another five days – heartbreaking when we had nearly killed ourselves just to get a sighting,' says Chadden.

After three weeks of gruelling, freezing work, they had only a couple of shaky shots. Time and money were running out. Their last hope was to blow the rest of the budget and risk calling in the Cineflex, operated by Hollywood cameraman Michael Kelem.

Chadden calls directing a Cineflex shoot as 'God's view of a nature experience.' Now they could watch the wolves' movements from a height that didn't disturb the animals, see how far away from the bison they were and predict where the wolves would go. On the very first flight they located a male and female and one of their offspring trotting at a marathon gait, tails high. The wolves had located the trail of a bison herd and were using it like a railway track – the only way to follow the bison in thick snow. The excitement of

1

2

3

getting the first shot, 'pinprick wolves one end of the frame and tiny bison the other', was huge. But that was just the beginning.

Face to face, a bison has a good chance of killing a wolf, and so the wolves' strategy is to try to get the bison to stampede and then attack from the rear. The pack may test a herd for days at a time, and as long as the bison hold their nerve, the result is a stand-off. But on this occasion, the bison started to run. The pilot tried to parallel the chase, with the animals now at a gallop, turning the nose of the helicopter into the breeze to give stability. But that meant flying backwards. 'He now couldn't see the wolves,' says Chadden. 'So I had to yell instructions over the roar. "Jim, Jim hold steady. Michael pan left." In the monitor, I could see what was happening, but with his eye to the camera, Michael couldn't see how far ahead the bison were, so I'd have to tell him when to zoom in.'

Once the wolves had singled out a yearling bison, the male acted as the matador, distracting it while the female did the bloodletting. 'When they finally got their teeth in, Jeff knew that was it,' says Chadden. 'They wouldn't give up until the death. But I didn't realize that. So when he begged me to set him down so he could shoot from the ground, I was reluctant to risk disturbing them with a landing.' But with the combatants so focused on each other, Jeff was able to be let down and film the final duel at eye level – footage that would make all the difference back in the cutting room. 'It was the most extraordinary behaviour I have ever seen in the wild,' he says (see page 185). 'The bison flung the wolf over its back and then jumped on her. So staggering was the beating she took that I was sure the bison was going to kill her. But she would stagger up, covered in blood, and they would both stand panting.' Finally, as the sun set and the helicopter fuel was about to run out, the bison sat down. It was over. The wolf walked a short distance away and collapsed. 'Hollywood couldn't have scripted it better,' says Chadden.

But that wasn't the end of the team's luck. On the very last day, they filmed the epic sequence that was to be a highlight of programme one. This time it involved a pack of 25 wolves. Following the chase, they filmed as several wolves latched onto a bison as it kept running and, in the same shot, got the finale as a tank of a bull charged up from behind and rammed the scrum, seeing probably just a wall of wolves but effectively sealing the victim's fate by throwing it to the ground. Action, drama, cut.

Making tracks. Part of the large Wood Buffalo Park pack is setting off on a hunt, the alpha male and female doing the hard work of making a trail through the thick snow. There are enough bison in the park to keep such a large number of wolves fed even in winter. But to film them hunting, the team had to wait until February, when there was enough light, at least, in the middle of the day, to see and record what was going on.

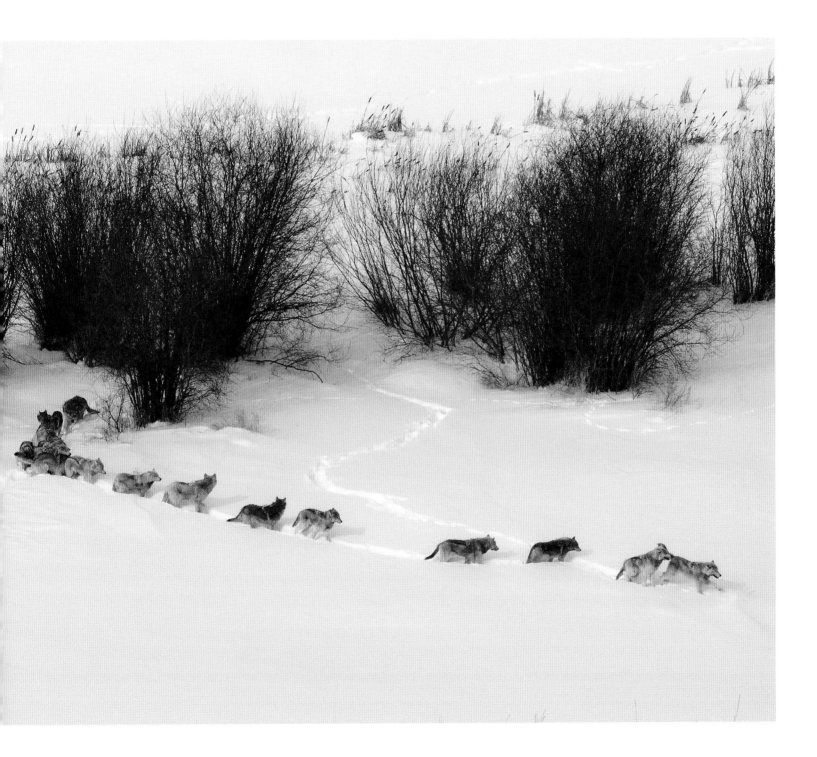

Time and space, snow and ice

To make visible the normally invisible was one of the aims of *Frozen Planet*. And that meant manipulating time. Time-lapse involves shooting continuously but with gaps between each frame, so that many hours can be compressed into a shot lasting just seconds. It reveals things we wouldn't otherwise notice. But for longer periods, interrupted by nightfall and weather changes, a 'time-study' shot is more effective. It's how *Frozen Planet* condensed the seasons.

The old way was to bang a pole into the ground with a camera plate attached, take a static shot and then return and take another at the exact spot a week or a month later. But *Frozen Planet* wanted moving shots (to show more of the landscape and to edit with aerials). A cold-adapted, motion-control rig was devised that would move the camera and store the coordinates so the exact same move could be replayed when the team returned in a different season. 'It's the best way to show how the landscape is transformed by the passage of the seasons,' says producer Mark Linfield, 'something outside our ability to see.' It was also the way to reveal the great Arctic melt.

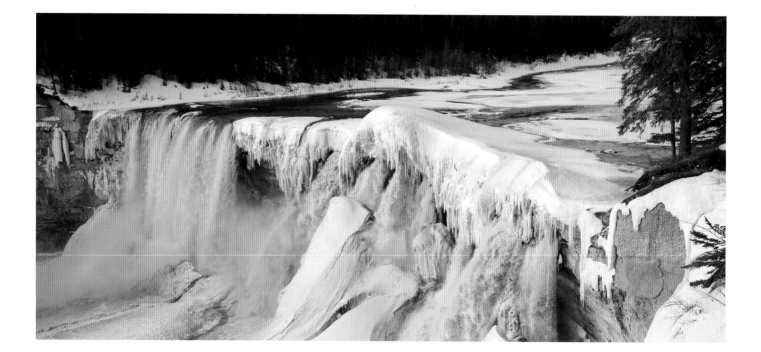

When the Arctic ice melts, most of the water emptying into the Arctic Ocean comes from six vast rivers, five in Russia and one in Canada – the Mackenzie. With it comes an enormous load of sediment, which fertilizes the ocean and causes a blooming of life. The scale is so great (the Mackenzie looks like a sea) that Mark chose an area that would give context – a frozen waterfall on a tributary. Here cameraman Warwick Sloss used time-study to reveal the transformation as the ice broke up and the river started to flow again.

MOTION CONTROL

At the other extreme was a time-lapse study of the long, long life of the Arctic woolly bear caterpillar. It survives only days as a moth, but as a caterpillar it lives for 14 years, mostly frozen solid. Suitable leaves to eat exist for only a few weeks, after which the caterpillar just shuts down and freezes, thawing out the next spring to carry on eating. It goes on like this for years until the caterpillar is large enough to change into a moth. Time-lapse filming

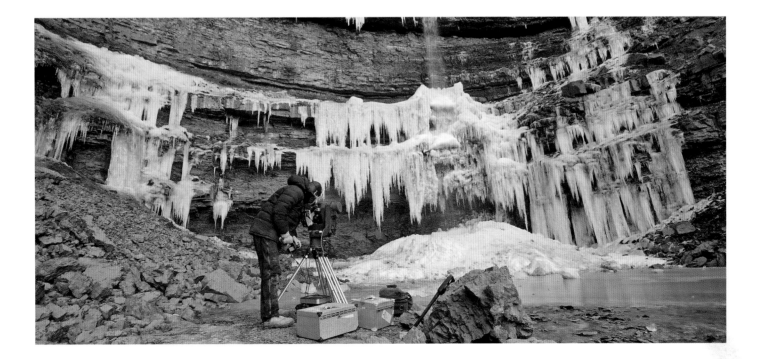

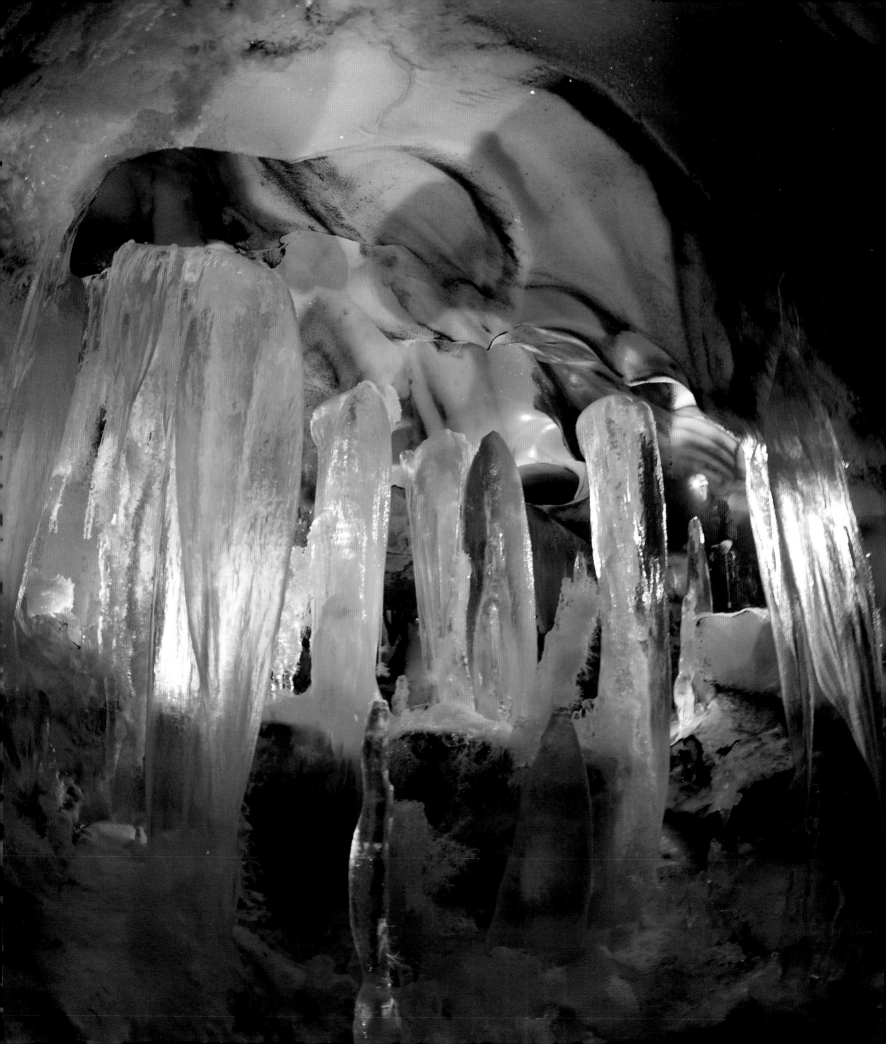

was used to show in one shot the caterpillar freezing, thawing and then walking off – no trick edits, just amazing behaviour. But to film the act of freezing required a learning curve as well as time-lapse. Using a walk-in freezer room in Cambridge University and a plastic tent to adjust the humidity, cameraman Tim Shepherd learnt how to make frost and finally ice crystals, tracking their growth with the motion-control rig.

Shooting the formation of snowflakes, though, required the expertise of Ken Libbrecht in California and his specially designed snowflake photomicroscope. The result was an art show (see page 162). But the most perfect laboratory for growing ice crystals turned out to be a natural one.

THE ICE-CRYSTAL CAVES

Antarctica's Mt Erebus is a volcano covered by a mini ice sheet, and under the ice is a labyrinth of melt caves created by seeping gas. These are uncharted, and the year director Chadden Hunter and cameraman Gavin Thurston filmed in them was the first year they had been explored by scientists. So there was no map – and no way of knowing when a chamber might melt and collapse.

'Every chamber would be more spectacular than the last,' says Chadden, 'full of crystals of every shape and form' – each one just H_2O, modified by the airflow and humidity. But to film the sparkling beauty required light and movement. The only option was to drag down 'railway' tracks and a dolly for the camera to sit on so it could glide round the crystal forms and capture the diamond shimmer. In the process, accidental carnage ensued. 'We would enter a chamber saying that was the most beautiful spot on the planet. Then just one breath in the wrong direction and a chandelier would drop to the floor,' says Chadden. 'Thank goodness we knew that the ice-works would take just days rather than years to grow back.'

There was a price to pay, though. Chadden and Gavin suffered incapacitating headaches, which at first they put down to working 14-hour, physically exhausting days at great height. No one, it turned out, had warned them about the dangerous levels of toxic volcanic gases.

The great melt

'Climate change isn't a theory. At the poles, it's happening, and on a very large scale,' says producer Dan Rees. The challenge was to find a way to show it. In 2009, the Wilkins Ice Shelf – a floating sheet of freshwater ice the size of Jamaica on the Antarctic Peninsula – began to break up. But from satellite photographs, 'it was impossible to tell what it would look like in reality – it could have just been an undramatic jumble of broken ice.' So it was on a wing and a prayer that the team set off to film it.

They took with them Dr Andy Smith from the British Antarctic Survey (BAS), to get his first impressions of the spectacle. BAS also provided two Twin Otter planes. 'They wanted to tell the world about what's happening in the Antarctic,' says Dan. 'As we flew over the last ridge, suddenly there it was in front of us – a vast, vast area of flat-topped giant icebergs, some at least a kilometre long, hundreds and hundreds of them as far as you could see.' The ice sheet was just disintegrating. Andy was gobsmacked.

'We landed on an iceberg, did a piece to camera with Andy and were finishing when the chief pilot came over and asked how much longer we'd be. I just thought

Opposite

1 Wilkins shelf ice-runway. Ted Giffords and sound-recordist Andrew Yarme film the arrival of the scientists in the second Twin Otter. 2–4 The view from the plane of the collapsing ice sheet and the flat icebergs, some a mile long. The scientists were there to place satellite transmitters on the icebergs so they could monitor their movements and lifespans (up to a year) as they drift north towards South Georgia and South America.

Below

Refuelling. The only way to get to the Wilkins Ice Shelf was in a British Antarctic Survey (BAS) plane, and the only way a plane could get there was to have a petrol-drum halfway fuel dump.

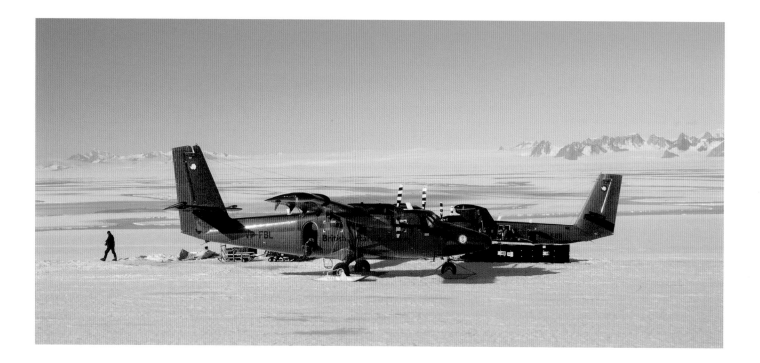

he wanted to get back for his tea. Then, pointing at the plane skids, he added, "It's just that there's a little crack opening up." We wrapped up fast then. Flying back, Ted filmed the other plane to give a sense of scale – a tiny, tiny plane over a sea of bergs.'

An Antarctic ice shelf is formed when glaciers stream out onto the sea and coalesce, acting like a cork to slow the flow of the glaciers or ice sheets behind. But if the water it's floating on or if the air above it warms, the shelf will thin and crack up and a lot more ice will be released into the sea.

'There's evidence', says Dan, 'that the West Antarctic Pine Island Ice Shelf is thinning as warmer water creeps under it.' That shelf is holding back a huge amount more ice than the Wilkins shelf is. If it disintegrates, the effects of the ice entering the sea and raising sea levels will be felt far away from Antarctica.

THE BREAK-UP

Researcher Adam Scott went to Greenland with cameraman Mateo Willis to film the Greenland Ice Sheet at its interface with the ocean, where huge icebergs are calved. 'We reached the Store Glacier knowing that a warm winter was affecting the behaviour of the big glaciers. As soon as we landed, we heard it – great cracks and bangs as it slipped forward.' They set up the cameras on a mountainside overlooking the glacier, focusing on the big tongue, hoping that it might break off. Three days later, sea fog rolled in. There was nothing they could do except listen to the increasing noise.

At 1pm the next day, the fog lifted, the sun came out and it happened. 'Spray was coming out of the top of the glacier as if someone was letting off dynamite. The weird thing was that being several kilometres away we would see the action but didn't hear it until seconds later . . . The entire middle section of the glacier, a kilometre wide, was breaking off, rolling backwards – the bottom two thirds that had been hidden was rearing out of the water, pushing the sea up with it. Then another enormous bit broke off, and another . . . 20 minutes of holding our breath, filming the most awesome thing I have ever seen.'

THE GREAT DRAIN

'When a moulin opens, it's as if a plug's been pulled,' says Vanessa. 'You hear it happening, like a massive earthquake. Then the lake just vanishes.' This was the scene on the top of the Russell Glacier, part of the Greenland Ice Sheet, where a record summer melt was in action. The team was there to film scientists monitoring how meltwater affects the ice sheet – key to understanding what will happen as the climate warms. 'Rivers drain off

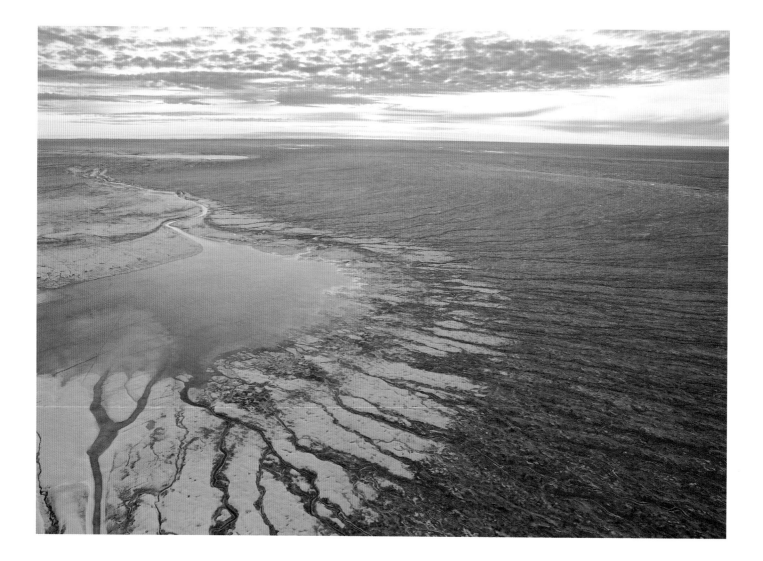

the huge blue meltwater lakes,' says Vanessa, 'creating great canyons and deltas.'

The water that pours down a moulin (basically a tube that goes right down to the bottom of the ice sheet) lubricates the glacier as it glides towards the sea. 'Even in a helicopter the noise of the water thundering down the moulin was deafening,' says Vanessa, 'as if it was plummeting to the core of the Earth. Looking down into that black abyss, I got vertigo for the first time ever in a helicopter. We hovered over the hole and then spun the Cineflex round to look back. We did it four times and were about to go round one more time when the pilot pointed to the fuel gauge and then the abyss. Time to stop.' They also filmed scientist Alun Hubbard descending into the abyss to drop instruments into the heart of the ice sheet to monitor what was happening. Camerawoman Justine Evans hung on a rope in the creaking, groaning ice tunnel filming him. She also filmed over the edge of a canyon as the white-water rapids raced down to a moulin. Three days later, the ice beach she'd been filming from had vanished.

Above

Blue water, Greenland. The meltwater lake is fast draining away into a delta of rivers and streams down the sloping dome of the ice sheet. One day, the lake could just vanish down a moulin that may suddenly appear in the middle of it like a giant plughole.

Opposite

Justine the Brave. The best way to film the waterfall was to abseil into the ice shaft, which plunged almost a kilometre (half a mile) down to the base of the glacier. The thunder of water and the creaking and groaning of the ice were so deafening that communication had to be by sign language.

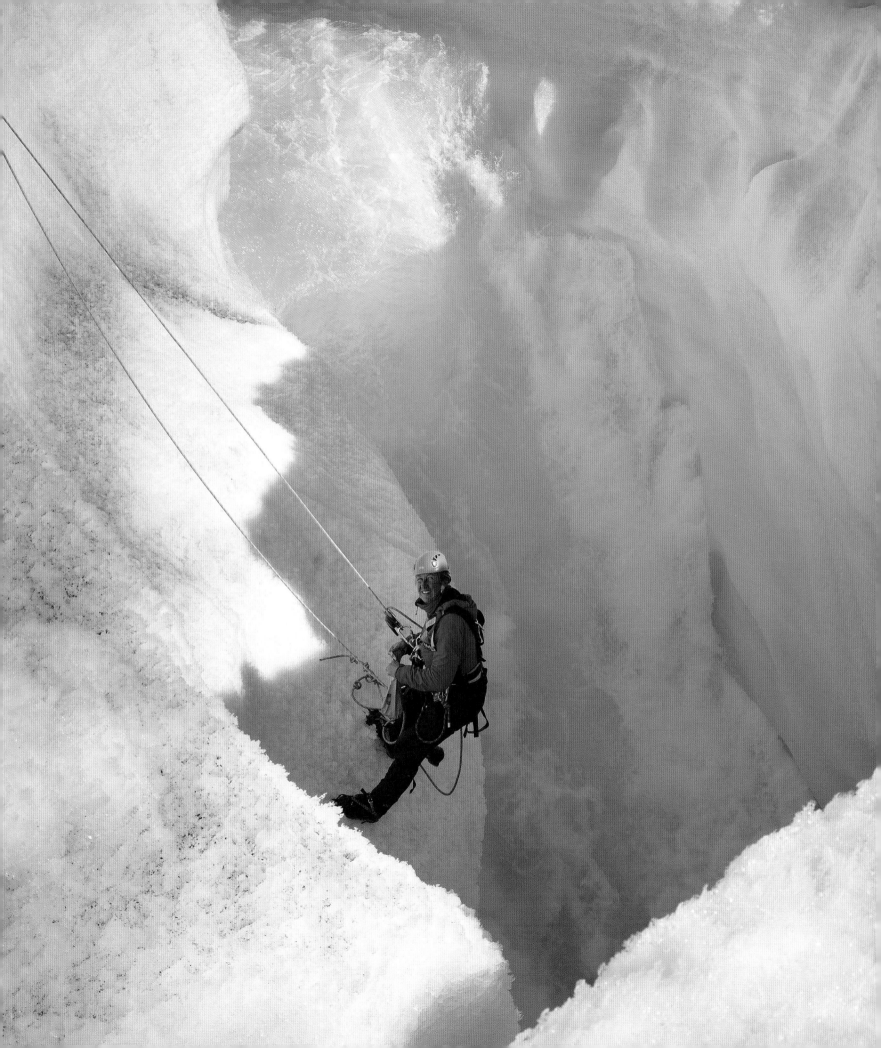

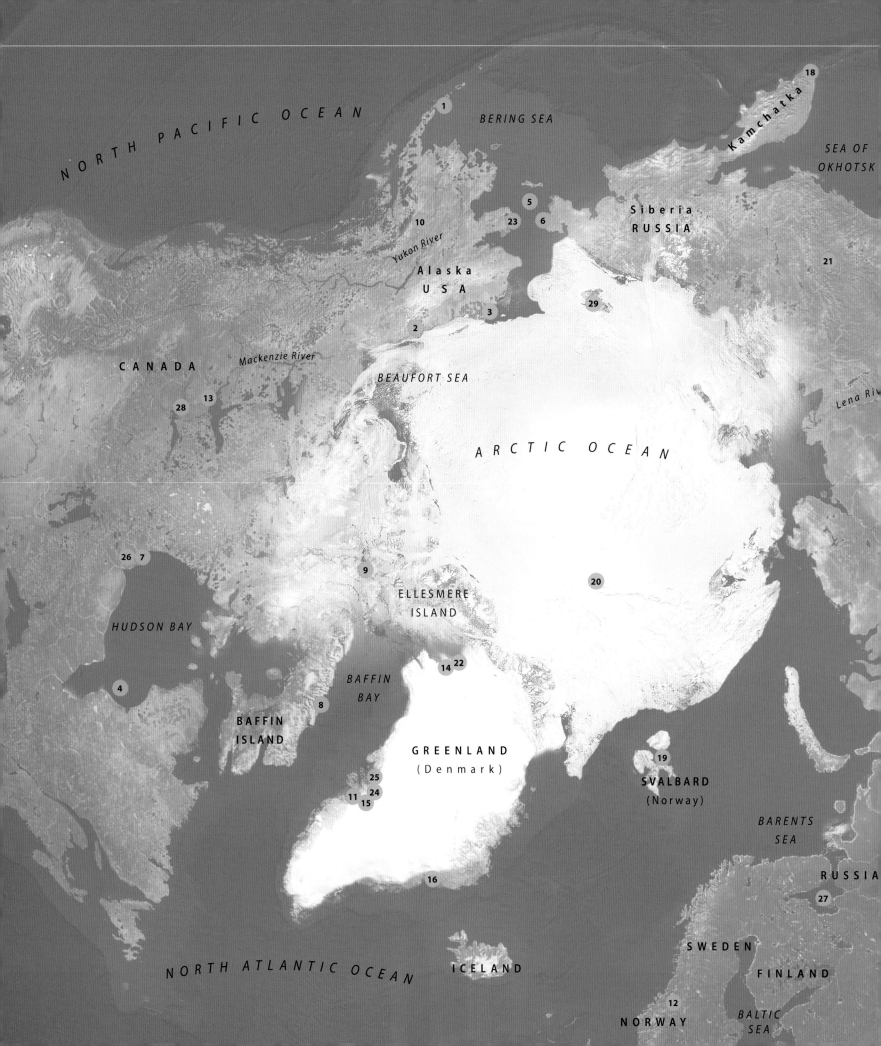

Taymyr
Peninsula

RUSSIA

17

Yenisey River

Ob River

The Arctic

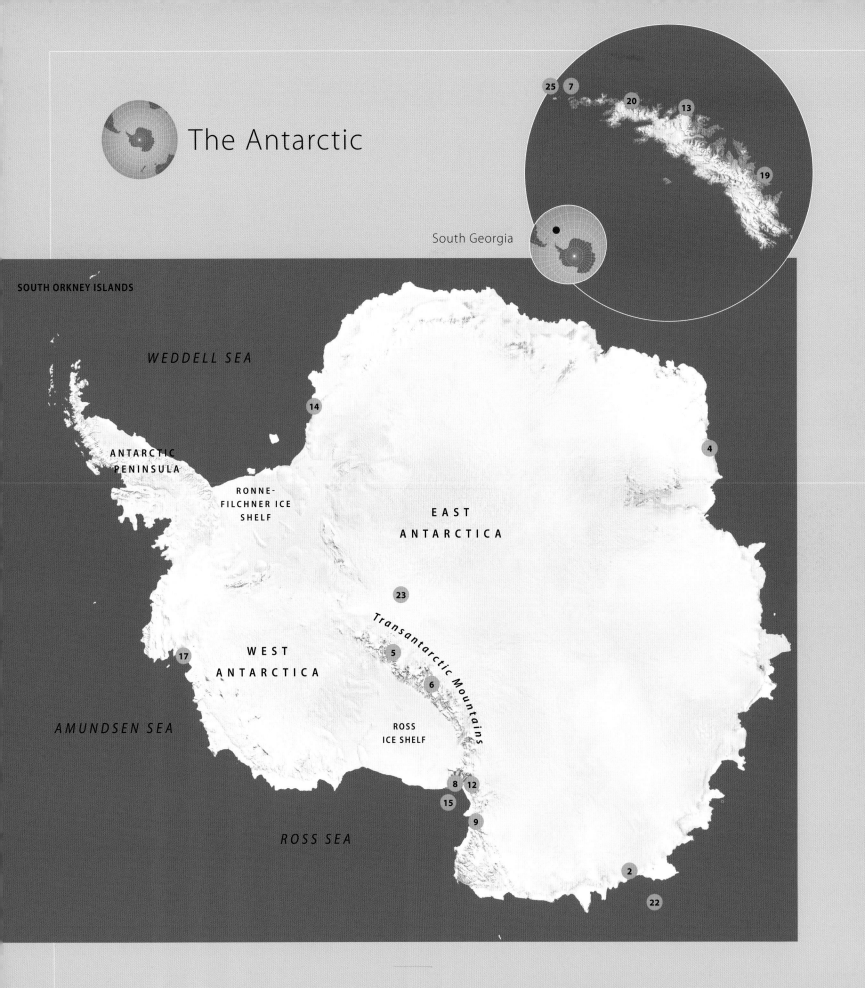

The Antarctic

South Georgia

SOUTH ORKNEY ISLANDS

WEDDELL SEA

ANTARCTIC PENINSULA

RONNE-FILCHNER ICE SHELF

**E A S T
A N T A R C T I C A**

Transantarctic Mountains

**WEST
ANTARCTICA**

ROSS
ICE SHELF

AMUNDSEN SEA

ROSS SEA

The Antarctic Peninsula

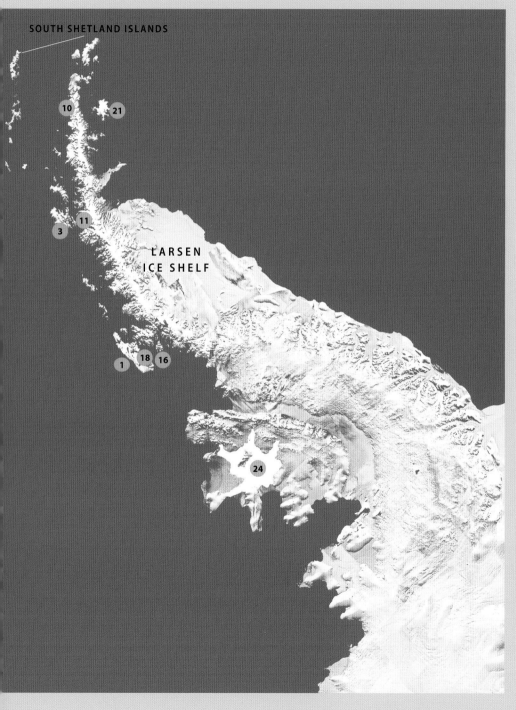

SOUTH SHETLAND ISLANDS

LARSEN
ICE SHELF

1	Adelaide Island
2	Adélie Land
3	Anvers Island
4	Auster emperor penguin colony
5	Axel Heiberg Glacier
6	Beardmore Glacier
7	Bird Island
8	Cape Crozier, Ross Island
9	Cape Washington
10	Charcot Bay, Graham Land
11	Danco Island
12	Dry Valleys
13	Fortuna Glacier
14	Halley UK base
8	McMurdo base
15	McMurdo Sound
16	Marguerite Bay
8	Mount Erebus
17	Pine Island Ice Shelf
18	Rothera UK base
19	St Andrews Bay
20	Salisbury Plain
21	Snow Hill
22	South Magnetic Pole 2010
23	South Pole
24	Wilkins Ice Shelf
25	Willis Islands

Index

kittiwakes *70–1*, 100
 black-legged 102
 red-legged 102, *105*
krill 24–6, 38, 72, 118
 bubblenet fish traps 120, *120–1*
 crabeater seals and 90
 elephant seals and 112, 114
 penguins and 89, 129
 whales and 120
 in winter 194
Kuril, Lake 190–3

L

lakes, meltwater *2–3, 232–3*, 233,
 299–300, 300
larch, Dahurian 176
Larsen B Ice Shelf 242, *242–3*
lemmings 110, *111*, 189
 collared 28, 110
Lena River 24
Libbrecht, Ken 295
lichens 26, *26*, 106, 139, 144, 213
light
 auroras 168–9, *168–9*
 looming 19
 in summer 15
 in winter 15, 167
limpets 196
Linfield, Mark 268, *292–3*
Longyearbyen, Svalbard 6
looming 19

M

Mackenzie River 24, 293
McMurdo US base 254, 256, 260–4,
 262, 268
McMurdo Sound *196–7*, 199
McPherson, Jamie 268, *269*
Maiviken *76*
Marguerite Bay 283, *283*
meltlake holes *210*
meltwater lakes *2–3, 232–3*, 233,
 299–300, 300
methane 237, *237*, 246
microbes, Dry Valley 48
migration 28, 32, 118, 135, 139, 144,
 227
Miller, Hugh 262, *262*, 264
molluscs 199
Montagu Island *40–1*
moon 167

moose 32, 144, 180
moss 118
moths 108, 293
moulins 20, 22, *234*, 299–300
mummies 210
Murphy, Paul 256
muskoxen *35*, 110, 139, *140–1*, 142

N

narwhals 72, *72*, 100, 135, 174, 227,
 268–70, *270*
NASA 222
National Snow and Ice Data Center,
 Colorado 220, 223
nematode worms 48
Noiret, Didier 264–7, *265–7*
Nordaustlandet *226–7*
North Pole 6, 15, 167, 223, *258*, 259
North Star 167, *167*
Northwest Passage 228
Northwest Territories, Canada 105
Norway 228
Norwegian Current 24
Novaya Zemlya 105

O

Ob River 24
ocean currents 22, 37, 225
oil reserves 228, *229*
Onyx River 48
owls *142*
 great grey 190, *191*
 snowy 28, 110, *110–11*, 139
Oymyakon, Siberia 19

P

Pacific Ocean 24, 228
pack ice 16, *16–17*, 37, 62, *63*
pearlwort, Antarctic 118
penguins 41, 129
 Adélie *43*, 44, 92–4, *92–5*, 118,
 128–9, 129, 152–9, *152–3, 156–7*,
 238–9, *238*, 259, 271–5, *272, 274*
 chinstrap *40–1, 88–9*, 89, 118, *119*,
 129, *154–5*, 159, 287, *287*
 emperor 160, *160–1, 165*, 202–5,
 202–5, 264–7, 265–7
 gentoo 86, *86*, 118, 129, 156, 239,
 240–1, 287
 king *4–5, 77, 77*, 82, 112, *115–17*,
 151, *151*, 202

macaroni 86, *87*
permafrost 105, 108, 176, 236–7
Petermann Glacier *210*, 233
petrels 41–2, 44, 85
 blue 85
 diving 85
 southern giant 149, *149*
 white-chinned 85
 Wilson's storm 42
phalaropes
 red 102
 red-necked 102
phytoplankton 24
Pine Island Ice Shelf 299
pintail duck, South Georgia 151
pipit, South Georgia 112
Pitman, Bob 281, *281*, 287, *287*
plankton 22, 38, 197
plants
 Antarctic 118
 Arctic 74, *75*, 106, *107*
 tundra 74–5, *74*, 105–6
 under snow 188
platelets, ice 194
polar bears 16–19, *19, 97*
 adaptations for ice 16
 in autumn 132–5, *133*
 birthing dens 170, *171–3*, 172
 cubs *7, 18*, 56, *56, 57–8, 98–9*, 99,
 167, 170, *172–3*, 227
 effects of climate change *224–5*,
 225–7
 filming *276-80*, 277–80
 fur 170
 hunting 62–4, *64–7*, 66, 68, 99–100,
 100–1
 mating 56, 60–2, *60, 61*
 metabolism 170
 numbers of 19
 milk 170
 play-fights 132–5, *134*
 scavenging 105, 132
 sense of smell 60, *278–9*
 sleep 100
 territory 19
Polar Front 37, 41, 112
pollinators 106
polynyas 72, 174, *175*
Poncet, Jérôme 254, 281, 283
poppies, Arctic 106, *106*
pressure ridges, ice 16, 62

Prince Albert Mountains *252*
prions, dove 85
ptarmigans 139, *176*
puffins 68

R

ravens 28, 139, 168, 180, *180*
razorbills 68
Rees, Dan 296–8, 299
reindeer (caribou) 28, 110, 144,
 144–7, 180–5, *212*, 213, *214–15*,
 236
rime 176
rivers 24, 48, 293
rocks
 Dry Valleys *49*
 Transantarctic Mountains 46
 ventifacts rocks 48
Ronne-Filchner Ice Shelf *52–3*, 245
Ross, James Clark 44, 46
Ross Ice Shelf 245, *245*, 268, 271
Ross Sea 53, *122–3, 251*, 260–4, *261–3*
Royal Navy 221, 254
Russell Glacier 299–300
Russia
 birds 105
 North Pole flag 15, 228
 oil prospecting 228
 population 210
 rivers 24, 293
 traditional hunters 217–18, *217*
 tundra 27
 see also place names

S

St Andrews Bay, South Georgia *4–5*,
 81–2
St Lawrence Island *175*
Salisbury Plain, South Georgia *116–17*
salmon, sockeye 190–3
salt 48, 199
Sami 168
saxifrage, purple 74, *75*, 106, *107*
Scientific Committee on Antarctic
 Research (SCAR) 246
Scotia Arc 42
Scott, Adam *298–9*, 299
Scott, Captain Robert 46, 53, 248,
 258, 259, 273
scree 176
sea-level rises 50, 234, 245, 246, 299

A Firefly Book

Published by Firefly Books Ltd. 2012

First printing

A CIP record of this book is available from Library of Congress

A CIP record of this book is available from Library and Archives Canada

Published in the United States by
Firefly Books (U.S.) Inc.
P.O. Box 1338, Ellicott Station
Buffalo, New York 14205

Published in Canada by
Firefly Books Ltd.
66 Leek Crescent
Richmond Hill, Ontario L4B 1H1

Printed in Italy

Developed by:
BBC Books, an imprint of Ebury Publishing.
A Random House Group Company
www.randomhouse.co.uk

Commissioning editors:
Shirley Patton and Muna Reyal
Project editor: Rosamund Kidman Cox
Designer: Bobby Birchall, Bobby&Co Design
Picture researcher: Laura Barwick
Image grading: Stephen Johnson, Copyrightimage
Production: David Brimble

Acknowledgements

This book could not have come to fruition without the television series it accompanies, and it is no exaggeration to say that the television series could simply not have been made without the extraordinary and talented team that spent four years producing it. From Bristol, our production management coordinated some of the most complex and remote shoots ever attempted by the BBC Natural History Unit, while our teams on location braved the harshest conditions on our planet for up to six months at a time. Their absolute commitment to record unique, often unrepeatable, images and sounds from the poles, was matched by the determination of the post-production team to ensure that all these elements were brought together and finished to the highest standards in the final films.

Beyond the immediate production teams, there are people and organizations without which we simply could not have accessed a fraction of the wonders of the poles. In particular, the National Science Foundation agreed to support seven different film crews in Antarctica, some for nearly six months at a time, so that our series could capture an extraordinary range of groundbreaking footage. We are extremely grateful to all the Raytheon employees and scientists that were based at McMurdo – all of them so generous with their time and assistance during our stay. NSF also gave us major aerial support so that we could take our cameras into some of the most inaccessible parts of the Antarctic, filming places that few humans have ever seen. The Royal Navy similarly supported our crews over a number of Antarctic seasons so that we could capture unique aerial images of the Antarctic Peninsula and South Georgia. We are extremely grateful to all the brave and talented pilots who made our ambitious aerial filming possible at both poles.

The British Antarctic Survey helped to support our teams at their bases at Bird Island and Rothera. The Polar Continental Shelf Project provided vital logistics in the Canadian Arctic. The Inuit communities made us welcome and guided us across tricky ice. Jérôme and Dion Poncet once again proved that the *Golden Fleece* is the best possible boat for filming in Antarctic waters, while Jason Roberts and his team on Svalbard provided outstanding support and logistics for the many shoots we did in that beautiful archipelago. Without the help and advice from Dr Alan Hubbard and his team, much of our filming in Greenland would not have been possible. There is simply not the space to list all the scientists who gave so freely of their research or the field experts who provided us with vital support. However, we will always be grateful for what they did.

Finally, we would like to thank Shirley Patton and Muna Reyal for commissioning this book; Laura Barwick for sourcing the wonderful images and Bobby Birchall for the excellent design; and Rosamund Kidman Cox for writing the stories for chapter 7 and being everything you could want in an editor.

PRODUCTION TEAM
Miles Barton
Vanessa Berlowitz
Helen Bishop
Katie Cuss
Samantha Davis
Fredi Devas
Alastair Fothergill
Chadden Hunter
Bridget Jeffery
Kathryn Jeffs
Anna Kington
Mandy Knight
Karen Le Huray
Mark Linfield
Dan Rees
Jason Roberts
Adam Scott

Matt Swarbrick
Elizabeth White
Jeff Wilson

CAMERA TEAM
John Aitchison
Doug Allan
Doug Anderson
David Baillie
James Balog
Barrie Britton
John Brown
Richard Burton
Jo Charlesworth
Rod Clarke
Martyn Colbeck
Stephen de Vere
Justine Evans

Wade Fairley
Tom Fitz
Ted Giffords
Oliver Goetzl
Joel Heath
Max Hug Williams
Michael Kelem
Ian McCarthy
Alastair MacEwen
David McKay
Jamie McPherson
Justin Maguire
Hugh Miller
Peter Nearhos
Didier Noirot
Ivo Nörenberg
Petter Nyquist
Mark Payne-Gill

Anthony Powell
Adam Ravetch
Tim Shepherd
Warwick Sloss
Mark Smith
Gavin Thurston
Jeff Turner
Mateo Willis
David Wright
Mike Wright
Daniel Zatz

SOUND RECORDISTS
Mark Roberts
Chris Watson
Andrew Yarme

FIELD ASSISTANTS
Steiner Aksnes
Tim Fogg
Oskar Storm
Lisa Ström
Oskar Ström

ADDITIONAL PRODUCTION
Penny Allen
Amirah Barri
Felicity Egerton
Sinead Gogarty
Justine Hatcher
Amanda Hutchinson
Simon Nash
Lisa Sibbald
Martin Tweddell
Elizabeth Vancura
Jo Verity
Robert Wilcox
Simon Wylie

POST PRODUCTION
Marc Baleiza
Ruth Berrington
Rowan Collier
Andy Corp
Richard Crosby
Kate Gorst
Harry Grinling
Miles Hall
Janne Harrowing
Wesley Hibberd
Richard Hinton
Shaun Littlewood
Rebecca Murden
Ruth Peacey
Steve Pelluet
Caroline Stow
Sarah Wade
Josh Wallace

MUSIC
George Fenton
Barnaby Taylor
BBC Concert
 Orchestra

FILM EDITORS
Nigel Buck
Andrew Chastney
Andy Netley
Dave Pearce
Steve White

ONLINE EDITOR
Adrian Rigby

EDIT ASSISTANTS
Darren Clementson
Robbie Garbutt
Jan Haworth

DUBBING EDITORS
Jonny Crew
Paul Fisher
Kate Hopkins
Tim Owens

DUBBING MIXER
Graham Wild

COLOURIST
Luke Rainey

GRAPHIC DESIGN
BDH (Burrell Durrant
 Hifle)
Steve Burrell
Mick Connaire
Paul Greer
Jess Lee

OPEN UNIVERSITY
Mark Brandon
David Robinson
Janet Sumner

AXSYS
Babette Foster
Tanya Foster
Jason Fountaine
Eric Groome
Colleen Zimmerman

WITH SPECIAL THANKS TO
Jon Aars
The ABC Crew
Nok Acker
David Ainley
Airlift AS
Alaska Department of
 Fish and Game
Tom Allen
Wayne Alphonse
Magnus Andersen
Ben Anderson
Bill Andrews
Antarctic Heritage
 Trust
Arctic Circle Dive
 Centre
Arctic Watch Wildlife
 Lodge
Josée Auclair
Australian Antarctic
 Division

Lisa Baddeley
Baffin Region
 Hunters and Trappers
 Organization
Al Baker
Grant Ballard
Barrow Arctic Science
 Consortium
Fergus Beeley
Leah Beizuns
Jørgen Berge
Bob Bindschadler
Dustin Black
Dave Blackham
Don Blankenship
Scott Borg
Rob Bowman
Victor Boyarsky
British Film Institute
Gordon and Lewis
 Brower
Sue Buckett
Bernard Buigues
Darcy Burbank
Richard Burt
Misha Bykoff
Linda Capper
Tony and Kim Chater
Natalia Chervyakova
CMS, University of
 Cambridge
Jessie Crain
Brian Crocker
Bruno Croft
Kim Crosbie
Tom Crowley
Niall Curtis
Christopher Dean
Andrew Derocher
DigitalGlobe Inc
Marko Dimov
Athena Dinar
George Divoky
Alice Drake
Dave Drake-Brockman
John Durban
Jessica Farrer
Shawn Farry
Sue Flood
Erlend Folstad
Bill Fraser
Gretchen Freund
Gina Fucci
Robert Garrot
Shari Gearheard
Henk Geerdink
Craig George
Grant Gilchrist
Toni Gilson-Clarke
John Gordon

The Government of the
 Northwest Territories
The Government of
 South Georgia and
 the South Sandwich
 Islands
The Governor of
 Svalbard
Greenland Command
Alexander Groothaert
Julie Grundberg
Don Hampton
Roland Hansen
Lisa Harding
Joe Harrigan
Michelle Hart
Jack Hawkins
Pic Haywood
Stig Henningsen
Greg Henry
Roger and Fiona
 Hickman
Faye Hicks
Karen Hilton
Denver Holt
Barry Hough
Igloolik Hunter and
 Trappers Organization
Claudia Ihl
David Iqaqrialu
Iviq Hunters and
 Trappers Organization
Nicole Jacob
Barry James
Piotr Jarkov and
 family
Jessy Jenkins
David Jobson
Brian Johnson
Rasmus Jørgensen
Henry Kaiser
Valentine Kass
Liz Kauffman
Juha Kauppinen
Aziz Kheraj
Stacy Kim
Richard Kirby
Andrei Klimov
José Kok
Gerry Kooyman
Olga Kukal
Jyrki Kurtti
Bjørne Kvernmo
Phil Kyle
Olli Lamminsalo
Pascal Lee
Gerald Lehmacher
Gordon Leicester
Kenneth Libbrecht
Ian Llewellyn

Geoff Lloyd
James Lovvorn
Alain Lusignan
Tim McCagherty
Jimmer and Alyssa
 McDonald
Jim McNeill
Paula McNerney
Jen Mannas
James Marsh
Cory Matthews
Alan Meredith
Aled Miles
Mittimatalik Hunters
 and Trappers
 Organization
Montana State
 University
Paul Morin
Paul Murphy
NASA
NASA Scientific
 Visualization Studio
Ron Naveen
The New Island
 Conservation Trust
Louis Nielsen
Novoe Chaplino
 Hunters' Collective
Jimmy Nungaq
Leetia Nungaq
Petter Nyquist
Kieran O'Donovan
Frederique Olivier
Clive Oppenheimer
Alexander Orlav
Lasse Østervold
Liemikie Palluq
George Panayiotou
Lane Patterson
Lloyd Peck
Jari Peltomaki
Scott Pentecost
Aaron Peters
Kenett Petersen
Stephen Petersen
Kevin Pettway
Bob Pitman
Polar Geospatial Center
Simon Qamaniq
Quark Expeditions
Julie Raine
Mark Reese
Dave Reid
Ignatius Rigor
Ceiridwen Robbins
Rob Robbins
Thomas Romsdal
Trent Roussin
Jane Rumble

Steve Rupp
Steve Scammell
Florent Schoebel
Glenn Sheehan
Tore Sivertsen
Mike Skevington
Janice Sloan
Andy Smith
Matt Smith
Adia Sovie
Sharon 'Rae' Spain
Glenn Stauffer
Ian Stirling
Martha Story
Cara Sucher
David Sugden
Paul Sullivan
Monica Sund
Dr Janne Sundell
Dylan Taylor
Becky Thompson
Niobe Thompson
T'licho First Nation
Jez Toogood
Matthew Torrible
James Travis III
Hailaeos Troy
Nick Turner
The University Centre
 in Svalbard
USCG Healy
Mark van de Weg
David Vaughan
Rindy Veatch
Andrey Vinnikov
Peter Wadhams
Katey Walter
Jeremiah Walters
Stewart and Cody
 Webber
Richard, Tessum and
 Nansen Weber
Wood Buffalo National
 Park
Dave Wride
Yacht Australis
Lena Yakovleva
Hannu Ylönen
Yellowknife Dene First
 Nation
Paul Zakora

Picture credits

1 Nick Cobbing/Greenpeace; 2–3 Daisy Gilardini/Getty; 4–5 Ted Giffords; 7 Sergey Gorshkov; 8 Dan Rees; 9 R Pitman; 10–11 Daisy Gilardini/Getty.

CHAPTER 1

13 Wild Wonders of Europe/Jensen/naturepl.com; 14 Daisy Gilardini/Getty; 15 BDH/BBC; 16 Pål Hermansen; 17 Andy Rouse; 18 Daisy Gilardini/Getty; 19 Andy Rouse; 21 Adam Scott; 22 Jenny E Ross; 23 Nick Cobbing/Greenpeace; 24–5 John Aitchison; 26 Jack Dykinga/naturepl.com; 27 Sergey Gorshkov; 28–9 Sergey Gorshkov; 30–1 Wild Wonders of Europe/Munier/naturepl.com; 32–3 Orsolya Haarberg/naturepl.com; 34 Laurent Geslin/naturepl.com; 35 Sergey Gorshkov; 36 Tui de Roy/Minden Pictures/FLPA; 37 Tui de Roy/Minden Pictures/FLPA; 38–9 Chadden Hunter; 40–1 Maria Stenzel/National Geographic Image Collection; 42 Jan Vermeer/Minden Pictures/FLPA; 43 Yva Momatiuk & John Eastcott/Minden Pictures/Getty; 44–9 Vanessa Berlowitz; 51 Dan Rees; 52–3 Daisy Gilardini/Getty.

CHAPTER 2

55 Paul Nicklen/National Geographic Image Collection; 56 BBC; 57 Staffan Widstrand/naturepl.com; 58–9 Jason Roberts; 60–2 Jason Roberts; 63 Andy Rouse; 64–5 Jenny E Ross; 66tl Daisy Gilardini/Masterfile; 66tr BBC; 66b BBC; 67 BBC; 68–69 Pål Hermansen; 70–1 Ted Giffords; 72–3 Paul Nicklen/National Geographic Image Collection; 74 Adam Scott; 75 Matt Swarbrick; 76–9 Andy Rouse; 80–1 Roy Mangersnes/naturepl.com; 81 Miles Barton; 82–3 Matt Swarbrick; 84 Andy Rouse; 85 Fred

Olivier; 86–7 Andy Rouse; 88–9 Maria Stenzel/National Geographic Image Collection; 89 Andy Rouse; 90 John Aitchison; 90–1 Andy Rouse; 92–3 Jeff Wilson; 94–5 Jeff Wilson.

CHAPTER 3

97 Andy Rouse; 98 Daisy Gilardini/Masterfile; 99–101 Jason Roberts; 102 John & Mary-Lou Aitchison/naturepl.com; 103 Jason Roberts; 104 Pål Hermansen; 105 Jenny E Ross; 106 BBC; 107 T Jacobsen/ArcticPhoto.com; 108 Pål Hermansen; 109 Kieran O'Donovan; 110 Andy Rouse/naturepl.com; 111 Markus Varesvuo/naturepl.com; 112–13 Nick Garbutt; 114 Ingo Arndt/naturepl.com; 115 Andy Rouse; 116–17 Andy Rouse; 118 Flip De Nooyer/FotoNatura/Minden Pictures/FLPA; 119 Rick Tomlinson/naturepl.com; 120 Yva Momatiuk & John Eastcott/National Geographic Image Collection; 121 Steven Kazlowski/naturepl.com; 122–3 Chadden Hunter; 124–5 John Durban; 125 R Pitman; 126–7 Kathryn Jeffs; 128–9 Colin Monteath/Hedgehog House/Minden Pictures/National Geographic Image Collection.

CHAPTER 4

131 Sergey Gorshkov; 132 Jenny E Ross; 133 Sergey Gorshkov; 134 Jenny E Ross; 136–7 Elizabeth White; 138 Sergey Gorshkov; 139 Ryan Askren; 140–2 Sergey Gorshkov; 143 Bryan and Cherry Alexander/naturepl.com; 144–5 Wild Wonders of Europe/Munier/naturepl.com; 146–7 Ingo Arndt/naturepl.com; 148 D Rootes/ArcticPhoto.com; 149 Pete Oxford/naturepl.com; 150 Jenny E Ross; 151 Suzi Eszterhas/naturepl.com; 152 Jenny E Ross; 153–5 John

Aitchison; 156–7 Jeff Wilson; 158–9 Daisy Gilardini/Masterfile; 160 John Aitchison; 161 Jason Roberts; 162tl BBC 162–3 Ken Libbrecht/BBC.

CHAPTER 5

165 Daisy Gilardini; 166 Pål Hermansen; 167 Kaj R Svensson/Science Photo Library; 168–9 Jamie McPherson; 171 Jason Roberts; 172–3 BBC; 175 James Lovvorn; 176 Morten Hilmer; 177 Fredi Devas; 178–9 B&C Alexander/ArcticPhoto.com; 180 Markus Varesvuo/naturepl.com; 181 Sergey Gorshkov; 182–3 Chadden Hunter; 184 BBC; 186–7 BBC; 189t Kathryn Jeffs; 189b Sergey Gorshkov; 191 Markus Varesvuo/naturepl.com; 192–3 Sergey Gorshkov; 195 Neil Lucas/naturepl.com; 196–7 Doug Anderson; 198 Hugh Miller; 200–1 BBC; 202–3 John Aitchison; 204–5 Pål Hermansen; 206–7 Fred Olivier.

CHAPTER 6

209–210 Nick Cobbing/Greenpeace; 211 Bryan and Cherry Alexander/naturepl.com; 212–13 Dan Rees; 214–15 Bryan and Cherry Alexander/naturepl.com; 216 Jenny E Ross; 217–19 Adam Scott; 220 Elizabeth White; 221 Adam Scott; 222–3 BDH/BBC; 224–5 Jenny E Ross; 226–7 Andy Rouse/Getty; 228 Richard Olsenius/National Geographic Image Collection; 229 Lowell Georgia/National Geographic Image Collection; 230–1 Morten Hilmer; 232–3 Nick Cobbing/Greenpeace; 234–6 James Balog/ExtremeIceSurvey.org; 236 Sue Flood/Getty; 237 Todd Paris/UAF Marketing and Communications; 238t BDH/BBC; 238b John Aitchison;

239 BDH/BBC; 240–1 Joel Sartore/National Geographic Image Collection; 242–3 VisibleEarth/NASA; 244 BBC; 245–7 Daniel Beltra; 249 Pete Oxford/naturepl.com.

CHAPTER 7

251 Hugh Miller; 252 Alastair Fothergill; 253 Dan Rees; 254 Doug Anderson; 255 Elizabeth White; 256 Alastair Fothergill; 257 BBC; 258 Jason Roberts; 259 Dan Rees; 260 Nataliya Chervyakova; 261 Hugh Miller; 262 Doug Anderson; 263 Hugh Miller; 265t Chadden Hunter; 265b Pål Hermansen; 266–9 Chadden Hunter; 270 Mark Linfield; 271–2 Jeff Wilson; 274 Jeff Wilson; 276 Jason Roberts; 277 Andy Rouse; 278–9 Sergey Gorshkov; 280 Miles Barton; 281 Kathryn Jeffs; 282 R Pitman; 282–3 Kathryn Jeffs; 284–5 John Durban; 285 R Pitman; 286–7 R Pitman; 287 Doug Anderson; 289–291 Chadden Hunter; 292 Mark Linfield; 293 Adam Scott; 294 Jason Roberts; 295 Chadden Hunter; 296 Dan Rees; 297 Dan Rees; 298–9 Adam Scott; 300 Adam Scott; 301 Vanessa Berlowitz; 302–3 Planetary Visions Ltd/Science Photo Library & NASA/GSFC, MODIS Rapid Response; 303 iStockphoto.com/Anton Seleznev; 304 Planetary Visions Ltd/Science Photo Library; 304 inset NASA Landsat ETM+ imagery; 304 iStockphoto.com/Anton Seleznev; 305 British Antarctic Survey/Science Photo Library.

endpaper front: Sue Flood/Getty; endpaper back: Jenny E Ross.